GOTHIC EUROPE

Frontispiece: Stone figures climbing the buttresses on the Cathedral at Bois-le-Duc ('s Hertogenbosch)

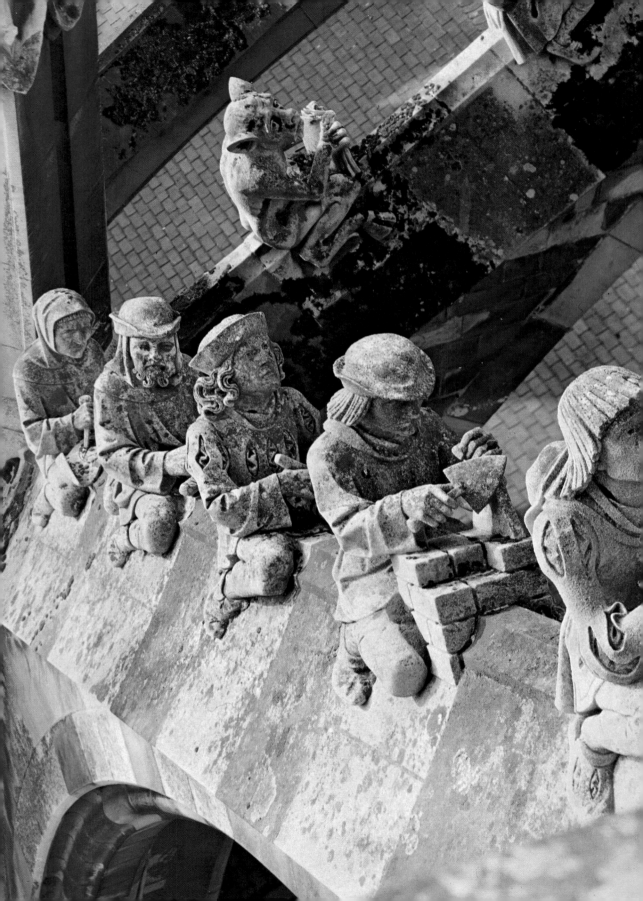

Gothic Europe

SACHEVERELL
SITWELL

HOLT, RINEHART AND WINSTON

NEW YORK CHICAGO SAN FRANCISCO

TO SUSANNA AND
GEORGE

Contents

List of Illustrations

LIST OF ILLUSTRATIONS

Picture Research by Julia Hornak

The author and publishers particularly wish to thank Edwin Smith and James Austin for unfailing help in the preparation of this book. The photographs of Tomar and the interior at Belém were kindly lent by Dr Robert C. Smith.

Preface

Perhaps an explanation is needed for the scope and purpose of what follows in these pages. But having written of our domestic architecture in its prime from 1660 to 1830 in *British Architects and Craftsmen*, and contributed an introduction to Mrs Esdaile's *English Church Monuments, 1510–1840*, I have long wanted to write of the earlier period in England with a pen, I dare to hope, all the fresher from having worked for long years on subjects and themes that lie outside those limits. It will be noticed that there are omissions just as there are of course additions. Much as I admire mediaeval tombs, for instance, I have felt absolved from writing an entire chapter on them for the mere reason that it would be too depressing. Instead, I have written in lighter mood of fan vaults, flushwork, angel ceilings. Not that it would be impossible to write of a whole string of churches and give them the composite individuality of the persons in a novel but I would not want the reader to think this whole book is about churches. Certainly churches, and cathedrals too, come into it, but now as ever it is the world of human beings that is the theme and subject. It treats of the beautiful and inspiring things of the world, and not of charnel pits and houses of the dead.

The abstractions and austerities of the age we live in, and the call for 'breakthroughs' in the arts 'after which nothing will ever be the same again', only make the more permanent many of the things written of in these pages, even in remote village churches, and they are seen to possess therapeutic and life-enhancing qualities. For the many people who find all they want in the Romanesque, which is entirely to be understood at Conques, and at other sites in many parts of France, there is the tendency of the age to neglect such a wonder of its kind as the Angel Choir at Lincoln. It is easy enough by the same token to admire a Perpendicular church tower while dismissing as frippery a fan-vaulted ceiling. Yet both are in the same category of peaceful and quiet music. The apocalyptic terrors, Last Judgements, and plight of the damned, are no less a part of the greater or major Gothic which could surpass and transcend all moods. I have found a special delight in writing of tapestries,

and could wish there were more of the secular and less of the religious in my theme. But the attempt has been to write of sacred objects as works of art, and to show and manifest pleasure and not only the religious implications in them.

It is my great regret that I have been unable to compile a demonology of gargoyles, as was my intention, and even have conversations, or hold dialogues with several of the demons. For many years I have been hoping to find a work on gargoyles similar in scope and in patient labour to the mid-Victorian *Spires and Towers of England*, in three volumes (1853–5) by Charles Wickes, with more than fifty lithographs, and at times as many as five or even seven towers or spires to a single plate, making a total of some hundred and twenty or thirty separate drawings, and as many, or more visits, of course, to the towns or villages concerned. The book on gargoyles could be in any language; and I have felt sure there must have been someone going round the gargoyle countries – which are France, England, Germany, and the Low Countries – patiently, with camp stool and field glasses, rain or fine, to make the drawings. But I have failed to find him. What a compilation it could have been! And what an anthology or dictionary of oddities, from which of a certainty some secrets would have emerged by now!

The first part of the book is concerned with this country alone, after which a 'Fantasia on the Gothic' attempts to enlarge the theme into France, Germany, Italy, and Spain. Over such matters it is more than ever necessary to keep one's head and not admire everything indiscriminately only because it is old and genuine. There are cathedrals in Northern Europe that on a wet day can look like old abandoned railway engines in a railway yard. At others we are lost in wonder and admiration the more we see them. There is always our national tendency to ignore or belittle what is our own, or praise it for the wrong reasons. By no argument is our best inferior to that of other countries, while in equal sense the refinements of the Perpendicular which is our national style are only found here and nowhere else.

There follows the chapter on tapestries which I could wish to have been of greater length, but it is difficult to write in detail of any work of art which is not illustrated. A book on tapestries should be all illustrations. An episode on the Manoelino style in Portugal by way of entertainment and divertissement, and a chapter, or charivari, on approaches to the Gothic in other, non-Christian lands concludes the programme. Because the book has been written with the hope and intention of being easy to read, which is very far from inevitable in the subject chosen, it has been a pleasure to write; and once again and always, it is written in praise, not of the deity but of the God in ourselves, and the wonders of which human beings are capable during the short span of grace that is the difference between the living and the dead.

Opposite: Viollet-le-Duc's chimaeras from the parapet of Notre-Dame, Paris

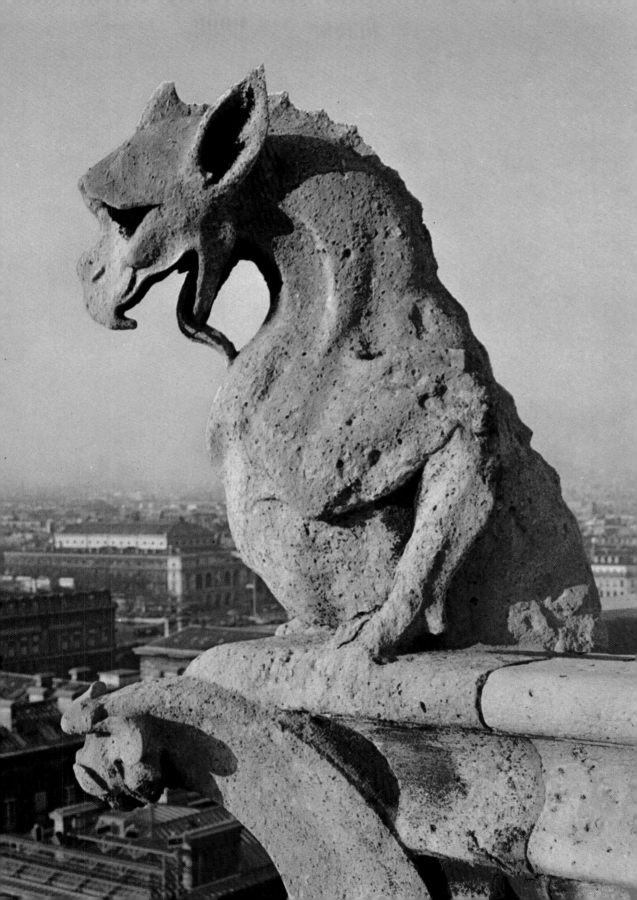

BOOK ONE

I

The Spires and Towers of England

In this age of crisis, of indecision and disintegration in the arts, and of a headlong rush of amateurs into the vacuum in music and poetry, in architecture – less there than in the other arts if only, perhaps, because there are still examinations to be passed – in sculpture and in painting, it is more than ever salutary to look into the future out of the past. From out of our own past, not that of someone, or, indeed, everyone else's past. We have to look in the glass and face ourselves, and not the selected, if hypothetical, ancestors of no blood affinity at all. To invoke, even with the most skilled and versatile of hands, children's drawings; Negro sculptures from the Congo or Benin; ceremonial masks and canoe-paddles of the Pacific Islanders; or the Chacmul of the Mayans, an enigmatic stone figure lying knees up, resting on both elbows, head turned with fixed, if sinister vacuity, to one side, and in its lap the hollow or receptacle for a heap of freshly plucked and still palpitating human hearts – all such, really and truly, is of little help or encouragement to mid-, or indeed three-quarter way through, twentieth-century man. We must be ourselves and desist from dressing up, figuratively, as Red Indians; even if it be true that the nomads of the steppe were consummate artists-in-little in their gold objects, and that the rock-paintings of the Sahara, no desert then, more than the Athens of Phidias and Praxiteles, than the Stanze of Raphael, or the Sistine Chapel, may be the real, because aboriginal, academy of drawing.

We, in this island, were ruled for four centuries from Rome, awareness of which does not dispel the shock of reading the name *Londinium* spelt out in Roman capitals on a piece of stone or tile. In the darkest times of the sixth and seventh centuries there must still have been knowledge of Roman roads and coins, of mosaic pavements in 'cold harbours' or deserted villas, perhaps some tradition of Roman theatres, their hot baths, even their central heating. There had been a civilization, and it had gone, but another was slowly forming in its place. That, too, like the Roman, came from a foreign landing or invasion. To the adventurous, the rapacious Normans, only a few generations away from the Norwegian Fjords, or, it could be, the milder sand dunes of Jutland, it was a promised land almost within sight from the farms and cider

orchards of Normandy, and they did not wait long to make a successful attempt at it. This was the Anglo-French ancestry of our early Middle Ages, the French dimension of which had the Norman, and on top of that, a later sprig of the Angevin grafted upon it, while from the Anglo or native English part in it, the Saxon or the Germanic has been, as though purposefully, omitted. Such has been our indigenous growth into what we are; and neither former possession of the biggest empire there has ever been, nor its voluntary dispersal by mutual agreement into many disparate constituents, large and small, can fundamentally change or alter that basic origin. Wherever there have been Middle Ages, even if the antecedents are different, the residual problems are the same and have become identical, if with greater opportunity and on a larger scale in the USA.

Sooner or later the abstract doodle, and the flat-iron and packing-case for architectural model, whether it be hotel or offices or block of flats, must go. There will have to be recognizable portraits and statues of human persons, and there must be ornament again . . . Or is it hopeless? For that may well be the case. The future probabilities being over-population, and atomic annihilation. Or both. Or either... Or it could be that the hand of man returns and can do no wrong, as has happened in the arts before, not once, but many times. But, once and for all, he will have to control the combustion engine and master the machine. There could be great architects again; virtuosos in ornament; canals and waters, Martian in scale; tropical and sub-tropical gardens which would form another, and a new art in themselves; the art of the new pleasure haunts of the Barrier Reef and the coral atolls, this is no impossibility; tunes or airs that remain as long on the ear as those in Beethoven symphonies; once again memorable human statues in public places . . . Though we, the white races of old Europe and of North America, have resources and mechanical aids which are beyond the dreams and the imagination of the Middle Ages it is unlikely that we will accomplish great works of art, or anything more than engineering feats; tunnels and bridges; oil-tankers a mile long; Polaris submarines costing fifty million pounds even before they are equipped with their atomic bombs; improvements in satellite transmission; in gadgetry generally; and ever increasing speed on the roads and in the air.

There are the means, but not the motives, which were spiritual or religious. Those can never come again. Certainly not from the youthful Red Guard of China who break up the works of art in the Tibetan monasteries, outside Lhasa, and use them as material for making roads. Neither from them – and mark the inherent danger between strength and weakling – nor from the 'flower children' of the West who, coming after the 'Mods' and 'Rockers', have at least disrobed the 'collar and tie' acquiescence and uniformity of the big city, and by that much made easier the task of painter and sculptor when, if ever, they have to face their own species again.

Those Guelphs and Ghibellines of the brick terraces who carry their tournaments to the seaside sands, and roar back on their motor-bikes, are in revolt against convention and are the first move of the sort for more than a century since the Cockney protagonists of Dickens and George Cruickshank. It is the first change in a stagnant, and to all appearances lifeless, environment, but it is a stirring and a fermentation in those very backstreets of red brick houses and the sign of a determination not to miss much that had been lost and missing in the lives of two or three generations before them. As such, this movement coming from the working classes in our urban population is in rectification of the wrongs and ugliness of the nineteenth century.

What is intended in the pages that follow is to point to the future from the past by a discussion of items in their achievement which, as to any or all of them, it should not be beyond our capabilities to equal or surpass. The inherent improbability of this happening, despite all our technical and mechanical equipment and skill and our reaching out for the stars, makes more poignant the contrast between achieved and unachievable. Because we know it cannot happen, it becomes that much more impalpable and interesting. But, given certain states of mind, as often before, it could easily be done. And not only that, but be improved upon, and even surpassed. If we can send a manned rocket to Mars or Venus, a project which is past the drawing-board, we should be able to built a Chartres Cathedral. Or why not? That is the question.

For an answer to which there must be an attempt at a survey upon new lines, beginning with the disentanglement of the Middle Ages from the label 'Gothic', which is misleading and altogether meaningless. Not that the term 'Middle Ages' is any better, for time has progressed two centuries and more since that was thought of, and the 'Middle Ages' are no longer in the middle of anything. According to which way you look at it, they are long left behind, or to one side; the more potent, therefore, their lesson to us now that our hands are no longer touching. As to the term 'Gothic', it may have seemed apt and neat, but it has of course no authority or relevance whatever, and was probably as much of an embarrassment to its amateurs and devotees as 'Baroque' and 'Rococo' with their silly implications are in like contingency today. The Goths, it is needless to say, of all conceivable races had nothing whatever to do with the style of architecture to which their name is tied. It is only by chance that a different barbarian name, that of Vandal which has taken to itself a different connotation, was not made use of in the place of Goth. All that is implied is old and uncouth; not subject, as it were, to the laws of classical grammar, and in total ignorance of the Greek and Latin. To educated persons of the seventeenth century the mediaeval builders obeyed no known laws of architecture, though there is visual evidence that men of the calibre of Wren and Hawksmoor and Guarini saw the point of it and emulated its effects.

The words 'round-arched' or 'pointed' would be the simplest and surest way of covering the whole Middle Ages in most countries of Europe; where England alone is concerned, it being really not necessary to indulge in all the cold luxury of Early English, Geometrical, and on to the familiar Decorated and Perpendicular, terms of a chilling effect which rid their incumbents of much of romance and poetry. It is beauty more than accuracy in dating which is important, and that gets the message through to us. For that they do speak to us is certain. Not only do they talk to us; they tell us what to do, pointing, as it were, to what they have done themselves, so as to show that it is possible. But our thoughts and talents lie in other fields. Not, be it understood, that it is the religious motive behind all this that is the interest. It is the results, rather than the source of the inspiration that we would want to study, in the knowledge that they have their parallel in pagan temples and that we do not hold the monopoly in great works of art. Other faiths have raised an Angkor, frescoed the caves of Ajanta, and dug the Kailasa into the hill of Ellora. All these are incomparable, and to be named in the same breath as the great monuments of our Middle Ages, but they are of another philosophy from which we can learn, and take delight, but which is altogether alien, as though of another creation of human beings. Wonderful they may be, but it is not in our bloodstream.

There are no naked sadhus, trident-holding and rubbed with ashes, in our spiritual ancestry; but, in their place, the hermits and anchorites of the beehive-cells and, later, of the 'anchorages' built on to churches, or even, on occasion, at special request and as a favour, joined on to the north face of the church steeple. From which it can be gathered that an important difference is that of climate; and that just as the wonder of India and Further India is that their marvels could have been worked under a blazing sun, so, in the Occident the case is just the opposite. The enemy of the craftsman was not the heat, but cold. This, in northern countries where fine weather could be expected for but five months in the year, by which are intended chiefly those parts of France, Anjou, Poitou, the Dordogne and the Île de France, where the winters are severe. This is of application, too, to England, to Germany, and to Northern Spain of the high plains of Castile and Aragón where there are extremes of heat and cold; it being noticeable that where the climate is more amenable as in Italy, Lombardy, Venetia, Tuscany, and so forth, this essential style of the North does not catch on, and is out of place. Such is the polychrome or coloured Gothic of Giotto's Tower in Florence, and of the Duomo at Orvieto, with for extreme instance, the zebra stripes of Siena Cathedral; but the Italian temperament was more itself in the Romanesque all over Italy, and perhaps in particular up and down the Adriatic coast, at Barletta, Bitonto, Molfetta, Trani, and so on, where it is true the heat could have been a bigger problem than the cold. Perhaps, in general it may be the fact that there have been slight climatic changes within historic time, and that from the sixth

to the sixteenth century, to put it simply, it was cooler than we might think it to have been in the East, and warmer in the West. This would help to explain and attenuate the appalling labours of the Kailasa and of Angkor, while rendering more endurable the winter rigours of building Chartres Cathedral, the octagon of Ely, or the nave and central tower of Durham. As though in dependence or adaptation upon that, the varied and polyglot wonders of the Occident are predominantly Northern in temperament, whether Romanesque or Gothic, and it is an art therefore not of the heat, but cold.

Polyglot it was, most certainly, though with Latin for an Esperanto or universal language and French, in full meaning, for its *lingua franca*. But also, in so many parts of Europe and not least in England, it was an affair of dialects or patois. What tongue, for instance, would be spoken in Tournai, the capital city of the tapestry looms and as important in that sense as Ching-te-chen in the manufacture of porcelain, or Isfahan in the weaving of carpets? Would it be Walloon, 'an early French (Romanic) patois, with Celtic and Teutonic elements, but almost as unintelligible to a Frenchman as Flemish is to a German', as it has been described? Would it be the French of the Burgundian Court? Or Flemish which, 'although rich and expressive' – as one can judge for oneself on hearing the announcements on loudspeakers in the Belgian railway stations – 'cannot be called a highly cultivated tongue'?

It is indeed a babel of tongues. We are to think that the stone-masons who competed among themselves to give variety to the church towers of Somerset would have scarcely understood the carpenters fitting and hammering in the open timber roofs and angel ceilings of East Anglia; that the craftsmen working on the incomparable Heckington, in Lincolnshire near Sleaford, a masterpiece of the Decorated style dating from about 1345, or on the church and spire of Bloxham at the start of the Cotswolds, near to Banbury, would have found conversation difficult with the red sandstone carvers of Lichfield or Cheshire. It could be that the very diversity of local dialects helped to intensify the local difference in styles. Where there was a common language it would draw the strings together and quicken the communication of ideas. Fashions would alter too fast. There are arts in which it is essential for the craftsman to remain a little old-fashioned and behind his time. Otherwise he can never finish what he has begun. Styles should change slowly and at long interval, or their practitioners are outrun. The perfection and plenitude of much mediaeval work is due just to the fact that these circumstances prevailed. Life was unhurried, and the time spent on a work of art was a part of its value. There were not perpetual changes as of Parisian dressmakers, something which in its turn and in our time, led by the most protean genius in painting that there has ever been, has ruined or exhausted Paris as the capital of painting and surrendered the leadership, rather more than improbably, to New York.

It is a steady growth, paused by the Black Death which has the impact of an early amateur's world war, and only dimmed to our apprehension by the stupidity of continuing to call it 'Gothic'. Far better to know its masterworks big and little, by the century in which they were made; in contradiction to which the term 'Romanesque' has most decidedly its own sense and meaning. The Regalia and Sacred Relics of the Holy Roman Empire in the Schatzkammer at Vienna – whether the Crown of Charlemagne be that of Conrad II who lived two centuries later, or the so-called Coronation Robes be those of the Norman Kings of Sicily, but the work of Saracen craftsmen – form some little tangible evidence of the continuous aspiration and hankering after a proud, though shadowy thread of connection or descent from Rome. Where Germany is concerned there are the unmistakable signs of this assumed, if affected, Latinity along the Rhine and Moselle from Trèves to Cologne, a region of as much Roman association as French Provence, where the sculptors of the triple portals of Saint-Trophime at Arles, and of Saint-Gilles a few miles outside that town, if interrogated, would not deny that they directly copied and adapted the figures from Roman sarcophagi for their carved figures. Saint-Trophime and Saint-Gilles of Arles are indeed the ultra-Roman Romanesque.

This then is an attempt at a survey upon new lines, beginning with an anthology of towers and spires from all over England. It is the early miracle of sending up a needle of stone to pierce the clouds, and as near a feeling as mediaeval men would ever know to that of flying. Work, too, that was certainly in the nature of a closed brotherhood or mystery with more than a little, one might apprehend, of the 'security' and secrecy that surrounds a rocket base. The spires and towers were to some sense tethered and sacred projectiles, impracticable of use, and for which the plea that they were bell-towers was not enough excuse. Their size could be altogether disproportionate to the sound shed from them, but not in every instance. The booming of the great bell in the campanile of St Mark's rings out – it is a baying more than a ringing – all over the water city and far out into the lagoons. But its sound of course is not there to be swallowed up in the roar of traffic. Yet, in the primitive concept, they were bell-towers pure and simple, and outside the silent town at night-time would lie the beet fields or the sheep folds, according to locality, in the implication of which sentence one is carried from end to end of Europe. It is a cosmology of uniform aim and purpose, but carried on in many different tongues, with its ritual in a common language that only the learned and the initiate could fully understand. The diversity is infinite, and there is an instinct which has died, or is at least dormant in the world today.

But in what manner can these extraordinary structures have been achieved? Did they have cranes? How did they lift the huge blocks of stone? What a sensation to have been sheathed in a web of scaffolding to work on the highest, topmost stone

Opposite: Spire of Salisbury Cathedral, from an oil sketch by John Constable

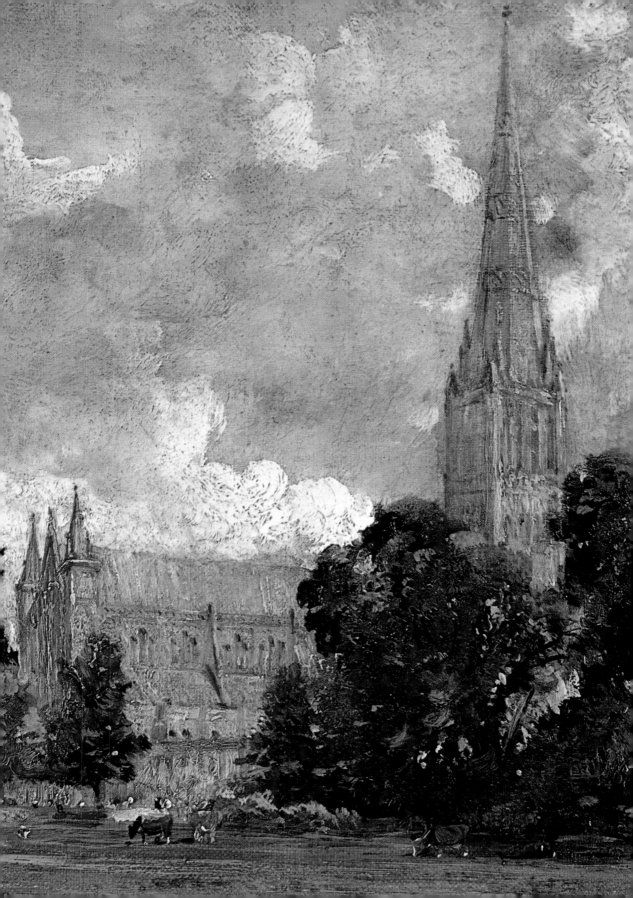

courses of Salisbury spire! Already in the thirteenth century astounding altitudes had been attained. There is no existing skyscraper in New York or in any city of North America which climbs to much more than twice the height of the tallest spire of the Middle Ages. The Eiffel Tower at 984 feet is less than double the height of Ulm Cathedral at 528 (making it 1,056 feet), or of Rouen at 495 (making it 990 feet); and this with every resource of nineteenth-century engineering at its disposal, the Eiffel Tower being in fact an openwork iron skeleton more than a building.* The New York skyscrapers, impressive as they appear, especially after dark, at the great gathering of them upon Park and Fifth Avenues round Grand Central Station, a collection or congeries which is indeed among the present wonders of the world, are in fact little taller than the iron girder structure of the Eiffel Tower, built solid and turned from a skeleton or cadaver into a body, while their starkness has in compensation and for wonder of wonders, the speed with which they are demolished and put up again. They are twice the height of the tallest of the mediaeval towers and that is all; to which it could be advanced that there is no point in building higher than this, and that neither Corbusier nor Frank Lloyd Wright thought of building 'block-cities' more than a mile high. So, in fact, in this matter, as always and in every way where the arts are concerned (excepting in music), those years from the twelfth to the fifteenth century led in instinct and intuition over all that has happened since.

The procedures involved were painstaking and pedestrian and would seem to our minds of an agonizing slowness, though no more protracted, comparatively and really, than the writing of a book in rough copy over and over again, and eventually as a fair copy, in laborious long hand. We know from the annals of Buckfast Abbey, and elsewhere, that a handful of monks can build a monastery church in a matter of years and well within a lifetime. It is a question of disciplined work without strikes or stoppages, and continuing year after year. That is perhaps easy enough as a concept, but it is more difficult to conceive of the huge symphonic structures of the scale of Chartres, or of Lincoln, or Durham, where work was in progress for two centuries or longer. We have to think of parts of a building continually in scaffolding, workmen always on the roof, some portions hidden in sacking and forbidden of entry for years on end, with the anticipation that nothing would be finished while anyone then living was still alive. There was no end to their energies until the money or the spirit, or often both together, ran out at the same time.

A continual hive of activity, then, if in terms of population with but a few bees in it, and those all workers, with for drones the monks or priests. But, at times, of course, with much more activity than that, when the whole of the vast stone mass

* It is true that the tower of Ulm was completed in 1880–90 by the addition of the octagon and pyramid from a design left by Matthäus Böblinger (d. 1505), and that the central tower of Rouen is topped by an iron spire only erected after a fire in 1822.

must have seemed to be alive. When human beings, as small in scale as bees or ants, were crawling all over the building, hod on back and carrying stones and mortar, or running up and down the ladders, like the inhabitants of a whole seaport manning the yards and busy in the rigging. There must at times have been scores even hundreds of workmen engaged upon the huger symphonic structures. It is a spectacle we have to think of for ourselves for there is no direct record of it, or at least no piece of evidence that does justice to its gigantic bulk. In that most beautiful of illuminated prayer books *Les Très Riches Heures* we can but see in the near distance the turrets and white walls of the castles. It is an unsatisfactory, because finicky, vision of the giant hand of those dead centuries, for confirmation of which, we now repair to an unexpected but rewarding source. It is Pieter Bruegel's *The Tower of Babel* in the picture gallery at Vienna. There is another and rather different version of it in a museum in Holland.*
This, which is the smaller version, belonged to the *virtuoso* Emperor Rudolph II (1576–1612) and was in his collection at Prague; while a miniature version of it, painted on ivory, and now lost, belonged to the famous illuminator Giulio Clovio, who lived in Rome. It is not unreasonable to think that *The Tower of Babel* in both existing versions of the painting is taken from the Colosseum, which Bruegel must have seen and studied while he was in Rome, but the painter had no knowledge whatever of Roman building methods and so what we see in his picture is a gigantic structure symbolic of pride punished, or the vanity of all human endeavour. A mountain of stone, out of which shape is emerging as it must have done with the great cathedrals, most of which were just finishing or getting as near as they ever did to completion, in about the years (1520 to 1525) when Bruegel was born. For the present purpose of representing any one, or all, of such structures in process of building, we take both Bruegel paintings of *The Tower of Babel* together, amalgamating them into one composite picture, while remarking that in the smaller version, the one in the museum in Holland, the building is more circular and higher still by several storeys, it is an obsessive mass made tedious by the regular repetition of its window openings, for which there is in fact no structural reason, and that in other ways, too, it is the less satisfactory of the two paintings.

In the version in Holland the tower is brought up nearer and is directly before our eyes. In the Vienna version there is more space and altogether less crowding, and immediately in the left-hand foreground the blocks of stone are being shaped and squared. Just how those square blocks, weighing two or three tons each, are to be transported down that steep slope through the bushes to the tower we are left to think out for ourselves. But indeed the distance is foreshortened. That gigantic and

* Boymans-van Beuningen Museum at Rotterdam; cf. *The Paintings of Bruegel*, by F. Grossmann, London, 1955. Giulio Clovio owned several paintings and drawings by Bruegel, including a miniature by both painters in collaboration.

cloud-piercing tower must be nearer to us than the tiny ant-like figures at the foot of it would argue. And we are down the bank and up in front of it in a moment's scramble. There is the sea and a harbour to the right, and a whole mediaeval town, no less, at the foot of *The Tower of Babel* to the left hand of the painting. The way into the tower, as into a huge cave or into the heart of a mountain, is just a little to the left of where we stand looking up into the gigantic earth-sinking bulk, for surely it must sink lower of its own weight, and even lean or topple a little to one side.

The town under *The Tower of Babel* is no collection of peasants' houses, they are the high-gabled buildings of Bruges or Ghent with steep roofs and more than one flight of windows under their eaves. Little or no arrangement of the houses; they stand at all, or any angle to each other, and it is to be remarked that there is no sign of a street. There can be no more than narrow alleys leading in and out between them. A fair-sized river, wide enough to have a three-arched bridge spanning it, divides the town; and there are tall houses built directly into the water, as in the northern water towns with which Bruegel was familiar. But remark also that, though there are a very few human beings in sight crossing the bridge with a waggon, not a single one of all the chimneys is smoking, which gives to the whole of the city a peculiar static, as though frozen air, just as if something important has been forgotten, all the doors of the houses locked, it could be, and the keys taken away and lost.

But tall as those houses are, they come up to less than half the height of the foundation, not even to the ground floor of *The Tower of Babel*, which comes up out of the earth from who knows how far below. And eventually, walking about half-way round the side of it facing us, we come to some kind of a road and begin to climb. There are two-wheeled carts in front of us, all loaded with stone, and now another road leading up from the harbour joins on to ours; and we cross over two great gaping openings which suggest the ruins of huge Roman baths with a hut built over the edge of them at a dangerous angle, and we have set foot in *The Tower of Babel*.

A few steps more, and we are on the ramp or platform above the lowest floor of the whole building with the harbour below us, and in fact the quay lies just under where we are standing. Here it is no longer the bare rock. The masonry has begun. There is a winch for hauling up heavy objects and the steep buttresses slant down on to the quay. But behind us the solid rock rises up as though the tower was to be hewn out from it, and the work on this part of it has not yet begun. Another huge storey climbs perfectly, this interruption of bare rock apart, and up there on top of it there is some great wooden construction engine; and another storey above that, with the naked rock showing again; and now some arches that are in process of building, with the timbers in place where the stones are to be, and a number of men at work upon them, and indeed working in both directions for as far as one can see.

Along every terrace at the recession of each storey, with ever more dizzying drop

below, are little sheds and huts exactly as there must have been on the roofs, even between the flying buttresses of the great cathedrals. Sometimes they are over cranes or pulleys, or they are regular workmen's shelters where, as ever, they eat and drink their 'elevenses' and carry on their tasks out of the not infrequent rain. They could indeed live up there away from their families for days at a time. And now we come to another outcrop of rock with men working at it, hewing a flight of steps out of it, as though Bruegel has forgotten for the moment that this is *The Tower of Babel* and not, had he but known of them, a rock-temple like the Kailasa or the temple of Abu Simbel. Certainly the workmen are hewing away from the rock and not building. We are nearing the top of the tower and the harbour is far, far below with an infinity of small craft tied up to the quay, one or two bigger ships lying off shore, and the long sheds and storehouses of a big seaport, and there are as many persons busy down there as a cloud of midges.

We have reached the top of *The Tower of Babel* and can climb no further, just when a cloud touches on it and one feels the sudden cold. I have seen the Rockefeller Center hidden in mist as to its highest rows of windows, and there will have been mist down the chasm and up the cliff faces of Wall Street. Is there ever sea-fog round the topmost spire of Mont St Michel? I do not know; but the rock rises to not much more than two hundred feet above high tide. The fogs of England apart, which have their special defects and their qualities, I have seen the town of Morella half-hidden in cloud, an astonishing sight which takes one's breath away. It has mediaeval walls all round it, and is built round the neck of a huge column of rock with a gigantic castle on top of that. No one, who has been there, could forget the discomfort and dark horrors of its inn; the sentry boxes – dating from the Carlist war, or earlier? – and their ghostly trumpet-calls; or the thought of Morella lonely in its cloud, even on a spring morning when the apple orchards are in blossom, the airs are fresh, and all is burnished with gold as in a missal-painting.

And having got to the top of *The Tower of Babel*, the problem is how to come down it with as little trouble as possible. What can the interior, the core of it, consist of? Is it, as the outer galleries would suggest, open like the interior of a bull-ring? Or is it a stump of rock, reinforced with stonework, and contrived or worked into the semblance, not of a phenomenon of nature, but a building? There is no way of telling. There are those, after all, who will tell you that Milan Cathedral, in its white marble, is an imitation or a suggestion of an Alpine mountain. It could be that 'there are few rocks, even among the Alps, that have a clear vertical fall as high as the choir of Beauvais',★ but Milan is of another category. It is Milanese which means, ever, overworked, and more, mountain-wise, of a fretted Dolomite or freak river-gorge, than the true and eternal Alps, Andes, or Himalayas. Coming down from *The Tower*

★ Ruskin: *The Seven Lamps of Architecture.*

of Babel is the descent from a mountain of stone which at the same time, like a mine, is full of passages and galleries, and there are moments when one may wonder whether we are under or above ground.

It is easy to lose oneself in *The Tower of Babel*. But now the descent grows easier. It becomes manageable, and is but an endless series of turret stairs. Coming down inside a tower, that must be it. A tower with the men still working on its roof, a tower that is all windows and pinnacles, lancet-windows fifty feet high with the wheel of the great crane seen through them, and the stonecutters' shed at the foot of it, as in Van Eyck's drawing of *St Barbara*,* a shed which is a quarter or a fifth the height of the whole tower, so that this is not even an exceptional tower. It is an ordinary, rather richer and more ornamental-than-usual tower, as it could be in almost any or every town in Northern Europe, if perhaps with a preference towards Northern France or Belgium, towns, let us say, like Rouen or Amiens, or Bruges or Ghent, where rain and snow can be as much of an impediment as the tropical heat in other lands. Thus it is with Van Eyck's *St Barbara* at the foot of the late Gothic tower with human beings, herself in predominance in the foreground, larger in scale than could have been the living truth. And so it is, too, with Bruegel's *Tower of Babel*, with memories it could be of southern seaports – he had been to Naples and to Messina – but with the tower for all that, set in the flat water lands of the Campine, which is the plain north-east of Antwerp.

Beginning, then, with an anthology of towers and spires from all over England. And taking, first, the spires, for they are more original in conception as architecture. Towers are universal and ubiquitous from ancient Babylon to Zimbabwe, and from New York or Marrakesh to the towers of the Kremlin. The minarets of the Andalucian Moors, and of the Egyptian Mamelukes are towers. It is but the needle-thin minarets of the Ottoman Turks that were an invention, though one allowing of but little variation. All other towers are towers, as solid of intention if less piercing in their meaning. Is the spire in any descent or connection with the pyramid? They could be in but faint rumour from tales brought back by the Crusaders. The earliest of them are contemporary to that possibility. The octagonal chapels of the Templars (four of them in England)† are of direct contact with the Holy Land. But the attenuated pyramids of the spires of England are of native growth, uninfluenced by tides of fashion from anywhere further afield than France.

The archetypal English spires are those of Salisbury and Lichfield. That of Salisbury, built towards the middle of the fourteenth century, is of ever to be recalled

* In the Antwerp Museum.
† The Temple Church in London, and churches at Cambridge, Little Maplestead in Essex, and at Northampton. It has been disputed whether the last named was the work of the Templars or Hospitallers.

effect and prominence as one comes towards it from any direction over the downs. The setting, alone, puts it apart; and, conversely, the spire must have been conceived and designed especially for its particular background. Which we accept as normal; but in the dearth of descriptions of England by foreign travellers, it would be good to know the effect of this strange category of landscape scenery upon a sensitive and trained intelligence of alien blood. It is undeniable that the presence of Stonehenge upon the plain adds a primitive solemnity and strangeness both to first impression and to lasting memory. There it is, the great spire of England, seen from several miles away over the shoulder of a hill rising to more than four hundred feet above the roofs of the town. Or it can be the spire, just the spire, coming up out of the distance; the basic and for all time specimen of its kind; at once the unconscious pattern and cynosure of spires from every corner of the kingdom, and of a hundred villages and market towns. The proportions of it from far away are arguable, but not obvious. Like many works of art it is both gigantic and of ordinary size. Only on getting nearer is its huge stature to be apprehended; and in intimacy on emerging from the chapter house into the cloister. There it is, before our eyes, soaring up higher than the lark sings up above the downs; if, on nearer sight, a little dulled by copying itself over again as if not completely sure of itself in both storeys of its bell-chambers. It has turrets at the corners, and above that the octagonal spire starts up banded at three places, as though to keep itself together for its leap into the air. I have been told that a family of falcons have nested up there from time immemorial, perhaps ever since the spire was built, though one cannot see any opening into that needle-thin stone structure. Perhaps it is below, in the bell-chamber that they have nested, but one would like to think of them up there where once there was human foothold, before the last scaffolding was taken down and the spire left alone in the wind and rain. Salisbury spire, with the stone circle of Stonehenge and the still stranger Avebury not far away, has some aura of sheepfold simplicity about it as though it is the dunce-cap spire coming up out of the plain in Blake's woodcut illustrations to Virgil's *Pastorals*.

Of a different meaning and rhythm altogether are the triple spires of Lichfield which at a certain distance – you cannot see them from far away – and from their seeming so near together, join the memory of seeing from the train-window the five square towers, in local patois, the bell-loud '*chongs clôtiers*' of Tournai against a darkening sky. But it is the multiple form of both cathedrals that makes the analogy, for there is no other point of consanguinity, and in fact Lichfield is built of dark red sandstone, not a favourite building material, and the blemish alike of Strasbourg and of many German mediaeval churches. Nevertheless, Lichfield is a grand performance in an unpleasing medium. It has an extreme homogeneity as though conceived and carried out in one flight of execution; west front with its three doorways, row of

statues above that (all restorations), rose-window continued within its lancet arch to the bases of the two great towers. Out of much-fringed arcading these spring up in duo as high as their bell-chambers, which have not the doubled lights of Salisbury, and further to the turrets above those bell-chambers, only, like any pair of twins, to be separated at some stage in their lives which is where each spire begins out of its tower. One of them in any case is a very little smaller in girth than the other. Or is this so? Because from whatever angle one looks up at them, and plays or compares the one against the other, there is always some discrepancy and it is difficult to be certain.

A Midland town, of justifiable pretension to be among the most pleasing in the kingdom, is Stamford, of which only a solemn greyness as of nearing more northern regions, deflects comparison with Broadway or other of the stone towns of the golden west. Stamford is conspicuous for its spires, and for two of them in particular, St Mary's and All Saints. St Mary's has five storeys of blind arcading in its tower. The broach spire, rising from that without pinnacles, plays fancifully and delightfully with its spire lights (or spire windows), repeating the same game on each four sides of its octagon so that no two lights are next to each other on the same storey, and giving their canopies bold vertical projection from the slanting body of the octagon, and on the four storeys varying each pair of them in size in quasi-humorous, nearly playful fashion. All Saints, across the stream and up the hill opposite, out of date here but in position so as to be near St Mary's, has a Perpendicular tower with octagonal turrets and a crocketed spire with two storeys of spire lights, neat and compact if not much more remarkable than that.

Even where the spire becomes but the adjunct of the tower there are fine instances, chiefly in town churches in the Midlands if one has the patience to pass the traffic lights and park the car. Typical of these are Newark and Grantham, Kettering and Oundle, towns, the last excepted, of an even mediocrity, but all four of them have towers and spires of a strong and sure hand in building. That at Kettering, familiar to the point of dulness, and most often when I have passed it, rain or fine, pushed aside in my mind, I have to confess, for thinking of some façade in Italy or Spain, some temple in India, or pagoda in Japan, but splendid none the less with the turrets at its corners, resembles, when one gets down to examining it, All Saints, Stamford. All Saints has larger three-lighted windows to its bell-chamber and more interesting and varied stone pannelling below that, but their spires are so nearly alike except for spire-lights in only two storeys at All Saints, that they may well be from the hand of the same architect. The other pair, Newark and Grantham, have good spires; but one must award the palm to Newark because of the glorious statement of the bell-chamber on the fourth storey of its tower; canopied double lights on each face with statues in little niches at the foot of them to each side, and a crocket-less spire with corner

turrets and more storeys of spire-lights than at Grantham, where the two sets of spire-lights are banded together boringly instead of being given an intriguing spacing. Compared to these, Oundle with its rebuilt spire is beautiful but dull to the point of respectability.

Rotherham is perhaps hardly the town where, pushing past Boots and Wool-worths, one would look for good architecture, but its church spire, blackened from years of smoke and soot, stands out in authority above the roofs and factory chimneys. Coventry was famous for its 'three fine spires', but the writer of these pages stupidly and purposefully avoided going there although it is so near his home – near enough to hear the 'blitz' on Coventry and see the far off explosions – because it is an industrial town, and thus missed seeing the three hundred foot spire of St Michael's 'set upon its hill above its two attendant spires', a steeple that in the words of a great authority and writer upon mediaeval architecture, 'deserves mention as one of the wonders of the world.'* In palliation it could be said that St Michael's was of red sandstone, a building material that not even where it carves like sandalwood as at the Red Chapels of Banteai Srei, near to Angkor, where one could say that the stone almost is scented like sandalwood, does it justify itself so that it can be thought of as stone. A great window, above that some blind arcading, a grander version of the same over that, to the bell-chamber of double lights flanked by nine statues under their own canopies in triple rows, and out of that the spire, castellated at the start with bold buttresses to support it, and so into the upper airs which were clearer, then, than now.

The other steeple, which the same writer just quoted calls 'second, if that, only to St Michael's, Coventry,' is the great tower and spire of Louth. Even in these days Louth is still a considerable distance from anywhere, out in the wolds of that part of Lincolnshire known as East Lindsey, with huge areas of chalk uplands or downs on which flocks of sheep pastured in the Middle Ages, whence came the wealth. It lies in a landscape of as much character almost as Salisbury Plain. The spire and tower of Louth, built of the local and flashing white limestone, is one of the last, if local triumphs of the Perpendicular, built between 1501 and 1515 in this deeply religious district full of monastic houses, and one of the centres of the religious uprising or Pilgrimage of Grace in 1536. The tower is in three stages; doorway and much larger west window; a second storey of coupled lights; and more ornate bell-chamber with larger double lights under crocketed canopies; from which spring the fifty foot pinnacles and the flying buttresses that uphold the tower. As to the spire itself there is some difficulty. It is now 294 feet tall; but was originally, so it is said, 360 feet high; partly blown down twice, in 1587 and again in 1634, rebuilt but shortened in the process. All that can be said is praise for its splendid and appropriate proportion. The

* *Gothic England*, by John H. Harvey, London, 1947, pp. 30, 31.

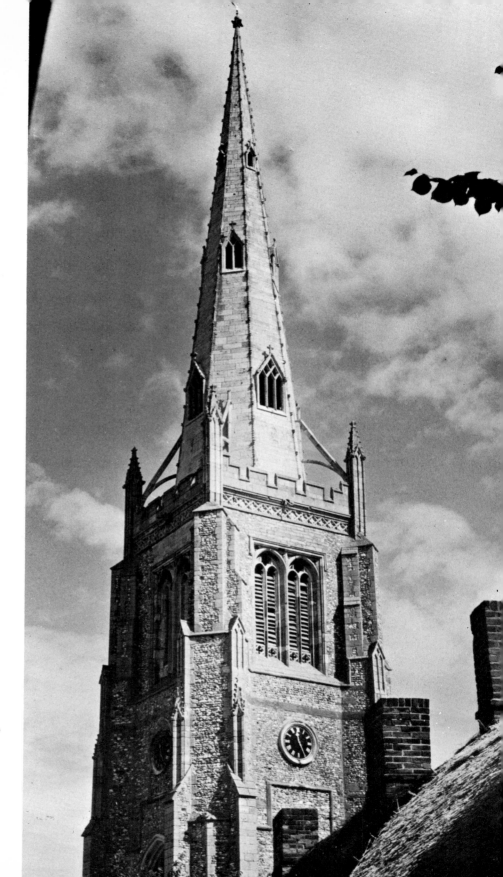

Spires
and
Towers
of
England

Spire of St Mary's,
Thaxted, with
triple, double and
single spire-lights

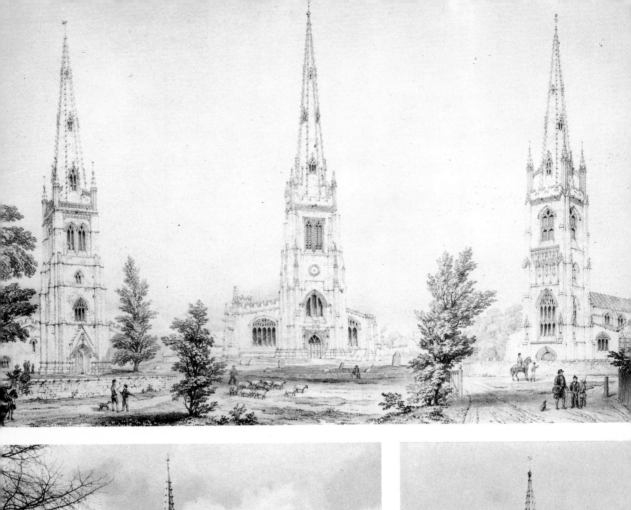

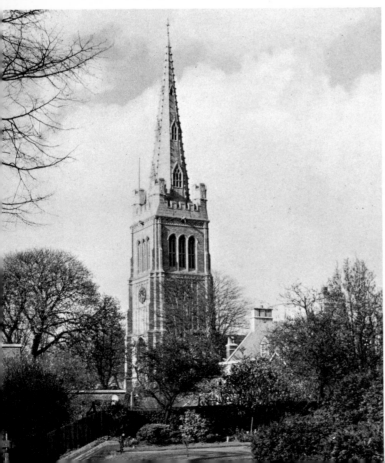

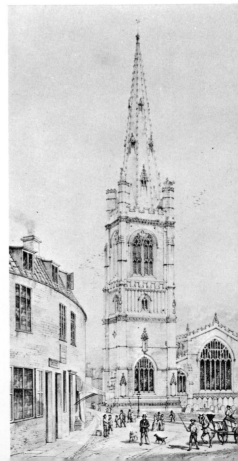

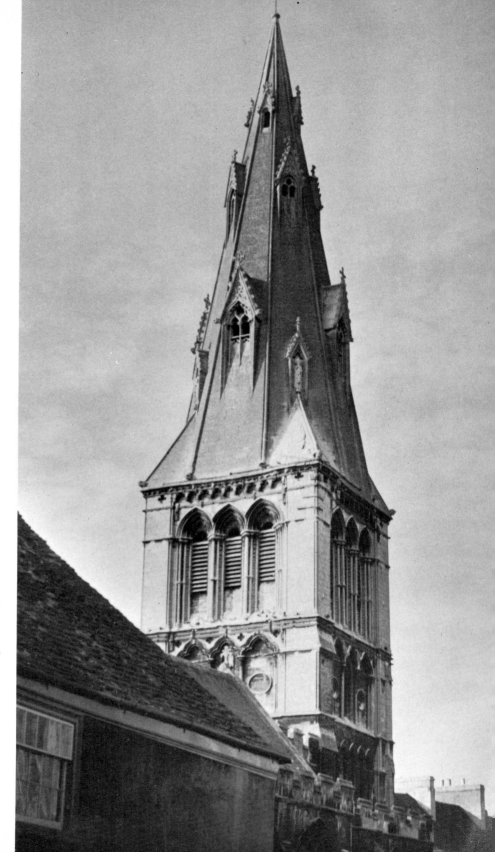

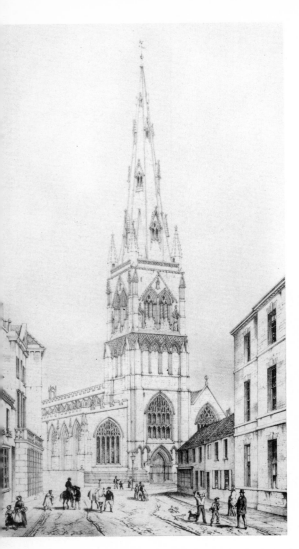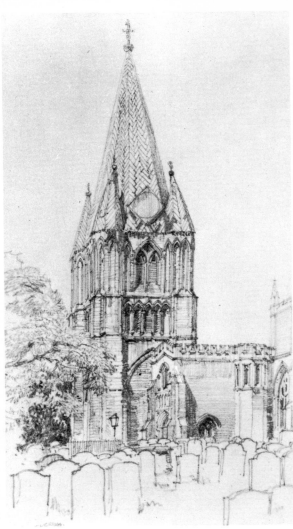

Left St Mary Magdalene, Newark (Notts), with fanciful bell-chamber; from Wickes
Right Early Gothic spire of Long Sutton (Lincs), drawn by F. L. Griggs

Opposite Spire of Heckington Church (Lincs)

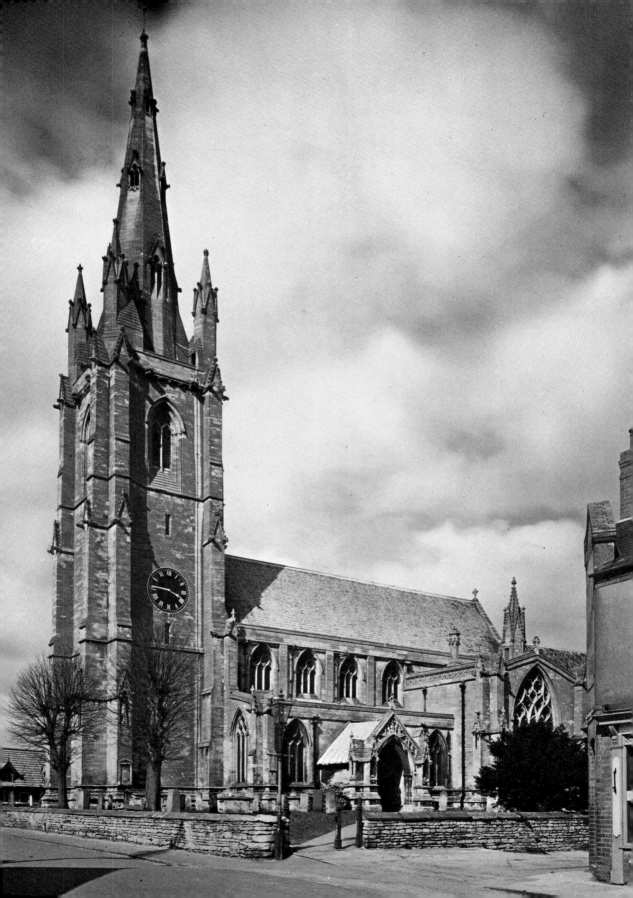

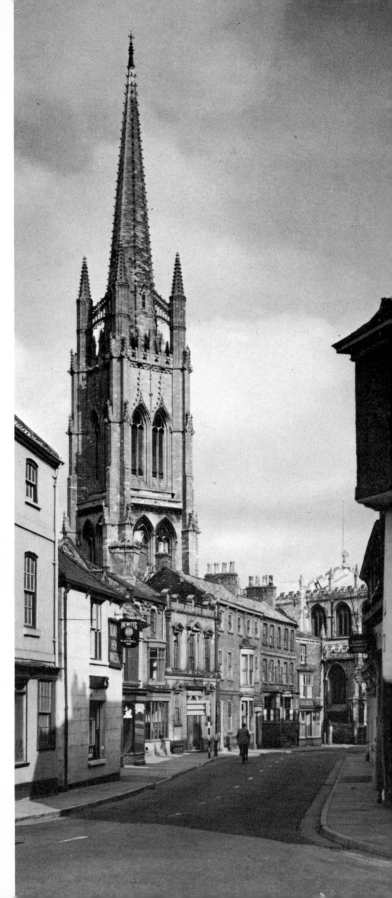

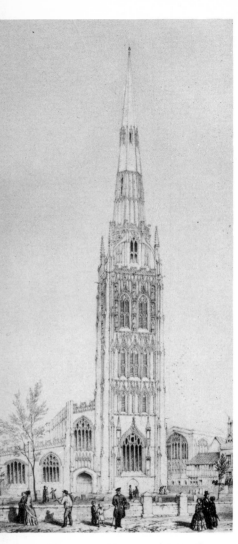

Red limestone spire of St
Michael's, Coventry
(Warwicks), destroyed in
1945; from Wickes

Right Spire of St James,
Louth (Lincs), in white
limestone, a masterpiece of
the late Perpendicular style
(1501–15)
Opposite Combined spire and
sixteen-sided lantern of St
Patrick's, Patrington (Yorks)

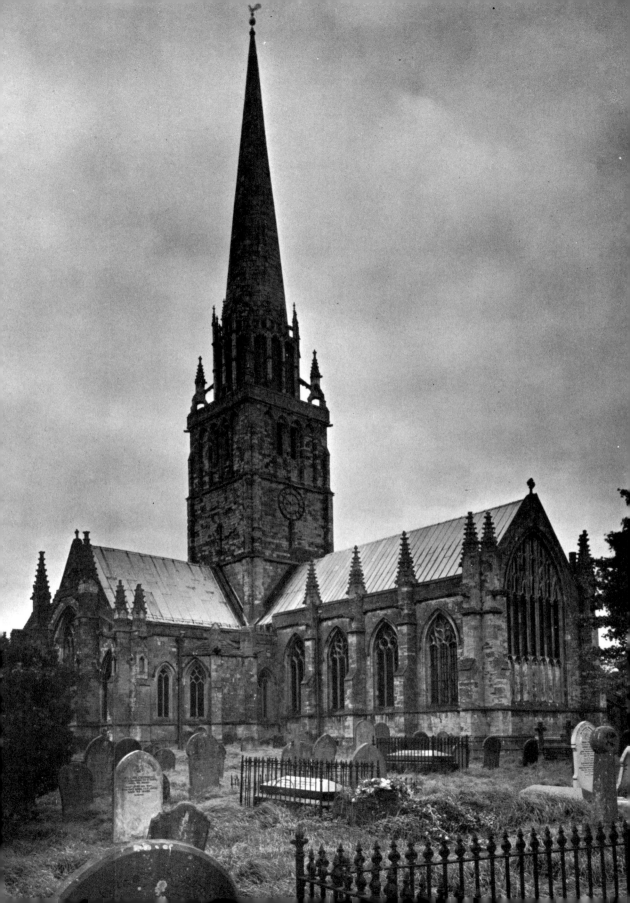

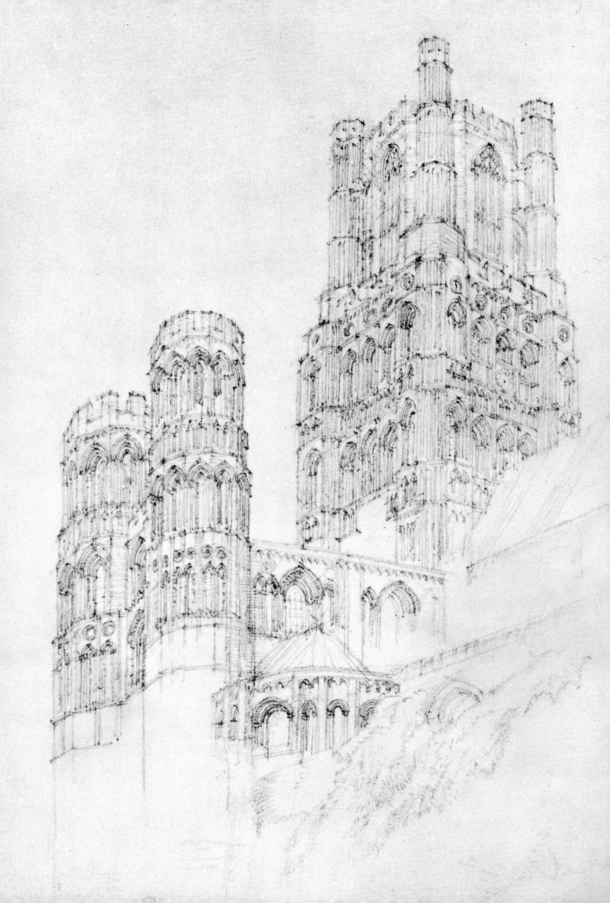

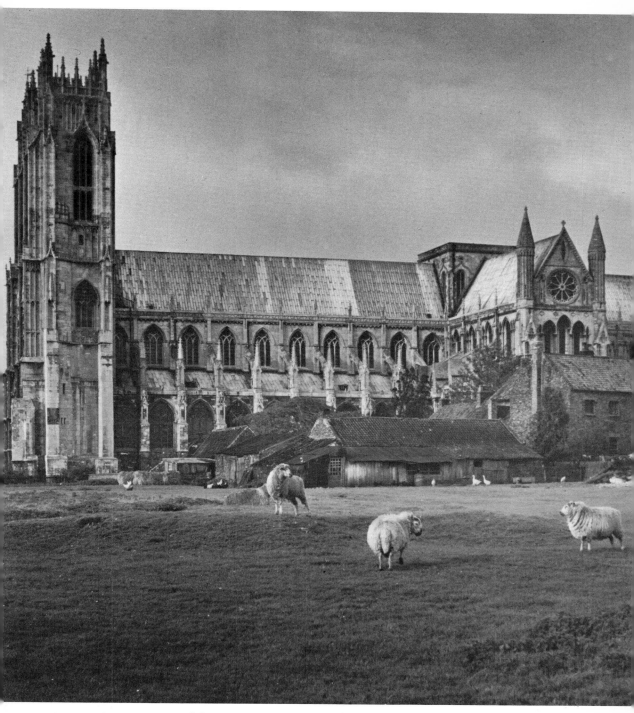

Above Beverley Minster in Yorkshire
Opposite The tower of Ely Cathedral, from a drawing by F. L. Griggs

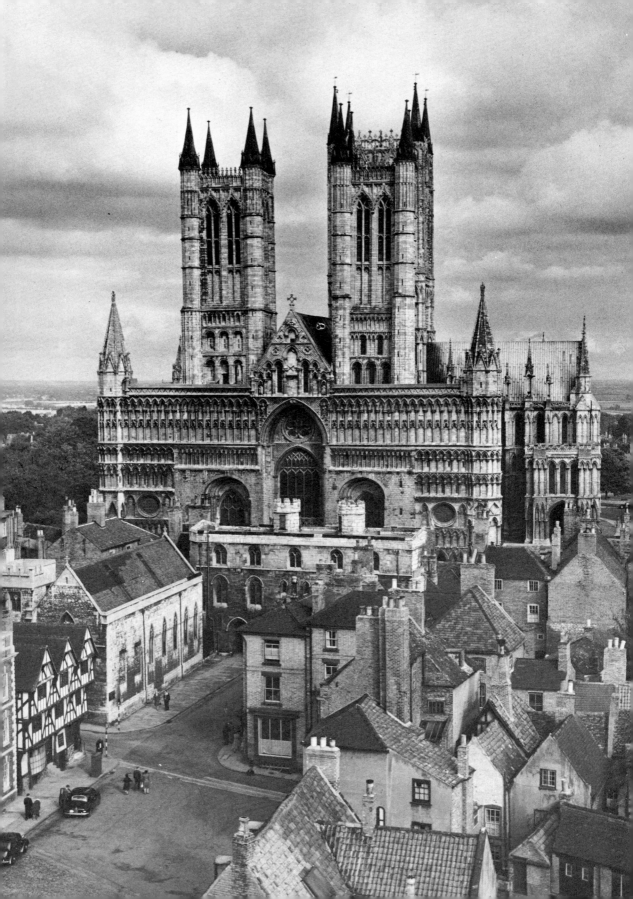

Opposite Twin towers and west front of Lincoln Cathedral

East façade of Lincoln

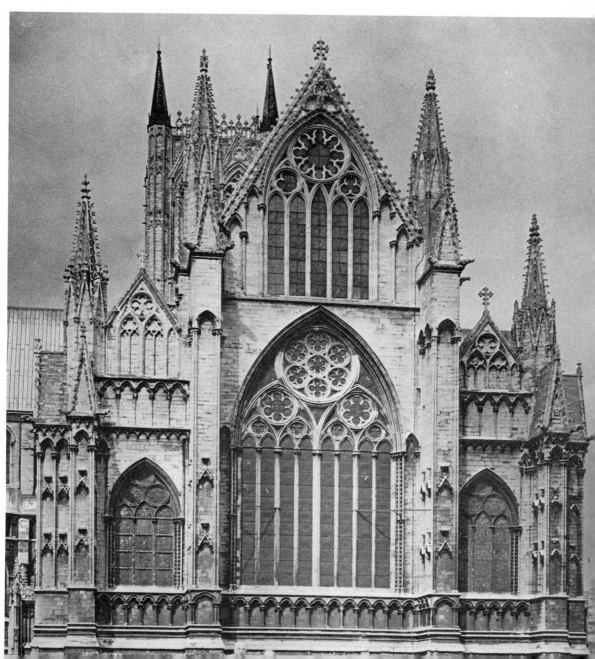

Two illustrations of towers from the second volume of Wickes's work; *left* St Giles, Wrexham (Denbigh), with fine perpendicular west window; *right* All Saints, Derby

Opposite Medley of five towers from Wickes

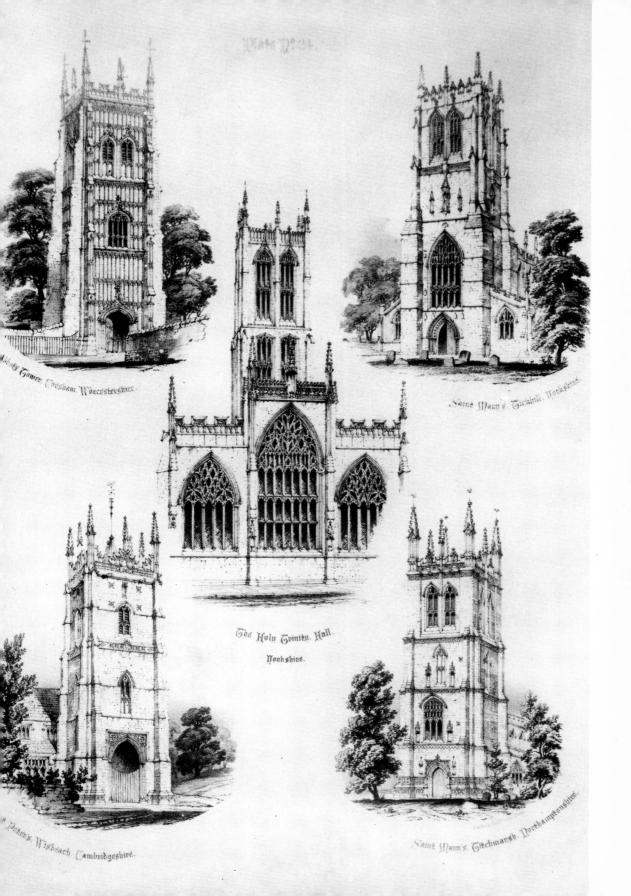

Abbots Tower, Evesham, Worcestershire.

Saint Mary's, Tickhill, Yorkshire.

The Holy Trinity, Hull.

Yorkshire.

S. Peter's, Wisbeach, Cambridgeshire.

Saint Mary's, Titchmarsh, Northamptonshire.

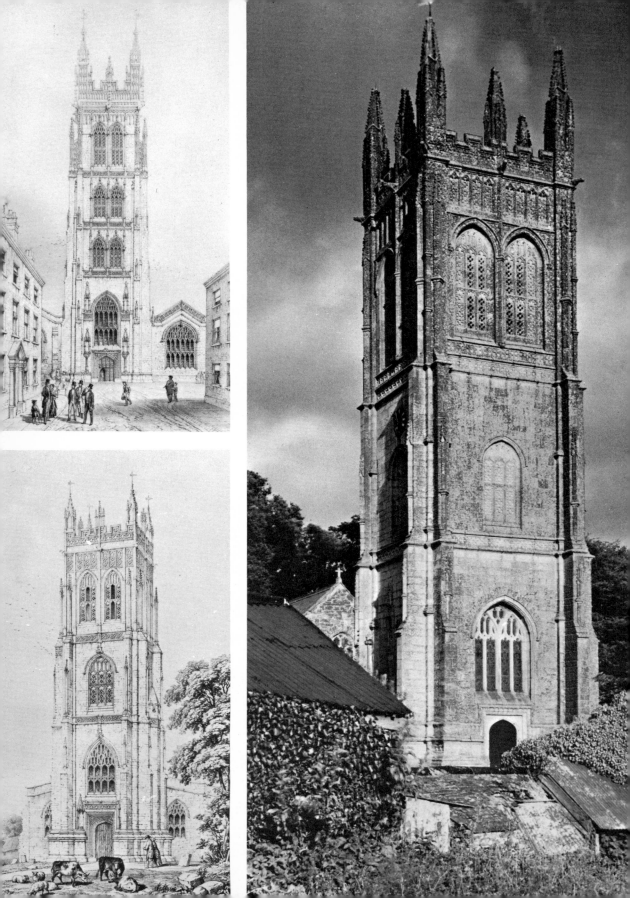

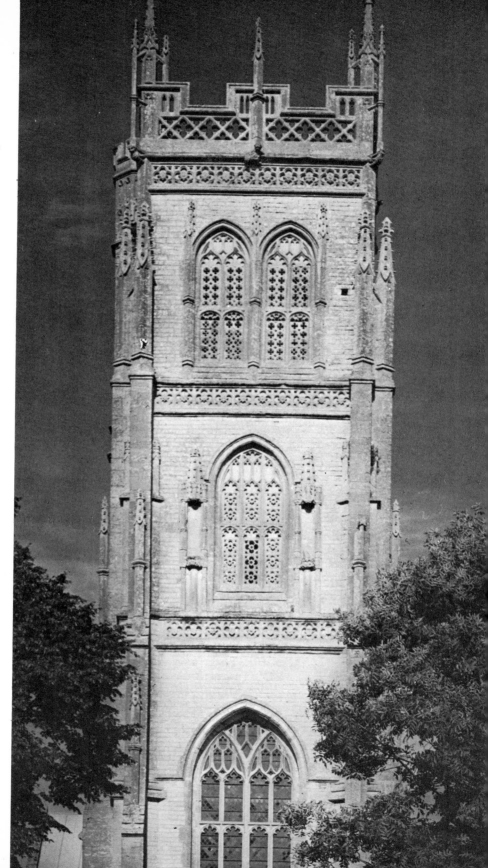

Far left Wickes's plates of two of the Perpendicular church towers of Somerset; *top* St Mary Magdalene, Taunton, tallest of the group; *bottom* St Mary's, North Petherton

Left Tower of Probus, Cornwall, the rival of North Petherton and of closely similar construction, both decorated with quatrefoil ornament

Right Huish Episcopi, most beautiful of the Somerset towers

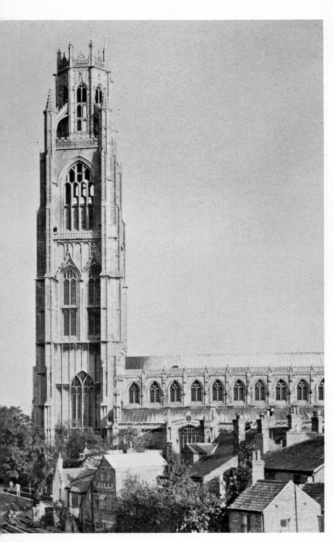

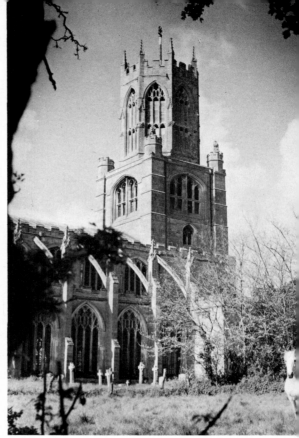

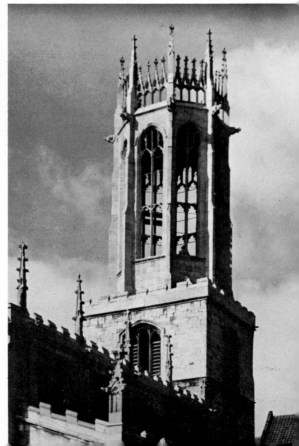

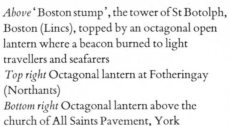

Above 'Boston stump', the tower of St Botolph, Boston (Lincs), topped by an octagonal open lantern where a beacon burned to light travellers and seafarers

Top right Octagonal lantern at Fotheringay (Northants)

Bottom right Octagonal lantern above the church of All Saints Pavement, York

first moment of seeing Louth spire from far off, and on nearer approach down the narrow street in front of it with the huge white pyramid holding itself up above the town, is among the architectural and aesthetic sensations of this country, of a different order, it is true, but of comparable intensity to the exterior and interior of Hardwick Hall, and the first view of Stourhead across the lake to the temple under the hanging wood.

If the impact of Louth spire gains from its unexpectedness and remoteness which, I think, is not to be denied, then there are the village spires where the difficulty is now to account for their certainty of hand and sense of beauty. Out of a dozen or more of these it is sufficient to cite three or four; Raunds, in the Nene valley, an unspoilt specimen of the first half of the thirteenth century; the curious pallor of which, I have written before

is as the white tent or pyramid above the sheep pens in a shepherd kingdom belonging to that world of the long gowned effigy of Edward III in Westminster Abbey and to the pastoral subjects of William Blake; or, for another, Patrington spire which is in Yorkshire near the mouth of the Humber. This, of closed lantern type, and of intent to cheer the souls of departing or returning seamen, has a sixteen-sided pinnacled arcade, above cusped obelisks at the corners, and from it springs the tapering octagon up into the 'sea-rauks' or fogs of winter.*

In order to experience Patrington and its beautiful, unspoilt interior, it is necessary again to make a special, laborious and otherwise pointless journey.

The same, almost, could be said of St Mary's, Whittlesey, which is in Cambridgeshire. Impressive as it is now, its effect must have been much greater when it stood not above the fens only but over its own Whittlesey Mere of more than fifteen hundred acres of water, and above Whittlesey Wash. The tower is in four storeys, entrance and west window, bell-chamber above that, and then the exquisitely fanciful parapet and pinnacles or obelisks in the midst of which springs up the spire, more than one writer having drawn attention to 'the graceful manner in which the spire is united to the tower'. Whittlesey, just for its spire alone, as much as near-by March with its double hammer-beam ceiling and 'whole rookery of angels', is worth the troublesome detour in which to reach it. I found this Perpendicular spire to be among the most beautiful of all; but how to explain its grace and elegance, without pointing, not very far away and in the same county, to the brass of Sir John de Creke in the church at Westley Waterless? It will be seen from the footnote that no Japanese warrior in his laced lobster-armour could be more elaborately garbed than Sir John de Creke but, withal, he is waisted and of an excessive thinness, as elegant indeed as

* The spires of Raunds and Patrington are described in my *Journey to the Ends of Time*, 1959, pp. 381-3, from which a few lines are quoted here.

the spire of Whittlesey rising above the fens and meres not many miles away.★

The other two spires to be recalled are those of Bloxham and King's Sutton, within sight of each other, and which have been familiar to the writer since he was a child, and again during the forty years and more that he has lived in his present home. There could be so many others; the trio of Rushden, Northants; Thaxted in Essex; and Moulton in Lincolnshire; all three of them crocketed, with wonderful diversity of bell-chambers and spire-lights; yet so alike that they could be the triplets of the same family, and it is impossible to choose between them. As for the spire of Bloxham, it is of dark golden stone; an octagon superimposed upon a square, and, as I have written of it, 'altering above that into the bell-chamber which has a fringed parapet, called the "allis" by Bloxham people, whence the steeple rises, not crocketed up all its length, but with an occasional cusp left, here and there, for handhold to lift off the steeple', and see what is going on inside. King's Sutton, some three miles away, is a minor miracle of the imagination at work in stone. It has a cusped pinnacle rising at each corner of the parapet, and set back from that, at each angle of the squinch, where, in fact, the broach begins, another taller pinnacle; each pair of them, the one behind the other, joined by a flying buttress that pierces, or so it seems, the taller one at the back and continues, allowing for an airy quatrefoil, into the body of the steeple. In addition, the spire has the most fanciful lights or openings worked into it, in and out of which pierced apertures I have watched the daws flying on a windy evening. For how long must the nameless designer of King's Sutton steeple have altered and remade his drawing until he knew he had reached utmost perfection! How far afield had he been? Had he seen the spires of the fens? He cannot have spent all of his life in this village on the edge of the Cotswolds. I am unwilling to think that he, also, designed the spire of Bloxham, which seems to me to have sprung from another hand. No one but a collector and connoisseur of spires could have designed the spire of King's Sutton.

There is a basic and fundamental difference between spires and towers, the components or elements of which go back to childhood. At my first school, aged nine to thirteen, bored and disillusioned with every form of 'work', but with algebra,

★ I have attempted in my Introduction to *English Church Monuments* by Katharine A. Esdaile, London, 1946, p. 6, to resume Sir John de Creke's military panoply and equipment: 'chaussés of banded ring-mail, a new species consisting of rings of steel attached to strips of leather fastened, in turn, to another underlining; jambarts of plate, spurs of rouelle form; a hauberk; a haqueton padded and, as well, stuffed with cotton; vambraces of plate; demi-brassarts complete with coudières; roundels fashioned to resemble lion-heads upon his arm-joints; for helmet, a fluted bascinet of plate; the wambeys or gambeson, stuffed with wool and padded with lines of needlework; and a special or particular garment, the so-called cyclax, laced at the sides, and cut very short in front. One authority on brasses thinks that he can detect yet another garment, to which he cannot give a name.'

geometry, and Greek grammar in particular, in which last subject one master had established a real reign of terror, without books to read, and averse to every form of 'game', miserably unhappy in fact and missing my home, I found relief, long before I knew the proper name for it, in studying ballistics, a science that the dictionary defines as 'pertaining to the throwing of missiles or firing projectiles; ballistic curve, the curve of a projectile in flight, the path of a projectile', etc.; etc.; in terms which exactly describe and explain it. Much as I disliked the masters, and the distaste was reciprocal, I admired the height to which they could hit or throw a cricket ball; or, even, more prosaically, kick a football. I used to watch them driving off golf balls within the 'grounds' of our concentration camp, which was under the chalk-hills of Reigate. And it was precisely the height and the line of flight which interested me. I may add that as soon as I was 'released' and moved on to a public school I was interested in other things and no longer an amateur of ballistics.

But a comparison of spires, as suggested in the previous paragraph in the person of the anonymous designer of the steeple of King's Sutton, is very sensibly and noticeably in the direction of ballistics. It is in the line of flight and height of the spire that lies the fascination. If there be some remote phallic significance and importance to this, as will certainly be argued, so much the better. There is no need to be ashamed of it. The thought of Louth or Salisbury steeple does take me back to my school days where I knew the longest 'throw' of a cricket ball (140 yards, I remember, and by an Australian 'black-fellow' or aborigine; and the longest drive, 380 yards, can it have been? All from *Wisden's Almanack*). Spires or steeples, undeniably, are record-breaking triumphs of height reached, in combination with force and elegance during that process, and of purpose to be seen from miles around.

But the purpose of a church tower is different. It is to be a tower, and has to have a bell-chamber towards the top of it, with a roof over that on to which it is tempting to climb in order to look down and admire the view. The urge of the spire or steeple is upward; that of the tower, if not downward in the direct meaning, is at least to tempt one to stay aloft for a little and not come down. And not only to be seen from below, but in order to give enjoyment while you are up there on the roof. Nearly always the towers are enlivened with parapets and pinnacles. It is on the top of Magdalen Tower that, 'in accordance to a custom which is said to have originated in a requiem for Henry VII, in commemoration of his visit in 1488, glees and madrigals were always sung at sunrise on May Morning to usher in the spring. . . On this occasion the bells (the most tuneful and melodious in all these parts) are all rung, when the whole tower shakes and bends perceptibly,' to quote from a *Murray's Handbook* of more than seventy years ago.*

It is only a wonder there have not been more ceremonies on the top of towers; the

* A painting by Holman Hunt depicts this ceremony.

Perpendicular towers which are one of the glories of the kingdom and 'the grand and truly distinctive offspring of our national architecture', (Charles Wickes). Not, antiphonally, atop the twin towers of Beverley Minster, aerial bandstands as near to each other as the Glass Towers of Mies van der Rohe on Lake Side Drive, at Chicago, and which for their period are more stupendous, and in a word, beautiful; but it would be interesting to know how many foreigners, Americans included, have penetrated to this remote corner of the East Riding which has two of the finest mediaeval churches in all Europe? No less than five storeys of blind panelling framing in a huge west window; huge soaring, engaged, not flying buttresses, richly cusped and canopied; and then the leap of the twin towers that are exactly, perhaps unimaginatively alike in every detail. Neither the towers of Beverley, nor the Angel Steeple, or Bell Harry Tower of Canterbury, under its other name, are intended for music. They are too tall for that. The proper venue for music of this sort is a collegiate chapel tower like that of Magdalen, or any one of several dozen other Perpendicular towers in country towns and villages all over England.

But it is to be noticed that with certain exceptions they come in particular districts and are apt to occur in clusters as though, as was the identical case with spires or steeples, there were some communication or common link between them. It was nothing else than rivalry and competition as to who could outdo the other, a species of game or entertainment that, given their slow processes of building, could outlast the best years of a human generation. Into the secrets of campanology, alas! I cannot enter for they are unknown to me, but the music of the church bells was of course an integral part and consideration in tower building. It is true that Magdalen Tower, fine as it is rising above the bridge, and affording one of those classical scenes of England like Warwick Castle seen from the bridge over the Avon, is by no means the most beautiful of the Perpendicular Towers. Its three lower storeys, blank and of no interest, and bell-chamber above that, all are subordinated to the parapet and flat roof-top with its eight pinnacles which are more than twice lifesize. A tower like that of All Saints, Derby, improbable as it may seem in the midst of all the smoke and grime – its silhouette seen from afar over the middle of the town and familiar to the writer for a lifetime when going north to his old home – the unfortunate and aggregated setting apart, is much better and more interestingly designed than Magdalen Tower. It rises in three perfectly proportioned storeys: doorway, with west window above that, neither of them excessive in size; then, a storey most beautifully latticed and ornamented with blind tracery and arcading; last, the bell-chamber of large window surface to let out the sound; then, pinnacled and parapeted roof-platform, all the metal pennons flying from the four corner-pinnacles. But who would want to stand up there to look down on the china works and engine yards? Once, as can be seen in a 'primitive' painting of Queen Anne's time at my old

home, Derby was a red brick town of fine houses – but how subtly differenced from a Dutch town of the same date! – with the tower of All Saints, even then, rising over it as though it had stood there for ages.

Derbyshire leads on to Yorkshire, and with only a slight detour to the fine tower of Hedon, along the Humber. This, too, had it been a fifteenth-century minaret, would have been more written of and better known. There is a solidity about the tower of Hedon that puts it a little apart among Perpendicular towers, and does not detract from the tapering graces of its engaged buttresses; but the double-tiered parapet guarding the platform on its roof may suggest that for once the view from it was not the object and that it is a bell-tower, pure and simple. Could Boston 'Stump' be seen from it, which is only a few feet short of the white spire of Louth? It is said to be seen from forty miles away on the Norfolk coast. Boston 'Stump' which, at least, is well known from association across the Atlantic, being less English than Flemish or Netherlandish of appearance, a huge giant of a tower of purpose to be seen from miles around and out to sea, with high bell-chamber where the beacon burned till the octagonal lantern was added for that purpose; a gaunt tower, then, topped by a conceit. It is reminiscent of the much more graceful octagonal lantern – and it is a much higher lantern chamber – of All Saints Pavement, York, wherein a 'lamp was hung at nightfall as a beacon for travellers on their way to the city through the forest of Galtres'. There are, too, octagonal lantern chambers of beautiful fantasy at Fotheringay and at Lowick, both in Northamptonshire.* At Lowick, it is true there is a plenitude; there are, indeed, too many pinnacles.

Another of the splendid Perpendicular towers is at Wrexham, in Denbighshire, and, therefore, just inside Wales. How curious to think that this tower, added soon after 1500, is within so few human generations of the last of the native Welsh princes! It is a building often seen and admired by the writer on his way to or from Cheshire or North Wales. A five-storeyed masterpiece of its kind, if of the ubiquitous sandstone that is the bane of both Nuremberg and Heidelberg. What an exquisite west window, though, of five lights above the doorway, with traceries above it that are the epitome of delicacy; paired windows over it with statues in niches to both sides and in between; a storey of smaller windows with the like number of statues contrived, as those below, in cusped niches worked into the supporting buttresses; great bell-chamber over that with paired windows and more statues at every side; and the grandest of grandstands on top of all with corner pinnacles as tall as turrets, of Tudor aspect like the towers of Nonesuch, and three lesser and ordinary pinnacles on each face of the parapet between! A grandstand to listen to the music of the bells coming up from the floor below, and to look out on the Welsh hills.

* It has been suggested, not improbably, that the octagon on Wyatt's tower at Fonthill Abbey was inspired from Fotheringay.

Corner-pinnacles, hardly less elaborate and with again the touch of Tudor None-such on them, adorn the Perpendicular tower of St Neots in Huntingdonshire. But the scale is smaller at St Neots, looking down upon the streams bordered with willows and distant cottages thatched with reed. At St Neots, as in the Norfolk churches, the delight is in the slope and reduction of the stone outline of the buttresses; their set-offs, their drip moulds (to throw off the rain), all calculated with extreme precision and through their good sense and utility giving aesthetic beauty and satisfaction.* But it has not quite the expertise and taste of the Norfolk towers where every alteration of line has been long considered; while the roof-turrets are a little too flamboyant and could be flying the pennons of a tournament. Another, more bucolic tower on a hill in an old market town at Folkingham, in Lincolnshire, could be by the same hand. It is not far away across the fens and willowed streams. But, as ever with works of art, there is a mystery. At St Neots it is understandable that there should be a fine church tower. But why at Titchmarsh, in Northamptonshire, where, and rather out of its place because it looks of provenance from the Cotswolds or the West Country, there should be the perfect model of a Perpendicular village tower? Or, more mys-terious still, the tower of Tickhill, which is in Yorkshire, not far from Doncaster, which latter is so unspoilt that there are still statues in their proper niches? At Tickhill, the buttresses in the lower stages of the tower are too heavy; but the double lighted bell-chamber and pent-house bell-terrace on top of it are beautifully and richly pinnacled in token of pastoral riches, long before coal and iron had reared their dirty heads and yet dirtier hands.

It is, however, in the West country that the Perpendicular, our national and idiosyncratic style had origin (from Gloucester), and it is to be seen in perfection at Chipping Campden. How often has the present writer come towards it through the Cotswold country that in his reckoning, coming from his direction, begins just the far side of the dark golden stone of Bloxham, but on certain days the spire and bell-chamber of Bloxham church can be darker still, almost as dark as 'black' Barbados sugar; and, at last, and perhaps the apple-orchards will be in blossom this time, we see the town of Chipping Campden with the Tudor gazebo of the old walled garden of the Noels beyond, and rounding the corner and taking the beauty of it for granted, we are beside the most reticent and beautiful of almshouses, a row of build-ings that in their dignity could be said truly to make little difference between prince and beggar! To judge from its buildings Chipping Campden must have been some-thing of an Arcadia of rich farmers and peasants in its day, but of course, as with the Perpendicular churches of Suffolk, the real wealth came from the wool trade,

* A particularly beautiful example of this treatment where the buttresses are like clasps holding in the tower and then releasing it into the air, is at Stoke-by-Nayland which is in Suffolk. The buttresses are set diagonally with niches worked in them, and the whole is exquisite in calmness and proportion.

and at least in Suffolk it was another kind of Perpendicular. I think there was more of fancy and imagination at work there than in the Cotswolds perhaps only because it is near the coast and many persons will have heard tales of, or even have been to Bruges and Ghent. But the Cotswolds were untroubled by news of foreign parts. There are no nerves or apprehensions in the architecture of Chipping Campden; or for that matter of Broadway, or Burford, and their attendant villages. This must be the most quiet and contented architecture in the world. And so it continues, through Bibury and Northleach and Cirencester and a hundred more villages and hamlets, down to what we can only look back on out of our time as yet another pastoral Arcadia.

This was in the late fifteenth century and early sixteenth century in Somerset, during those years when the local wool trade was as valuable as in Suffolk or on the Yorkshire Wolds. There arose a direct competition, for it was little less than that, between villages and small market towns in the matter of church towers, to which perhaps the only living equivalent in our day has been the rivalry in Balinese villages over their gamelan orchestras and their troupes of dancers. There have been times in human history when equivalent fevers of creation have seized upon certain areas of population, and I am not thinking of Saturday football results. Something of exactly the same nature was happening in East Anglia in just the same years, but in Somerset it was the towers chiefly and particularly; while in Norfolk and Suffolk it was flint 'flushwork', a local speciality, immensely long naves lit with many windows, 'angel ceilings', and much else besides. In Somerset it has been estimated that there are fifty, or thereabouts, fine towers; and that they can be divided into three or four groups which, luckily, cohere together because each group tended to work out its own problems as though in competition, not against each other group, but in friendly rivalry among themselves.

The 'play', so to speak, or cup of contention was in matter of arrangement and display of windows and in the cresting and parapeting of the towers, though never in the sense of aerial grandstands, or for choir-singing on May Morning. Not even, I think, particularly for convenience in hearing the church-bells, but only and simply to be looked up at and admired, with the details of other near-by church towers held in mind, and ready there to be compared. One group is near Wells; another group lies south of that, below the Mendips; while the other towers are in the Vale of Taunton. Within the limits of play it is certainly extraordinary the variety that could be worked into their towers; it being, also, an important feature that there were different building stones, sometimes even within the same small area, and that therefore the towers are to be judged by colour, too, and not only for their outline, disposition of windows, diversity in arrangement and display of pinnacles, and so forth.

Starting south-west from Bath or Bristol, spread out fanwise over an area of some

fifteen to twenty miles and at about the same distance from either city named, are the towers, from east to west of Mells, Chewton Mendip, and Wrington. All three towers being in the direction of Wells, are of the type of the parish church of St Cuthbert, Wells, which church in that cathedral city seems to have been the pattern; long rectangular panels, that is to say, of blind arcading and bell-chamber above that, all expressed in restraint and calm. The beauty of the villages of Mells and Wrington is marvellously set forth and enhanced by their Perpendicular church towers. A few miles south-east of Wells, and east of Glastonbury, is Evercreech which has another of these sedative and quiet towers, designed for confidence and calm in villages of thatch and beautifully coloured stone.

A second group of only slightly different character and detail lies a few miles from Yeovil, its fame deriving from the towers of Isle Abbots, South Petherton, and the matching, yet contesting twins of Kingsbury Episcopi and Huish Episcopi. Isle Abbots looks to be a model of its kind winning on all points possible in this pastoral or Arcadian contest of towers, and South Petherton I have not seen. Huish and Kingsbury Episcopi, to write of them as brothers – and they are but a mile or so, or, as it were, a year or two apart – have indeed but the vaguest of facial differences by which to distinguish them and tell them apart, and one would have to run from one to the other repeatedly in order to feel at all certain as to wherein these differences lie. A few words of description of Huish Episcopi must suffice. Built of blue lias, a phrase which a little belies or exaggerates the visual truth, like its companion it is within a few inches of a hundred foot high; it has a large west window of four lights over its west door; ringing-chamber above that with three-light windows, and two-lighted bell-chamber; the whole, buttressed to this height with three tiers of attached pinnacles, diminishing and clasping the tower closer at each tier. Roof platform, nothing spectacular, but nicely pinnacled with quatrefoil battlement for rail. Huish and Kingsbury Episcopi are probably the most beautiful and typical of the Somerset towers, and are so beautifully matched as to be an architectural and aesthetic satisfaction, more than a sensation, in themselves.

A third group of towers is round Taunton, and includes North Petherton – (the best part of twenty miles away from South Petherton) – Bishop's Lydeard, Kingston, and St Mary Magdalene, in Taunton itself. North Petherton, in fact, much resembles the Episcopis, if it is a little taller, and its tower is more richly parapeted and made into more of an aerial feature. Both Bishop's Lydeard and Kingston are of red sandstone, of which latter village – and it is not inconsequent to the beauty of its church tower – the Arcadian fame was its Kingston 'black apple' from which a dark or even blood-red cider was produced; 'and it was the custom till within the last few years for rustics on Christmas Eve to go to every orchard and sing to the apple-trees to make them abundantly fruitful'. The tallest of all the towers is St Mary Magdalene

at Taunton, which is one hundred and sixty feet high and rebuilt, moreover, but in exact copy, in Victorian times, except that the material is pink sandstone in place of the original grey stone. Above the five-light window over the west door there come two storeys of identical three-light windows, with bell-chamber over them which has still taller windows; the whole flanked by buttresses as high as the bell-chamber where they divide into tall pairs of pinnacles set at an angle to the wall. Where they stop, just below the parapet, there is an awkward thinning which makes top-heavy the exaggeratedly tall roof-pinnacles that in any case project themselves awkwardly as though thinned and then broadened out to no purpose. The top of the tower at Taunton, is, at once, too heavy and light; too large and looming, and yet pierced with openwork so that it is like a transparent crown.* The high detached pinnacles that balance themselves on the backs of projecting gargoyles add to the confusion of points and cusps, and are as though acrobats had been brought in to balance billiard-cues or other things of the sort upon their heads.

The tower at Probus, in Cornwall, is far saner in design and strictly of Somerset type; its two lower storeys unremarkable except for their dignity; wonderful and considered recession of planes as the buttresses refine their width, and yet have tripled themselves to finish with three engaged pinnacles apiece just under the parapet; and at last the same gargoyles, almost, but with no conjuring tricks being played upon their backs as at Taunton, openwork battlement of quatrefoils and parent pinnacles each with six pinnacles at its sides. It is the tower of Probus which is as unlikely as any more far-famed minaret or church tower in France or Italy or Spain, and has certainly been much less admired and seen. It is of course late in date. Work was in progress in 1523. It is more Tudor than Gothic; particularly in the bands of quatrefoil ornament on the base of the tower which rise to more than shoulder height. That there was contact between the builders of Probus and those working miles away in Somerset is more than obvious. They must have heard of, and then seen for themselves this competition in the building of country towers. But it does not seem so likely that the architect was an importation from Somerset. More probably he was sent there to have a look at them, and set to work on his return. The chief resemblance is between the towers of North Petherton and Probus. Were they set down side by side away from their villages it would be difficult to tell one from the other. It could be that, remembering the quatrefoil ornament on the plinth of Probus tower, one would look for it again this time where Probus has but blind arcading, under the very cornice where the battlements begin, and fortified in our opinion look a little further up the tower for the swans with spread wings about to take flight from the four corners in their play at being gargoyles, and know that this

* A tower that has manifestly that of St Mary Magdalene at Taunton well in mind is at Dundry, at the other end of the county, built as a landmark on a hill above the Bristol Channel.

is North Petherton. For such a degree of certainty long acquaintance, and a good deal more than that would be necessary, as with someone even now in all the roar of traffic, the glare of traffic lights, and constant changing of traffic regulations, who would derive permanent pleasure and delight from the steeples of Wren's City churches. Either, or both, are a game or pastime that can last for the best years of one's life.

2

Cloisters and Chapter Houses

The fact, and it was not haphazard, of the writer's birth at Scarborough, on the Yorkshire coast, the most northerly watering place and pleasure resort upon the map of Europe, causes him to cast a wary eye upon climatic hypotheses and pretensions. 'The air is bracing and pleasant. Sands remarkable for extent and smoothness stretch away under both north and south cliffs. Bathing is good.' But for how many days in the year, I write, as one remembering the line of old wooden, horse-drawn bathing machines? 'All classes meet and enjoy themselves here.' And the Spa? 'A long and wide terrace extends in front; and at one end is a kiosk for the company's band – a very excellent one – which plays every night.' But not during the winter, I have to comment. 'The effect of this terrace, crowded with company, and brilliantly lighted by lamps along the front of the buildings, with the sea breaking close under the balustrade (as it does when the tide is up), and the moon rising over the water, is very singular: such a mixture of nature and art is altogether uncommon in England.'

The argument continues that north of about this point the building of cloisters becomes rather more than less half-hearted. At Jedburgh and Dryburgh Abbeys, over the Border, there are the ruins of cloisters, but it is perfunctory and a matter of form, not practice. Coming south, Furness Abbey on its promontory or *presqu'île* in Lancashire, founded here by monks from Savigny in Normandy on this spot, then called Beckansgill, or the Valley of Deadly Nightshade, and 'built of the red sandstone of the district, the softness of which did not admit of that minute and elaborate ornamentation which distinguishes some of the other abbeys of England', had cloisters though there are no remains of them, but they must have been in use as passages more than for recreation. For how many days in the year at Furness Abbey did one long for the peace and silence of the cloister, and perhaps a memory of the south, even Mercutio's 'dew-dropping south' having, maybe, had a taste of it in south-western France, or even Italy, and of the splashing waters of a fountain! Answer: for as many days as bathing was possible from the Scarborough sands, or on the bathing posters of a British Railways station. One must not exaggerate the climate either way; but it would seem to me that even the famous cloister at Gloucester is in reality an indoors

cloister. The purpose of it was to keep warm, not cool. That, too, and above all to keep out the draughts, was the aim both of our chapter houses and our choir stalls, which form the other subject matter of these few pages.

The line of chapter houses can begin, appropriately, at Westminster, where the attendant cloister does not command much attention or arouse happy memories of possibilities latent in its blackened precincts. It is an octagon with central pier or column of a 'bundle' of eight slender columns of Purbeck marble; and built under Henry III its six tall windows, out of the eight spaces available, show the influence of the Sainte-Chapelle in Paris and like that are indeed high walls of glass. The whole chapter house was cleared out and restored by Sir Gilbert Scott, who must have assisted or prompted the grimness of the trefoil arches of the dado above the seating accommodation. The chapter house at Westminster is E.E. (Early English) with a vengeance, and the retribution has been wielded with an unsparing and stern hand.

In this present chapter the repertory of examples is limited; and the limitation comes of necessity, not choice. At Canterbury there are cloisters, but they do not give the delight that comes from opening an unobvious side door and finding sunlight and a traceried light and shade. There is, too, a chapter house but it is oblong in plan, and in reality, as it stands (restored), 'a sermon house to which the congregation retired after prayers.' While, at Winchester, there is only the site of the cloister and nothing left of the chapter house. But there are the choir stalls which are of very early date, around 1300, darkened by the centuries and architectural of form as though their traceries were from the drawing board, and of an angular disposition and correctness reminiscent of the tomb of Bishop Aquablanca in Hereford Cathedral. They are not, that is to say, particularly adapted for woodcarving though their two-light arcading, and floreated and very pointed arches are of course richer of effect than the Purbeck colonnettes or grouped columns, two-light openings and strong-cut arches enclosing quatrefoil circles of Bishop Aquablanca, whose tomb dates positively from 1268.

Salisbury, thanks to Wyatt, is no place in which to look for choir stalls, and the cloister and chapter house are lucky to have escaped alive. But the beauty of the cloister derives not so much from the cloister itself as from the cedar trees in its midst and the view of the incomparable spire from different angles along its walks. Even so, the chapter house has been to some degree 'hospitalized', i.e. by excessive zeal and scruple cleaned and cleared out until it appears empty of itself and more apt for the beds of a dormitory than for a synod. It is octagonal in plan, with many-shafted central column spreading out its spandrels across the ceiling, pointed and uncomfortable-looking sedilia along its walls under tall trefoil windows, but with a beautiful two-arched and cusped entrance of noble effect. From those so far seen and entered, little idea could be formed of what a chapter house is capable in terms of a work of art.

At Exeter there are neither choir stalls nor chapter house; but on the other hand there is the Bishop's throne, dating from just after 1300, which is an extraordinary pointed and floreated *tour de force*, of airy openwork with the dry lightness of a clump of dead-flowers. The wooden spire of it rises sixty feet into the air, and in its exaggeration or distorting of vine-clusters, bindweed and other local forms, is as extreme as the giant groundsel and other common plants growing on the volcano slopes of Kilimanjaro. It is by the master of the stalls at Winchester who came to Exeter to chose the timber for it, and make the drawing.* This, in a county later to be conspicuous for its rood screens of Perpendicular date, reaching sometimes right across the church. Why Devon should have had such expert carpenters and carvers stays unexplained, except that it is a sea-faring county like Suffolk of the double hammer-beam roofs, and that carpentry may like boat-building have been in their blood for centuries.† The screen at Chawleigh runs across the church from north to south; another at Swimbridge, traverses nave and aisles and its coving above the spandrelled arches is in full summer leafage; another at Atherington, still with its rood loft is as late as 1540 and of a Burgos-like richness in detail. At Bradninch, another village, the rood screen once again goes across both aisles and nave; while at Dunchideock of the delightful name the screen is of the same scope and direction, and the carving looks to be superlative. There would seem to be no end to these delights in this small part of the world. In the matter alone of wooden rood screens the county of Devon must be as rich in examples as is the case with the flushwork of Suffolk, or the open timber roofs in East Anglia. Such are things of beauty in which England stands alone, details though they may be, but when they are added to the churches of the same counties and of the fens and marshlands; to the churches of Lincolnshire, one hundred and thirty of them, alone, starred in *Collins' Guide to Parish Churches*,‡ and that total but little exaggerated by local patriotism; and with the 'wool churches' of the Cotswolds still to be added in to the total; then there is a formidable competitor in other and different ways to France, or Italy, or Spain.

But now there comes a work of art on another scale altogether, and that can hold its own with any other in Europe of whatever date. This is the chapter house of Wells Cathedral. It is a sensation in itself that it is approached, as you turn leftward before reaching the choir, by and under the inverted or strainer arches inserted to hold the weight of the tower in 1338–40, a feat of original genius that made a virtue out of necessity. The conception is of a boldness that puts the triumphs of twentieth-century engineering to shame. The arches, four sets of them to form the quadrilateral

* The Bishop's throne at St David's, in South Wales, is said closely to resemble that at Exeter.

† In his two volumes on *Devon*, 1952, in *The Buildings of England*, Dr Nikolaus Pevsner gives a daunting list of no fewer than forty 'outstandingly impressive' rood screens, most of them in village churches.

‡ Edited by John Betjeman, 1958.

shoring up the tower, rise from the floor with their brave mouldings, each pair of them intersecting in the manner that the larger branches of a beech tree of rare instance can grow through or into and out of one another, and continue upward on their course. In fact, in giant form they are as a pair, four pairs indeed, of bent trunks that have been trained and inculcated in this manner. And in the spaces left empty by their arching are huge pairs of round *ocelli*, like great portholes, with the same simple mouldings. But it is better still to put off entry into the chapter house until one has seen the Lady Chapel which is in the apse of the church behind the choir. It forms five sides of an octagon, but the play and interplay of its supporting columns – they are clustered columns – develops a theatrical richness and diversity of effect as one moves between them, and prepares one for the shock of entering the chapter house.

The chapter house has another prelude or fanfare which is the staircase leading to it. This is incomparable of effect and as a prelude, with its plantation or grove of wall columns all around, and age-worn steps. And so to the right into the chapter house, the mere entry into which is a sensation of the first order. It is a marvellous but frozen palm-house of organic growth, arrested, but still dormant and nourishing itself on air and water. The central column and its spreading palm-ribs hold the eye, but the chapter house is octagonal and as many more of the fan-trees of the oasis sprout and spread themselves upon the walls. But there is a static orderliness about this arboreal growth. All is trimmed and kept to order and proportion. This central shaft or bundle of columns, tied in with base and capitals, has thirty-six ribs rising in parabola from it towards the ceiling and the pollarding or lopping of its foliage. Round the octagon, beneath this arboreal springing of palm-ribs from all around, are tall two-light and trefoil windows and the stone seating. There is no surer or firmer conception and sensation in any stone architecture than in the chapter house of Wells, which like its Lady Chapel can only be from the hand of a master.

Neither at Hereford, nor at Worcester, is there any particular interest in the field into which we are enquiring. At Hereford there is a chapter house pulled down in the eighteenth century and too late recognized as an early instance of fan vaulting, of which hardly any trace remains. At Worcester, of dark red sandstone again, the Perpendicular cloisters are restored, and the decagonal chapter house is but the ghost or shadow of what it may have been. At Gloucester it is perhaps fair to say that the fascination of its cloister lies more in its appurtenances or fittings than in its fabric, for does it not contain the fan-vaulted *lavatorium* for the monks with the stone troughs for the water, and even the towel-cupboards at the corners? Not only that, but the most complete set of *carrels* or reading cubicles set along the cloister walks, no fewer than twenty of them, but such incidental detail does not equate with beauty, and Gloucester is not a beautiful cloister. The fan-vaulting makes the abiding interest of

it; but it is for indoors, not for the sun and shade. At Lichfield there is no cloister, and the chapter house – again with a ribbed roof and central shaft – is not outstanding; but perhaps the red sandstone, which detracts in no way from the marvels of its nave and triforium, is to blame for this.

One other Midland site, in the county of Nottingham which is far from being as rich in mediaeval works of art as East Anglia, the Cotswolds, or the West Country, is the locally famous chapter house of Southwell Minster. This I have known since childhood for it is not far from my old home. It is polygonal but with no central column. An extraordinary and fantastic floral profusion, or blossoming and leafing in stone, characterizes this chapter house and its approaches, but more especially the entrance to it; the columns of which are of Purbeck marble with beautiful floral capitals and floral mouldings in stone above them, the entrance itself being through and under a double archway of an airy elegance with delicate tracery in the opening above it. Dr Pevsner, who has devoted a small volume to the chapter house, remarks wisely that 'it will never be possible to determine how far they (the flowers and leaves) were copied from sketches in notebooks made during French apprenticeships or journeys and how far from nature. Both methods were no doubt used.'* Maple, oak, hawthorn, ranunculus, potentilla, vine, ivy, and hop have been identified among other plants. This floral persistence has almost an obsessional character in the chapter house at Southwell, and it may have been a fever which lasted but a few years in the minds and hands of its creators, probably a single master-sculptor and his pupils.

Where chapter houses are concerned this leaves us with York and Lincoln. Wyatt, the putter-to-rights of Salisbury, had been at work too at Durham destroying the Norman chapter house and tampering with the cloister, where are still some thirty of the *carrels*, half as many more of them as at Gloucester, and not so well preserved as those; but at Durham they were wainscotted, and entered by doors, the tops of which were pierced so that each monk could be under survey as he worked. Durham is too far north for the pleasures of a cloister. And of cloister there is no trace left at York, but the octagonal chapter house which has no central column is fine and bold of design, 'generally considered the most beautiful in England', but this is one opinion with which it is unnecessary to agree. There is nothing exceptional in its design. The window traceries are not particularly interesting or fanciful, and as an interior it is fine, but not to anyone who has seen the chapter houses of Wells or Lincoln.

At Lincoln the chapter house is decagonal, ten-sided, inside and out more like a celestial kitchen, peak-roofed, and of an extra fascination because of its buttresses like tie-posts, eight of them, no less, standing a little apart from the building and

* Dr Nikolaus Pevsner, *The Leaves of Southwell*, London, 1945.

31

stretching their stone arms out to keep it steady. It seems even then on the point of ascent, but has been tied down these centuries with the stone columns and tall pinnacles at all its angles. This, again, is a chapter house with a central shaft or column. The interior gives an impression of masculine strength with more in reserve, and could be the council chamber of warrior monks, if not active militarists, at least of some of their Buddhist *confrères* far off in China who were famous for their boxing. But the interior glory of Lincoln Cathedral, supernumerary to its Angel Choir where Purbeck marble shows not inferior to the marbles of Imperial Rome, is its spired choir stalls, in double storeys topped with cusped spires and high pinnacled standards. The misericords at Lincoln, i.e. the underneath of the stalls which, when turned up, were the support of the priests while they were standing – and many of them would be aged – are of extraordinary variety, including the well-known Fall of Pride, an armoured knight falling from his stumbling or wounded horse. The stalls, with seating space for one hundred and eight, and volume of sound, musical or other, commensurate to that number, tower up like spired headdresses and are suggestive of cold matins and colder evensong, as though they were in fanciful protection against fog and sleet. They are of wholly English invention, far removed indeed from the spikiness of German Gothic although they may be seething and pricking with their points. But it is difficult to admire them without thinking of the agonies of cold their occupants must have suffered during perhaps seven months of every year. The cold was indeed a strong suit in the ritual. If the stalls at Lincoln are compared with those of Gloucester it will be noticed that the stalls at the latter place are of flat contrivance with only a symbolic hood or canopy, no more than that, over the head of each occupant of a stall. But, and one must be cautious about climatic changes and conditions, it was the county of Gloucester, not Lincoln, that was famous during the Middle Ages for sweet red wine.

There is the same naturalistic pinnacle work over the stalls at Ripon as at Lincoln – what is left of it – for the hand of Scott fell here as heavily as the fist and housemaid's duster of Wyatt, wherever that iconoclast of rare genius had his way. It is naturalistic, but of no known flowers or plants except the stems of ferns, and straggly ferns at that. Mr Crossley suggests, and it reads almost prosaically, that the York 'firm' of Drawswerd famous for three generations (and one of them member of Parliament and twice Lord Mayor of York early in the fifteen hundreds) was responsible for such work as this. Also, another local 'firm' in Ripon, but let us rather call them 'studios' or 'woodyards'. At Beverley Minster, with stalls for sixty in the choirs, the complexity of detail is more than sensational, and one could be lying in the bracken looking up into the trees, lime trees, it could be, that have taken on mullions and minor castellations among their leaves and then, as with a change of focus we see the spires of ferns again. Mr Crossley rates this northern school of woodcarving far

Opposite: Decagonal chapter house at Lincoln

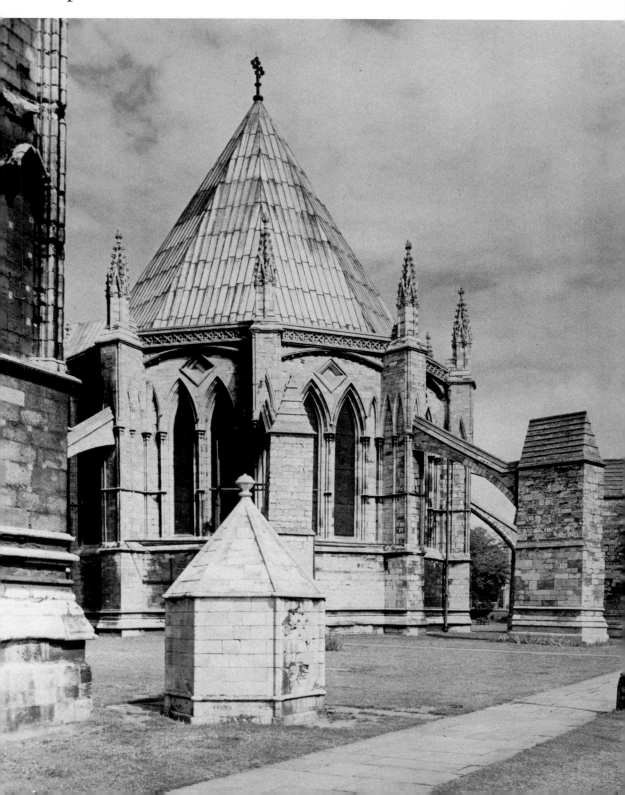

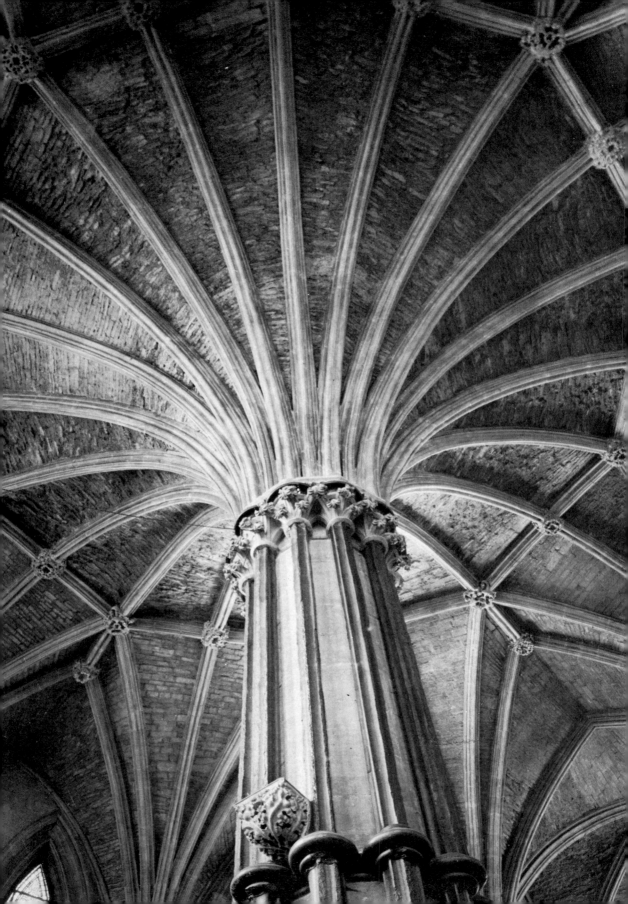

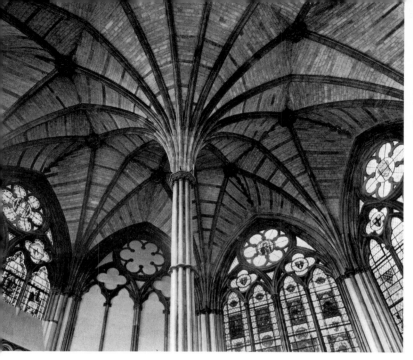

Chapter house of Westminster Abbey built under Henry III

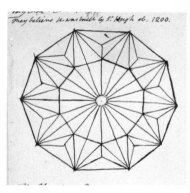

Above Plan of the vault of the chapter house at Lincoln; from an early 19th-century manuscript
Far left Central shaft of the chapter house at Lincoln
Left Entrance to Lincoln chapter house

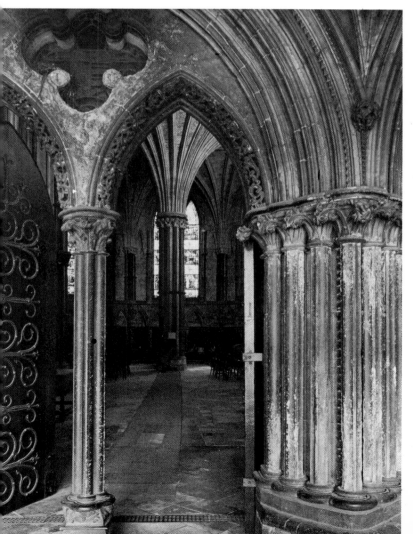

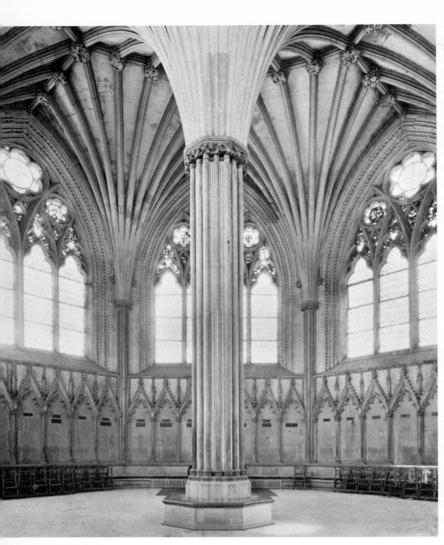

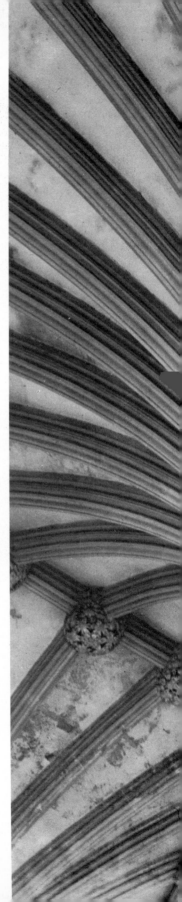

Above Octagonal chapter
house at Wells Cathedral
Right Plan of the vault of
Wells chapter house
Far right The thirty-six ribs
of the palm-like central
column of Wells chapter
house

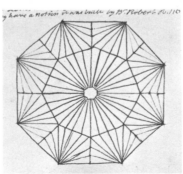

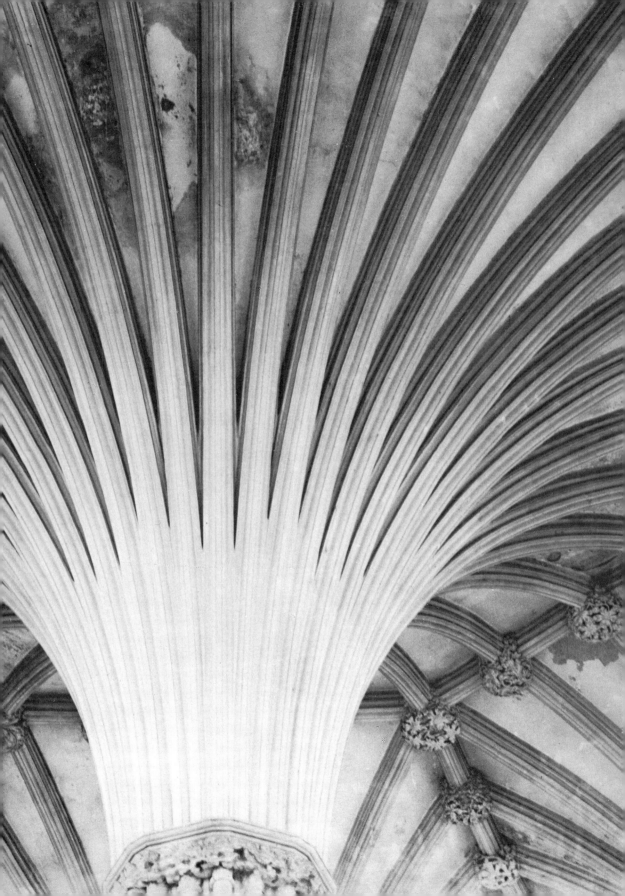

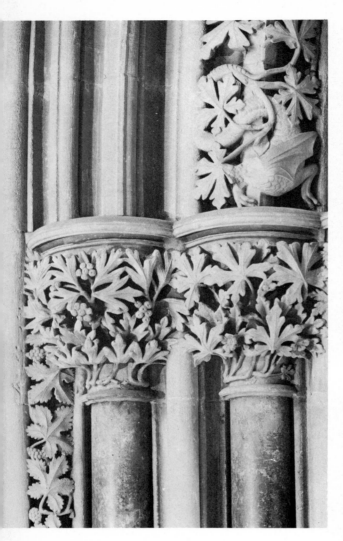

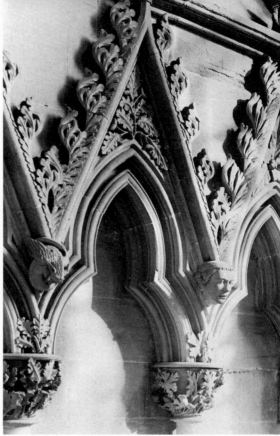

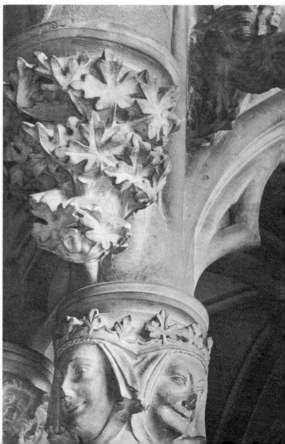

Above Leaves of mulberry (or vine), hawthorn and buttercup from Southwell chapter house
Top right Carved canopies of the sedilia round Southwell chapter house; the capitals have oak, buttercup and hop leaves
Right Detail of the carving from York chapter house

Opposite Fan-vaulted lavatorium of the monks in Gloucester Cathedral cloister

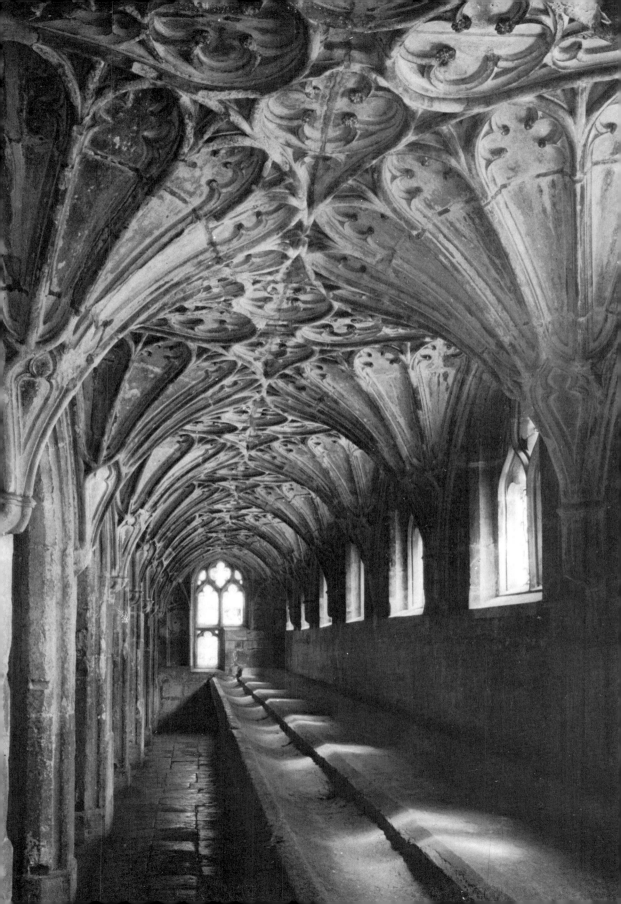

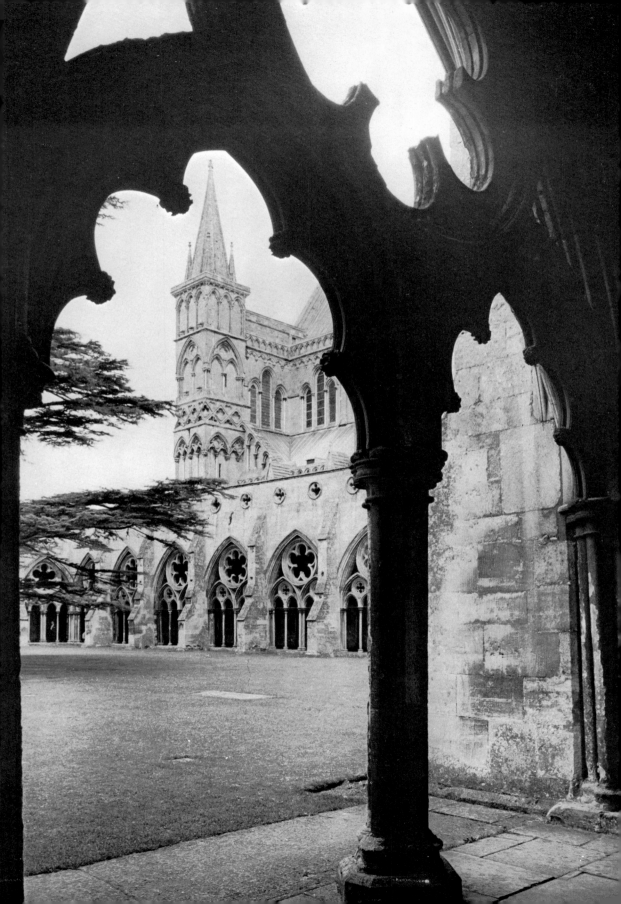

above the southern. 'It is cleaner cut, more faultless in design, less fussy and con-
fusing'.*

At Carlisle Cathedral, where probably there was another sub-variety not, so to
speak, given varietal or botanical name, in photograph the stalls are spired in two
tiers or layers, deeply crocketed as though they were the dead spires of bluebells,
and calculated to keep the draught out while enabling one to see if one's neighbour
was awake or sleeping. Perhaps the stalls here are too uniformly alike to be interesting.
Chester Cathedral has its arrays of stalls in remarkable state of preservation, two or
even three spired niches are superimposed on each other; and there is the dean's stall
carved with the Tree of Jesse and a strange little figure in wide-brimmed hat sitting
to the side of it, staff in hand, and reminiscent of the charlatan or necromancer in
paintings by Hieronymus Bosch, though it may date from a hundred years before his
time. All these mentioned, however, are but the tithe of what has been destroyed, and
not so much by iconoclasts of the stature of James Wyatt or Sir Gilbert Scott, petty
and local interference to be added and included, as by the commissioners who went
on tours of destruction at the Suppression, and by those waves of Puritanism that, as at
present in another, and yet the same old form, have been the bane of English history.
Worse still, as Mr Crossley observes, the majority of these beautiful works of
carpentry and of woodcarving were only finished during the fifty years before the
Suppression, and at once destroyed. As he says, in the north of England alone, sets
of stalls at Byland, Bolton, Cartmel, Combermere, Fountains, Furness, Kirkstall,
Meaux, Rievaulx and Vale Royal, thus perished; and there is no key to what
vanished.

There remain other and outstanding minor works of art of which the chief may be
the font cover at Ufford, in Suffolk. This is eighteen feet high, all crockets and pin-
nacles, once coloured and gilded, and articulated so that its three tiers or storeys can
slide into and over one another like the parts of a telescope. It is so fine a work of
art that even the Cromwellian iconoclast and image-breaker Dowsing – neither the
first, nor the last of his sort – writing of it in his diary, 'there is a glorious cover
over the font, like a Pope's triple crown, a pelican on the top picking its breast, all
gilt over with gold' – even Dowsing spared it and passed by.† Another wooden font
cover at Woodbridge, also in Suffolk, has freestanding pinnacles at its sides, taller, as

* *English Church Craftsmanship*, by Fred H. Crossley, London, 1941, pp. 56, 57. The sets of stalls in
the Henry VII Chapel at Westminster, at King's College, Cambridge, and the earlier set in the Garter
Chapel at St George's, Windsor, are tinged, as to the first and last, with Flamboyant Gothic influence
perhaps from Flanders, while of the stalls at King's College, Dr Nikolaus Pevsner remarks that 'they are
the purest work in the Early Renaissance style in England ... And their quality is not excelled in any
contemporary woodcarving anywhere north of the Alps.' Cf. *The Buildings of England: Cambridgeshire*,
1954, p. 87.

† Quoted from *Monks, Nuns and Monasteries*, 1965, p. 67.

Opposite: Cloister of Salisbury Cathedral

it were, two-light windows pierced into it, and a less exciting spiral finish; but the stone bowl of the font, to make up for this, has a pair of ladies with butterfly head-dresses carved upon it. At Ewelme in Oxon, where lies buried Alice, Duchess of Suffolk, the niece of Chaucer, in one of the most beautiful tombs in the kingdom – which has her effigy in alabaster, coroneted, the Garter on her arm, and below angel-weepers of alabaster, shield on arms, standing in niches, each gilt-haired angel with a pair of long red wings from high above his shoulder to down below his knees – at Ewelme, too, is a spired font cover of singular beauty that can be raised from its bowl by a pulley and counter-weight that are in the shape of a Tudor rose. There are Perpendicular font covers, spiral in form but of different regional type, in the parish churches of Bradford and Halifax, unlikely settings for them, and at Thirsk. But it would seem as if, Ewelme apart, there was a preponderance of these wonderful pieces of craftsmanship, no two of them alike, in Suffolk. At Worlingworth, in this county, is one more of the spired canopies, which is twenty feet high, taller even than the font at Ufford; while at Sudbury is yet another of them, 'one of the finest mediaeval font covers in the country',* 'very lofty, towering far above the piers of the nave arcade, and from the traces which remain, was once splendid with gold and vermilion'. Such are these works of art, of a lesser order it may be, but all persons mindful of past, present, and future, who go to see them will take profit and draw their own conclusions from them.

* Dr Nikolaus Pevsner, in *The Buildings of England: Suffolk*, 1951.

3

Open Timber Roofs

The finest ceilings, whether of stone or wood or stucco, are to be found in England and in Spain, and this is true of England at all dates from the fourteenth to the early nineteenth century. Of the later date there are beautiful stucco ceilings in Danish castles (the best are at Clausholm in Jutland), and in the old town houses at The Hague, by stuccoists from the Ticino. At The Hague they were working in all probability under the influence of the Huguenot architect and designer, Daniel Marot. The 'Venetian' stuccoists, but many of them were from the Ticino, came in number to England, where it is to be noticed that they worked as they had never done in their native land. They came over, also, to Dublin, then the third biggest city in Europe, and were succeeded in the next generation by the native Irish stuccadors, artists as great of their sort as Robert West or Michael Stapleton. The apogee of the art, there can be no question, was in the ceilings designed by Robert Adam, and scarcely less so by James Wyatt. Especially in their use of colour, the stucco ceilings of Syon, Mellerstain, Saltram, Osterley, at 20 Portman Square and at James Wyatt's coloured dining room at Crichel in Dorset, reached a height of finesse and delicacy which it is obvious will never be surpassed. They are among the beautiful things of the world of human beings, even though they are no more than coloured plaster.

But long before this the English had excelled in wooden ceilings where, as has been said, the only rivalry was from Spain and, there, from craftsmen or artificers of Oriental, or semi-Oriental origin. After a quick glance at these it will be easier to assess our native talents and look at the hammer-beam ceilings that are unique to England. Nothing, certainly, could be more different than the stucco ceilings of the Alhambra at Granada. But the stalactite ceiling of the Sala de los Abencerrajes, and the honeycomb dome of the Sala de las dos Hermanas still take one's breath away. They are the last flowering, or bel canto of a decaying art but they could hardly be more beautiful with their *media naranja* or half-orange domes, wild bees' nests corners and dependent stalactites. The art of the Moors died in plaster, both in Spain and in

the filigree of the half-dozen *medersas* or sacred colleges of Fez,* and in the Saadian tombs of Marrakesh. These latter, and several of the *medersas* of Fez, have ceilings of inlaid cedar wood, not stucco, and honeycombed stalactite arches of plaster. Perhaps the most glorious of all these works of the Andalucian Moors being the exquisite golden stalactite ceiling, a miracle of carpentry and gilding, in the porch of the mosque of Bou Medine, a couple of miles from Tlemçen, which is just inside Algeria. It is a shrine and *medersa* raised over the remains of a saint called Choaib Ibn Hussein el Andalousi who was born, it is pleasant to think, at Seville, and who was a student here and in the schools of Fez.

This art of the Moorish carpenters continued with the *Mudéjares*, or Moslem craftsmen who remained in Spain. An example of this *Mudéjar* work is the *artesonado* ceiling to the *sala capitular* or Winter Chapter House of Toledo Cathedral. As could only be expected of a city in which Arabic was the second language until the expulsion of the Moriscos in 1609, within the lifetime of El Greco, there are other fine *Mudéjar* ceilings in Toledo, notably in the Casa de Mesa, a house of the early fifteenth century where the arabesqued walls and *azulejos* and *artesonado* ceiling are completely in the Moorish style. *Artesonado* ceilings, to quote Mr Bernard Bevan, can be 'flat, peaked, polygonal, deeply coffered, and in the form of domes, the designs upon them made from tiny pieces of wood to form interlacing geometrical patterns' … and he adds 'they sometimes rise from stalactite cornices', and 'are found all over Spain'. In Seville there are of course fine *artesonado* ceilings, particularly in some of the old convents, San Clemente el Real, Santa Clara, Santa Catalina; and coming into one of these convent churches out of the warmth and scent from the orange trees in blossom in the courtyard, the Moorish ceilings seem to be in perfect accord and harmony with the droning of the nuns hidden behind the lattices of their high choir or *coro alto*.

The most elaborate ceilings of the kind were in the Infantado Palace at Guadalajara, through which Italian tanks were driven during a street battle in December 1936, this being the worst artistic casualty of the Spanish Civil War. The most beautiful of the rooms were below those balconies like mastheads, from which François I looked down on the tournament, and we may be sure, the assembled Spanish ladies, when he was prisoner in the palace after the battle of Pavia in 1525. They were the Salón de Cazadores (hunters) with a gilded ceiling of utmost magnificence, and the Salón de Linajes (genealogies) with stalactite frieze, carved figures of satyrs, and *artesonado* of the type that is inlaid with *lacería*, or flat patterns. This had been the bedroom of the French King; and typical of Spanish pride, it was hung with a hundred coats-of-arms, of the hundred best pedigrees in Spain. Both ceilings must

* Medersas Attarine, Bou Inania, Cherratine, Seffarine, Sahriz and Mesbahia, their names are not the least beautiful part of them. For an account of the mosques of Tlemçen, cf. *Mauretania, Warrior, Man and Woman*, 1940, pp. 79–82.

have been the work of *Mudéjar* carpenters. All this has disappeared entirely, and with it the two-storeyed patio with lions 'that have heads like hedgehogs', though the façade is still standing. The only other ceiling in Spain to vie with these of the Infantado Palace, I saw only last year (1966) in the convent of Santa Clara at Tordesillas. This is the nunnery in which Juana la Loca, the mad mother of the Emperor Charles V, was incarcerated for forty-nine years in, it is said, a small cell without windows. The convent was only opened to the public a very few years ago after special permission from the Vatican. It had once been the Palace of Pedro the Cruel (d. 1369), and the choir of the convent church was his throne room.* This is a ceiling of indescribable splendour both of design and execution, as brilliant of effect as if it had panes or slats of mother-of-pearl in it, and there can be nothing finer of the sort in Spain.

This sort of ceiling, it has been said, was a legacy of the Moors. It was specifically an Oriental art, and like the delicate and complicated arabesque, so rightly named, upon the walls it was flat art, decoration and not construction. But in England the mediaeval carpenters made wooden ceilings as intricate and as specialized as shipbuilding, and indeed the process of installing the start of a double hammer-beam ceiling must have resembled, in reverse, the laying down of a ship's hull. The hammer-beam type of ceiling was peculiar to East Anglia, especially to Suffolk, and reached to extraordinary heights of execution and imagination. The craft must have been in the hands of particular families and of 'mysteries' or guilds who guarded their secrets, and who only took on apprentices under stringent rules of secrecy. There could be arch-braced roof timbers, curved beams that, is to say, hewn from the wood; or they could be brought down and joined into a horizontal or hammer-beam projecting from the wall; or even, arch on arch and two projecting beams in support of them, which formed the double hammer-beam. The arched braces projected upwards from the wall-posts, and supported carved figures of angels with outspread wings. Such were the angel ceilings.

They are the masterpieces of English carpentry. To start with a simple example at Necton in Norfolk, where there are winged angels, and less obtrusively winged than some others, on every other or alternate beam, and statues below them standing on pedestals on the wall-posts. But this is one of the less elaborate of the angel ceilings. At Necton the angels – or are they saints, it is not quite the same thing! – though gilded, have their wings folded, beetle-wise, as though in wing-cases, and do not look capable of prolonged flight. They even have the look of winged priests in surplices, with wings only for ceremonial purposes and not for use.

Such roofs or ceilings are notoriously difficult to photograph, and must be more awkward still to draw. But, as is nearly always the case in this restricted field, a

* For an account of the convent of S. Clara at Tordesillas, cf. my *El Camino de Santiago*, 1967, pp. 9, 10.

Victorian book more than a hundred years old comes to the rescue.* And demonstrably open timber roofs they are, in contrast to the flat roofs of Somerset, Devon, and the West Country! In the book in question there are careful coloured drawings of the roofs of Palgrave in Suffolk, Bacton in the same county, and Knapton, which is in Norfolk. In the first of these the prevailing tint is a vinous-red, and in the third, yellow, I would call it an almost laburnum-yellow. We do not know enough of the Brandon brothers to determine how subtle or unsubtle was their sense of colour; and of course the colouring will have deteriorated further during the hundred and twenty years that have passed, and, also, there may have been, there almost certainly will have been repainting. But the interest lies in the fact that this work of the Brandon brothers chose to depict what are by no means the most interesting of their kind. Murray says of Palgrave, 'the nave roof is Perpendicular and good'; makes no mention at all of Bacton roof; and merely remarks of Knapton, 'there is a rich open roof of the Perpendicular period'. One of the most conscientious of modern authorities says of Palgrave, '15th century hammer-beam roof' (Palgrave is one of the 'red' timber roofs); has no mention at all of the roof at Bacton; but says of Knapton, 'It is worth going a long way to see the wonderful double hammer-beam roof here',† a criticism that I can fully endorse for I have seen it, as, also, the open timber roof of Trunch near by.

A person of ordinary proclivities out of this prodigality of timber roofs must content himself with what is best. At St Mary's, Bury St Edmunds there is a wonderful specimen with winged angel figures standing against alternate hammer-beams; winged angels but, again, it could be said, flightless, and described in Murray, unaccountably, and surely without reason, as 'constructed in France'. Bury St Edmunds, being nearest to London, can be the introduction to the 'angel ceilings'. Woolpit – whence arose the legend of the Green children who came up, a boy and a girl, out of the ancient trenches or 'Wlfpittes' at harvest time – has a wonderful open timber-work roof which must be among the masterworks of all carpentry. The bodies of the Green children of Woolpit were of a green colour. At first they could speak no English; but when they were able to do so, said that they belonged to the land of St Martin, an unknown country, where as they were watching their father's sheep they heard a loud noise, like the ringing of the bells of St Edmund's monastery. And then all at once they found themselves among the reapers in the harvest field at Woolpit. They were caught and taken to the village, where for many months they

* *Open Timber Roofs of the Middle Ages*, by Raphael and J. Arthur Brandon, 1846. Cf. also *Murray's Handbook, Eastern Counties*, 1878 edn; and *Collins' Guide to English Parish Churches*, edited by John Betjeman, 1958. Asterisks are prodigal in this latter. Norfolk has 78 'starred' churches; Suffolk 77, and Lincolnshire, no less than 130. A long life of leisured ease would be needed to see all 285 of these.

† 'With a total of 138 angels, all with spread-out wings and certainly not all genuine.' *The Buildings of England: North East Norfolk*, by Nikolaus Pevsner, 1962.

would eat nothing but beans. They gradually lost their green colour. The boy soon died, the girl survived, and was married to a man of Lynn. After which divagation we look up at the double hammer-beam roof of Woolpit which is no less of a marvel than that of Bury St Edmunds.

Then again, there is Needham Market, not half-way between Ipswich and Bury St Edmunds, where the open roof earns the highest encomiums of all; 'the climax of English roof construction': 'the culminating achievement of the English carpenter' and so on; but its details, and not only its details, owed a lot to the Victorian restorers. The effect is like the projection of an inverted ship's hull into the body or vessel of the church, and the woodwork hangs up there with as much or little of magic as the glass ship in a bottle. How does it keep there? How was it put up there? And yet it is heavy, and looks as though it might slip down the walls. Its mathematical certainty of construction delights the pundits, but it does not please as do Woolpit, Mildenhall, or others not even mentioned here.

Mildenhall, much further inland, and on the way to Ely, has a double hammer-beam which is an extraordinary feat of its sort. The master-carpenter must surely have had the skill to make careful preliminary drawings, and the planning of such a roof to cover nave and aisles was no less a feat of mathematical planning. There could be a dozen or more of the angel ceilings in Suffolk, both in market towns but often, too, in out of the way villages. Crossing into Norfolk there are a famous pair of remote villages Salle and Cawston, but at the latter the romance is a little tarnished by the ridiculous aspect of the winged figures on the cornice of the roof which look like a hybrid of fish and cherub, though the life-size angels on the projecting beams look ready to take wing. At Swaffham, another of the market towns, the choir of winged angels are more impressively angelic, and are in two rows or positions to take flight and flutter about the open roof. Impossible, too, where mention has been permissible of the Green children of Woolpit, not to remember out of this bucolic or Arcadian past the market cross, a rotunda of Tuscan columns with lead dome above and figure of Ceres on top. How many miles hence to its Arcadian sister, the butter-cross of Bungay, another octagon of Tuscan pillars, domed, and with statue of Justice with her scales as a threat to rustic crime! But in fact every angel ceiling is surpassed by that of St Wendreda's at March, in Cambridgeshire, which is 'a bright wood of angels', a hundred and twenty of them in all, eight pinions to a wing for every pair of them, in double ranks set one above another, so that the whole roof 'is aflap and alive with wings'. The rest of the church at March is entirely uninteresting. Why there should be this extraordinary concourse of angels at March is unexplained.

Quite another kind of timber roof is found in Somerset and Devon, less complicated of structure, if no less detailed in execution. Another kind of carpentry altogether is involved. This is the 'waggon-roof'; and if only Gypsy caravans were not

now things of the past it would be easy to see why they are so called because such a ceiling as that of Shepton Mallet does closely suggest one type, if one type only, of Gypsy caravan construction, though curiously enough it is not the interior ceiling of the caravan that it suggests so much as the exterior roof under which the Gypsies moved and lived between the hedges. In any case, it is a flat form of roof construction the placing of which must have entailed more hammering and less noise of sawing, much nearer to the *artesonados* of Spain than to the double hammer-beams of Suffolk and Norfolk.* There are winged angels, priests or presbyters along the cornice but they hardly obtrude, and although they have spread wings, seem flightless. But there is, also, the other type; of which the best specimen may be that of Weston Zoyland of the delightful name, as to the latter part of it, which seems to contain in itself the local accent, and may recall to some readers that occasion when Pepys goes down to Somerset and teases the villagers in order to hear them speak. At Weston Zoyland, from photographs, the angel hierarchy are busy in the ceiling. There are tie-beams resting on the heads of angels, but they are the lesser of the tie-beams, and the larger, resting on full-length angels, carry the kingposts. In fact, angels are pressed into service to hold up the ceiling. In addition, fluttering in the middle of the tie-beams are angel figures, wings aflap, and reminiscent of the angel-rookery of March, where you could almost listen in the silence and hear them moving on their nests, and if not their laughter, then, at least, their cawing.

* Numbers come into it again, as with the 'crews' manning the porches, fronts and towers of French cathedrals, cf. pp. 96, 99. On the 'waggon-roof' of Shepton Mallet are 350 panels and over 300 bosses, all of them different; while at Martock, on another waggon-roof, there are 768 panels in all, with only six different patterns repeated. If numbers do not make works of art, they on occasion do not impede them. Cf. *Somerset*, 1958, in *The Buildings of England*, by Nikolaus Pevsner; and the work on Somerset churches by Kenneth Wickham, 1952.

Opposite: Angel from the roof of St Mary's, Bury St Edmunds (Suffolk)

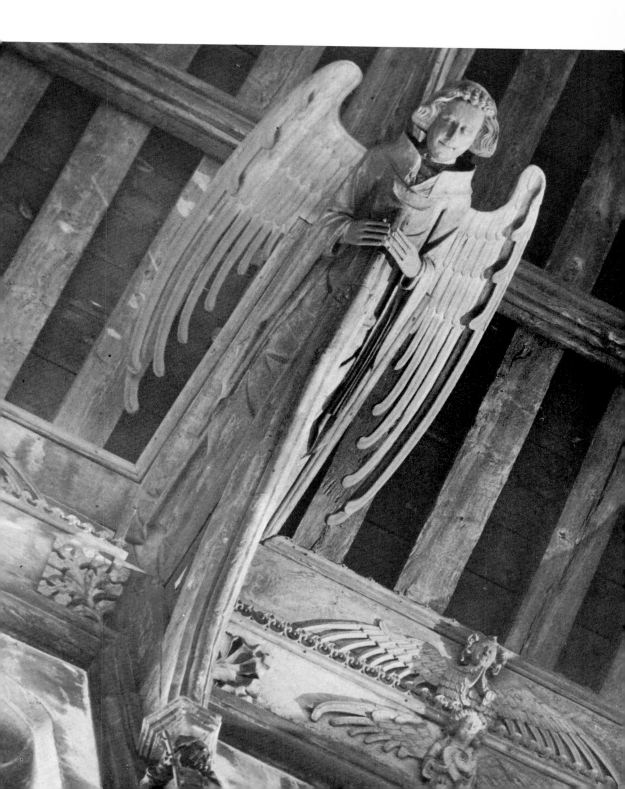

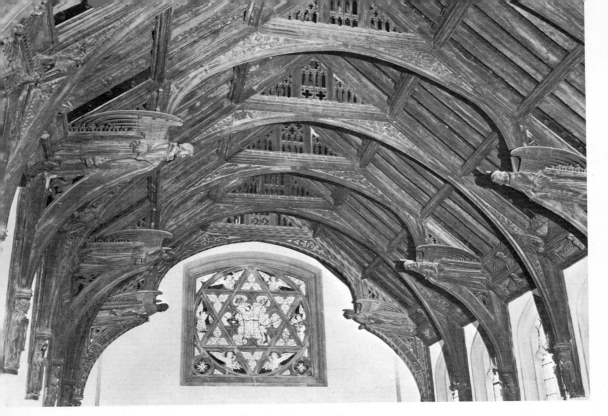

Top Angel roof at St Mary's, Bury St Edmunds (Suffolk)
Bottom Carvings on supports of arch braces of Bury St Edmunds roof; *left*; a wolf guarding the head of
St Edmund; *right* pair of woodwoses

Opposite Fancifully carved roof supports, with angels and monsters in horizontal position, at
Mildenhall (Suffolk)

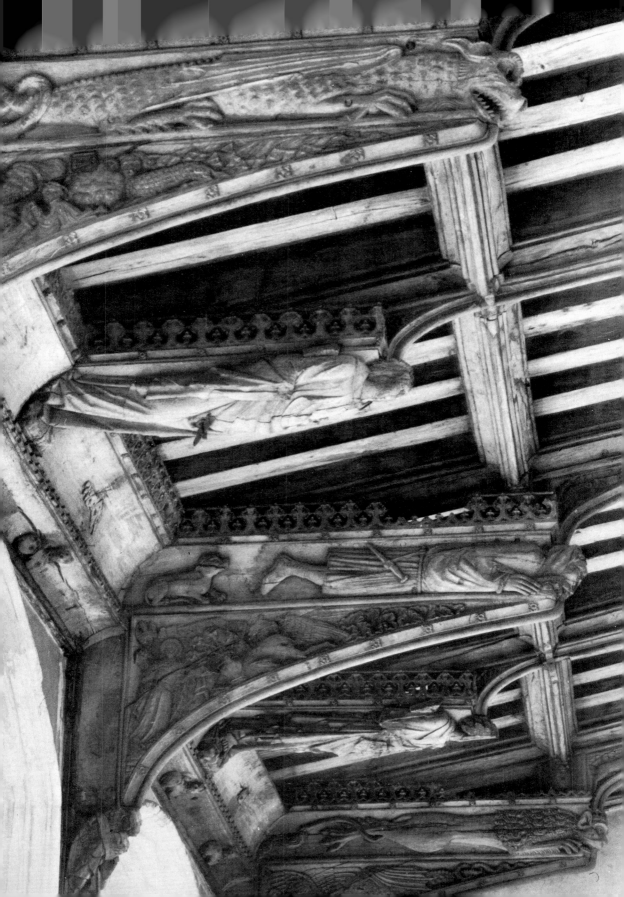

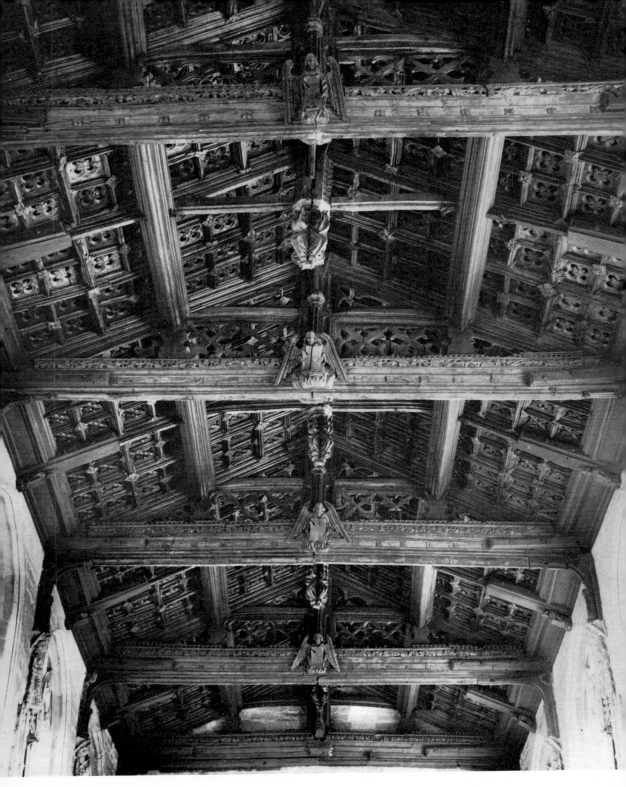

Waggon-type ceiling above nave of Martock (Somerset)

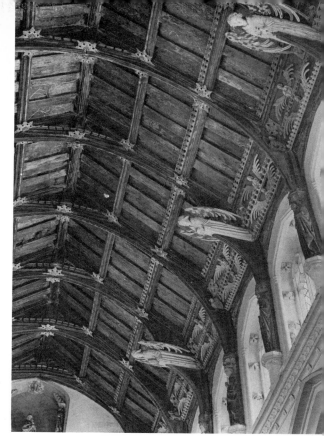

Right Angel ceiling at All Saints, Necton (Norfolk)
Below right Angel ceiling of St Wendreda's, March (Cambs)

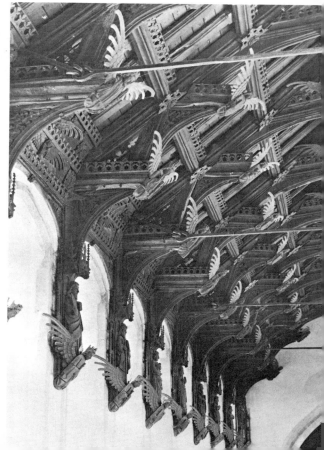

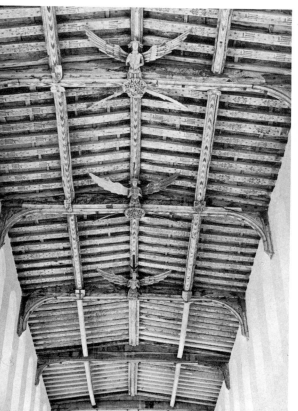

Carved and painted roof of Blythburgh church (Suffolk)

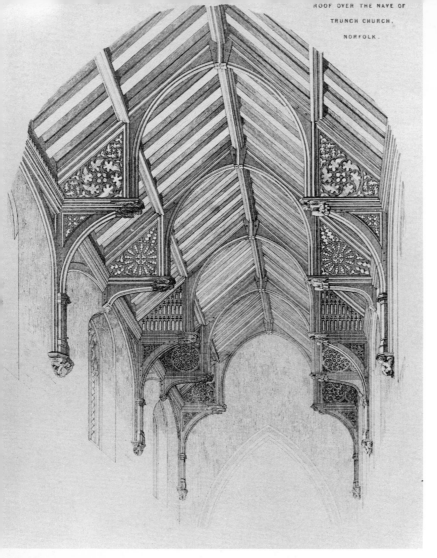

ROOF OVER THE NAVE OF
TRUNCH CHURCH,
NORFOLK.

Drawing of Trunch church
(Norfolk) from R. and J. A.
Brandon's *Open Timber
Roofs of the Middle Ages*

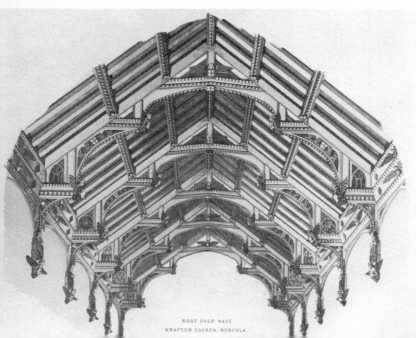

ROOF OVER NAVE
KNAPTON CHURCH, NORFOLK.

Roof of the neighbouring
church of Knapton, built like
a ship's hull; drawing by
the Brandons

Opposite Two spired font covers
in Suffolk, at Woodbridge
(*left*) and Ufford (*right*)

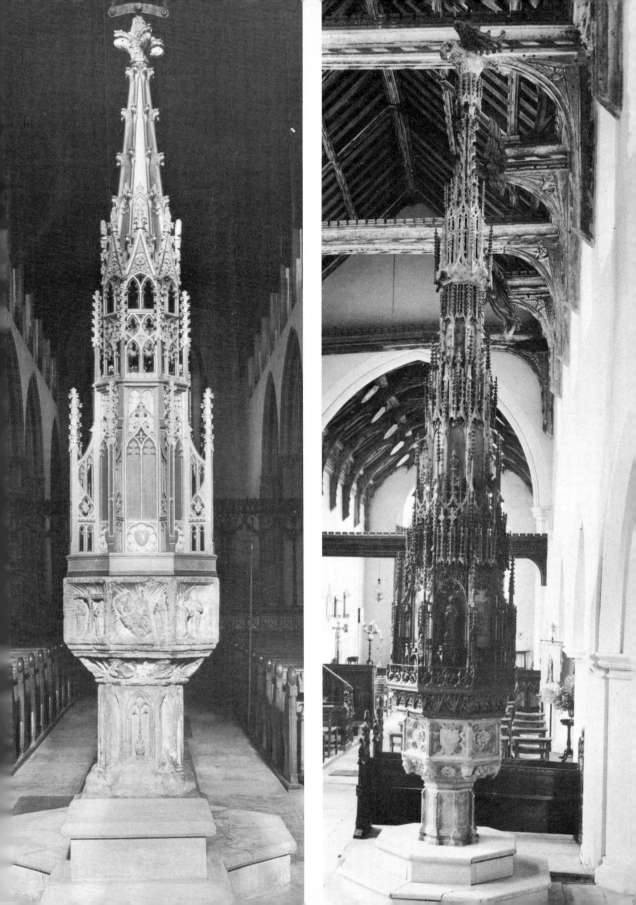

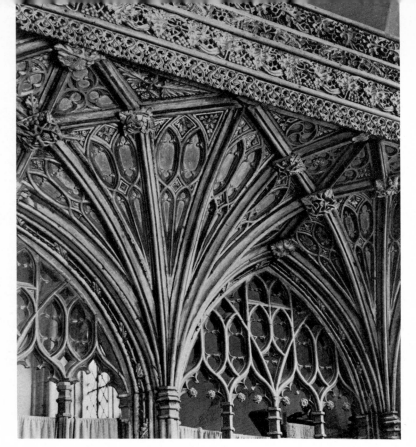

Left Detail of wood-
work from the rood
screen at Plymtree
(Devon)
Below Rood screen at
Kenton (Devon) stretchin
across nave and aisles

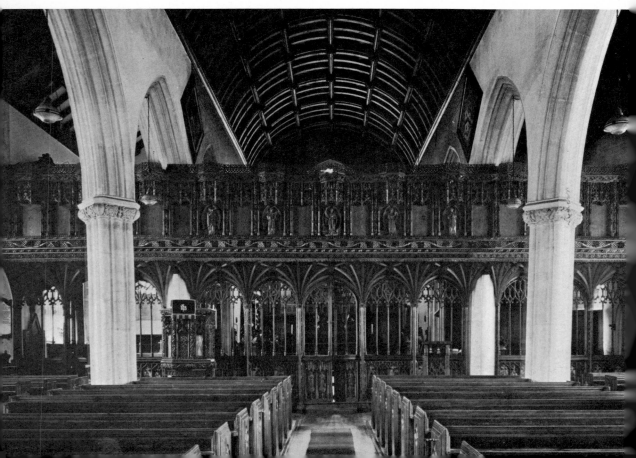

4

Chantry Chapels

The Chantry Chapel could be big or small; it might, even, have hardly space inside for the officiating priest. What exquisite invention there is to choose from! The most glorious in imaginative conception of all the mediaeval Chantry Chapels is the Percy Shrine in Beverley Minster, but the monumental effigy has long disappeared, so that it is a shrine without a tomb. There is Cardinal Beaufort's Chantry Chapel at Winchester Cathedral; though, to our own taste, that of William of Wykeham in the same cathedral is more beautiful, for it is like a latticed cavern. But, and we mention only what we admire most ourselves, there is the chapel and tomb at Arundel, in Sussex, with its flat applied ornament and twisting pillars; the little Trinity Chapel at Tewkesbury; that of Abbot Thomas Ramryge at St Albans; and another, that of Bishop Richard Fox at Winchester, a chapel like a panelled wooden chest; almost too rich an example, that of Bishop Alcock at Ely; the Kirkham Chantry Chapel at Paignton, Devon; and the lovely tomb chapel of Prince Arthur at Worcester.

Introduction to *English Church Monuments*, London, 1946, pp. 3, 4.

While it would not be true to say that the chantry chapel is a specifically English idea, there are certainly more of them to be seen here than in any other country and it was an invention or innovation of particular appeal once the Perpendicular was established as our national style, if only because 'being often vaulted they formed small complete buildings within themselves'.* There was a decided tendency to set them up within the aisles or transepts of a church in the guise of small detached, draught-proof rooms, and this not only for the benefit of their own clergy. In certain instances where fantasy is carried to its extremes one has the feeling that had the custom continued a little further and not been damped down and extinguished by the Reformation it could well have culminated in the provision of creature comforts such as they were used to in life, as in burials in Ancient Egypt, for the occupants of the tomb. They were reserved apartments in perpetuity, with staff of priests who were servants almost as much as they were intercessors or remembrancers, as witness the pair of three-windowed, self-contained tomb-apartments of Bishops Longland and Russell to either side of the Judgement Porch in Lincoln Cathedral, which are

* F.H. Crossley.

exactly similar in exterior. And the same reflection comes to mind, I think particularly when viewing the chantry chapels along the choir at Winchester.

At one time there were of course far more of the chantry chapels. According to a leading authority 'there were two thousand or more perpetual chantries at the time of the Suppression', and 'the chantry priests far outnumbered the parish priests'.* Of this large total of chapels perhaps one in twenty has survived, and by the irony of history probably the greatest destruction was in the more important churches. There the attention of the iconoclasts was particularly attracted to them, and the more beautiful or historical an object might be, the more certain it was to be marked down for mutilation. In this way, despite the depredations of Dowsing, the image-breaker, and his like in East Anglia – there is the onomatopoeia of destruction in the two syllables of his name – more of the chantry chapels have survived in parish churches in the country than in big cities. The best and most perfect of them are likely, then, to have been destroyed; and it is improbable indeed that the chapels in Wells, or Ely, or Tewkesbury, which were always centres of population, let alone that of Prince Arthur at Worcester, should have survived.

From those that have come down to us some idea may be formed of what is lost, especially when we read from the authority just quoted in our footnote, that at the beginning of the fifteenth century in Old St Paul's there were more than seventy perpetual chantries in the Cathedral, and that the priests attached to them who lived in special quarters or 'Presteshouses' were thirty-six in number and, *passim*, that at the Suppression there were still thirty-five chantries while the number of priests after the manner of that gorged octopus of our day the Civil Service had augmented to fifty-four. There was the Royal Chantry founded by Henry IV for his parents, John of Gaunt and Blanche of Lancaster, whose alabaster effigies, of which there is an engraving made before the Fire of London by Wenceslaus Hollar, were enshrined there; and other splendid chantries or chapel-apartments of Edward IV, and of different Bishops of London, some of them with two floors and wooden staircases. Nothing is left of these; but there were a greater number of them in Westminster, where it could be said that the number of royal tombs alone made the erection of individual chantry chapels somewhat of a difficulty. The chantry of Henry V, the hero of Agincourt, who died at only thirty-five years old, is there in the Abbey; of curious construction for it is in the form of a bridge across the ambulatory, and in a cathedral in Spain might well have been intended not for a tomb-chamber but for a *camarín*, or room in which to keep jewels and dresses for the images of the Virgin. The

* *Mediaeval Chantries and Chantry Chapels*, by G. H. Cook, London, 1963, pp. 32, 47 and 51. There were nearly two hundred chantry chapels in London and its suburbs, forty-two at York, and thirteen, alone, in the town church at Newark. Mr Cook's work 'the preparation of which has spread over some years,' in his own words, is a vast compendium of interest and information, and it is impossible to mention this subject without being indebted to him. For Old St Paul's, cf. pp. 140, 145 of the same authority.

exterior of this bridge-chantry, which has octagonal stair-turrets at either end, has many statuettes in niches. It has indeed an extraordinary number of small carved figures standing under two-tier canopies, the mullions of which carry over them heraldic figures of chained swans which were the badge of the de Bohuns, his mother's family. Under this row of figures, and a frieze of more chained swans and other heraldic animals, are angels in pairs holding heraldic shields with the lions of England and lilies of France, while in the middle of them is a group portraying the act of coronation with two mitred bishops placing a crown on the King's head. This is on the south side of the chapel; and on its other wall amid similar figures is a central group representing the act of homage. Within, the effigy of the King had a head of solid silver which must have been a portrait, long since gone. The chapel of Henry VII with its tomb by Torrigiano is the chantry chapel *in excelsis*, but this is the supreme example of fan vaulting, and so we leave it to be discussed separately when the occasion comes.

Which said, it seems better to follow the chantry chapels on an itinerary round the Kingdom on the pattern I followed in *Monks, Nuns and Monasteries* so that it can be given some form of narrative and not be hung, chronologically, upon a set of hooks or nails of time. A hypothetical journey, then, which can begin in a few moments and need only be delayed in the three chantry chapels at St Albans, the former great Benedictine Abbey, just outside London. It would be superfluous to remark that this building, which is conspicuous from far off for its immense length and bulk, and for its promise of early Norman work built of Roman bricks and tiles from Verulamium, let alone for vestiges of sculptures by Matthew of Paris and his school, disconcerts on entry because of the hideousness of its Victorian painted ceiling, which could be the handiwork of the local Women's Institute. In compensation are two chantry chapels. That of Duke Humphrey Gloucester (d. 1447), brother of Henry V, is in two storeys; an open chamber where the tomb should have been (his coffin was found elsewhere in the abbey) and three arches above that which are open without supporting pilasters, and then the upper storey with four traceried windows in double stages and niches, now statueless, between them. It is a little uninteresting in fantasy and composition. More beautiful is the chapel of Abbot Ramryge (d. 1521), so that in date it is very late indeed. Again it is in two storeys, and of the 'stone-cage' form which was one of the minor, if special inventions of the Perpendicular. In fact, an openwork stone screen of three-light windows, unglazed of course, a little conventional perhaps, but redeemed out of the ordinary by the imaginative delicacy of the work above where the stone cage-work is reinforced and made more interesting by the canopied niches, again without statues, that alternate the three-light windows; or, in this storey it more resembles a stone grille. And the fan-vault below within the tomb-chamber brings that taste of Andalucian-Moorish, almost of the

medersas of Fez and Marrakesh, that is the culminating and unexpected, indeed the un-English, yet ultra-English, and departing delight of the Perpendicular style.

Our journey, of which this is the beginning, takes us first to Canterbury, where are the chantry chapels of the Black Prince and of Henry IV, his nephew, and son of John of Gaunt, their chapels but not their tombs which are elsewhere in the former abbey church. The chapel of the Black Prince is worked into the Norman crypt, but the surpassing interest is his tomb which deserves separate notice. That of Henry IV, it has to be admitted, is small and uninteresting with a fan-vaulting of unpromising and ineffective kind.

Very different is the situation at Winchester Cathedral where is the church of all churches in England in which to admire this most English of inventions. The series of them produce an effect from the moment one enters this former – like Westminster, like St Albans and Canterbury – Benedictine abbey. The chantry chapels are to be seen ranged along both inner sides of the choir and along the south aisle, no less than nine of them in all. Three of them are outstanding. The chapel of that pre-eminent cleric, William of Wykeham (d. 1404), who founded New College, Oxford, as well as Winchester College, is the pattern of its kind, marvellous in elegance and lightness of design, and the embellishment not the obstruction of the space in which it stands. Filling a whole bay of the nave, with a two-tier grille of stone lights, then rising above that to a great height of emptiness, masked by slender pillars so that it forms a high three-light window with pinnacled hoods above that, that touch upon the clerestory. Within the chapel is the bishop's tomb.

The chapel of Bishop Waynflete, founder of Magdalen College, Oxford, stands in the choir. It has an enclosure of three-arched openings, and an openness and emptiness above that, crowned on its exterior with great array of cusped canopies and niches. It is not as fine in conception as Bishop Fox's, which is the south side of the choir. His is the perfect stone cage, to the degree that it could have been assembled or built outside, carried bodily into the cathedral and set up there. In its elegance it looks more portable than permanent. It is in two storeys; the lower built solid without openings, the upper of traceried window finished as to its top with pinnacles and crenellations like an ornamented chest, and with countless niches now statueless, save for the pelican feeding its young, which was Bishop Fox's emblem, both on the exterior and within. In a space to itself in the retrochoir is Cardinal Beaufort's chantry chapel. This most notable of English clerics with Thomas à Becket and Cardinal Wolsey, and ablest of the three – indeed the most able of the Plantagenets after the death of Edward III, since Henry of Agincourt, his great-nephew, was a fighting soldier, more than a great general – was the illegitimate son of John of Gaunt and Katherine Swynford. He was Bishop of Winchester for four decades, was made Cardinal and Papal Legate, and died in 1447. He was a Shakespearean character, dear to scholars of

Shakespeare, so that he appears in paintings and drawings by the romantic Fuseli and might well, though in fact he does not, have a part in some Verdi opera. His chapel, as to its upper part is a maze of pinnacles and niches, with a great emptiness below that with low, indeed knee-high balustrading; and the high empty vault where his effigy but not the original can be seen, under fan tracery, but not of the first order of elegance or skill in execution. One carries away from Winchester Cathedral a very strong image of the English tomb-chambers which in their elegance give a lightness and ornament which yet do not detract from the solemnity of death.

In Christchurch Priory, not very far from Winchester, lies buried almost the very last of the Plantagenets, the unhappy Margaret Pole, Countess of Salisbury, who was daughter of the Duke of Clarence, brother of Edward IV. Her brother the Earl of Warwick, the last legitimate male of the family, had been beheaded by Henry VII, simply because of his origin, as early as 1499. She survived until 1541 when Henry VIII had her brutally beheaded, a harmless old lady who was more than seventy years old. Her son, Cardinal Pole, as a Catholic had taken the dangerous step of denouncing the King's marriages, as a result of which all his family including his mother were attainted. He was thus in some sense responsible for his mother's death, but escaped that fate himself by living abroad, though he returned in Queen Mary's reign to become last Catholic Archbishop of Canterbury, and dying in 1558 achieved safe burial in the cathedral. His headless mother lies still buried in the chapel at the Tower where she spent two years imprisoned. Her chantry chapel at Christchurch, though Gothic in its exterior arcading, is touched by the Renaissance and positively Tudor in its lower portion. Over that above blind arcading are two tiers of four-light windows. Within, despite the depredations of Thomas Cromwell and his commissioners who were as intent on destruction of the past as are the Red Guard in China, there is an extraordinary and coffer-like richness of ornament. Three canopied niches rise up the wall; and the whole ceiling of this small, bath-room size cell or chapel is cobwebbed with fan-like spreads of stone though, as has been pointed out, it is not really a fan vault but of fan implication or suggestion,* and with a splendid, if mutilated carved boss in the middle of the ceiling, representing the Coronation of the Virgin. This little chapel with its heraldic devices and broken or chipped badges is the latest or last relic of the Plantagenets, and of a richness more to be associated with for instance the Cathedral or the Cartuja of Burgos, than with this former house of White Canons in the Hampshire meadows. But, at least, the King and Queen and the Infanta who lie buried in the Cartuja were this unfortunate lady's near relations, and there were many things they had in common.

At Salisbury, thanks to Wyatt, an architect and decorator of immense talent in his own field, but of fatal tendency when allowed to interpolate or sweep away, there is

* *Fan Vaults*, by F. E. Howard, in *Archaeological Journal*, vol. LXVIII, pp. 1–42, 1911.

little left of its many former chapels. The Hungerford and Beauchamp chapels were removed on order from the dean and chapter, with an alacrity in destruction that only persists in our day in Portugal where the accumulations of time and history have been sacrificed in order to achieve the dull heartlessness of many a hospital ward. There remains Bishop Audley's chapel dating from early in the fifteen hundreds, with balcony and cornice and half-cornice reminiscent of some temporary pavilion put up from which to watch a tournament or coronation procession. In particular, the columns at either end and in the middle, rising above the chantry as though they are sockets intended to hold flags or banners, give strength to this illusion.

There can be no question that in every respect Wells is unique in this country, and the only rival in the West of England to the trio of Ely, Lincoln, Durham, that are the architectural wonders of the eastern region. It is therefore a small satisfaction that at Wells there should be at least two chantry chapels worthy of their setting. Bishop Bubwith's chapel is set down in the nave like a beautiful little portable stone bird-cage. A little blind arcading at waist height, and then just filling the bay in which it stands, up to the capitals of the clustered columns, graceful and light arcading, a two-light window in depth, and a pair of those longitudinally on each side of the fretted door-arch. Over that a graceful cornice for frieze and elegance of finish, and Bishop Bubwith's chantry could be raised on castors and wheeled away.

Dr Sugar, who was treasurer of the cathedral, built his chantry across the nave, and in little it is incomparable in richness, and a lesson to those modernists from Mies van der Rohe downward who are frightened and run for their lives from ornament. Here, their motto 'the little, the more' is flatly contradicted. The canopies of the five-fold or quintuple canopies on the interior wall, and the incipient fan or spray or inverted sun-burst rising from the middle one of the canopies in the midst of a vertigo of mini-ornamentation, with carved cornice after cornice above that, and here and there on the exterior and among the fans and other devices of the ceiling, the doctor's rebus of three sugar-loaves under a doctor's cap, are a lesson in delicacy of touch and a light and fearless hand.

It is unfortunate that neither Hereford or Gloucester have much to offer in this particular field. But Worcester has the tomb chapel of Prince Arthur which is among the most beautiful of all, and commemorates this elder brother of Henry VIII who at only fifteen years old was married to Katherine of Aragón, went after his wedding in his role as Prince of Wales to live at Ludlow Castle, and died within three months. Two years later the Spanish Infanta married Henry VIII. The stone screen of the chapel is elaborately beautiful in the Perpendicular manner, vying in interest with any *reja* or *retablo* in a church in Spain. It is in two storeys, the lower being of light stone trellis or arcading through which can be seen two other tombs left undisturbed at the building of the chantry. Above this is a wide band of stone panelling which is worked

with heraldic badges; the portcullis of the house of Lancaster, the Tudor rose, and the falcon and fetterlock of the house of York. Over this is a high screen of three-light windows, but irregularly arranged and the better for that; and the chantry is topped with a cornice of open panels and tall pinnacles. The contrast between the open part of this stone screen and the ends of it, where the open traceries have become blind panelling, is most telling and effective. In the interior, the altar end of the chapel has four large canopied niches, still with their statues, and the ceiling has pendentives and is quasi-Tudor, in distinction to the exterior which is the ultimate in Perpendicular.

Individually, Prince Arthur's chantry may be the most beautiful of all, but the other place beside Winchester in which to see them in quantity is Tewkesbury Abbey, which was yet another Benedictine foundation. In this old abbey which is as wonderful as anything of the sort to be seen in France, or Italy, or Spain, are three chantry chapels; the Fitzhamon chapel built by the monks in his honour two hundred years after his death for he had been a personage of utmost importance, a cousin of William Rufus, of odd repute, and Lord of Tewkesbury, Bristol, Gloucester and Cardiff; a chapel correct in every particular, and leading on to greater things. To the Warwick Chapel built by the widowed Isabella le Despenser for her husband Richard Beauchamp, Earl of Worcester and Abergavenny, who was killed in the wars with France. It is in two storeys; the lower, once again, being delightfully irregular and varied in its height of stone screening; its base of blind panelling with figures of angels in the guise of mourners holding shields of heraldry. Above are open canopies ending in crown-like cornices, and over the upper floor which has an elaborately pendentive and almost stalactite ceiling. But the great and abiding fascination of Tewkesbury is the chapel of Sir Edward le Despenser (d. 1375) built by his widow; and not even so much the chapel, with its two-arched windows of five lights, as in the canopied niche or tabernacle on the roof of the chapel, within which kneels the helmeted and mailed figure of Sir Edward le Despenser with his face towards the altar. My pen can do no better than quote what I have said of it already, that 'it is as effective in that silence as a trumpet blown from a tower in the dark of night. And, at that, some old cavalry call of the armoured horsemen ... The effect, almost the sound of it, is as strange and haunting as that first time one hears the *muezzin* calling from a minaret, and we come out of Tewkesbury Abbey, and back into the present enriched by an experience in its little way as marvellous and memorable as any shock of the suddenly revealed past in whatever other land.'*

Removing now to the other side of England there is a chantry of very different

* In the introduction to *Monks, Nuns and Monasteries*, 1965, pp. 5, 6. At Evesham, another former Benedictine abbey, near Tewkesbury, are the two little chapels or churches of All Saints and St Lawrence, which with the Perpendicular Tower of the abbey are all that is left. Each of these little chapelries of parish churches has a chantry chapel built by the same abbot, and each has a fan vault ceiling.

import and of nearly theatrical effect and presentation in Bishop Hatfield's chapel and throne at Durham. Perhaps the chapel with the tomb and effigy are sacrificed to gain effect, for a stone stair mounts over it from one side and leads straight through the wall to his throne and the two seats for his chaplains to either side of him under high canopies reaching to the top of the arch. This stair is very much 'back stage' and invokes curiosity as to the mysteries playing at the other side near to the high altar. This is an early work of its kind, for Bishop Hatfield died in 1381.

At York and Lincoln in spite of the great number of chantry foundations, very little remains. There are the two chapels of Bishops Russell and Longland, mentioned earlier as flanking the Judgement Porch at Lincoln, but their exterior symmetry of twin aspect does not imply a corresponding interest from within. The only other church with chantry chapels to vie with those of Winchester and Tewkesbury is Ely. I have written elsewhere of 'the seething and pricking of the stone stalagmites of Bishop Alcock's chantry chapel in chamber-music Perpendicular', and indeed I think this is the effect they produce on one. Bishop Alcock died in 1500; his chantry chapel is a hundred years later than that of Bishop Hatfield, and it has lost any theatrical purpose or wish to impress with anything of solemnity or terror. The interior with its many canopied niches empty of statues, and therefore lifeless as a huge stable without horses, is too richly crowded and verges on the Manoelino of Portugal. Bishop Redman's tomb chapel with but room for a priest to stand at the altar, lies under three cusped arches with bird-cage panelling rising to the capitals of the clustered piers. A stone bird-cage, but suspended in air and centrifugally upheld, for it has no supporting columns.

There remain the chantry chapels that are in parish churches, of which the most splendid and sensational is the Beauchamp chapel at St Mary's, Warwick. It contains the tomb of Richard Beauchamp, Earl of Warwick, which should be noticed separately, but for the present the interest is in the minute, indeed the mini-chapel leading from it which has one of the most exquisite and satisfying of all fan vault ceilings, small enough to have but three pendant fan-stalactites to a side, a little masterpiece of concise and perfect masonry, mathematically conceived, drawn, and carried out. It is not much larger, and certainly no wider than the dining-car on an express train.

Newark, which I have known well since childhood on the way north to my old home, in anticipation of the Keep of Bolsover, that strong place or fort of poetry on its steep hill passed on the hill opposite, down into the valley of iron and steel and to Renishaw in the tall trees, in the midst of it with all it meant to me – has its private church, with tower already looked up at and admired, but the church not entered as often as it could have been. For in this unlikely Midland town are two chantry chapels, the Meyring and the Markham, so alike as to be interchangeable and mistaken for each other, except that the latter has thinner, taller window-lights

Chantry Chapels and Flushwork

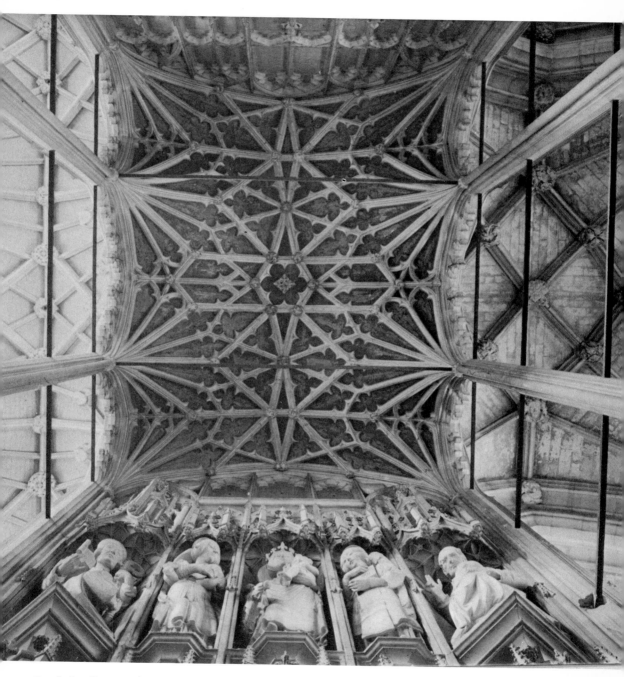

Roof of William Wykeham's (d. 1404) chantry chapel in Winchester Cathedral

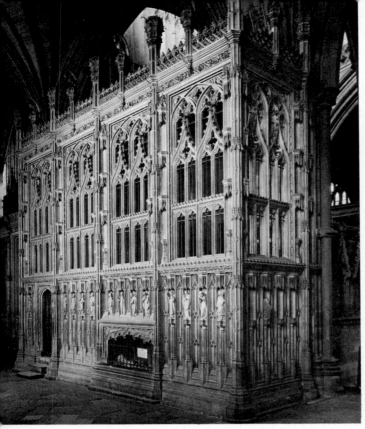

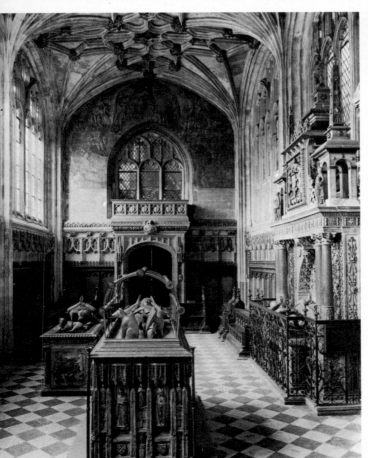

Above The helmeted and mailed effigy of Edward le Despenser (d. 1375) kneeling with his face towards the altar, in his chantry chapel at Tewkesbury (Glos)

Top left Bishop Richard Fox's (d. 1528) chantry chapel at Winchester with pinnacles and crenellations, like an ornamental chest

Left The chapel and tomb of Richard Beauchamp, Earl of Warwick (d. 1439), at St Mary's, Warwick

Opposite Chantry chapel and tomb of John Fitzalan, Earl of Arundel (d. 1435), at Arundel Castle (Sussex)

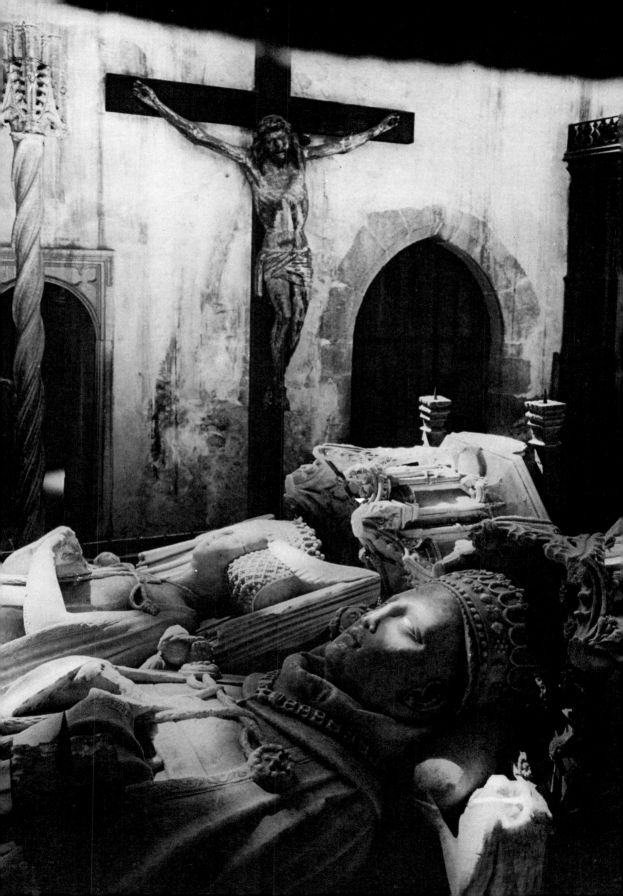

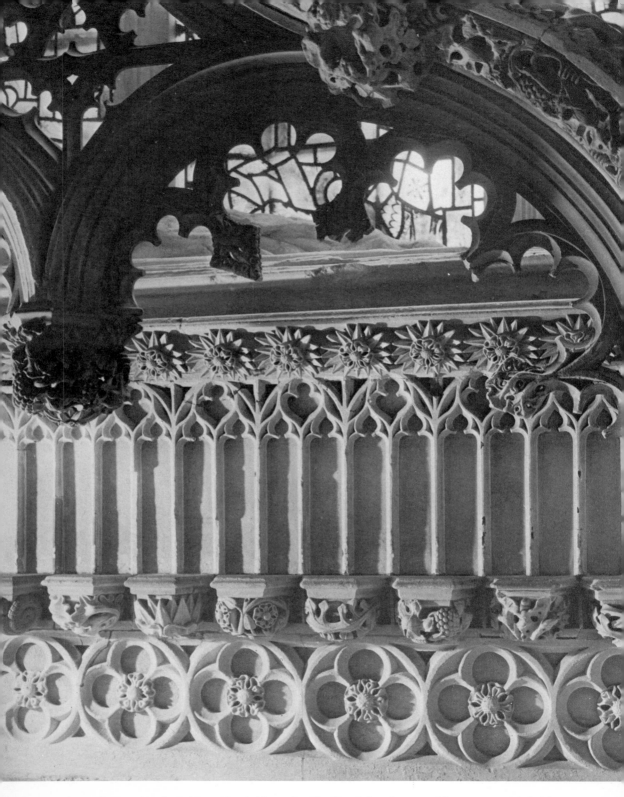

Chantry chapel of Bishop Alcock (d. 1500) at Ely. Detail showing one of the many canopied niches, with their richly crowded decoration, of a later and less austere period than the chapels of Tewkesbury or Warwick

Percy Shrine at Beverley Minster. A detail showing ogee arch, and elaborate fruit and vegetable ornament

Chantry of Dr Sugar at Wells Cathedral (Somerset), with unusual central fan above the five niches

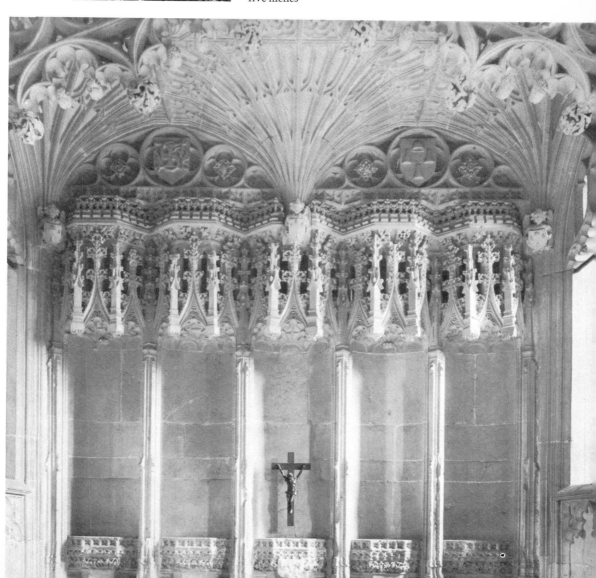

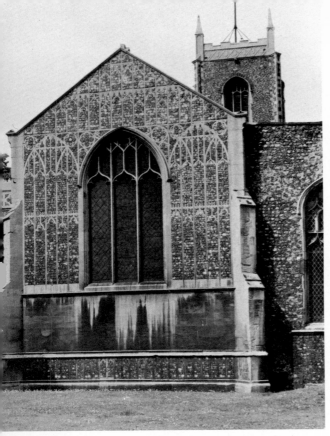

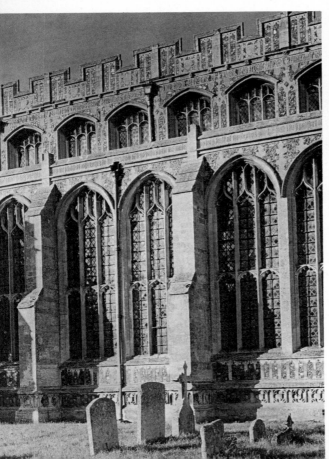

Above Detail showing the mosaic of coloured flints used in the flushwork at the base of the tower of Bungay Church (Suffolk)
Top left East wall of chancel of St Michael's Coslany, Norwich
Left South side of the nave of Long Melford (Suffolk)

Opposite Porch of Woodbridge Church (Suffolk) showing flushwork patterns

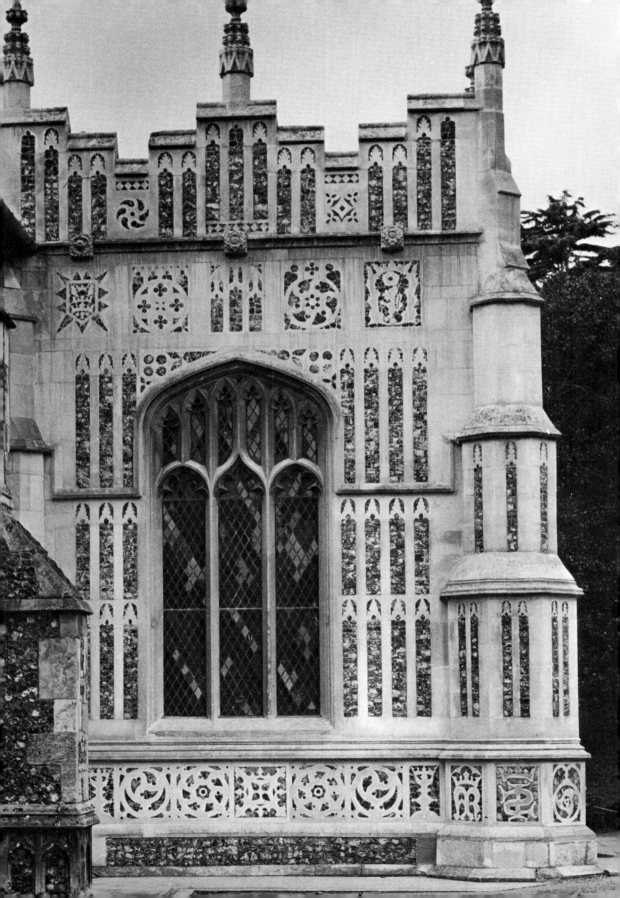

Parapet of Long Melford

Parapet of Tower Ixworth

Parapet of Walberswick

Clerestory at Coddenham

South Porch at Halesworth

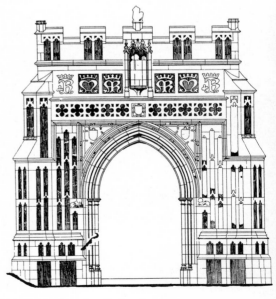

South Porch at Mendlesham

Six drawings of East Anglian flushwork, from Frank Baggallay's *The Use of Flint in Building especially in Suffolk*

and a crested, not a battlemented cornice. Both have the look of ancient, but portable stone cages.*

The Arundel chapels, in the Catholic part of the church at Arundel in Sussex, I have not seen, and can only admire in photographs the twisted or spiral columns in the chantry of William Fitzalan and his wife, who was sister of Warwick the King-Maker – which are like narwhal horns. Nor have I seen the Baynton Chapel at Bromham in Wiltshire, with its long range of windows, battlemented parapet and pinnacles, and painted ceilings; nor the Greenway Chapel at Tiverton in Devon, with its exterior, tell-tale carvings of woolpacks and ships and horses; nor, yet, the Kirkham Chapel at Paignton, also in Devon, having never to this moment set foot inside that county, and thus missed, so far, that double folding stone screen of a chapel with its crocketed canopies and effigies and statuettes; as, also, the Lane Chapel at Cullompton in Devon, where, again, are carved bales of wool and merchant ships, and in repute one of the most beautiful of fan vault ceilings in all of England.

St George's Chapel, Windsor, is another matter for it was an inspiring place of release from school, and it is full of chantry chapels. Coming in at the west door, on the right-hand side and polygonal in shape, there is the Beaufort chapel or chantry of Charles, Earl of Worcester, who in view of his origin, though illegitimate of descent, was lucky to be left alive by Henry VIII; but all else in St George's Chapel must pale beside the Garter Chapel and the stalls of the Knights which are no less than a gold-mine of chivalry and poetry. This chapel, among the masterpieces of the national or Perpendicular style, is doubly appropriate for an end to this narration of the chantry chapels, which are an unique feature and something a little apart and no-where else to be found in such quantity as in this country.

* The Babington chapel at Kingston-on-Soar, also in Nottinghamshire, with its dwarfish, faceted and coroneted columns, is late in date (1547), and in the ugly, bastard-Manoelino style of sporadic appearance in this island, as at the Roslin Chapel near Edinburgh.

5

Flushwork

Beside the open timber roofs the other feature peculiar to Norfolk and Suffolk – and again it is to Suffolk in particular – is the flushwork, or the facing of buildings with split or knapped flints and brick or freestone. It was a discovery of the Perpendicular style; and the county of Buckinghamshire apart, where it was used to much less purpose, it is found nowhere else but in England. There is no trace of it in France or in the Netherlands, and nowhere but in England in the absence of building stone was it thought worth while to make use of the flint pits of the seashore. But flints are found inland, too, where the sea once was, and flint-knapping or the chipping of flint stones according to the line of cleavage is still, or was till very recently, the local industry of Brandon, which lies, contrariwise, in Norfolk. It was here that a hundred years ago a sand mound was excavated, and it was not the Green children who came up out of that, but a passage was found eighty feet deep, and in the side of it a pick-axe made of a flint stuck into a stag's antler. Flint knapping is a primaeval craft, and the Green children in any event had they appeared at Brandon would have come up, not into the harvest field but into land famous for its warrens, one of which alone is said to have sent forty thousand rabbits every year to London. At Brandon flints must have been worked in this way for many centuries, perhaps for four or five thousand years, until during the Perpendicular heyday of East Anglia the industry greatly expanded in order to supply flints for building; for church towers, particularly for porches, and for the parapets that are a feature of churches like Lavenham or Long Melford, and which have elaborate schemes of ornament, and often long and ornate inscriptions worked into them.

In the hands of the Perpendicular craftsmen a quite extraordinary variety was given to the use of this seemingly unpromising material; not only in use of ornaments and patterns but even in alternations of colouring. As much use was made of flint if with very different effect, as with the blue and white *azulejos* of Portugal, and the mental vision of East Anglian building is to a great extent composed of flushwork. The units are of course much smaller than with tile-work, and the results, correspondingly, if less pictorial, that much more subtle. It more resembles some form of

exterior mosaic work with a restricted palette, but with shades of white, black, green, and even other colours; and someone used, like the writer, to see pieces of 'clinker' or ironstone upon the roads of Derbyshire in their startling hues of blue and jade-green could wish there had been an admixture of these into the darker flint stone when a coloured architecture might have been achieved of startling brilliance. Even so the effects are remarkable enough, and at least they are unique and to be seen nowhere else.

The church of St Michael Coslany is an extreme instance of flushwork carried nearly to the point of the tattooing on an old-time Maori warrior. It is a strange sight standing there in the middle of Norwich. One writer comments that the best time to see its beautiful panelled flintwork is during the winter months. Then, the trees at the side of it are not in leaf and, also, the winter light works the best advantage from the trimmed flints. It is late in date, probably after 1500; offering, it is certain, a better prospect of what might have happened but for the coming of the Renaissance, than can be deduced from Flamboyant Gothic. It is an extraordinary feat to have produced this sobriety and dignity from building material which might seem to offer a good deal less promise than the broken china that gives gaiety and pantomime fantasy to the pagodas of Bangkok. The old authority is not to be contradicted who said that 'no better example can be pointed out of the advantage to be gained by the judicious use of local material'. A good deal of the flint surface of St Michael Coslany has been refaced, and the flushwork was completed about a hundred years ago, so that St Michael Coslany is now in pristine order, having been well repaired. Its high Perpendicular windows of varied tracery have no less beautiful blind panels of flushwork beside them, and the frieze of flintwork ties in, and binds as it were, and completes the building.

The two great, near-by, flint and freestone Perpendicular churches of Long Melford and Lavenham, in Suffolk, well known to hundreds or even thousands of persons here, are, it could be said, unknown outside this country, a fact which is not without its own degree of satisfaction in it. Perhaps it is their length which impresses at a distance (one hundred and fifty feet)! And then, on nearer approach, the flushwork ornament along the plinth, above the tall three-light windows, and so many of them in a line – and higher up again, above the clerestory windows and along the battlements where the flushwork spells out the names of donors and benefactors in late Gothic lettering. The church at Long Melford is of course more beautiful than St Michael Coslany, and it is difficult to take one's eyes off the intricacy of its flintwork where, incidentally, the expense was considered, and there is more flushwork ornament on the south side than on the other. The church at Lavenham is no less extraordinary, and would call forth volumes of praise were it anywhere but in Suffolk. It is not so long as Melford despite its flight of a dozen

windows in the clerestory, but it has a flintwork tower of utmost magnificence, a veritable campanile of the sheepfolds, both churches being due to rich wool-merchants and the cloth trade.*

Throughout the county of Suffolk there must be other examples beyond number of satisfying and appropriate flushwork mixed with brick or freestone; as at Blythburgh, on the sea-coast with a clerestory of eighteen windows divided by flint panels, and flushwork initialling along the parapet; and with the hundred foot tower of Eye, all of flushwork, at the other side of Suffolk, near the Norfolk border; neither of which churches I have been able to see. If we now cross into Norfolk where, alone, the number of starred churches in the most well informed guides would take six weeks to two months to see, it is necessary to do so in company with an authority who not only writes of them but produces in evidence as well his detailed and careful drawings.†

The flints, as he remarks, were dug up in pits, or found upon the shore; and he refers to the process of 'galletting in the joints', which entailed the pressing of small flakes of flint into the chalk blocks, chalk again being a local material found upon the coast, while his reference to these small pieces of flint as 'clinker' raises again my query as to the effects that might have obtained had the real and genuine clinker of blue or green ironstone from the North-Midlands been made use of, when results could have been achieved to put the china pagodas of the East to shame. This was not to be, but the uses of flushwork are splendid enough without this further adventitious aid.

In the first of his books Mr Wearing has many comments on the uses of flint and brick, and of flint and stone in the town churches in Norwich, of which no fewer than ten are noticed by him; and then proceeds to Loddon, a village hardly mentioned by other authorities, where is a fine flushwork porch in two storeys, richly panelled with knapped rough flints producing, that is to say, a slightly obtruding surface. It is not unreasonable to compare this porch and chamber over it to the very similar porch at Cley, which I have seen in the unforgettable semi-darkness and mystery of a November evening. At Cley the upper storey windows are lancet-shaped and higher and more important, and there is the rich cresting of its battlements; but it lacks the flushwork panels of Loddon, which yet is but a façade of flint, and it has not the wonderful recesses and angles of the porch at Cley.

In the second of his books, *More Beautiful Norfolk Buildings* there are perhaps fewer churches dealt with, and in consequence less flushwork. But he gives the church porch at Aylsham with its breastplate of knapped flint and stone above the doorway;

* The church at Cavendish, only a mile or two from Long Melford, has a clerestory panelled in flush-work that must be of like provenance.

† *Beautiful Norfolk Buildings*, 1944; *More Beautiful Norfolk Buildings*, 1947, and *Beautiful Norfolk Buildings*, 1960. All three volumes are by Stanley J. Wearing and are illustrated with his pencil drawings.

there is a drawing of Deopham where the buttresses of the tower have 'dark knapped flints' worked in chequers into the stone, their outer angles bound, as it were, with flintwork; and he writes of Haddiscoe tower and its flints, 'almost white in colour but with some shading from umber to dark grey', and varying in size from small flints to others 'as big as a fist'. But Pulham St Mary is most beautiful of all; a two-storeyed porch with the importance of a separate building on its own, with rich 'Isabelline', as it would be called were it in Spain, cresting to its parapet; niches that once held statues either side of the door, and figures of eight angel musicians, with trumpets to their mouths or playing lutes and viols. Over this are as many carved shields, heraldic or religious emblems, and seven canopied niches over those for statues; while Mr Wearing draws attention to the 'black' flint panelling to the sides, buttresses and plinth of this fantastic porch which, were it not for its many local compeers, it would be difficult to believe is but a rustic village building.

In the last of his volumes Mr Wearing starts off with Worstead, a 'wool' town where the cloth of that name was made, and hence the magnificence of its church, with tower of flint and stone, and traceried 'sound holes' in the tower which are a special feature in many Norfolk towers. Even to these 'sound holes' they contrived to give a wide variety of design. The blank arcading and bands of quatrefoils in flushwork at the base of the tower must be of fine effect, the porch, too, is elaborate, as much so as the porches at Cley and Loddon. But in the drawing it lacks the elegance and standing of the other two, and is rougher and more self-assertive. At another village, Blakeney on the Norfolk sea coast, with not only a tower but a beacon tower as well for fishermen to steer by ... 'if they got the small tower in line with the bigger one, they were on the right course for the harbour' ... he notices the squared white flints set chequerwise with stone over the doorway; reverts to the church of St Michael-at-Plea in Norwich for the darkness of its flints which are 'almost black', though in the upper part of the tower whole flints are used and it is therefore lighter in colour; and arrives at Northrepps and Southrepps near the North Sea, the Norfolk equivalents to Huish Episcopi and Kingsbury Episcopi. Of Northrepps he writes of the tower of whole flints, 'dark in tone', with flints 'that are cream in colour' over the west door. At Southrepps, with its beautifully traceried tower window, the flints are dark 'but with lighter ones worked in', while in the buttresses they are 'light to purple-coloured' squares of flint. He writes of the light and dark varieties of flint used to purpose at unknown Dickleburgh, but in his drawing it is muddled and intricate compared again with Cley or Loddon. His professional interest gives variety and colour to all these specimens of flushwork; to end with Great Witchingham – and where can that be? It is in fact not far north of Norwich – with a rather ungainly-looking porch where the flints are 'black, with burnt sienna-coloured ones worked in', and the side walls are faced with 'some ginger-coloured whole ones and fully

galleted'. With for postcript Ringland church, where some of the flints in the tower are 'quite white'; and Tunstead with arcades of flushwork where the flints are square faced, and 'of cream colour, becoming greyish as they get higher'.*

* Besides those examples of flushwork mentioned in the foregoing, the parapets on the towers of Woodbridge and Walberswick, and in particular the former of these two; the clerestory of Coddenham, with arched panels and initials, all in flushwork; and the porches of Halesworth, Blyford and Mendlesham, all illustrated in *The Use of Flint in Building, especially in the County of Suffolk,* by Frank T. Baggallay, in Vol. I of *Transactions New Series,* of the R.I.B.A. for 1885. A peculiar technique for rendering flushwork has been evolved in these drawings. Of the three porches mentioned, Mendlesham is the most elaborate, and it is in an upper chamber there that the most complete armoury of any church in England is preserved, of all dates from 1470 to 1610.

6

Fan Vaults

Among the glorious and incontrovertible and unrealizable assets of England are its Perpendicular church towers and its fan vault ceilings.* The former are in such number, and of so great a variety of design and of variation again within their variety, that there are not hours enough in a lifetime to see them all – or only time for that, and an ensuing dullness and confusion, with little else beside. As for the fan vaults it is not so difficult. There are not so many of them. It was at Gloucester, the veritable cradle of the Perpendicular, our national style, that the fan vault was invented, in the cloister of the Benedictine Abbey which is now the cathedral. In the cloister, 'with its stone winnows or fans forever opening along the cloister walks', though truth compels one to add that this is far from being the best of the fan vault ceilings. It is, even, rough and rudimentary both in design and execution, and far from rivalling as do its successors the 'apiarist work' of the Alhambra or of Isfahan. But the cloister ceiling at Gloucester contains the germ or beginning of the idea. Incidentally, it is a very curious, an unexpected kind of work to find in England because of its quasi-Oriental character and connotation. At first glance, at least. Though, once assimilated and understood, it fits in with such anomalies as the pre-eminence of our needlework or *opus anglicanum*, and the costermonger, even Cockney 'show off' and extravagance to whatever height in elegance, of Richard II's 'fish-stall' dress which has been made the theme, here, almost of a special episode.

It may have had simple beginnings. It looks in Gloucester cloister like the simple sprouting of the vaulting, and takes on the regularity of some form of palm frond. The suggestion is of a kind of palmate growth. It sprays up from its bracket towards the ceiling, and is the shape in the simplest terms of any spreading tree. Unnecessary to think that it is inspired by stories of the date palms in a green oasis. The Orientalism of the fan vault came in later with its years of luxury. In this early stage it has little or nothing to do with fans, and so it may have remained perhaps for a score of

* The term fan vault has been used throughout this chapter in a general sense to cover lierne and groin vaulting as well. For instance, the ceiling of the Divinity School at Oxford is of groin type, and that of St George's Chapel, Windsor, an example of lierne vaulting.

years. But development was bound to follow in this fertile age. In the cloister at Worcester and, too, at Croyland Abbey, in different parts of England it is still the natural vegetable growth of the roof-groining. There is good sense, but no degree of fantasy in either place. And so it is with the multiple branching from the stems or columns in the Lady Chapel of Gloucester, up into the ceiling the design of which is much complicated by the roof-bosses which proved an irresistible temptation to the mediaeval craftsmen, even if the detail was all but invisible to those below. But, at Croyland it is, as it were, but the ribs of the palm with no vegetable growth between. In the end, wherever there is vaulting, if obsessed by its future development into the fan vault, one begins to look for stone leafage and vegetative sprouting.

Croyland and the cloister at Worcester, both of them nests of the Benedictine Order – the former of these, nest, indeed, for it grew up as one of the many islands in midst of the 'almost inaccessible fen' – date from shortly before 1400, but with the spreading of the new development far and wide from one end of the Kingdom to the other, by the time it reached to Norwich Cathedral in another couple of human generations (1460–70), the vault of the nave is the pure instance of 'palmate' vaulting, with the intermingling of the fronds at the middle of the roof, and the carved roof-bosses in the midst of them appearing like the purposefully exaggerated fruiting of the date palm.

In other parts of England different ideas. At Sherborne Abbey in Dorset, once more of the Benedictines – it being impossible to take these things in strict chronological order – the nave vault has ceased all vegetative resemblance and is undeniably made up and composed of fans. They are half fans, half wind vanes, and at the same time are shaped just like one half of the 'funnel' which you use for pouring liquid from one vessel into another. Their edges touch on one another, not altogether comfortably, and then there has to be a composed design of stone lozenges and quatrefoils to fill in between the fans spreading out towards each other from both edges of the ceiling.

Of almost the same date (1480–90) are the Eastern Chapels or New Building of Peterborough Cathedral (where yet once more were Benedictine monks), and here the fan vault is in combination of both types. It is the fan-palm, a hybrid of the palm tree and the fan. Here, the fans or trimmed palm fronds, whichever we prefer to call them, are bigger in scale than at Sherborne, and touch each other in their circumference across the ceiling, with no need for any ornament in particular in between them. They are palm trees, it could be in fallacious theory, of a couple of years of growth, trimmed twice over until their outer edges meet. And it has been suggested, probably with good reason, that the same master mason designed the famous fan vaulting of King's College Chapel, Cambridge.* Here it floats, one could almost say it waves or

* Mr John H. Harvey, in *Gothic England*, 1947, suggests John Wastell as his name. The same author, p. 129, is quoted below in the next paragraph.

Fan Vaults

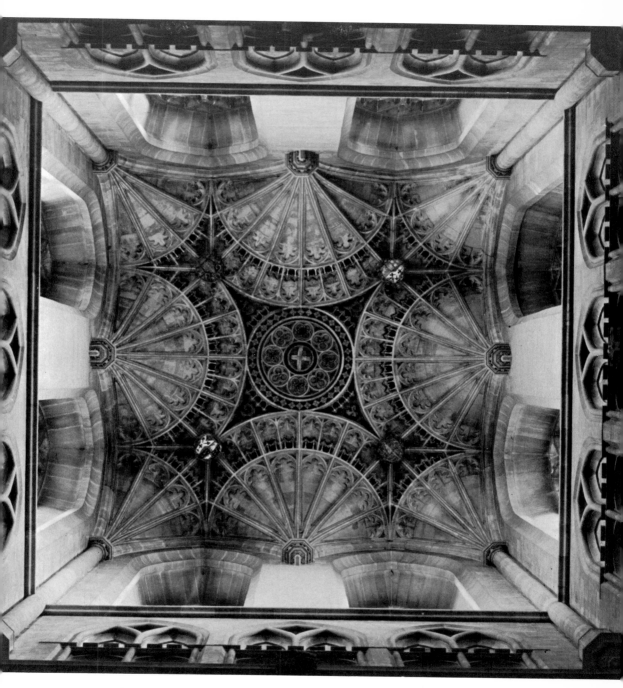

Vaulting inside the 'Bell Harry' Tower at Canterbury Cathedral

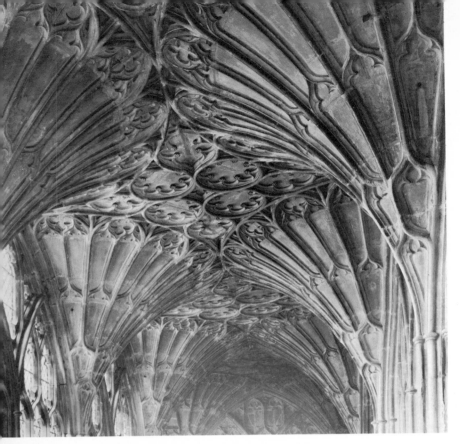

Prototype fan-vaulting in
Gloucester Cathedral
cloister

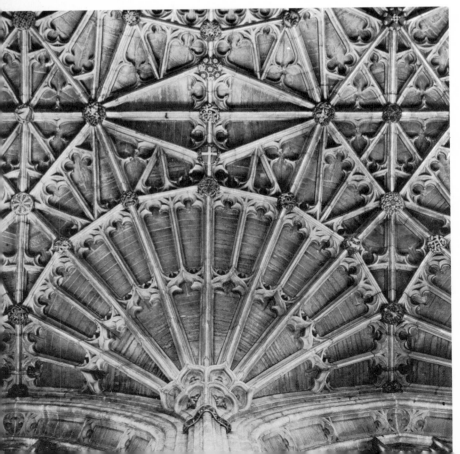

Fan-vaulted nave roof at
Sherborne Abbey (Dorset)

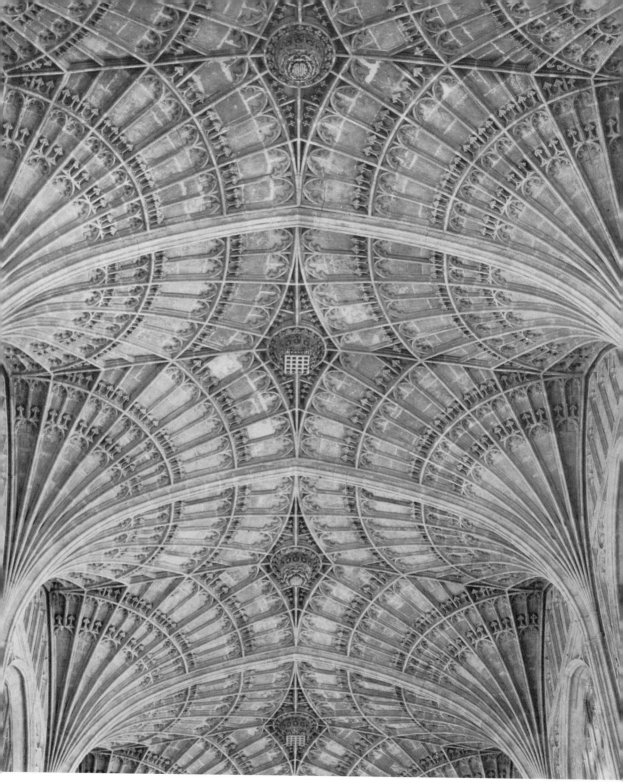

The roof of King's College Chapel, Cambridge, recently cleaned.

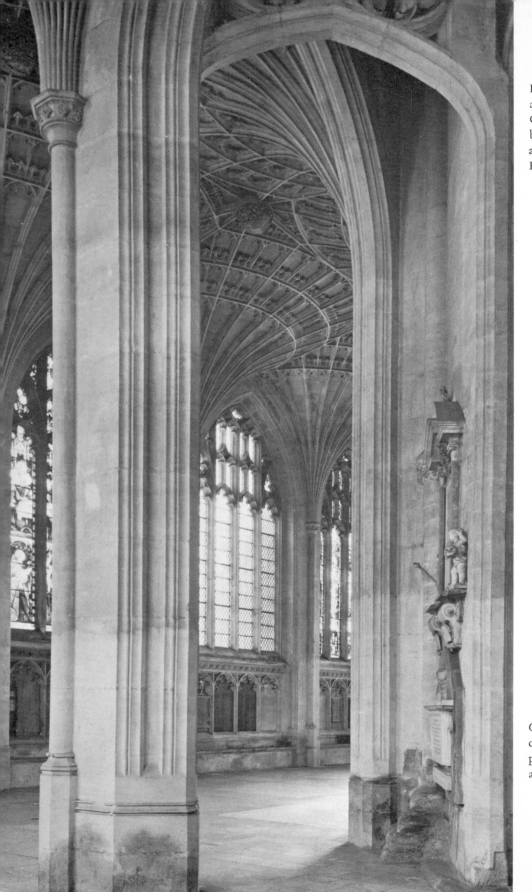

Fan-palm vaulting at Peterborough Cathedral, perhaps by the same hand as the vaulting of King's College

Opposite Nave crossing with palm-vaulting at Bath Abbey

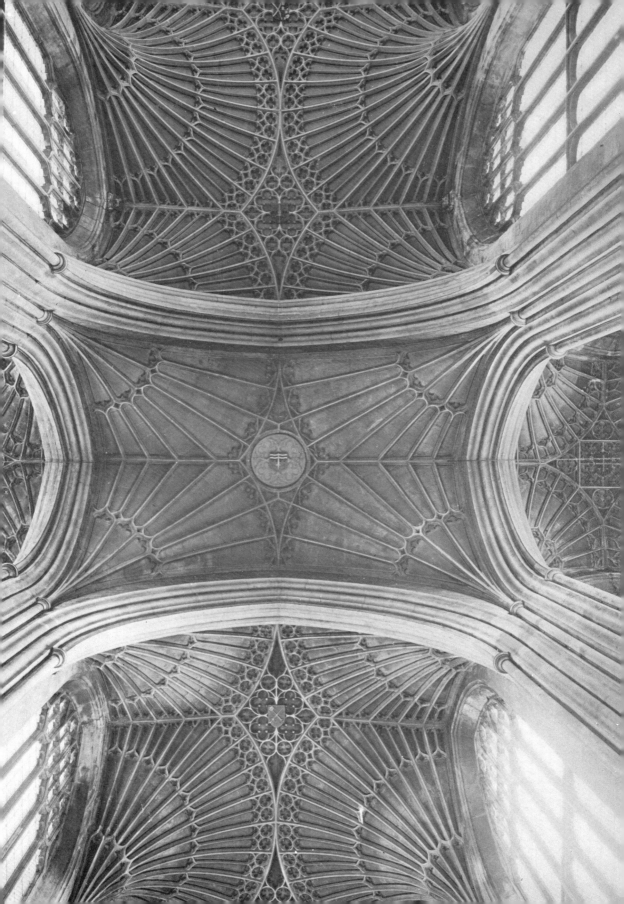

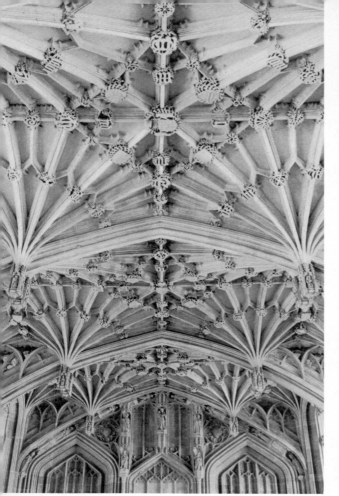

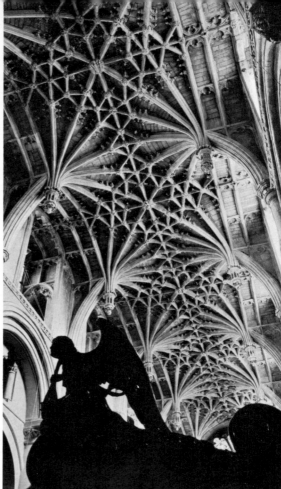

Left Pendant vaulting of the Divinity Schools, Oxford
Right Elaborately vaulted nave roof of Oxford Cathedral

Opposite Roof of King Henry VII's Chapel in Westminster Abbey, finest and most extreme of the English fan-vaults
Below Diagram of the structure of the vaulting of the Henry VII Chapel

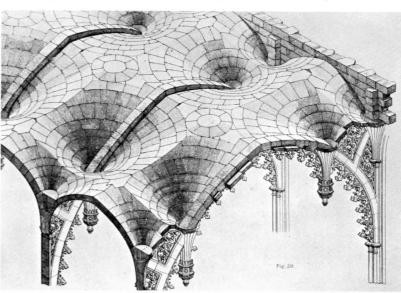

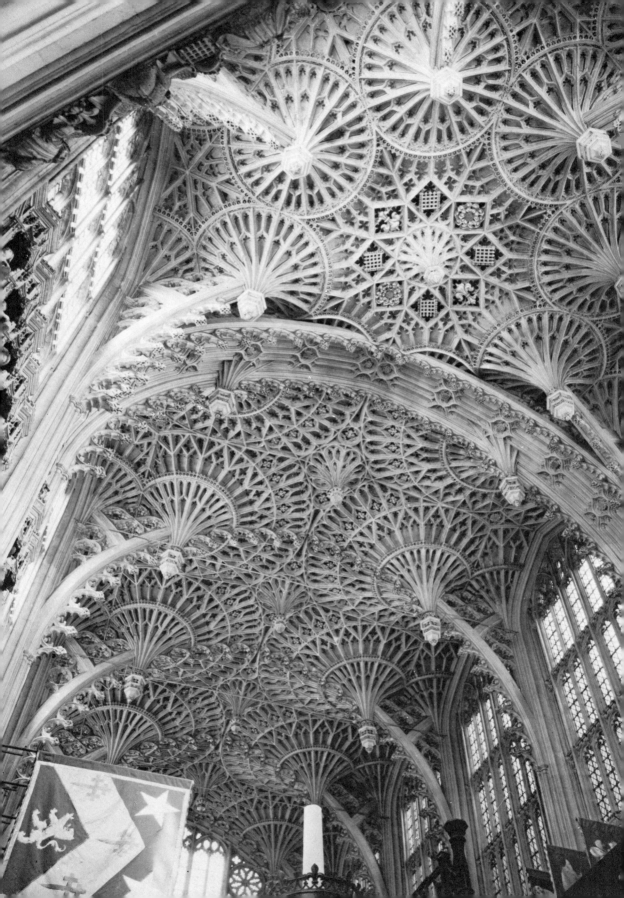

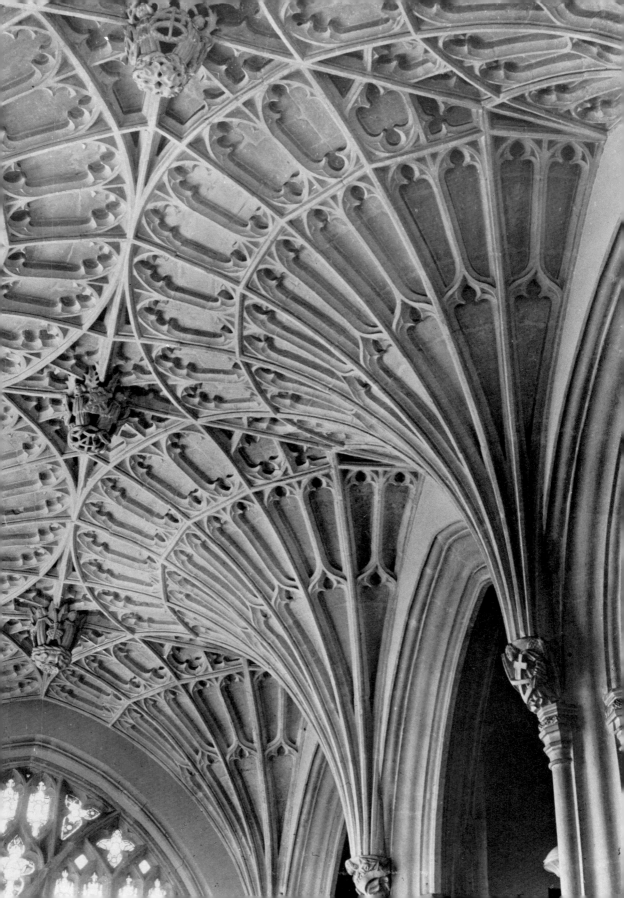

shivers, above much higher Perpendicular walls that are largely window. The fans touch in the middle again with what one could term a two years' growth of palm frond, and certainly the resemblance is conspicuous between both fan ceilings.

And now a note of caution comes creeping in. One of the most learned and cautious critics of this architecture writes that 'the fan vault was cheap because it was standardized in its parts; all the ribs were of the same curvature; it was easy to build because rib-and-panel design was only apparent, and in most cases the whole work was cut from the solid block; it was consequently less "alive" than other vaults and needed less buttressing'. Not, as one would have thought, more, but less buttressing is what he states. And he warns one only to look out for supreme examples that were the work of great masters. Decidedly the ceiling of King's College Chapel is among the latter, although every one of its fans has had to be bound in by an extended rib that arches across the whole ceiling. There is good use of fan vaulting in Bath Abbey where, indeed, considering its location in the West Country it would have been curious did it not appear. Both the choir and choir aisles have the fan treatment, the effect of which is like a recurrent dream of Palm Sunday. For they are palms, palms, and hardly fans at all. Less so, perhaps, in the choir aisles where the bosses, hanging down from stone roundels at the intersection of the fans, detract from this fantasy-marriage of Palm Sunday with the palms standing in corners of a Late Victorian conservatory and drawing-room.

The Divinity School at Oxford, known to tens of thousands who have attended there in cap and gown, has a vaulted ceiling of stone from just these years; but could one honestly say that it is beautiful? They are dependent, not growing fans; and have the aspect of strengthened or reinforced umbrellas, placed upside down as would often be the case to dry off after a day and night of Oxford rain. Umbrellas, not with ferrules on their ends but carved and awkward-shaped bosses; while the stone ribs that arch across and carry the ceiling, separate, but do not show the fans to advantage among the thronged bosses and carved badges of the stone ceiling. As for the roof of Oxford Cathedral (the chapel of Christ Church), it is curious and complicated indeed, with at first glance a touch of the Manoelino, as though, below, there could be the twisting, the clasping or entwining columns of Setúbal, that 'are formed of three stems of stone that enrol and wind round one another'. But nothing of the kind. There is nothing else to disturb the calm. It is but the ceiling. The fans or palms for this time sprout downwards out of nowhere from the middle of the ceiling, which is further entangled with stone thickets; and these same dependent or hanging fans or palm fronds are holding ornaments that could well be lanterns, lighted on occasion. But, as well, each of the palms or fans has to be supported or pushed out into its right place in the ceiling by a curving buttress, itself disguised palm-fashion with ribs cut into it, as though it were an aberrant, wandering, and unwrapped, unfolded palm

57

Opposite: Fan-vaulted Lane Chapel at Cullompton (Devon), with pendants displaying the instruments of the Passion

frond. The ceiling at Christ Church, though interesting and certainly unusual in the extreme, cannot be said to be successful. As fan vaulting it is inferior in conception to the great fan vault springing from one central column over the stair leading to the hall of the college, though that was built in the delayed Gothic of the time of Charles I. *

At St George's Chapel, Windsor, which is just where the fan vaulting should be at its finest height of refinement and invention, one might be inclined to think it fails again. This, although it is attributed to William Vertue, one of the two brother master masons who worked the ceiling of Henry VII's chapel at Westminster Abbey. At St George's Chapel the roof errs on the side of simplicity. For a chapel not a large church, and with its infinite possibilities for expenditure on a great scale, it is disappointing. They are palm pillars of ordinary proportion, neatly trimmed and arranged so as to make room for a triple row of carved bosses that proceed in straight line along the ceiling. Nor do things improve much in the Garter Chapel. It is the stall plates of the Knights that are the unique and overwhelming interest. The ceiling is perfunctory and adequate, no more than that; where, after King's College, the most beautifully elaborate and pseudo- or fanciful Oriental of all ceilings could be expected. But the choir aisle ceiling has a different and more subtle treatment. Here, the fans spring in authentic manner from the capitals of slender columns; their trimmed and unfrayed edges meet in the middle and enclose octagonal panels with carved bosses in their centre.

The smaller examples of fan vaulting are often those worked most satisfactorily and with the greatest skill. That for instance to the Salisbury Chapel in Christchurch Priory, that blends in so perfectly with the three canopied niches on the wall where the altar stood, and in the middle of which is a carved boss which, with the Coronation of the Virgin and the devices of the Plantagenet family, is, so to speak, a floreated version of the fan vault. The ribs of the fans have hexagonal thickenings or inflorescences half-way up their length, and lozenge-shaped compartments between the ribs. The minuscule chantry chapel attached to the Beauchamp chapel at St Mary's, Warwick, has a fan vault of umbrella type with hanging pendants, but worked out with neatness, more as if it were a carpenter's work and was a wooden ceiling. The Lane chapel or aisle at Cullompton, in Devon, looks to be, for I have not seen it, simply and beautifully luminous in its pallor with 'funnel' fans coming up from brackets on the walls, which brackets have the form of angels 'bearing implements used in the wool industry', while the pendants from the fans have 'emblems of the Passion, the astrological symbol for tin, and various monograms'. The mediaeval

* Mention should be made of the fan vaults in the ceiling of the Angel Steeple, or Bell Harry Tower of Canterbury, which I have written of elsewhere as 'the geometrically exact unfolding or opening of no fewer than eight fan-shapes of stone, all fitting into the square, a contraption which appears ready to fold in on itself at any moment with a shutting and snapping of stone slats'; cf. *Monks, Nuns and Monasteries*, 1965, p. 33.

craftsmen could even have made something of such a theme as compulsory insurance. Another instance in Devon, the ceiling of the Dorset aisle at Ottery St Mary, has remarkable and curious pendants of 'open work bars of which numbers one, two, four and five are straight, but three (in the centre) of spiral shape'. Were these the special jobs of imported craftsmen? Probably they came, a master mason and an assistant or two, to Cullompton and to Ottery St Mary, for a few months' work, from Sherborne Abbey; and of course they were not monks, but laymen.

It is of little avail to pursue the fan vault to further purpose up and down the country. The most beautiful examples of it in little have been at Peterborough, at Christchurch, Hampshire and, of presumption, at Cullompton, Devon. Those, surely, are not 'standardized, cut out of the solid block', and put up in sections, in which event the lesser examples mentioned could have been assembled and put in place in a matter of days. Sometimes there is delicate and beautiful fan vaulting inside a porch, a purpose for which it is eminently suited, as, it would seem, in a few villages in Devon.* And to the stranger the effect of the fan vaults is as unexpected almost as the finding of a *Mudéjar* ceiling in a church in Spain, for it is something at once natural and alien, and at the same time, exclusively and conspicuously English, and nowhere else to be seen. It is so very different from the 'excesses', and excesses they are, of the Flamboyant Gothic in France or Belgium. No one could accuse a fan vault ceiling of being out of place, or in bad taste. On the contrary they fit in perfectly and naturally into their surroundings, as though the normal, if unusual and unprecedented development of what was bound to come. Particularly do they seem appropriate above the slender, high walls or screens of Perpendicular glass which are the supreme grace and elegance of English building.

It will have emerged by now that there were several different types of fan ceiling, more than ever touched the imagination of James Wyatt, the delicate arachnid-elegant fan-patterns in the corners of whose stucco ceilings are so characteristic as to amount to his personal signature and who, ardent sham Gothicist that he was to become later, surely learnt his lesson from what he must have admired at Sherborne, or Evesham, or elsewhere, on the way to see his country clients in Gloucestershire, Wiltshire, or in Dorset. Then, again, as Mr Harvey comments, 'many of the finest late vaults are either not fans at all, or only partially of fan form'.†

But the ceiling of Henry VII's Chapel is both the most extreme and by far the most beautiful of these conceptions. It is here in the middle of London, in the midst of the Thames fogs, within sound of the tugs, and in the face of the parrot-house of Parliament, that there is this very unique and special fan vault the transcendental beauty of

* Dr Nikolaus Pevsner, in *The Buildings of England: Devon*, 1952, gives Holcombe Rogus and Torbryan as 'beautifully fan vaulted' in their porches.

† John H. Harvey, *op. cit.*, p. 129.

which puts it on a par, however much the purists may cast up their eyes at the comparison, with such architectural gems in their different kinds as the Sainte-Chapelle, the Cappella Palatina, the pilgrimage church of Die Wies, or the Shaikh Lotfollah mosque on the Maidan at Isfahan.

What, then, is the effect of coming into Henry VII's Chapel at Westminster and looking up at the ceiling for the first time? As an impression it is indubitably beyond precedent and very extraordinary. The ceiling has been described, not as a fan vault but a transcendental parody or set of transcendental variations on a fan vault. A musical analogy is not unreasonable. I think the sensation given is that if you listened you would hear these hanging pendants ringing. In the unlikely event of our being left alone for the night in the chapel one would expect to hear some sort of noise from them. 'Musical stones' were a feature in ceremonies and processions in past Imperial China. They were struck with wooden or stone hammers and gave out a note. There could even be a stone orchestra. And if the uncouth and awkward stones of the lake-bed, why not the highly worked and articulated stone stalactites above us? One would anticipate high notes and scales as on a seraphic glockenspiel. Some sound or other must emerge and come down from that colourless, yet coloratura ceiling. The stone ribs with their fringed edges arching across the whole vault would seem even to hold and bind in the ringing.

But musical anticipations apart, entry into the chapel provides a very strange sensation which, too, seems capable of change or alteration within itself, even as you look up at it. Coming in part, perhaps, from the play or change in the stalactites as they move and take up new positions, as you walk below them, within their hierarchy. Those circular fans or funnels, or that inflorescence but perhaps of marine not terrestrial flowering, is whirring, spinning, while perfectly and visibly motionless and still. Particularly if you can look up at it from a little to the right or left, and at an angle, the ceiling seems unprecedented and extraordinary. It is then that you get the sea-cavern, polyp-hiding, madrepore-growing effect of it, and could almost expect to see little brightly coloured fish swimming in and out between the pale stalactites and hanging lanterns. Being not natural, however, but artificial, and, at that, the height of artifice, the effect of the fan vault ceiling is Oriental. Had our Indian dominion come a little earlier, and coeval with that of Portugal, one could think it the work of imported craftsmen from some Dravidian or other temple.

To describe its structure in words is far from easy. The 'fans' are in fact not fans at all; nor are they palm-fronds, nor funnels, nor umbrellas. Here, for about the first time, and the last (the dates are given as 1503–19, well into Henry VIII's reign) the stone shapes are complete circles, in their turn held out there, balanced, as it were, kept spinning, each by a fan or hemicycle on the wall, that touches the edge of it and gives it motion. We have the illusion that the spokes or pattern of the circles is not in

their stillness but in their spinning. The bay or far end of the chapel over its three windows has no fewer than four of the stone tops or gyroscopes filling the whole compartment of the roof over the apse, loaded, otherwise, with little traceries and ornaments for a surround to the smaller or central gyroscope or parachute, it now resembles, ending in a dependent boss shaped like a lantern. But the stone stalactites or parachutes, choosing the term carefully, are suspended, held up in their descent from below, or from the side, at least, by a buttress coming out from the wall and passing into them, gripping them, midway in their stone folds. The purpose is that of the pedestal sometimes to be seen in an equestrian statue coming up out of the ground and supporting the horse by the middle of its belly. All along the chapel roof there are those stone struts or supports coming up out of the wall, providing in themselves a part of the scheme of ornament, but offering their aid to hold the stalactites or parachutes in place, to keep them up and prevent them coming down. There are in all three compartments of the ceiling twelve of the larger stalactites or parachutes, and four of the ones in the centre of the ceiling; each, and all of them with its dependent boss or lantern.

It is the planning and working out, and the paper, or, rather parchment stage of the designing, and resultant effect that makes the wonder of this fan vault ceiling. And it is this complexity or inflorescence that calls to memory such an Oriental marvel as the Shaikh Lotfollah mosque of Isfahan. It is the smaller of the two mosques upon the main square or Maidan. 'A tiled dome', in short, 'the colour of *marron* or of a *mousse* of coffee with a drop of raspberry or strawberry juice added, on which a branching rose-tree is inlaid in black and white, and overall a faint blue lustre from its china surface.' As to the interior, a huge formalized peacock, all eyes and lozenges, is inlaid in the dome. It should seem to rattle and shake its feathers which grow bigger and bigger as they descend. But they do not move, they are still and static. They are frozen and have no movement. On the walls are panels of white calligraphy on a blue ground.* The reader will, I hope, excuse this interjection of other matter from a writer who has often been accused of irrelevance, because it is in fact a cogent and informative comparison. The fan vault ceiling of Henry VII's Chapel is of so extraordinary and exotic a nature that it calls for far-fetched compliments and comparisons. Were it in the East it would count among the wonders of the Orient; and it is strange indeed to find it only a stone's throw from the Thames. A peculiar and striking feature of it is its pallor. It has no colour but that of its stone which may have paled with age.

But there is the evidence that, not this, but several of the other fan vaults in their time were painted. 'Deep blue panels with gilded carving, and the ribs having their ogee mouldings painted red and the hollows green, while the fillets are gilded', so

* A few sentences adapted from my *Arabesque and Honeycomb*, 1958, pp. 60–61.

runs an account of the colour scheme on the lower storey of the Beauchamp chantry chapel at Tewkesbury, though its details are a little difficult to follow.* Again the vault of the Audley chapel at Salisbury had 'deep blue panels shaded to green, and the ribs left plain except for the fillets, which were gold'. The heraldic bosses were subtly dealt with; and in one of them the leaves of the roses and the pomegranates were painted and gilded. Sometimes the colour was restricted to a few parts of the vault, and the rest left plain, which may have been effective. The choir of Sherborne, according to the same authority, had panels of chalk and ribs of yellow Ham Hill stone; and the bosses in the nave and transepts were picked out in gold and colours. Most astonishing of all and destructive of all accepted canons of admiration, 'it is known that the great vault of King's College Chapel was to have been painted'; and there are estimates for the painting and gilding of the twelve bays of the roof amounting to £320 in all, 'equal to between three and four thousand pounds of our money', but this was in 1911 before two world wars, and between thirty and forty thousand pounds would be nearer the correct answer. So the roof of King's College Chapel was to have been in gold and colours; and this may be as surprising to some tastes as that the sculptures of the Parthenon were once coloured. As, too, the sculptures on the porches of Chartres Cathedral. To which it can only be added that those who carved them will have been the best judges of such things. The fan vault of King's we can perhaps take on trust, but it is difficult to envisage the Elgin marbles or the porches of Chartres ablaze with gold and colours. But, then, again, many tastes would not approve the chryselephantine statues of the Ancients, though we should have learned by now to prefer the live flesh to the skeleton.

* *Fan Vaults*, by F. E. Howard, in vol. LXVIII of the *Archaeological Journal* for 1911, pp. 1–42. The same author wrote *On the construction of Mediaeval Roofs*, in vol. LXXI of the same *Journal* for 1914, pp. 293–352.

7

Opus Anglicanum

The Middle Ages, if we must call them that, seem to have been under no illusion as to what is beautiful or not. And beauty meant, or was the sugar-content or the equivalent of poetry to them. This, as distinct from religious themes which were another matter, over which indeed their imaginations were not so free to wander. In the painting of religious subjects, or the weaving of tapestries with themes taken from religion, there is no doubt they worked from complicated schemes drawn up in minute detail, a process which can be far from disastrous in the arts, as witness in an altogether different medium the score of Tchaikovsky's *The Sleeping Princess* which was composed in strict accord with the stipulations and written directions of Marius Petipa, the choreographer, and in the result is the supreme masterpiece of music for the dance. Down the centuries many a tapestry, many a cycle of frescoes, and huge areas of painted ceiling have emerged with great success from this unlikely process, wherein, it would seem, inspiration must be entirely lacking. But, improbable as it may appear, far from being so, such a scaffolding has often been the very means of obtaining the most effective results.

Thus, we may be sure, were the designs of the sets of mediaeval tapestries approved and settled. Nothing was left to chance or for the *tapissier* (Eng. tapicer) to fill in, this last English-French equivalent being of little present moment because tapestries were all in effect of Tournai or Arras origin. But it was English embroidery, the *opus anglicanum* that was famous, an art of which almost the only existing relics are a very few embroidered copes surviving in different parts of Europe.* Of solemn import and significance, even if the orphreys of the Piccolomini cope at Pienza are embroidered with medallions of pelican, peacock, falcon, hawk, heron, partridge, pheasant, thrush, finches, magpies, and a pair of swallows, in evidence that the spring-like freshness of the English work could not help itself but must creep in. Such copes

* The Syon cope and the Butler Bowden cope, both in the Victoria and Albert Museum; and others preserved in churches at Ascoli Piceno and Pienza in Italy; a pair of copes given by Pope Clement v at Saint-Bertrand-de-Comminges in the French Pyrenees; and others at Vich and Toledo in Spain, and Skå in Sweden. Cf. *English Mediaeval Embroidery*, by Mrs A.G.J.Christie, Oxford, 1938.

would almost certainly be nuns' needlework. But of course the secular embroideries and needlework would be less solemn still, and the work chiefly of craftsmen who were embroiderers by profession. What Isfahan is, or purports to be in the weaving of Persian carpets, so were the cities of Tournai and Arras to the manufacture of fine tapestries. But it is probable that the English embroidery was the most beautiful in Europe. The English Kings were both richer and more victorious than the Kings of France. It was the Dukes of Burgundy, rulers of the water cities of the Low Countries, who owned the great sets of tapestries. The English Kings, of Norman and Angevin descent, and rulers of a third or more of France, were of greater or superior potency to their French or Burgundian equals; and it is certainly arguable that St Louis (Louis IX) apart, the Plantagenets produced the better Kings. France had no Henry III, no Edward I or III, no art lover like our Richard II. The power of the mediaeval Kings of France, because of the natural riches of their kingdom, was greater in theory than in fact. That the French had a deeper instinct and tradition in the arts is equally true; they were the innovators and the English followed in their footsteps though to some degree on sidepaths and detours of their own finding.

If the subject of their tapestries is reserved for later discussion there is poetry of sumptuary sort, and to spare, in the mere inventory of the clothes they wore. May Morning, coming at the end of the long and dark winters of those days was of parti-cular significance, and it was the custom for kings and princes to give out mantles and other garments to their courtiers in their own colours, and sometimes bearing emblems of the spring. There was the 'livery of May', made of that 'gay green' cloth which the French King Charles VI gave to his friends and intimates at the beginning of each spring; and in the *Très Riches Heures du Duc de Berri* there is a miniature of three young ladies riding in a row, one behind the other, dressed in this 'livery of May'. Near to them in the cavalcade rides a knight dressed in the royal livery, in the King's colours, and it is likely that he is a prince of the blood. The livery is half red and half black and white; that is to say, the left side of his body is scarlet with a white sleeve, and his right side is black with an inner panel of white, and a white, flame-like border or edging into the black. He wears a black hat with white on the crown, and a long white, trailing end. All of them, knights and ladies alike, are crowned or garlanded with leaves. The ladies have spring leaves in their fair hair or upon their starched white wimples; while those knights who are hatless wear garlands of spring leaves upon their heads.*

This is an instance, and there are others. On May Morning 1387, the same King Charles VI and the Duke of Touraine, showed forth in mantles of green cloth embroidered with sprays of broom, the royal device, and presented twenty-five

* A few lines quoted from *The Hunters and the Hunted*, 1947, pp. 49–54, where there is a chapter on the castles of the *Très Riches Heures*.

Opposite: Coronation of the Virgin from the Pienza Cope, 1315–35, presented to Pope Pius II by Thomas Paleologus, Despot of the Morea

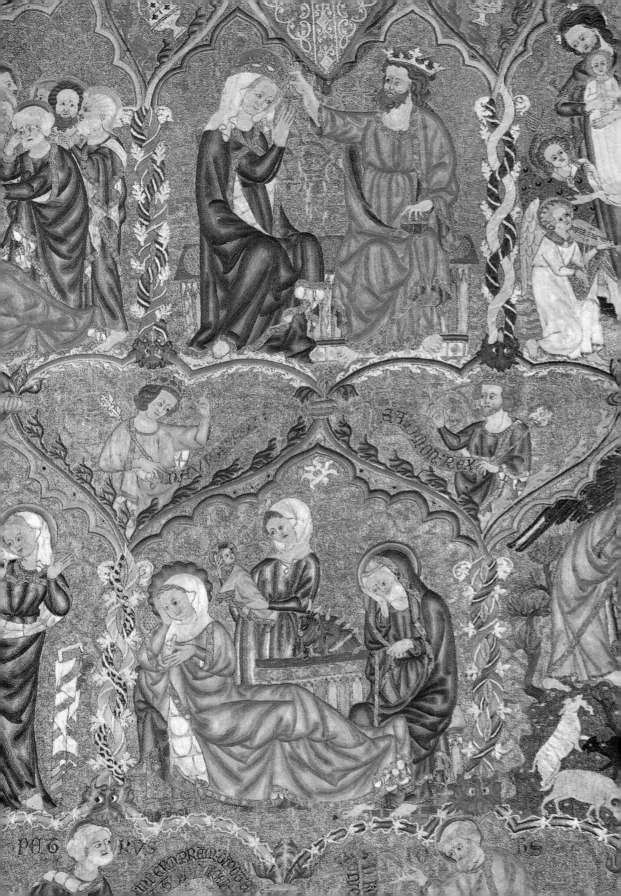

cloaks with the same device to the courtiers. During the same reign, Charles VI being the French King who was defeated by our Henry V at Agincourt, the Duke of Guienne appeared in a cloak with the peacock feathers and broom of the King's badges, mixed with hawthorn branches in honour of May, and sewn with the King's four colours, white, green, red, and black. And on yet another May Day, 1390, the Duke of Orleans gave *houppelandes* of black frieze with a band of his six colours and a wolf upon the sleeve; while four years after that his small son, aged two, had a green cloth robe with all six of his father's colours for May Morning, and very sweet he must have looked!*

Spring-like motifs were conveyed not only on their embroidered clothes, but indoors as well. Edmund Mortimer, Earl of March, had beds embroidered with his badge of butterflies, and wall hangings worked with children chasing butterflies; and one is curious to know if they were the common white cabbage butterflies. It seems unlikely. The rarer sorts apart – and there have been races of butterflies no living eyes have seen – peacocks and red admirals were of a certainty in greater number than they are today, and the unerring hand of the craftsmen-embroiderers, whether they were men or women, will have given the insects of the field their due importance and rendered them more than lifesize. We may be reminded of this, now that the sham Gothick has been so nearly related and re-attached to the Gothic and even claimed by the leading authorities as its direct heir and continuance, of the moth, 'as large as the figure of a man', in Fuseli's painting from *Lycidas*, in illustration of the lines: 'Under the opening eyelids of the morn, What time the gray-fly winds her sultry horn.' The shepherd and shepherdesses in this painting, so Fuseli's biographer tells us, are only ten inches in length, but happening to find in a friend's garden in Fulham, a beautiful moth, Fuseli was so delighted with the insect that, in spite of all propriety and his better knowledge, he painted it the size of nature, hovering above the figures with expanding wings.† It is the very essence of this 'better knowledge' that it should be the bane of works of art, and we may be assured that the butterflies in the wall hangings of Edmund Mortimer, third Earl of March, will have been large of wingspread as the children chasing them, and on coming into the room with one's mind on other things, as visible in that semi-dark as sheep on the chalk-down, or clouds when they darken to give rain.

The bed of Thomas of Woodstock, Duke of Gloucester, and uncle of Richard II,

* These details, collected from a variety of sources by a great scholar and writer on the art of the Middle Ages, are quoted from *Art in Mediaeval France*, by Joan Evans, Oxford, 1948, p. 185.

† Cf. *Splendours and Miseries*, 1943, p. 228 and footnote p. 233. The present whereabouts of this curious painting are unknown. But how typical of Fuseli that it should have been moths, and not butterflies that attracted him! 'By special care he sometimes reared in his house some of the rarer insects, among them, the Sphinx atropos, Sphinx uphorbial, and others; and books dealing with the nocturnal lepidoptera were his favourite reading during breakfast.'

was embroidered with 'woodwoses jousting'. Intrinsically unlikely themes such as 'clouds' or 'water' were willingly embarked upon as though confident in their undertaking and in no doubt as to their ready recognition. The same Thomas of Woodstock on the field of tournament, beside his own shield, had two shields of Bohun's wife, with her heraldic bearings represented as hanging from the stock of a tree, standing in water on which floated a pair of her Bohun swans. And Miss Joan Evans, in the chapter from which many of these details are quoted,[*] notices a single combat between Henry of Lancaster, Duke of Hereford, and Thomas Mowbray, Duke of Norfolk, in which the former 'on a white courser' had 'swans and antelopes on his dress', and the latter 'silver lions and mulberry trees' to stand for Mowbray. How many of the public in our day would recognize or could name a mulberry tree if they saw one? Edward III had a white linen doublet worked at sleeves and hem with clouds and vines; while Humphrey de Bohun, whose family badge was a swan, left seventeen carpets and bankers of green powdered with swans; the web-footed swans on the water-meadows, and neither riding on water, nor sitting on their nests.

The aesthetic, even poetic possibilities both of true, and of canting heraldry offered an endless field of opportunity to the designer. The brass of Sir Robert de Setvans, bare-headed, at Chartham, Kent, has a pair of fans upon his shield and the 'seven fans' displayed upon his person; but, and here comes the poetic touch, they are in fact fans of wickerwork for winnowing corn. It is largely this same question of the crest and badge. There was the Soldan or Turk's head of the de la Poles; the bear and ragged staff of the Beauchamps, to be seen in their chantry chapel at St Mary's, Warwick; the mailed fist of Fitzherbert.

The Black Prince had his badge of ostrich feathers, which is still the insignia of the Prince of Wales; Richard II, his white hart, sunburst, and broom-pod of the Plantagenets. In that most beautiful of English mediaeval paintings, the Wilton Diptych – if it is English, and not from Northern France! – Richard II wears a collar of broom-pods, his dress of gold tissue is embroidered with figures of his white hart within frames or collars of the same broom-pods, and the eleven angels in the other half of the diptych wear identical collars of broom-pods; all have the badge of the white hart on their breasts, and all wear coronets or chaplets of white roses on their hair.[†]

Richard III had for badge a silver boar; and there are the fetterlock and falcon of the

[*] In her book, *English Art, 1367–1461*, Oxford, 1949, pp. 56–65.

[†] Miss Joan Evans in an article in *L'Oeil*, for Christmas 1956, sees the three figures of St Edmund, Edward the Confessor, and St John the Baptist, standing behind the kneeling figure of Richard II in the left-hand panel of the Wilton Diptych, as portraits, respectively, of the Black Prince, the king's father, his grandfather, Edward III, and his uncle and guardian, John of Gaunt. Certainly they all have a family resemblance; while she quotes another authority, Dr Margaret Galway, as inferring that the blue dresses of the Virgin and eleven angels in the right-hand panel is the blue 'proper' to the Order of the Garter.

house of York, much in evidence in the church at Fotheringay, the portcullis of the Beauforts, the knots of the Staffords and Wakes, the dolphin of the Courtenays, sickle of the Hungerfords, pike or luce of the Lucys, the Pelham buckle, long swords of Longespée, and gray or badger of Lord Grey of Codnor. There followed the rebus, forming a pun upon a surname; the sheaves of corn at Wells, upon the tomb of Bishop Cornish; bay-tree and tree upon a Baynton tomb; the eye and the man falling out of a tree of Abbot Islip; wheatears at St Albans for Abbot Wheatham-stead; the babe-in-ton for Babington; to end with the tomb of Sir Thomas Marken-field, at Ripon Cathedral, who wears a livery collar representing a park paling with the badge of a couchant stag lying within it; and with the baudrick or sword belt of Sir Nicholas Longford, at Longford, in Derbyshire which has a clasp designed as a castellated gateway.

It is a theme without an end; but to which must be added in appendix the sup-porters or heraldic animals holding up the coats-of-arms; the pair of buttresses of Lord Botreaux; the yales or antelopes of the Somersets, as witness the brick gateway to St John's College, Cambridge, built by Lady Margaret Beaufort, Countess of Richmond and Derby, and mother of Henry VII. And the heraldic path leads inevit-ably to the stall plates of the Knights of the Garter in St George's Chapel, Windsor; ninety of them, wherein in small compass are to be found such poetic delights and genealogical puzzles as the red mantling powdered with golden lozenges of Sir Sanchet Dabrichecourt and his crest formed of a bunch of feathers; the black mant-lings of Sir Thomas Banastre and the Captal de Buch; black mantlings, but red-lined for the Soudan de la Trau; and purple mantle sewn with golden hanging locks for Lord Lovel,* no small part of the pleasure from which lies in discovering the identity of the romantically named Soudan de la Trau, or the Captal de Buch.

If it is to become again a question of sartorial magnificence, it will be evident that there is little to choose between the time we are discussing, which lies for con-venience between the reigns of Edward III (1327–77) and Edward IV (1461–83) with its climax in the reign of Richard II (1377–99), even though that came later than the Black Death which raged through 1348 and 1349, and those epochs in history that are famous for this very thing. They are the courts of the Grand Turk, the Mughal Emperor, and that of Shah Abbas at Isfahan; to which I would add in Japan the Age of Genroku (1688–1703), of all of which periods I have written at length, but with particular attention to the textiles and dresses of the last named epoch,† splendours and innovations of pattern which it is nearly impossible to describe in words.

* Some of the material has been adapted from my introduction to *English Church Monuments, 1510–1840,* by Katharine A. Esdaile, London, 1946, pp. 9, 10.

† Cf. 'The Age of Genroku', in *Splendours and Miseries,* 1943, pp. 86–91; and pp. 231–6 in my *Bridge of the Brocade Sash,* 1959.

What, then of this? It could be in a long high hall with timber ceiling; even in the, then, just completed Westminster Hall. What we see is a retinue of persons, the most of them in red and white which were the King's colours, and they are waiting for the King to make his entrance. They are kept waiting. Presently there is the sound of distant fanfares, growing louder and coming nearer, and it would be interesting indeed to hear those, for the trumpets and horns would have a shrill tuning our ears are not accustomed to, and yet they would be fanfares, they would have meaning. Their purport would be that there is someone coming; that he is on his way and all but inside the building. Dismounting at the door, it may be, because in that day there were only carts and waggons and no golden coaches. Now on the stone steps that lead up into the hall, and already in the anteroom that leads into it. At which moment the trumpets ring out louder and shriller than ever against the stone vaulting of the antechamber. A tirra-lirra of the trumpets as though a ceremony of some sort were taking place there and causing a delay; and then, as to the raising of the curtain, and to the blare of all the trumpets in unison the fair Plantagenet appears in the archway and comes into the hall. This in sober description is his apparel; a dress of white satin embroidered with leeches, water and rocks, hung with fifteen silver-gilt whelks, fifteen silver-gilt mussels, and fifteen cockles of white silver, doublet embroidered with gold orange-trees on which were set a hundred silver-gilt oranges.

As for leeches; who is there now who could tell a leech at sight? But it is not long since that the saleswoman in the chemist's at our country town told me she remembered her father keeping leeches for sale in big glass jars stowed away on a top shelf at the back of the shop, and of the horrid impression they made on her when she was a young woman. Why, then, should King Richard II, the art lover, have leeches embroidered on the white satin of his dress? And why whelks and mussels? The fifteen cockles can only have been to keep them company for it is no question of pilgrimage to the shrine of Compostela and the cockle-shells of St James. As to the golden orange-trees and the hundred silver-gilt oranges which must have been embroidered on him, front and back, it may be doubted if anyone who had not been on crusade had seen an orange-tree. Leeches, whelks and mussels, and cockles, they were familiar with; but why this mingling of the fish-stalls of Father Neptune and the golden apples of the Hesperides? As well embroider beetles, and then pomegranates, cockscombs and ermine tails. Or sea-anemones, which can be beautiful indeed, and with them, pink-apples. Glow-worms and strawberries, there is an endless choice of contrasts; and was it just for this reason? For the contrast between some object of everyday life and a thing of exceeding rarity, if displayed here in more than plenty, indeed in overwhelming force?

But how curious the art-loving Plantagenet must have looked standing there! Noisily, too, had the leeches, the whelks and mussels, let alone the cockle-shells and

oranges, been of metal and hung solid on him, when they would make a clanking sound at his every move, as much so as if he was clad in chain armour. Or, to give variety to this and write in technical terms of the armourer, he could be wearing 'laminated sollerets formed of scales or small shingles of steel'. How does he compare to the painting of St George by Pisanello, in the National Gallery, a young fair-haired knight who could be an Englishman by substitution, wearing full armour, and a remarkably huge, flopping sun-hat that Pisanello must have noticed on someone's head. He is not likely to have invented it. To keep the sun off St George's face, or prevent it from bleaching his flaxen hair? The same, wide-brimmed, high-crowned hats of Tuscan straw were worn when I was a child by begging or mendicant nuns in the streets of Florence. It cannot have been vanity with them. Their habit was the peasant dress of the early thirteenth century, and being discalced Franciscans they went with sandall'd feet. But decidedly it is foppishness with the St George of Pisanello. As, also, with the young Plantagenet King. He was no more than thirty-three years old at his death. In France, then, as now, the creator and leader of fashion, would his dress have been approved? For the French are disposed to start something and then regret how far it goes. They launch it, and then decline responsibility. An instance of which is the Rococo of Louis xv which was permitted when it was Madame de Pompadour but bitterly disapproved and termed barbaric by the time it reached to Potsdam, or came to further fruition in palaces and churches in Bavaria, and elsewhere. In like manner the arbiters of Paris may have despised, given such opportunity, the fish-stall and orange-barrow emptied or poured over the King's white satin dress.

It may be, even, that they thought it typical of the Englishman, though he was at least half-French by birth. His mother, the wife of the Black Prince, was Joan, the Fair Maid of Kent; but, as to his other maternal ancestors, his grandmother, wife of Edward III, was Philippa of Hainault (French-speaking at least); his great grand-mother, wife of Edward II, was Isabella of France; and before that Margaret of France, wife of Edward I; Eleanor of Provence, wife of Henry III; Isabella of Angoulême, wife of King John; and Eleanor of Aquitaine, wife of Henry II; while, paternally, the Angevins had their origin in Anjou. He was predominantly French, with only a third dilution of the Saxon in him. Yet, by the reign of Richard II, the Plantagenets had been on the throne of England for more than two centuries (since the accession of Henry II in 1154, and were to reign for another century, three hundred years in all and thirteen kings, till the death of Richard III on the field of Bosworth in 1485), and it is only reasonable to think of them as English, if not from maternal descent quite as much Frenchmen as were the Kings of France; and they will not only have imbibed, but demonstrated and given example to the English character.

It is in this sense that the dress of Richard II with its marine or conchological motifs and prophecy of the fruit-barrow is anticipatory of the costermongers, the 'pearlies' and their 'jonahs' of Lambeth and Bermondsey; and we can see in it the farthingales to come of Queen Elizabeth I, which were embroidered with sea-monsters and spouting whales, the garlanded straw 'boaters' of 'Monarch' and the other 'eights' at Eton on the Fourth of June, and even the sailor on shore with a flower behind his ear. But this is not to deny that the shell fish and citrus fruit dress of Richard II may well have been one of the masterpieces of *opus anglicanum* of the secular kind, and that it would compare to the finest robes of the *Nōh* actors in Japan which can present such fantastic themes as a kimono representing a landlocked harbour embroidered with Dutch three-masted and other sailing ships loaded with over-flowing cargoes of huge flowers; or another with two-wheeled ox-carriages, the court ladies hidden within them trailing their long sleeves out of the cabins which was their way of drawing attention to themselves, and all over the ground of the kimono heavy laden stems of huge lilies, as large or larger than the court carriages.* These robes were the gift of rich nobles who gave their finest dresses to the *Nōh* actors. A similar fate might have preserved the court dresses of Richard II and other masterpieces of English needlework, but alas! there was no theatre and such robes were unsuitable as donations to the priests and monks.

* Cf. *Textiles*, by Tomoyuke Yamanobe, English adaptation by Lyn Katoh, Rutland, Vermont, USA, and Tokyo, 1957, plates 8 and 18, 19.

BOOK TWO

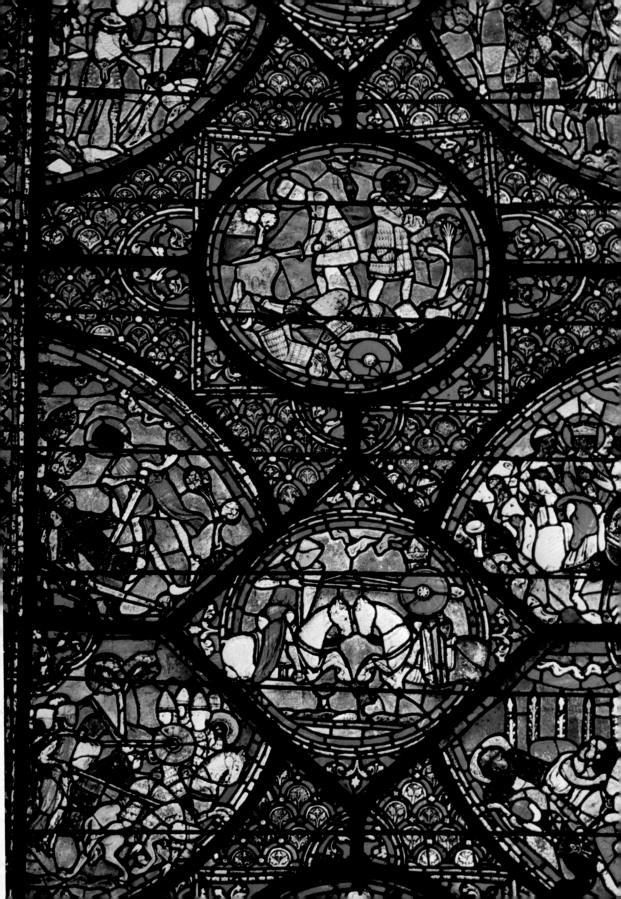

8

Fantasia on the Gothic

Let us suppose ourselves for a few moments of time on a rainy morning or afternoon in Lincoln. It is to be a wet day, raining all day long from the beginning, but with intervals so that one can go out with raincoat and umbrella, walk round the outside of the cathedral, look up at the towers, and then take refuge inside the building. There are strong gusts of wind and the jackdaws that fly out from the towers are soon blown back, wheeling and complaining, into their eyries. Likewise, back into the White Hart, too, when raincoat and umbrella are wringing wet, but out again and on the same round in another half-an-hour for there is nothing else to do. This is the way to see it and live with it, never for too long at a time, and let the extreme and extraordinary nature of the cathedral make its impression on one's mind.

First of all it is its whiteness against the rainy sky, and the black caps of its turrets, and an affinity in time and origin to the White Tower of the Tower of London. They are of the same blood and language, if of a different purpose. Then, the huge scale of the undertaking with the west towers coming up and shielding behind the Romanesque west façade; and something curious about the corner turrets to either end of this west façade, which is that they recall the French pottery jars of childhood shaped like beehives, and which when you lifted off their lids had honey inside them. That association with honeycombs at the corners of its west front, is a thing that clings to the stone like a swarm of bees, that one cannot dismiss from one's mind, and that adds a flowery fragrance to the rainy day. It does not rain here in Lincoln-shire any more than in Holland that is just across the North Sea; and yet the wonder of Lincoln Cathedral is that it was built, less in sunshine than in rain. There are no buildings on this scale across the Dogger Bank; no Ely, Lincoln, York, or Durham. They are only found on this side of the North Sea, along our east coast. The incon-ceivable energy they display is what is interesting about them, and that it was a display of strength inseparable from those other qualities that make a great work of art.

Of course there is summer in Lincolnshire and the occasional heat-wave but the cathedral on the steep hill is of wintry architecture. There are enough water-colours

of harvest time by Peter deWint to know that this county, that was once so rich in monasteries, had its spells of hot weather but, also, there are the wolds and fens. Ague, and kindred complaints due to cold and damp, were more common than death from heat stroke. The district known as Holland was even navigable fen in the Middle Ages; near-malarial conditions prevailed over large areas down to the last century; and the fens were as quick to be frozen over as the Dutch canals. The wolds where the huge herds of sheep grazed were no less cold and draughty, and not less treacherous if it suddenly warmed to summer. The climatic conditions were difficult and not propitious to great building, it being of no avail to compare them in this respect to those prevalent in Normandy, in Anjou, or the Île de France. Conditions were not impossible; there may even have been a stimulus and a keen edge in their hardness. But they cannot have been easy; and it was in this that lay both the challenge and the opportunity.

It could be argued that fine architecture is only suited to the rigours of either heat or cold. There is little good building in lands of eternal spring. Art does not follow climate but exists despite of it. That is why it is found in unsuitable places and in unsuited families. It can come unexpectedly and without warning so that we do not know where to look for it. Lincoln Cathedral may in itself come as no surprise because of the huge number of beautiful village churches in every direction, one of them for instance 'at about every mile' along 'The Cliff', 'the steep western face of a long wold range' that leads from Honington to Lincoln. One or two of these, Navenby for instance, are remarkable enough; not that this string of churches is comparable to those further south in the county in that exceedingly unpicturesque part of Lincolnshire, except when the corn is ripe and ready for harvest, lying between Spalding and Boston; or to the even more remarkable line of churches in the other direction, eight of them in the twelve miles between Spalding and Long Sutton; with others again no less beautiful and extraordinary across into Norfolk and ending at King's Lynn.★ These are in excuse, it could be said, but not in full explanation; though it makes it less unnatural that this stone monument worthy in terms of labour alone of the Pharaohs or the Khmer Emperors of Angkor should rise on its hill in the midst of the marshlands and the fens, the very name of the city it is thought being the same derivation with that of London, meaning 'the hill-fort of the pool',

★ The most interesting of the churches on 'The Cliff' between Honington and Lincoln are at Caythorpe, Leadenham, Brant Broughton, Navenby, and Coleby. Between Spalding and Boston the list would run, Algarkirk, Sutterton, and Frampton; and from Spalding it would be Weston, Moulton, Whaplode, Holbeach, Gedney, and Long Sutton; with Terrington St Clement, Tilney All Saints, Walsoken, Walpole St Peter, West Walton, Wiggenhall St German and Wiggenhall St Mary Magdalene in the area lying between Long Sutton, Wisbech, and King's Lynn. These village names may be familiar to natives, but they are given here to encourage foreigners and mere strangers to see these not so very minor wonders of Western Europe. Better than all photographs of these churches are the pencil drawings of F. L. Griggs.

and signifying a time 'when all the part below the hill was a stagnant mere'. These village churches named in the footnote, to which it is a hopeless and perhaps unworthy ambition to drag visitors from abroad because of the inhospitable nature of the locality and the uncertain weather, are extraordinary enough in themselves without the crowning wonder of the cathedral, but anywhere else, except where they are, they would certainly have aroused wonder and world-wide admiration. But so it is, and so they will remain, more of private interest than of public acclamation.

And out into the rain again to look up at the towers. We cannot envisage ant-like masses of workers removing baskets of earth, or carrying hods of stone or mortar. This is not the Orient where buildings go up behind lattices of bamboo or screens of matting, and armies of men and women work indiscriminately as beasts of burden and for tools use little more than their bare hands. Here they worked to careful drawings and only a few men at a time were on the towers, to which the ladders would be firmer and more substantial than those of poles and lianas up which the workers of another skin-colour swarmed with naked feet. Nor did they cook their meals and sleep at the foot of the cathedral but lived in town houses, however humble, built of wood or brick. They were skilled workers organized into guilds and having served long apprenticeship, not conscripted and pressed into service like a gang of slaves. There were master-sculptors and mass relief-carvers on the temples and long corridors of Angkor. At their best they were great artists; at their worst stylized and archaic strip-cartoonists. They have an exhausting and telling montony that no Gothic master-of-the-works would have countenanced or allowed to pass. For above all the Gothic craftsmen were adept at changing or varying the subject, introducing new themes, and were prime inventors and perfectors of the gimmick. The play on words was a mere pastime for them in all their fondness for another meaning or a rebus, games into which they entered with the spirit of the acrostical, double-meaning comic scenes in Shakespeare's plays. No hundred heads of the Buddha, all with the identical, mysterious and benign smile, as at the Bayon of Angkor, for the builders and sculptors of our thirteenth-century cathedrals! Their individuality, their personal identity would not have allowed of this. They could not have sunk their humour into the same mould. Even in their anonymity they were irrepressible. As for example the seated figures of kings – to judge from their crowns – all seated on thrones under canopies just over the Romanesque central porch of Lincoln. They are fourteenth-century figures, all in different attitudes as though seated in the stalls of a chapter house, and it is only surprising that more difference has not been wrought into the stone canopies above their heads.

Or take an isolated figure such as the statue of Queen Margaret* on the outside of the Angel choir, that is to say, at the far corner of Bishop Russell's chantry chapel,

* Probably the French Princess Margaret, second wife of Edward I.

the right-hand one of the two chapels flanking the south or Judgement Porch of Lincoln. One wonders what she is doing there, standing in her niche, no other carved figures near her, at the foot of a buttress above the cresting of the Perpendicular chantry chapel! Standing out there through seven hundred winters, indifferent to sunshine or rain! Her face, which is that of a beautiful woman, is the sculptor's idea of a queen, for it is too early to be a portrait. She holds the hem of her robe in one hand, and our eyes go up the buttress above her to where the rain drips down on her, or, in fact just misses her on this day at least, from a pair of stone gargoyles, which jut out perhaps thirty feet above her head. There they are, those necessary and inevitable, those almost obligatory parts of the baggage train of all Gothic cathedrals, in pairs at the foot of the gabled roof to every buttress all along the south front, and doubtless all round the building, carrying the rainwater in the hollowed troughs of their stone bodies and spurting it down; and behind each gable we see the arc of a flying buttress joining it like a stalk to the shell or vessel of the main building; one could say pressing its foot to keep its balance against the buttress, rather as an acrobat leaning perilously outwards presses the sole of his foot against his mast or pole to keep his balance.

They are gargoyles, but not dramatically arresting gargoyles, being indeed the norm or convention of their disseminated, yet esoteric race. For there is nothing diabolic about Lincoln Cathedral. It is not one of those demonologies with slant or disposition towards their own dark ranks. But neither is it one of those places where fantasy has lifted the ordinary, for after all gargoyles are objects of utility, into the empyrean of birds and angels. In the higher regions of this cathedral there is no flapping of stone wings. It is not like gargoyle-infested, as one could say 'rat-infested' Paris of the Middle Ages, for sign of which one has but to look up at the gargoyles of the Sainte-Chapelle, of giraffe-like prolongation of neck; or is it of purpose to drop their rain upon the crowd? In any case their necks look to be of unnecessary and disproportionate curvature and length as though to provoke attention; and to divert to Paris for a few moments from the Lincoln rain there can be little doubt that Mediaeval Paris was the city and place of origin of both gargoyle and chimaera – in its own time as much so, it could be said, as of the can-can dancer and the Folies-Bergères – the chimaera in its classical prescription, with the front of its body that of a lion, the middle that of a goat, and the hinder parts those of a dragon, being a monster of habitat along the parapets of Notre-Dame.

One fantasy leads to another, and it is probable that the gargoyles which were an embellishment of what was necessary came first, and the chimaeras later. It is they who lean out looking down on Paris, and are part of the strange population up there in the towers. Put there for entertainment of the crowd below, but playing the rôle of the villain in melodrama, or the repulsive brute in bouts of all-in wrestling, both

of whom are as much of a draw and as popular as the hero, but the applause has taken to another form and consists in hissing and booing. Physically, neither gargoyle nor chimaera, or, if we prefer it, hobgoblin, is on the side of the angels but like the skeletons of the Dance of Death they have their purpose. Those, beside the sensual delight, such as it may have been, of dancing to music, are also shown eating and drinking, mocking and tormenting the living, and indulging in other pleasures, so that death is not all deadness with them. They have most, if not all of the activities, of live human beings. It is not too bad for them, and there is some comfort in that. And probably the citizens of Paris, young and old, men and women alike, went to sleep on winter nights of wind and rain wondering more than once in a lifetime how the monsters were faring along the roof-line of Notre-Dame. Whether they left their posts when all the lights of the city went out and crawled to a dark corner out of the rain or snow? But, also, waking early on a summer morning if they stretched, still with hands or elbows on the parapets and sniffed the morning, in their stone nostrils, breathing out the airs and vapours of the night with, the city being so little across, a message of the green fields upon the morning wind. The hobgoblins and chimaeras have been so long up there, and it is difficult now to know how genuine they are. How much were they restored, or renewed even, in the time of the Middle Ages revived and come to life again with Claude Frollo, Pierre Gringoire the poet, and Quasimodo the bell-ringer, with the towers of Notre-Dame in the distance in the last scene of all?* In the years of Gavarni, Tony Johannot, and the 'cathedral bindings', now dear to bibliophiles? If one climbs the wearying and winding stair to the parapet or gallery of demons, it is true that more than one of them of blackish stone now resembling cement in texture has the claws of his nails suspiciously sharpened. Yet it is a sensation of no small scale of values to look along that parapet from tower to tower and watch the chimaeras looking down, not to keep guard on those below but on the look out for what they can, hyaena-like, jump and pounce on for themselves; or they are just listening for a row to break out somewhere down there in the hope they can join in. Of a certainty prayer and worship have no part in them. They are of evil intent and beasts of prey.

And we have come round the back of Lincoln, past the outside of the Lady Chapel, looking up as we do so at the demon-less, even gargoyle-less central or Broad Tower, to the decagon of the chapter house with its high conical roof and free-standing buttresses, each of them tied in with a flying buttress to the mother-body of the building. It is of curious effect, this pointed-roofed chapter house with high paired windows on each face of it, anchored or tied down as it were to those solid little free-standing, stone-built buttresses. Or it is some kind of stone mother and her

* In the old ballet of *Esmeralda*, by Jules Perrot (1844), based on Victor Hugo's novel, *Notre-Dame de Paris*.

litter, each of them umbilically connected or strung on to the parent? And there is another of the stone beehive buildings high up, near the entrance to the chapter house, and this could be of honeyed import to either or both the stone parent and her offspring. We are not going inside the chapter house, but were we to do so, we would find it has a central pillar and a star vault of some twenty or so radiating ribs which of custom make it like the corolla of a clematis or passion flower.

The interior of Lincoln is of moment for its Angel choir which is of unequalled beauty and in ultra-perfection of the early Gothic, mid-thirteenth-century style. It is not so much the lower as the upper or clerestory which is so beautiful, and of an Oriental moving or marching elaboration towards the high altar, which is Eastern in idea but of which no Oriental architect has been capable. It is masculine in intent and most emphatic and vigorous of effect; a gallery of paired arches, two of them at a time between the larger buttresses from which flow the stone ribs of the ceiling. These paired arches have a central column of clustered pillars of black Purbeck marble; half-quatrefoils of stone to either side of these, and a full quatrefoil above all enclosed in the pointed arch. And it is in or on the spandrels between these arches that are to be seen the angel-musicians that give the Angel choir of Lincoln its name. There are twenty-eight of them, in whose faces and figures Dr Nikolaus Pevsner distinguishes 'more than two hands, but only two masters', to judge by 'round faces and stronger limbs'.[*] There is room, but no more than that, for the angel-musicians in the spandrels between the arches; but those apart it is the wonderful masculine vigour of that arched gallery to both sides of the choir, and the simplicity of the huge trefoils, only, in the spandrels below the clerestory. There is no call for detail in this splendour of attack, though it is to be found in abundance in the stone roof bosses whereon have been identified 'leaves of the English countryside – oak, vine, maple, ranunculus', and according to one authority, 'the yellow waterlily', which carries with it the promise of slow summer afternoons passing with the punt-pole through whole water-meadows of the lilies, when most of Lincolnshire was fen and water and the fens were not always frozen. Below those ceiling bosses the majesty of the Angel choir of Lincoln is unsurpassable, if echoed with brass band orchestration in mid-Victorian town halls of the industrial North and Midlands, but without the yellow waterlilies!

It is possible that Lincoln holds a special place in the affections for the very reason that we have it to ourselves, and it is little heard or spoken of outside the Anglo-Saxon world as though apart and unrelated to the general genius of the human race. If this be so we have only ourselves to blame, for it was an universal flowering or burgeoning, as liable to break into some exceptional blossoming in a village near by,

[*] *Lincolnshire*, in *The Buildings of England*, 1964, pp. 106–8.

at Heckington,* at an 'angel'-ceiling in East Anglia, at a Perpendicular church tower among the buttercup meadows of Somerset, or in a carved and painted altar at a village on the Wolfgangsee. But for the hundreds, or even thousands who come to see the last named in every holiday season, there are perhaps as many dozens who take the trouble to seek out and find these others. But having lately, I speak for myself, come by boat up the Guadalquivir to Seville to be greeted at some miles from the city, the salt-marshs of Las Marismas passed, by the pervading and growing smell of orange-blossom, I cannot wonder at that quest for the yellow waterlily which is at once both a native and an exotic; the climax of the one, a court or cloister of orange-trees leading to the cathedral, and of the other, some memory of summer in a carving almost too high to be seen upon a ceiling.

It may well be that the naturalistic carving of the capitals at the chapter house of Southwell Minster can be taken in negative tribute to our native climate. Islands, 'happy valleys', idyllic lakes, or other places deserving, or not, to be called earthly paradises are assimilated lazily and do not call for the frenzy of examining and of appreciation. The tropics where there is an embarrassment of vegetation are surpassed by a few wild flowers and by the mere leaves of the endemic trees. At places like Southwell, and with Southwell's climate, they were searched for and collected with a botanist's energy and the precise care of a herbalist. He, and all the others, could not be more interested had they been exploring for wild flowers in Fiji or in New Guinea. But a mile from Southwell was all, or nearly all they needed; and at Lincoln, one day perhaps out of a few days' summer holiday, at some village reached by barge-pole or by rowing. The much, then, is less appreciated, as ever, than the little. There is no cathedral or abbey church with the fruits and flowers of the tropics carved upon its capitals; but this is not because it is impossible but for the reason that there was no such occasion. Had it been within the norm of the white-skinned races it would have happened. We have but to remember the entrance gateways to Angkor; 'triple gate-towers below stone faces of Buddha looking in all four directions under their tiaras of stone flowers' – and what one was not prepared for! – 'triple-headed stone elephants, just their heads and trunks coming out of the wall, tusk-less elephants feeding on lotuses and about to lift the stalks and lotus buds into their mouths'. The Gothic sculptors never met with those except as carved ivory chessmen; but neither do we find any equivalent to the prancing horses of Srirangam (*vide* p. 124). The lotus and the elephant which are as often met with as the Greek acanthus have for humble compeer the dog-tooth and the harebell, but they do not lose in the comparison. That which is important is what excites and interests the artist or the sculptor, and it may be the far-fetched or what lies near to hand.

* Cf. *Monks, Nuns and Monasteries*, 1965, pp. 48, 49.

If we try to enter into their minds we discover their quick response to any unusual or odd suggestion. The Gothic 'Trinity Bridge', for instance, at Crowland in Lincolnshire, once with three streams running under it including the Welland! Or their delight in the sharp planes and angles of the cut-waters in many mediaeval bridges including, we may be sure, special consideration to get the maximum of sound from the swirl and rush of the river! Or their pleasure in the conception of a chapel bridge as at Wakefield, much blackened by age and time, but still more damaged by the restorer! There was a St Thomas of Canterbury chapel on Old London Bridge, and chapel bridges, too, at York and Lincoln. Perhaps bridge chapels are a fantasy not exploited to the full in England. In variation upon this scheme are the river bank, indeed the embankment chapels of which an example is the little chapel of Santa Maria della Spina on the Arno bank at Pisa, built 'in the French Gothic style' in 1230 – but to the writer it looks most noticeably Italian – for sailors when about to go to sea. It once held a splinter or fragment of the 'Crown of Thorns', hence its name, and is appropriately prickly of ornament. This little chapel, admired by Ruskin, is much like a little floreated boatshed and may have appeared in this way to its builder.

But it is in France, their land of origin and starting point, that these fantasies most flourish and this is to be expected. Forgotten fantasies of the later Middle Ages like the fountain for the monks' ablutions at Valmagne, near Montpelier for example! This is an octagonal fountain-house in a corner of the cloister. An open arcade surrounds the fountain, and from each angle of its eight sides springs the rib only of a stone arch, the eight of them meeting and then falling together so as to form a cusp or stone drop above the fountain. In fact, it is an openwork canopy of stone above the fountain. Or there is the Perpendicular chapel above the Holywell in Flintshire, another architectural capriccio which would be more famous were it anywhere but just inside Wales. Or, again, there is the unusual, to say the least of it, outside or open chapel called 'La Recevresse' at Avioth, which is near Montmédy; hexagonal in form but supported on four columns and a pair of pillars, with open arches and a stone spire above. It was in this open air chapel, like a huge reliquary or an hour glass, that the priests served mass at an altar, and on the 29 August of each year received offerings from the surrounding villages on St John Baptist's Day. Also, children dead before they were baptized were brought here, and on occasion came to life again. 'La Recevresse', it is true, holds more than a hint in it of the Scott Memorial in Princes Street in Edinburgh, by Kemp the ertswhile shepherd boy, but this is not its fault; nor are those drinking fountains for humans or animals, often of Aberdeen granite, to be blamed on it.* All such are prior in date to the Albert Memorial, so

* One on Parliament Square, and another, not long ago, by the railing of Hyde Park along Bayswater Road.

Opposite: The Goldenes Rössl of Alt-Ötting

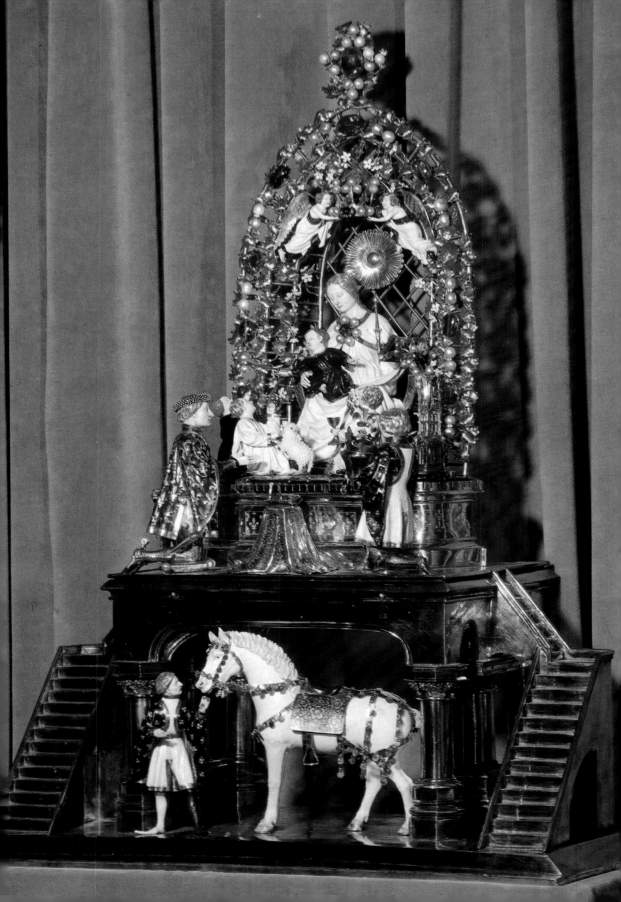

that it was not Sir Gilbert Scott who first conceived the idea of designing a monument in the shape of an enlarged or giant pyx.

But there are the original and far more curious objects of the kind, like the silver and copper reliquary in the form of a town plan of Soissons, the whole standing on a hillock complete with portcullis and entrance gates, with the churches and chapels of the town, and in the midst of them Soissons Cathedral like a hen among her chickens, this building only being partly in silver.* By no means is this object beautiful; but were the life-size golden llamas and their shepherds 'with their slings and crooks to watch them', all of gold, beautiful? or were they but valuable and interesting? The reliquary at Soissons is late in date (1560), but all about it is of the Middle Ages. Much earlier, of the late twelfth or early thirteenth century, is the reliquary in Orléans Cathedral shaped like a four-wheeled covered chariot of 'ancient Celtic type', with three slabs of rock crystal for windows and with a big boot or belly below its body also of rock crystal, to hold the relics. There is a mysterious air about this reliquary designating it as a sacred object, and connecting it in some way to the mysterious four-wheeled open carts or waggons, of unknown but supposedly religious purpose found in the ship-burials in Norway, and to be seen at Oslo.

Again, curious more than beautiful is the 'Resurrection' reliquary from Reims; of gilded and enamelled copper with the silver figure of Christ in red-enamelled robe emerging from his sardonyx coffin, and statuettes of four sleeping men-at-arms on the green-enamelled ground atop a crenellated wall of silver-gilt, of which the eight corner turrets carry each a winged figure of an angel. Beautiful indeed, though, was the *Reliquary of St Ursula* from the treasury of Reims Cathedral. It is a ship or *nef* reliquary – another formed from a nautilus shell on wheels converted into a sailing ship, with a cardinal enthroned on the poop is at Saint-Nicholas-du-Port – but this from Reims is of cornaline made ship-shape, planked as it were with gold with golden anchor dangling, golden deck and superstructure, mast-pole of gold with rolled sail of white enamel high on its rigging, and aboard, a gold and enamel statuette of St Ursula and ten silver and enamel statuettes of her virgin companions, all in their flower-enamelled robes as though on top of a church tower on May Morning.

All such precious objects from the Middle Ages pale, though, when compared to the Goldenes Rössl of Alt-Ötting, a small town in Bavaria. This must be the supreme masterpiece of French enameller's and goldsmith's work; and its name comes from the golden charger or Rössl, the mount of King Charles VI of France, for whom it was made by order of his wife, Isabella of Bavaria. The date of this object is about 1400. It is in two stages with a double stair, the upper storey like an altar, where the Madonna and Child are enthroned before a flowery trellis which has

* The objects described in this, and the following paragraph, were on view in the exhibition of *Les Trésors des Eglises de France*, at the Musée des Arts Décoratifs in Paris, in 1965.

fruited into pearls. Two boy angels and a baby lamb play at her feet; the king in a blue robe sewn with *fleur de lys* kneels before her, while a page kneels at her other side. Below, at the foot of the double stair, the King's white courser waits, ready saddled and bridled in gold, its head held by a groom in a white mantle, blue cloak and red and white hose.

For mere perfection in small objects of beauty nothing could exceed the Swan Brooch found but a year or two ago in the dust of Dunstable, along the Watling Street. It would appear to be not improbable that this brooch was dropped by King Henry VI in person, or, failing that, by one of his courtiers. The brooch is of gold and enamel, and is formed of a swan, not, be it noted, of preternaturally long neck, with ruffled plumage as though by a breeze upon the river bank; a cob swan with a golden chain on its beak to draw the Swan Knight in his skiff, and denoting descent from this legendary hero of the tapestries who was the pride of the House of Burgundy, and many other noble families in most northern Kingdoms, but of particular association with King Henry VI.

From such objects, of poetic as well as intrinsic and historic interest, it is no far remove to rose-windows and the extreme of diversity that could be practised in their design, forming indeed an additional chapter or appendix to a *Rosario d'Arabeschi*. There is the rose-window or rosette above the main doorway of the St Lorenz church at Nuremberg – the church in which is to be seen Adam Kraft's sixty foot high, stone Sacrament House rising nearly to the roof of the building, the top of it bent like a crook or crozier just in time not to touch upon the ceiling – but this 'rose' of pink sandstone is too much in the manner of Strasbourg Cathedral. The units of the window look to be 'twigs' of cast-iron too meticulously assembled, a work of arrangement by 'stick' insects whose life story is to lie still and look like something else. But, as well, it gives the sensation that the outer and the inner wheels might revolve within themselves, and to make it more complicated move in contrary directions. The beauty of a rose-window surely is its stillness, and that it should resemble an undying rose never touched by time. If it revolves, or seems to, it is a wheel-window and not a rose. Of which there are plenty, many of them with a veritable hub in their middle, and some form of pilaster for spokes all round the wheel. The rose-window can be more than forty-two petalled, and nearer to the centifolia, but of course in the extreme examples as at Chartres or Bourges or Reims the rose-simile is far surpassed and left behind, and in nearly every such instance it is the blue glass which is the beauty of the window and brings it into almost mystical relationship and association to the blue rose.

There could be an anthology and an anatomy of rose-windows as there has been in many a book, particularly in the painstaking earlier part of the last century, where the foliage or tracery of every form of window has been patiently drawn and copied

down under label, Geometrical, Reticulated, Flowing, and so forth, but in general it could be said that the rose-window is metropolitan and only to be found in the bigger churches. It is not to be sought for and discovered in village churches however impressive and wonderful the tomb or glorious the wooden ceiling, this said, in particular, of English village churches the like of which is seldom to be seen in any other country – being village churches *per se*, apart from the excuse of some abbey or nunnery for their existence. The ceilings were of local carpentry; the tombs in all probability were sent down from London; but the importance of a window was its stained glass and not its tracery, and for this, if it were at all on a big scale, a furnace and other appurtenances of the glass-painter were most necessary, as, also his living for some weeks or months near by.

Stained glass, then, is seldom if ever of local workmanship. The local or regional churches in, say, East Anglia or Lincolnshire, or in the West of England where again these are exceptional, are of country workmanship achieved by local masters, but probably in circumstances of far deeper awareness and sophistication than we would imagine. A large part of France, perhaps a third of it, being then under the same rule as England, there may have been more information in circulation than we would ever think; and though architects and craftsmen in East Anglia may never have met or even known the names of their compeers in Somerset or Devon they will have heard talk, at first hand of Normandy, Anjou, and Aquitaine.

These minor and country achievements are the chamber music of our architecture, but the grand symphonic abbeys and cathedrals were at the hands of more travelled masters, while in some cases (Canterbury) they were the work of Frenchmen. How many of the monks of Durham, Ely, Worcester, Gloucester, Winchester, Westminster, were of French or Anglo-Norman origin? They were no concourse of untravelled yokels. The Benedictine and Cistercian abbeys whether in towns, or, of purpose, in remote but chosen valleys, were alike in greater or lesser degree international foundations. They will have been inmates who had undertaken pilgrimages to Rome, Jerusalem, or Compostela, and who had observed things on the way. However isolated their activities they were the modernity of their own day which is difficult for us to realize who must think them meditative and behind the time. Indeed they were the catalysts and energizers retiring into themselves to shun the ignorant and unlettered world, and it was their elevation of the spiritual against the material that made these huge buildings a material possibility and an accomplished fact. They are not office buildings or commercial undertakings, but of ulterior and unworldly purpose.

Who could indeed think otherwise in not a hundred but a thousand sites all over Europe? They are in celebration of the mercies of this world while in fear and trembling but, also, in exaltation for the next. And probably a long life seemed

longer in those days. We have to consider the dark nights and the length of the winters. Every town at night was as quiet as the quietest town in Holland – I am thinking of Hoorn, Enkhuizen, and towns in Friesland across the Zuyder Zee, where mediaeval quiet reigns with modern comfort and there is only the insistent carillon to remind or disturb the sleeping. Even in townscapes of seventeenth-century Holland how few persons are in the streets or in the market place! It is only in the skating scenes of Hendrik Avercamp that there is a crowd but, then, it is an ice-carnival or lesser *kermesse*. And to come back to the Gothic world, misnamed – but what other word is there for it? – the grand lords and ladies off the tombs and out of the tapestries we would find strangely innocent. They would be uncomprehending of so much we take for granted without understanding. Mortality was ever present in their minds, and to judge from the number of infant sons and daughters portrayed on their tombs, it was often with good reason. Many effigies of knights in armour lie with a wife on either side and this is due to death in childbed. Infant mortality must have been as bad as it is still on the Altiplano of Peru. The greater the love, the more the danger; and who wants to meet with a second or third, or with the first wife in the next world? Peasants and countryfolk were old at thirty. The wounded in battle had little hope of recovery. All that mattered was the next world, and there was a lengthening, if invisible queue to enter it. Father Ronald Knox expressed all this not long ago when he said that passports must have the right stamp on them or none would be admitted, a point of view that shortens the life-line and typically enough only hauls on board those persons who agree with him. But the churchmen of the Middle Ages were as uncompromising. There was no latitude in entering into heaven. They held the keys and the necessary documents and the only entry was with their connivance. Hence the acclamation and the enthusiasm.

They had the twelfth to the early fifteenth century to themselves with little, if any dissent or protest. But there is this one great difference between the two great religions of the Middle Ages, between the Christians and the Moslems, that the latter wanted his co-religionist, whatever his language, to feel at home in mosque and *medersa* and in khan and caravanserai whether in Fez or Cairo, in Damascus, Meshed, or Samarkand. To this extent it was a universal brotherhood of believers, if split in one portion of the Moslem world into Sunnites and Shiites, whereas the many monarchies and princedoms of the occident allowed of much greater diversity of status and condition. To this were added the inconceivable energies of the Benedictine and Cistercian monks, normal human beings who had denied themselves one of the attributes of the living in order to devote their lives to transition into the world to come. It would be hardly an exaggeration to say that as much went into this as into the activities of the Spanish Conquistadors and their settling of Central and South America, though with far different motives. It was an explosion of energy equal to,

or greater than that displayed in the Crusades. The Cistercian style in building was one apart and to themselves, so that there is a similarity in their abbeys whether in France or England, in Italy or Spain. The hives of the honey bees were all alike in proportion and in disposition, although this in but a fragment and a small percentage of the whole.

Of which the total in England alone, or in France, or Spain, is enough in itself to form the study of many lifetimes. Only in the two or three local regions of England where there was great building activity in the Middle Ages, in those districts alone and apart from each other, there is enough and more than enough, and it is impossible not to feel sympathy with one authority on the church towers of Somerset, who had spent twenty years of his life in studying and admiring them, and cannot hide his resentment at a new arrival who falls in love with them and begins to write of them. But if it is presumptuous to try to describe them from a single, or even a repeated sighting, we must remember the dramatic critic or the music critic who has to write of a performance within minutes of the curtain coming down. To have known them beforehand from photography could be the equivalent to having read the score, except that the number of competent score-readers is minimal and that good photographs yield up their secrets at the first glance. Such must be the excuse for any writer adventuring into this field where earlier arrivals have pitched their tents these many years.

In the condition of nervous and spiritual energy necessary to creation, fashions in taste changed quickly and many a mediaeval artist was outdistanced in his lifetime. In the more intriguing bypaths of Gothic for an instance, is it possible to conceive of a work of art stranger or more backward-looking than the wooden group of *St George and the Dragon* (1498) in the Storkyrka at Stockholm, by the Lübeck sculptor Bernt Notke? This dates from more than twenty years after the death of Donatello (1466) and from six years after the discovery of the New World in 1492. It seems hardly possible that it is not a century earlier in date, so charged is it with the runes and *kraken* of the North in the very spikes and convolutions of the serpents' tail, and yet this sculpture is the product of Lübeck, a mercantile city in the forefront of its time, while the wooden group could be some kind of historical 'left over' from the serpent or dragon-haunted 'stave' churches of Norway. Such a sculpture would be unimaginable in a Perpendicular church in England, where such unnecessary superfetation in the way of workmanship as the eighteen foot high, wooden font-cover of Ufford in Suffolk, articulated so that its three tiers or storeys slide over and into one another like the parts of a telescope, appears now and always in perfection of its own or any other time, at the height that is to say of its own contemporary taste, but as 'modern' as a masterpiece of Swiss watchmaking. Yet Bernt Notke, in this and other sculptures of the same mood, lives and exists in a little nimbus and

vacuum of his own in company with Alessio Baldovinetti, Cosimo Tura, Ercole de Roberti, Sassetta, Caspar David Friedrich, and others, all different, but all with attributes that make them the same.

How they saw their own buildings is a question never asked, let alone answered. In Provence, even in Germany (Trier), and at Tarragona, Segovia, Merida in Spain, there was sufficient classical building above ground to show the Roman hand in architecture, and give an inkling of what was in truth anything but a golden age. Yet human naïveté, always surprised that others have had the same thought before them, has to express astonishment at being forestalled. The Romanesque grew imperceptibly into the Gothic, probably at intimation of the pointed arches of the Fatimids or the Saracens, and the whole stress of building altered to allow among other things of greater height. A 'skyscraper' like the cathedral of Beauvais, with its roof which has to be upheld by triple rows of flying buttresses, the ceiling of the choir being more than a hundred and fifty feet above the street level, and a tower above that five hundred feet high which collapsed – and no wonder! – within a century of its building, this herculean lifting and holding of masonry into the air, but so attenuated for the purpose that it is little more than a thin stone screen with high windows pierced into it to make it lighter still, is single-minded or obsessed to the point of fanaticism, and after its own fashion speaks more of the Orient than of Rome. There is no emulation of the Romans in the cathedral of Notre-Dame, or Reims, or Chartres. Of anything they have ever heard of except themselves their nearest, if remote relations are the mosques of Cairo and Damascus. Omit the sculpture which was forbidden to the Moslems and the kinship becomes more apparent. When the English developed of their own into the Perpendicular which is our national style, and the fantasy of fan vaulting was evolved, it was not given the compliment of being copied either in France or in The Netherlands, our nearest neighbours, and one could hazard that its greatest admirers would have been the Alhambra dwellers, and those with eyes used to the stalactite ceilings and minarets of the Mamelukes.

So a huge theme unfolds itself, and springs forth from a wet walk on a windy day in Lincoln, round the cathedral and back, and out again when it has stopped raining. It could be that its wonders are the more extraordinary against a grey sky and out of the sunlight. But, also, it can be seen in snow which is an element unknown to the hewers of the Kailasa of Ellora, most wonderful of Indian temples, carved or hewn down into a hill from above. As, also, to the builders of Angkor, obsessed, as those were, with the seven-headed cobra or naga, and familiar with the lotus and the elephant. The cathedrals, even when they have cloisters or courts of orange-trees, are buildings of the north, not of the tropics. They have been built in the cold, not the heat. This, I think we should remember, even below the spires of Burgos in Old Castile where it can be burning at high summer. But the horizon is heavy with towers

which crowd in from whatever distance in all directions. The chimaeras and demons of Notre-Dame are at their posts with hands or elbows on the parapet looking down over the city.* And what more? Twice in my life I have heard the *hejnat* – the fanfare from the high tower, blown at every hour in the four cardinal directions, and stopping in the middle where the Tartar arrow killed the trumpeter – in Cracow where Dr Faustus studied in the schools of magic.

* The date of the goblins and chimaeras of Notre-Dame has often been a matter of conjecture, and in default of direct evidence it may have been thought that their origin was of the time of Meryon, Viollet-le-Duc or Victor Hugo. It is now stated unequivocally (by Audrey Davis in *The Times* for 17 December 1968) that they were sketched by Viollet-le-Duc in his atelier and carved by the sculptor Geoffrey Dechaume and his assistants. They were in place in the 1850s and appear in Meryon's etching of *Le Petit Pont*. They must, thus, be counted a triumph of the sham Gothic style. The earlier set of chimaeras was removed and destroyed before 1750 as being too barbarous and ugly.

The same problem arises as to whether the scrambling figures of 's Hertogenbosch (see p. 126) were in place in the lifetime of Hieronymus Bosch. They would seem to date from early in the sixteenth century and doubtless their ranks were filled up and completed in the 'thorough restoration' of 1860. At the same time, as Hieronymus Bosch is supposed to have designed the stained-glass windows in the church, which were blown out during the siege by the Spaniards, it can safely be supposed that the buttress figures had at least been begun during his lifetime.

9

German Gothic

Just one more cathedral in this autumn of 1967, 'a pure example of the Gothic style', and would it 'display at the same time the utmost richness of decoration consistent with elegance and propriety'? That was the painful question, to someone who may say without boasting that he has gone through the doors of more cathedrals than most other persons. These unwieldy and conglomerate buildings can be of the sort that you would not willingly enter once in a year if you lived in the town a lifetime. That, in short, you are intent on forgetting; while, again, there are those others you are conscious of all the time, but do not want to hear of or look at in too much detail. Some, you appreciate from the moment you set eyes on them, and never tire of; others dawn on you at last just when they should be growing stale. All of which presupposes a degree of interest in the subject; and the acceptance that in their number will be found the greatest, both pure and composite works of art in the occidental world.

By which time we are in the cathedral square beside what must be the bishop's palace with pretty ironwork balconies, and the bishop's mitre prominently displayed on the façade. Some sort of fair is in progress; a lottery is being held on the steps of a public fountain of which the jets are running with wine for the occasion, and the tickets are being sold by young girls wearing black and green dresses and Alsatian-looking black satin hats. The cathedral is the Münster of Freiburg-im-Breisgau, 'almost the only large Gothic church in Germany which is finished'; or, again, 'the only masterpiece of Gothic architecture of any size in Germany to be wholly completed in the Middle Ages'; Freiburg being, in fact, at the southern end of the Black Forest, and near to Basle in Switzerland. How curious to discover that for over five hundred years, from 1368 to 1805, the whole of Breisgau was one of the hereditary dominions of the Habsburgs and a part of Austria; though it is true that a Spanish Carlist I knew who was brought up at Frohsdorf told me his grandfather remembered seeing the white coats of the Austrian soldiers on the banks of the Rhine just in front of Strasbourg.

Freiburg cathedral is of dark red sandstone, of that red which must remind readers

German Gothic

Figure of St George from the altar by Michael Pacher, 1471–8, at St Wolfgang in Austria

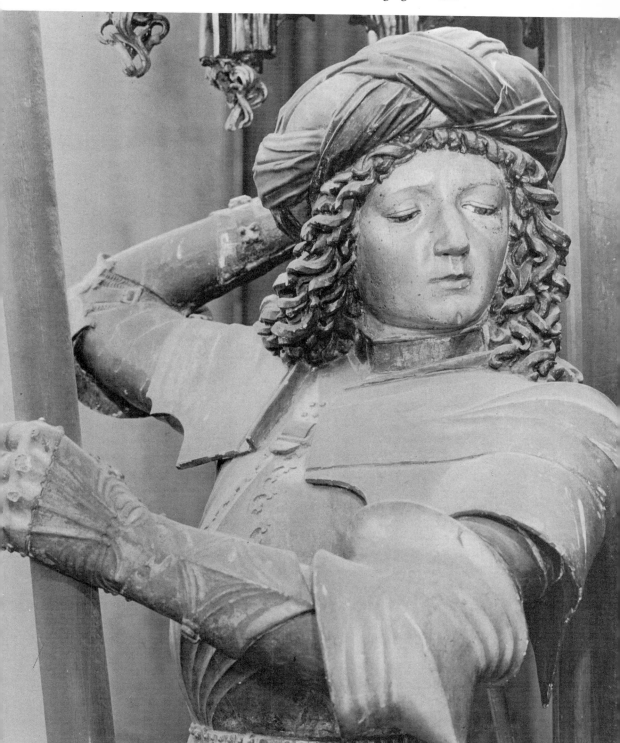

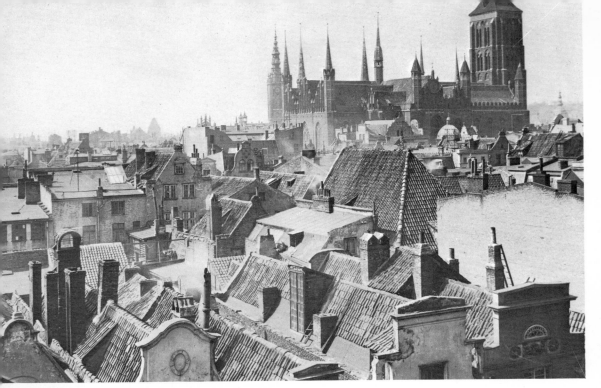

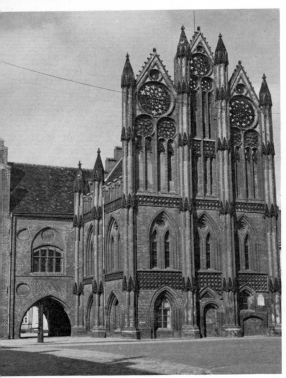

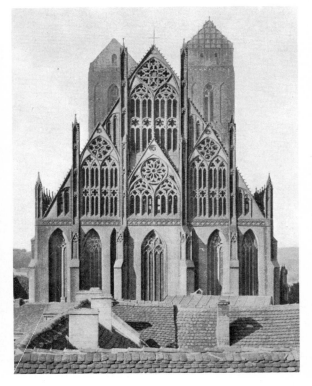

Top Gothic Marienkirche at Danzig, in brick
Bottom left Town Hall at Tangermünde, with openwork filigree rosettes in the tall brickwork gables
Bottom right Marienkirche at Prenzlau, Pomerania
Opposite Pointed gables with openwork brick rosettes at the Katharinenkirche, Brandenburg, probably by the same hand as the Town Hall at Tangermünde

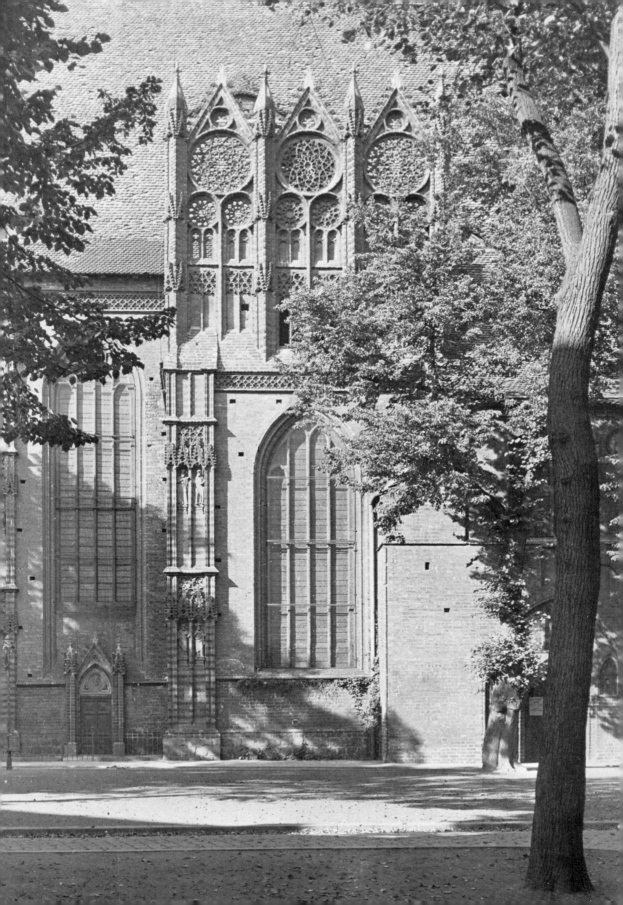

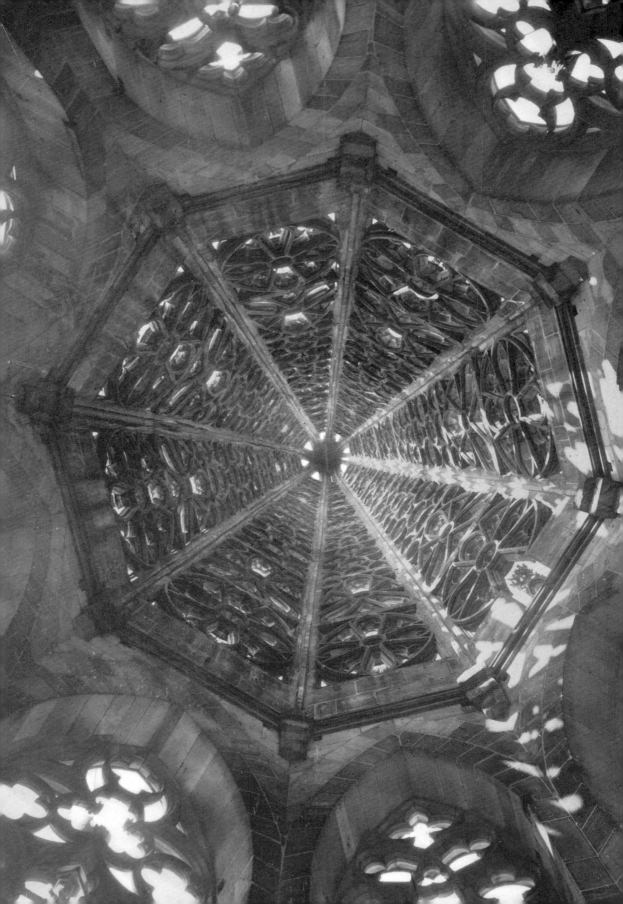

The spiky openwork spire
and lesser lantern of
Freiburg Münster

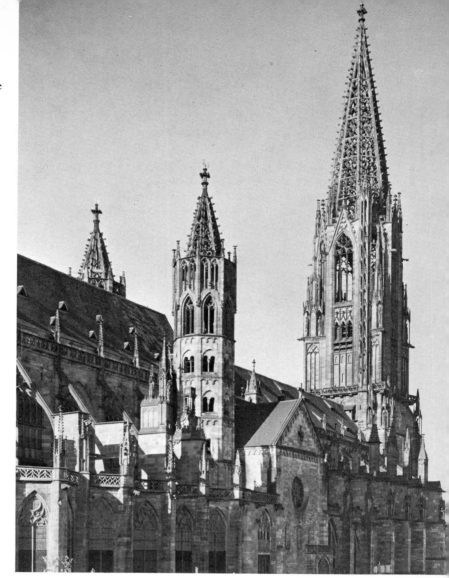

Elaborate window tracery
and blind arcading on the
south side of St Catherine's,
Oppenheim

Opposite Interior of the
openwork spire at
Freiburg Münster

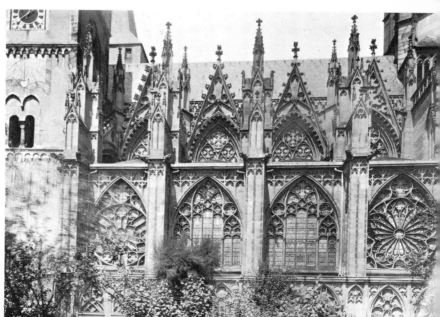

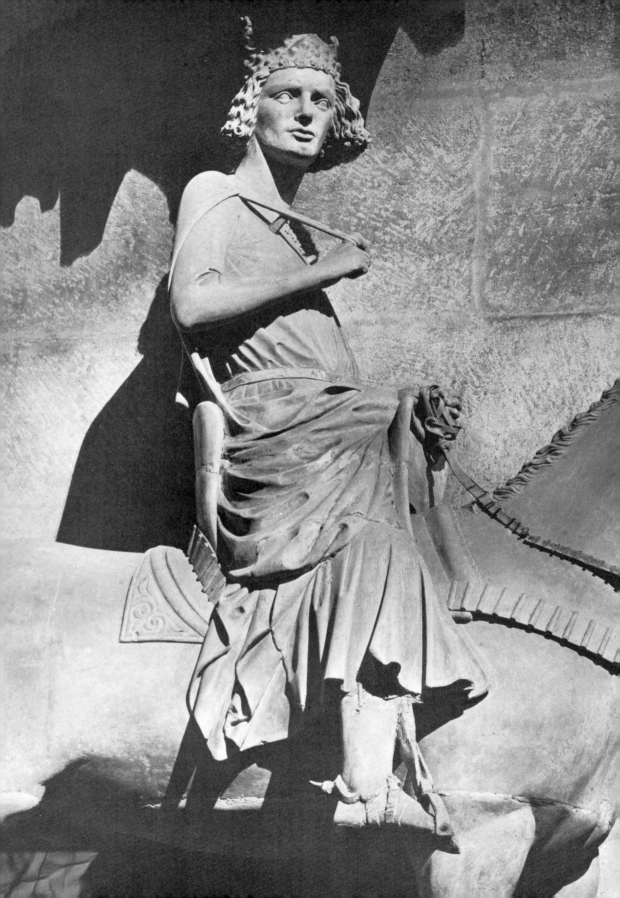

Above Effigy of Conrad of Schaumberg, who died in 1499 on his way back from the Holy Land, by Tilman Riemenschneider, in the Marienkirche at Würzburg
Top left Riemenschneider's carving of Empress Kunigunde, in Bamberg Cathedral
Left Detail from the Christmas Altar, carved in limewood by Veit Stoss, 1523, in Bamberg Cathedral

Opposite The Bamberg Rider

of my generation, and younger, of the dark red engines of the Midland Railway running from St Pancras, and of railway cuttings in the North-Midlands which are in ironstone districts. The cathedral which is spectacularly all of one piece, with the exception of some Renaissance carvings on its porch, is preternaturally spiky of exterior, a feature rendered more conspicuous still by its openwork spire and lesser lantern and which it is easy enough to identify as work of one of the Parler family of architects of origin from Cologne, or from Schwäbisch-Gmünd. One or more members of the same family built the nave of the cathedral at Prague and, also, the Karl Bridge in the same city; the radiating chapels of the former and the maze or web of flying buttresses and proliferation of pointed shapes being strongly indicative of a family style. So is it in Freiburg Münster; where the Parler 'masterpiece' is the tower, beginning with a square red sandstone base which becomes in its turn an octagon, 'and is surmounted by a pyramidal spire of the most exquisite openwork tracery, all of stone, of extreme boldness as well as lightness', part of the conjuring trick being that, 'when viewed cornerwise, the entire tower (380 ft high) has the appearance of an uninterrupted pyramid'. But how beautiful in fact is it? The octagonal chamber with its high window, is fine enough, it being difficult perhaps to make an octagon dull, once its mere shape is achieved, but the openwork spire could as well be, not 'all of stone', but cast in rusty iron.

The same strictness of form and material apply to the cathedral of Strasbourg which is only a few miles away across the Rhine. Undeniably it is among the moments of architectural experience when one turns the corner into the narrow Rue Mercière with its postcard stalls and magpie houses and sees the huge west front of Strasbourg Cathedral filling the street and towering above the house-roofs; and another great storey rises above that, and then the one gigantic tower. One does not know whether to be pleased or sorry there is but the one tower. But all of this worked breastplate of a church front is of red sandstone again; and mindful of our criticism of Freiburg Münster but a paragraph ago it is interesting to read one authority's opinion of 'the gigantic mass, over the solid part of which is thrown a netting of detached arcades and pillars which, notwithstanding their delicacy, from the hardness and excellent preservation of the stone, are so true and sharp as to look like a veil of the finest cast-iron'. It contains a circular rose-window 48 feet in diameter, and rises to the height of 230 feet i.e. higher than the towers of York Minster. It is that simile of 'cast-iron' which I thought of for myself and applied to Freiburg Münster, and now find to have been made use of by another writer in describing Strasbourg Cathedral well over a hundred years ago. Here, again, as at Freiburg, the tower is octagonal, with staircase turrets at the four corners, but it is a most elaborate and overworked octagon, and the spire above that which resembles a tapering tower built of units of iron rods set upright and on end, and rising to the giddy height of 465 feet, is so

89

Opposite: *Angelic Salutation* by Veit Stoss in the Lorenzkirche, Nuremberg

nearly ugly as to be unpleasant. The west front 'looks as though it were placed behind a rich open screen, or in a case of woven stone ... with a sacrifice of distinctness from the multiplicity and intersection of the lines', as another writer describes it. Does it, then, really 'excel in the splendour of its sculpture the other churches, not merely of Germany, but of the rest of Europe'? Too many of the statues were destroyed at the Revolution to form any decided opinion as to their merit compared to those at Chartres or Reims; and the ascription of the west front, but not the tower, to Master Erwin of Steinbach gives to the architect a justified importance over what must have been a whole studio of stone sculptors.

Nevertheless, there remains that memory of the pink sandstone mass of Strasbourg Cathedral dwarfing the street in front of it, that, and little more than that, which is but a low criterion to apply to works of art. That it is a gigantic manifestation of purpose and intent is not to be denied, if it may seem to pertain, now, more to the shapelessness, yet genius, of *Les Contes Drôlatiques*, or to the world of Claude Frollo, the poet Gringoire, Esmeralda, and Quasimodo the bell-ringer of Notre-Dame* – in short, to the Romantic Age of the eighteen-thirties rather than to the fourteenth century that was witness to its protracted birth. It is Teutonic, certainly, and not Gallic of nationality; belonging from the point of view of the Romantics to 'a Germany made up of an agglomerate of little kingdoms and autonomous duchies, bristling with battlemented castles, and preserving even in the Gothic character of its handwriting, the imprint of those Middle Ages which had vanished for ever in spite of the efforts of our poets to restore them and keep them living'. This was the time, and later, to the generation of the present writer's father, when Nuremberg was the most romantic city in Europe after Venice, a view which, even if the *Meistersinger* and the Nuremberg trials are forgotten, it is difficult to reconcile with a visit to its churches. Neither that curious object *The Angelic Salutation*, by the famous Veit Stoss, a wooden carving of the Annunciation, surrounded by a garland or wreath of roses and hung from the ceiling of the St Lorenzkirche; nor the Sacrament House of Adam Kraft in the same church, a Gothic tower of limestone resting on lifesize kneeling figures of the sculptor and his two apprentices, enriched all the way with statues and little carved figures, rising sixty-five feet, nearly to the roof, and the top of it bent like a crozier; still less the Shrine of St Sebald in the church of that name, by Peter Vischer the bronze-founder, justify the encomiums once lavished on them. It is true there were criticisms of Adam Kraft's Sacrament House (for the sacramental wafer), which was accused of 'a minuteness more commonly bestowed on ivory than on stone', while, 'some indeed, have doubted whether it really is stone, supposing it to be of plaster moulded, which however is clearly ascertained not to be the

* *Les Contes Drôlatiques* of Balzac: *Notre-Dame de Paris* of Victor Hugo. The passage quoted below is from the *Portraits et Souvenirs* of Saint-Saëns.

case'. Not any one of the Nuremberg masters, Adam Kraft, Peter Vischer, nor Veit Stoss, even when the latter is relieved of his German nationality, has become a Pole under the name of Wit Stwosz, and is at work on the *retablo* of Notre-Dame of Cracow, is congenial to the writer's taste. With Albrecht Dürer it is another matter; and it was Dürer and the Teutonic heraldry that were the magnet attracting the writer's father to Nuremberg which he first saw in 1874 when he was fourteen, and it may have been a mediaeval city indeed.

How often in the old churches the most beautiful objects are the hatchments of the patrician families! They form a study to themselves; and I have wondered if there is not some work of any date on German heraldry devoted to them. A painter of minor talent could find less inspiring work than that of recording these romantic, armorial relics of the past. There are these painted hatchments in how many churches; from those of the Baltic barons in the churches of Revel (now Tallinn), in Esthonia, along the flat Baltic shore to the Marienkirche in Danzig where they should be found in quantity; further west to Lübeck, where I have seen and admired them in the wonderful old Marienkirche★ and in the cathedral; and in how many Hanseatic or other Baltic cities with their own style and development of brick building; inland, at the Katharinenkirche of Brandenburg, with its four pointed gables, openwork filigree rosettes, and bands of dark green and red tiles, the whole a little reminiscent of a folding fire-screen; at the Rathaus at Tangermünde, probably by the same hand; at the Marienkirche at Prenzlau, and other churches at Stendal in this local and peculiar brick style. When I visited the, admittedly badly damaged, cathedral of Frankfurt in this present summer (1967) the armorial bearings were the best things in the church. With their bright colours and gilding, and mysterious components, they are of about the aesthetic value of the Japanese *surimono* woodcuts of still-lives by Hokusai and his followers. Their quantity is enormous, covering two or more centuries; and it is of interest who made these objects which required a high degree of heraldic knowledge and skilled drawing. Two places, in particular, to look for them are in the Chapter House of the Order of the Red Eagle at Bayreuth (where they are late in date); and at Ansbach in the church of St Gumbertus, where was the *Schwanen-ritterkapelle* or chapel of the Knights of the Swan with all their hatchments. What, we may wonder, is the significance of the pair of horns often to be noticed above a helm, and reminiscent both of the helms of Vikings and of the feudal warriors of Japan in their lacquered, lobster-armour? These, and many other mysteries could be studied in so many churches now in East Prussia; in the many churches of Cologne

★ Cf. 'The Organ of Buxtehude', in *Dance of the Quick and the Dead*, 1936, pp. 267–9. A place in which to study the German armorial hatchment in export, so to speak, is in the chapel of the 'German Nation' in the church of San Domenico at Siena. It has many tombstones and coats-of-arms of German students at the University.

where the hatchments must have hung in their hundreds; all over Germany; and as far afield as the 'Black Church' of Brasov in Transylvania and the Saxon church of Hermannstadt, now called Sibiu.

Perhaps the Gothic of Germany is to be seen at its best or worst at Rothenburg ob der Tauber. The dark mediaevalism of this town, and the sensation that the torture-chamber must be just round the corner, combine to throw their accent on everything that is unpleasant in the Middle Ages. The St Jakobskirche, this time of greyish-yellow Keuper sandstone, with its altar of the Holy Blood by Tilman Riemen-schneider, does not lighten this impression; any more than does another altar by this wood sculptor at the Herrgottskirche of Creglingen, a few miles away from the town. What a contrast is Dinkelsbühl, where all is cheerful with the magpie houses along two cross streets meeting in the middle, with the window-boxes of zinnias and glass witchballs, and there is the beautiful view of the backs of the black and white houses of the town. How delightful is the St Georgskirche of Dinkelsbühl, of hall-church pattern with the silver clasps and hinges to its doors! But it has to be accepted that the small German market town is among the fascinations of the world. The French villages and little towns by contrast seem empty of inhabitants except for old women dressed in black, and where there is anything that interests, nothing more seems to have happened since 1500.* It would be difficult to exaggerate the pre-war wonders of Lübeck and Bremen in the way of timbered houses – more especially the latter – while from Hildesheim and Halberstadt, from Goslar and Wernigerode in the Harz Mountains, down to wonderful old Bamberg, to towns like Nörd-lingen, like Landshut, down to the painted villages in the fir-woods and gentian'd meadows under the Bavarian Alps. Among these fascinations it is possible to be dis-tracted from their recent past.

If the most beautiful works of the Middle Ages in Germany are the sculptures at Bamberg, with the main portal and with the famous equestrian statue of St George outside the Cathedral† – and at Naumburg which I have not seen – then the Katharinenkirche at Oppenheim, which is on the Rhine below Mainz, is that spiky art at its worst if under influence from Strasbourg. Accounts of it hallowed by age, and dating from the time when such buildings were especially admired, describe its 'utmost richness of decoration consistent with elegance and refinement', and lead on the imagination to think of what it might have been had those limits been exceeded. But the sun which ripens the vines of the Rhineland would not have inspired an equivalent to the sculptures of the Black Pagoda and of Khajuraho. Yet the effect is

* Avignon would seem to be an exception; chapels of the Penitents-Gris, Penitents-Blancs, Penitents-Noirs, and churches with paintings by Mignard, Parrocel and other local masters. But Avignon was Papal property from the beginning of the fourteenth century until the French Revolution.

† Variously described as St George, or as King Conrad III. It is an armoured knight on horseback.

odd enough. Two windows apart, on its lower or ground floor there are a pair of 'wheel-windows' with elaborate tracery, 'boxed' within a pointed arch, giving the effect that with the pointed gables above, the whole church is some form of a caravan or decorated waggon which can move, if only the pointed wheel-covers slot back into place and let the wheels tread ground.

IO

French Gothic

Nothing could be more typical of its age than that both Notre-Dame de Paris and the Sainte-Chapelle should be situated on the Île de la Cité in the middle of Paris. With that again as the heart or kernel of the Île de France, and the two buildings in question embodying in themselves so much of the national character and genius. The exterior of Notre-Dame is as typically, as irrevocably French as a French railway engine, but this is of course until the impersonal introduction of the diesel engine when even trains lost their character and nationality. The idiom and idiosyncrasy of the outside of Notre-Dame is in the flying buttresses, and it is ever an experience to walk round the sides and back of Notre-Dame in order to look at them.

The flying buttresses are in every sense the stresses of the building: there, of necessity, and as implicit to the whole as sails to a sailing ship. Or they are more nearly equivalent to the tie-ropes that prevent the whole vessel of stone from heeling over, as, indeed, could happen in a heavy gale. Soon it is apparent that the nave of Notre-Dame could not stand up without them. Yet they come out of the walls, thicken in their downward descent, and join into free-standing pinnacles or tie-posts that are firmly planted in the ground, and now seem to us for a moment like the claws, whiskers, antennae, of some crustacean animal coming towards us slowly, purposefully, but with unco-ordinated walk along the seabed.

Have they, as well, an ornamental purpose? Are they like the curlers in a woman's hair? – which make the best of necessity when they are in position and leave things the better when they are removed away. But the flying buttresses are no temporary measure. They are not there to be taken down at an appointed time. And it is not the flying buttresses that are in danger, unless the building they are propping up collapses on them. It would fall in on itself while they stand out of the way. At Notre-Dame the flying buttresses are solid like stalks or limbs of stone. At Amiens, which may be a few years later in date, they have arches of varying size with little trefoil heads worked into them so that they resemble one side only, over and over again, of a Gothic Bridge of Sighs. And what will happen at Notre-Dame when the tie-ropes are cut and the stone vessel runs down the slip-way and is launched with a big

splash? It suddenly becomes clear to our eyes that the flying buttresses of Notre-Dame are absurd as well as necessary; that they are in some degree a confession of failure, of undertaking a building that they lacked the skill to make stand of its own strength and had perforce to leave the stays and the scaffolding permanently in place. That the flying buttresses are the props or crutches, not the wings and crest. But not for anything would one have them otherwise or not be there.

The front of Notre-Dame I find less inspiring, for most of the great iconographical schemes of sculpture on its three portals were seriously damaged during the Revolution. The iron-work of the doors is better preserved than the stone carvings, while the gallery of the Kings of Israel and Judah, mythical ancestors of the Kings of France, are nineteenth-century replacements and proclaim that at the first glance. For the lover of rose-windows like the present writer, there is a simple and beautiful specimen of its kind above them. But it is above the gallery that forms the third storey of the façade of Notre-Dame, at the base of its two towers, that there runs the balustrade or parapet on which are perched the strange beasts and birds, the hobgoblins and chimaeras that lean out, looking down over Paris:

> 'Fourmillante cité, cité pleine de rêves,
> Où le spectre, en plein jour, raccroche le passant'

There is perhaps nothing else quite so strange as these stone witnesses of whom the true purpose and meaning are difficult to explain. It is the apotheosis, the parnassus of the gargoyle; but as though in awareness of some of the horrors it would hear and see, from the Massacre of St Bartholomew to the *supplices* of Ravaillac and then of Damiens in front of the Hôtel de Ville; and to the sound of the great tocsin ringing out over the city during the Terror. In the long history of Paris there has been more darkness than light, and it is many other things beside *La Ville Lumière*.

The Sainte-Chapelle, itself shaped like a reliquary, could have had existence nowhere but in France. But we have to imagine for ourselves how beautiful it must have been! Even the tell-tale steeple of the Saint-Chapelle is a restoration. We can see the gracefulness of the open hall or porch leading into the upper chapel, with the rose-window over it which is full blown, as rosarians would have it, because late in date (1495). The wonderful lightness and airiness of the exterior with its elegant, thin height and only four bays in length are the feature of the Sainte-Chapelle which was, so to speak, made for its glass windows. But the troubles of the Revolution and the good intentions of Viollet-le-Duc have left little of this shrine built by St Louis in only five years (1242–7) for the Crown of Thorns bought, at a price, from Jean de Brienne, the Frankish Emperor of Constantinople. The fifteen windows in particular have suffered, with glass of the Second Empire inserted into their leads, while the polychrome painting of the walls and ceiling are only too correctly 'in harmony

with the coloured windows'. The Sainte-Chapelle is beautiful in idea and in execution, but not in what has been made of it by the restorer's hand which, in its equivalent, is as though an exquisite painting by Fra Angelico had survived into our time as a Victorian oleograph.

It is difficult to give to Amiens Cathedral the attention that it deserves. First of all owing to that contradiction in nature which renders the north of many countries more northern of condition and appearance than the south of the country lying to the immediate north of it, e.g. Picardy seems more northern than Kent or Sussex, the north of Germany than Denmark, or, and this is a typical example, Northumberland than Berwickshire. Amiens, according to this rule, is more northern than, say, Canterbury. Secondly, because Amiens is essentially a place of passage, and for English people a town to be rushed through, or, if possible by-passed, on the way south or hurrying home. Thirdly, to persons of the older generation, Amiens is stained irretrievably from the First World War. In the time of Ruskin it may have been different. His favourite mode of travel was by diligence. How many weeks and months did he stand writing and making drawings for *The Bible of Amiens*? Now the cathedral lies like some wrecked and abandoned engine of gigantic size. It is black and dripping in the rain; or I have seen it black and sweltering on an August evening after the open prairie of Picardy with its overtones of Flanders. It is not easy to appreciate the Bible-Lesson of Amiens in these conditions. The involved chronological scheme of its triple porches, and were they formerly painted and gilded? Are we, then, to think of the porches of Amiens in the vein of Voroneṭ and Suceava, of the painted churches of the Bucovina?* Was it only the sculptures of the three doorways that were painted; or the other sculptures, as well, and the spokes or petal edges of the rose-windows – one of them over the doors above the gallery of the Kings, twenty-two Kings of Judah, ancestors of the Virgin, or mythical Kings of France, and under the *Galerie des Sonneures* at the foot of the two towers (towers which were to have had spires upon them) – and the fiery or flaming rose-windows, or wheels of fortunes, of the transepts? There are beautiful sculptures, still, if difficult to find; for instance the smiling and coifed Virgin, outside the south transept door. If you can get far enough away from it, there is something both touching and that leaves a deep impression, in the three tiers of niches, each, or most of them, with its statue, all of them standing in a screen almost like a folding screen of stone with pointed, lace-like finials to either side of the great rose-window. In the interior which can be dark indeed, and in which the writer was once nearly left locked up for the night, there are the choir stalls one hundred and ten in number, from the incumbents of which, antiphonal effects of 'Ninevean' size, to quote a favourite phrase of Berlioz, could have been, and were certainly not, achieved.

* Cf. my *Roumanian Journey*, 1938, pp. 93–6.

Opposite: Chartres Cathedral painted by Camille Corot

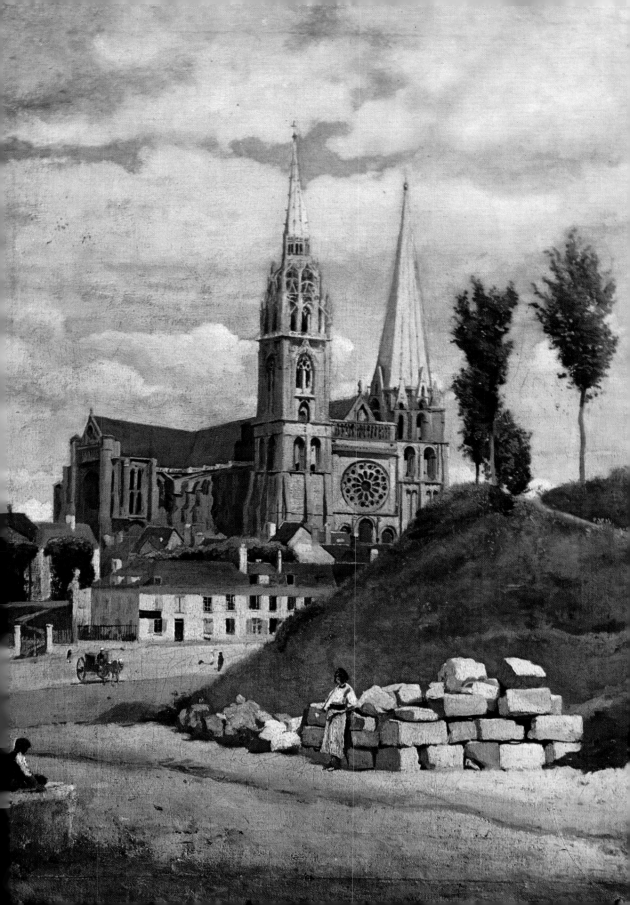

Rouen Cathedral, as I remember it, was more beautiful but, again, rained upon, blackened, and having a bad time of it generally. The hideous iron spire, nearly five hundred feet high, is an unforgivable error of 1822, and throws the mediaeval Tour de Beurre quite out of scale. There are triple portals again, which by the middle of the thirteenth century had become *de rigueur*, and rose-windows in the nave and transepts. The interior has monuments, and fine ones – that of Cardinal d'Amboise, minister of Louis XII, and of his nephew – but it lacks the Jacobean four-poster tombs and later wall-tablets of English cathedrals, and the glorious bric-à-brac of the ages which is the wonder of Toledo and Seville, of Burgos and Compostela, while the fabric of Rouen in itself is not sufficiently soul-stirring in its height or majesty to carry conviction that it is one of the beautiful buildings of the world. The church of St Ouen at Rouen has come in for yet higher, but more sustained praise, deserved by the octagonal openwork lantern of its tower, and, for the collector of rose-windows, by the rose-window over the south portal. But Rouen, as a city, has particularly ugly late Gothic buildings in Flamboyant style, especially the Palais de Justice of the time of Louis XII, much damaged in the late war, and which has, or had, all the faults imputed to the full-blown Rococo. A Gothic curiosity of the same order, and as prickly as a rose-thicket, was the church of Saint-Maclou which had five porches, a pentagonal porch of prickly arches, not improved as a whole by the spire added to it by Viollet-le-Duc, and with a delicately beautiful openwork turret-stair leading to the organ-loft, as Northern French in workmanship and spirit as it could ever be. But, after all, there may be others besides the writer who find the two great churches of Beverley, the Minster and St Mary's, many miles away from here in the Yorkshire wolds, more to their satisfaction than the churches of Rouen.

Le Mans, moving further into the endless monotony of the French provinces, has windows with some of the finest fourteenth-century stained glass in France. A magnificent rose-window on the north transept wall, and windows along the choir; Apostles in the clerestory; and along the aisles, windows given by the drapers, furriers, innkeepers, bakers of Le Mans, even the players of tric-trac who gave their winnings, all of them shown at their various employments but not, it has to be said, in very telling detail. There is danger of some modernist bishop inspiring a window with the motor-races of Le Mans for theme and subject.

Bourges, in quite as dull a landscape, though livelier as a town, and with old houses like the unpleasantly turreted, sloping-roofed dwelling of Jacques Coeur – and who could see this and not feel a longing for the Palazzo Strozzi and its spring-like air of the robust and young Renaissance? – has its cathedral standing on a hill with not three, but five sculptured portals on its west front; scenes of paradise and of hell, six rows of niches filled with saints, patriarchs, and the angelic choir. Authorities from the past extol 'the varied expression of the countenances, the elevated character of

many', etc.: and prepare the reader for the glass-shock of the interior which is profound, certainly, including a beautiful rose-window, but whether, or not, the finest in France it does not affect one as does the glass of Chartres. Bourges is another of the great leviathans, derelict six-wheeled engines, or drifting aircraft carriers, of French cathedrals.

And we come to Reims and Chartres which with Versailles are the great sights of France. Reims that, again, with the hand of Viollet-le-Duc upon it and the shattering damage inflicted upon it in the First World War, has to be taken to some considerable extent on licence with its beauties accepted without criticism. It is 'perhaps the most beautiful structure produced in the Middle Ages', but was this ever true of Reims Cathedral? There are the three portals to be expected, a full petalled rose-window over the main door, and very high up just under the twin towers a gallery or long line of huge statues with the Baptism of Clovis in the middle, and the Kings of France to either side. The towers above, which were intended for spires, have immensely elongated windows and must be most impressive within, as though of intent for a race of giants.

It is of course to be considered that Reims was the place of coronation of the Kings of France. Clovis, the first of the French Kings, was baptized here on Christmas Day, 496, by St Remigius, Bishop of Reims, and the Kings of 'the first and second race', so grandly called, with one or two exceptions, were crowned and anointed here with oil from the sacred phial or *ampoule* used by St Remigius,* down to the coronation of Charles x in 1830. That was the last-ever performance of one of the three great ceremonial liturgies and pageants of its kind; the two others being the crowning of the Holy Roman Emperor at Aix-la-Chapelle, the last being that of Francis II in 1792 – although the crowning of the Austrian Emperors at Vienna continued with little diminished ceremony till that of the Emperor Karl in 1916 – and the coronation in Westminster Abbey of our own Kings or Queens. As with its companions, the crowning at Reims must have been exceedingly curious to watch. Saint-Simon mentions the two crowns; that of Charlemagne which was too large to wear, and the personal crown of the King which was of ordinary size. But the crown of Charlemagne, which was used for the coronation, was so large and heavy that the King had to be led from altar to throne with eleven of the Twelve Peers of France lending a hand to keep the crown in place.† In the person of Charles x,

* The *ampoule*, with its contents and very existence miraculously renewed, was kept at the Abbey of St Remi at the other end of the town.

† The Twelve Peers of France were the Bishops of Laon, Langres, Beauvais, Châlons, and Noyon, the Dukes of Burgundy, Normandy, and Aquitaine, and the Counts of Flanders, Champagne, and Toulouse. The missing Peer of France was the Bishop of Reims who performed the ceremony of coronation. There are sumptuous books of engravings of the coronations of Louis xv, with the cathedral transformed in the coming style of his reign, and of Charles x, which in itself is a masterpiece of 'Cathedral-Gothic'; its fantastic pendant being the book of the coronation of the Habsburg of Habsburgs, in physiognomy, Ferdinand i, as King of Lombardy, in Milan Cathedral, in 1838.

last and perhaps the handsomest of the Kings of France, it was the erstwhile Comte d'Artois, builder of La Bagatelle and ghostly incumbent of Holyrood Palace, who was to die at Frohsdorf, that near legendary and prototype of Pretender's homes, outside Vienna. For those who thought of such things at all, Reims was the most sacred place in France; but it was, and will always be too near to Germany. That is its danger, and the reason that it has been both shattered and reconstructed. That Reims Cathedral as a whole is a sacred relic of utmost importance is not to be denied. It resumes in itself the labours and the higher feelings of many generations of human beings; and if as a spectator one can only disassociate oneself from any religion in particular in order to revere such monuments as a whole – it having to be accepted in the argument that the temples of Angkor, or the rock-cut Kailasa of Ellora are witnesses to a comparable depth of faith and religious feeling – then it will emerge that the great cathedrals with their triple portals and great schemes of sculpture, cycloramic narratives, and apocalyptic threats, benign virgins and rose-windows of the dawn, trumpets of the *Dies Irae*, and the galaxy of gargoyles and attendant demons, had this in advantage over those others, that they could construct an interior. There is hardly a room bigger than a cell in all Angkor, and only long stone passages. The 'libraries', so called, are carved like sandalwood and have almost the smell of that, but inside they are as attics with ceilings so low you cannot stand up in them. It is the same with the ancient Mayans as with the Khmers. They could build stepped pyramids but no interior larger than a tomb-chamber. Indeed the interior, and what that portends, eluded them as entirely as it did the builders of Stonehenge. They may have dreamed of interiors but could not achieve them. It was remarked by Fergusson a hundred years ago that there were in the south of India alone at least twenty temples representing as great or greater an expenditure of time and labour than that of any cathedral of the Occident. But as to the interior of those temples it was time wasted. They could build interior courts, but not true naves, transepts, or aisles, which is why Reims, or Amiens, or Rouen, however damaged their exteriors, or ravaged their interior contents, by their mere stone shells or vessels must surpass most, if not all the wonders of the Orient. The nearest modern equivalent in money spent and hours of work is a fifty million pound Polaris submarine, or a thoroughly up to date aircraft carrier where, in either case, the balance would be redressed and it is the Orient that wins. Even the statistics are in mathematical touch or correspondence; and the figure of 719 statues on the triple portals of Chartres, the 700 statues on its north façade, the 124 'subjects, some of them of great historic interest' on the rose-windows of Le Mans, and 1,610 figures in all on the windows of Bourges, seem to connect with the numbers of the ships' crews concerned.

In the case of Chartres no mere comparisons are needed. It seems to exist in a world of its own beside which those other names can scarce be mentioned. It is further away

from the Teutons, that alone has helped it. But all about it is exceptional and extra-ordinary, from the moment you just see its twin towers across the flat cornlands of La Beauce. In this respect the Roman amphitheatre of El Djem, in Tunisia, which can be seen for twenty miles away, must be its only rival. From twelve or fifteen miles away one can certainly see the towers of Chartres coming up out of the plain; and of course as one approaches nearer they seem smaller and disappointing, until one is in the streets of Chartres, which once was one of the water-cities of Northern Europe, a minor Bruges or Ghent, and comes up a slight hill and round a corner, and in another moment we are in front of this work of giants.

I think that this pre-eminence of Chartres is due to several reasons; not least, to the plain of La Beauce lying all round it which gives the effect of the stage having been swept clear for its entrance into vision, and then, nearer appearance. Then, the canons of stature have been revised and allowed to stretch to the limits imposed by nervous excitement and confident expectation of miraculous happenings, past and to come. It is like removing from the canon of Guido Reni to that of the Mannerists; of Michelangelo, Parmigianino, Tintoretto, above all El Greco, down even to Fuseli. Yet the elongation had, of course, nothing whatever to do with Mannerism, as such, but is an Orientalism of the imagination, in kinship of nature with the anchorites and religious extremists of the Eastern Church where, in fact, representation of the human form in sculpture was forbidden and non-existent. It is Eastern in ascetic feeling; and in distant relationship even to the curious phenomenon that priests of the Greek or Russian churches were, and often are still, exceptionally tall in height. An impressive personage in religion is not dwarfish but tall; and hence to the sculptured figures of Chartres.

The cathedral, as much as any theatre, has its three traditional entrances; in fact, a triple porch counting as one entrance, and porches in the north and south transepts. Above the triple portal are three pointed windows under a rose-window and over that the customary, but at Chartres only sixteen statues of the Kings of France. Statues of royal saints are on either side of the centre door or Porte Royale; and above, but not always easy to find and on occasion even seeming to change places, are the fourteen Prophets in a row, and above them the twenty-four Elders of the Apocalypse 'playing on instruments of the Middle Ages'. But, yet more, it is the side doors, the portals of the north and south transepts that are the marvel of Chartres. These, and the stained-glass windows. The north porch is indeed a moving and astonishing conception. Here, again, it is a triple portal with flanking statues in an extreme canon; they must portray human beings eight or nine feet tall. According to Viollet-le-Duc, the statues and both porches, themselves, north and south, were gilded and painted; and here as with the statues and frieze of the Parthenon, one must be allowed to express a doubt. It could have been; but was it 'marvellous',

in either case? This is something we can never know. The three-arched north doorway with its great rain spouts, gabled roofs, and deeply recessed archways projects its statues forward above a flight of steps. Most of Chartres Cathedral, then, was painted and gilded, and the hand of man, the *main d'œuvre* of the Middle Ages which seldom, if ever, went wrong, must be taken on trust for this extraordinary apparition in the sense of a coloured building. The north portal has scenes from the life of the Virgin; while the south, which is perhaps a very little less impressive in effect, depicts the Last Judgement. From either of these side doors it is a most wonderful entry into the Cathedral. Within, and after the marvellous experience of the sculptured porches and their thin, elongated kings and prophets, Chartres Cathedral like the Dome of the Rock, is a shrine that the convinced agnostic has to acknowledge as among the holy places, and wherein no one can be altogether impervious to the sacred precincts. It is because of the windows, well over a hundred of them, filled mostly with thirteenth-century glass. It is a sight nowhere else to be seen, not even at Bourges. Above all, for the rosomane among lovers of windows, there are three superb rose-windows, at the end of the nave and in the transept, the one facing the west with the Last Judgement for subject; and it is in the three rose-windows that the most fierily burning flames are managed, but, above all, the blue of sunset and sunrise, miraculously obtained, it is said from seaweed, and obtaining such a blue rose as no other human skill will achieve, or, once attained, will keep alive. It is the clear hyaline of early morning as seen from perhaps thirty thousand feet in an aeroplane, something never seen by previous generations except in the rose-windows and again, here and there, among the windows of kings and patriarchs at Chartres.

I think that after Chartres for a return to sterner things it is necessary to go to Laon. The lighter dissipations of the French late Gothic and Flamboyant do not weigh in the balance against the glories of the Perpendicular in England which is our national style and native genius. It is altogether too light in hand. When his own life as a writer was nearing its pitiful end, Ruskin could say, in *Praeterita*, 'for cheerful, unalloyed, unwearying pleasure, the getting in sight of Abbeville on a fine summer's afternoon, and rushing down the street to see St Wulfran before the sun was off the towers, are things to cherish the past for – to the end'. But Abbeville is tinged so darkly from the two holocausts of our century that such pleasures are no longer viable. That it can have been beautiful, once, we can believe but the account has to be signed by names of warranty. And the church of St Wulfran? It has three portals with pointed gables, an openwork balcony over them, then a great window flanked by the ringing-chambers in both bell-towers which rise up one storey more of bell-chamber to their balustraded summit. This part is late in date (1488–1539), but how inferior it is to the Perpendicular towers of England. There would have to be the

starched headdresses of the Pays de Caux in plenitude, and the chalk-waters of the Somme, that delighted Ruskin, would have to run green again, to make Abbeville beautiful in our time.

Such a *jeu d'esprit* as the porch of Notre-Dame at Alençon cannot have been intended to be taken altogether seriously. It is of the school of Saint-Maclou at Rouen. The porch attached as though it were three sides of a hexagon to the west end of the church, and its attenuated traceries crowded with stone figures in their upper tiers, make one think the architect must have known the *calvaires* of Brittany as well as the quintuple portals of the church at Rouen. Even richer of ornament, and more purposeless is the porch of Notre-Dame at Louviers. It has none of the quiet beauty and dignity of, say, the Perpendicular porch at Cirencester, but is self-assertive and more than a little vulgar, running up its spikes into false turrets and *tourelles*. How many times have I driven past it, turned round to look, and not bothered to go inside, where in fact there is not much to see! It has to be said that at no time during the Middle Ages were the English capable of such architectural silliness as that displayed at Louviers and Alençon. The grave and solemn beauty of our Perpendicular towers, the many windowed naves of our 'wool churches' like Lavenham and Melford, our angel ceilings and the fantasy of our fan vaulting are another matter altogether from the flimsiness and frivolity of the French Flamboyant.

For a further lesson in vacuity and on a much larger scale it is necessary to visit Brou, only mentioned here out of its geographical context because it pertains to the same overflow of the full blown Gothic, many miles away at the other side of France. Brou is outside the town of Bourg-en-Bresse, in Franche-Comté, which only became part of France after the Treaty of Nimegen in 1678, but the inhabitants of Besançon and its other towns would be outraged if spoken of as anything other than Frenchmen. The church at Brou was built by Margaret of Austria, who was made governor of the Netherlands by her nephew, the Emperor Charles v. In it she lies buried with her husband and her mother-in-law, who had vowed to build the church, in tombs by Michel Colombe and his pupils. The canopied stalls, the *jubé* or reredos, and everything else possible, is carved 'like lace' which is ever a bad augury, and the church at Brou is one of those places that have appeal to the worst instincts among 'art lovers'. Prosper Mérimée for instance has this to say:*

Qu'il me suffice de dire que tout ce qui semblerait difficile à exécuter en métal a été exécuté en marbre; qu'on y voit des rinceaux, des fleurs, des feuilles de vigne d'une délicatesse

* Quoted in *Southern France*, by Augustus J. C. Hare, 1890, p. 290. 'Let it be enough for me to say that everything that looks difficult to execute in metal is carried out in marble; that one sees twigs, flowers, vine-leaves, of an unheard of delicacy ... and which one cannot understand not snapping of their own weight. Count the petals of the marguerites, each separate from the others, all hewn from the same block; measure their thickness, and you will agree that a good maker of artificial flowers could do no better with her bits of wire and gauze.'

inouïe... qu'on ne peut comprendre comment leurs poids seul n'a pas suffi pour les rompre ...comptez les pétales des marguerites, tous detachés les uns des autres, tous taillés dans le même bloc; mesurez leur epaisseur et vous conviendrez qu'un bon fabricant de fleurs artificielles ne pouvait faire mieux avec ses fils de fer et sa batiste.

How did someone put down such nonsense who could write so well!

For contrast what a marvellous solemnity and awe emanate and are instinct from Laon! From the moment of first seeing the unique, and anything but simple outline of its towers, to the degree even that it seems out of the question one should be able to climb to the parapet and look down from them. The writer arrived at Laon late in the evening and could only see them against a darkening sky. But it was not too dark to form some idea of the extraordinary situation of the town which is built on a long sickle-shaped hill or spur of rock enclosing on three sides a ravine full of gardens and vineyards called the Cuve de Saint-Vincent. It is a site recalling that of Cuenca in Spain. But there are running streams and rivers in the ravine of Cuenca, and these there are not at Laon.

Next morning it was raining in reminder that this is to the north of Paris and on the way to Flanders. So early was it that the cathedral had not yet opened its doors but stood there to be seen in the drizzle, and it seemed better to stay in a nearby café for at least a few moments; and I fell to thinking of the narrow streets of the town remembered from last evening, and of the way Laon seemed to wrench itself right round in order to occupy the spur of rock. Inevitably, too, I was trying to recall what I could of Cuenca, where the *rejas* (wrought iron grilles) with those of Seville, Burgos, and Toledo are the best in Spain, and on that cold autumn morning I was thinking of how remote Cuenca was – I am sure, still is! – and of how at such hours as this the Spanish countrymen muffle themselves up with their blankets against the morning mist. But not only the Spaniards: Frenchmen, as well. And a whole succession of local characters came tumbling into the café as though precipitated out of their attic bedroom, unshaven, wearing the oddest collection of slippers, most of them smoking again, already, all of them coughing, and collar-less. All had scarves or handkerchiefs round their throats. Not one of them could have faced an English breakfast. There had been too many *coups de rouge* and *petits verres* last night. Laon was their place of detention. One and all, they longed to go away. But one gets chained to the rock of Laon and stays for life. And to a chorus of *parbleus, heins,* and the expletive I have never seen spelt out in cold print, but which has the sound of *bahn,* fully throated, with the heat of *bain* in it, and the bleating not of a sheep but horned ram, I walked out of the café towards Laon Cathedral. This foggy November morning, as I am writing, I expect some of them are still there, talking and coughing. One does not move out so easily from Laon; and once seen one does not forget it.

The cathedral has four towers, and there were to have been eight in all, two more

at each end of the transepts, and some of them with spires, as well, but it is the pair of towers of the west front which claim all our attention. To begin with the west front from the ground upwards – façade being a term with application to another kind of building altogether – it has a triple portal of no particular originality, its rounded tops somewhat clumsily hooded under pointed arches; a wheel-window flanked by deep, round arched windows, and we are at the foot of the towers. They start up from a square base and out of a gallery of small arches, and at once become interesting. Each has a pair of long high windows on every side with small canopied buttresses beside them; but on the next storey, where the tower windows are immensely long and narrow, the buttresses have taken on the shape of side-belfries set at an angle to the towers, a cluster of four belfries, then, to every tower. And now comes the mystery of Laon.

Leaning out of these belfries, looking out over the ravine and the plain below, are statues of oxen, just their horned heads and shoulders. How I wish I had climbed the towers of Laon to have a nearer look at them! Not too many of them. Upon this storey just a pair to each tower; one, looking inwards over the building; and the other, looking out over the town. Then, the belfries rise again another storey, self-supported and a little smaller, but still keeping pace with the immensely elongated windows in the towers; and now with slenderer columns to the belfries right up to the balustrades of the towers, of which they form a part. Can there ever have been spires at the top of them? It seems doubtful. From this top storey of each belfry, more of the oxen are looking out, and it is most curious to see the silhouette of their horns against the clouds. According to legend, the oxen on both storeys of the two belfries were 'in memory of the animals who dragged the stones from the plain to the site of the building'. But what foundation is there for this story? Was there a famous breed of cattle in these parts? Villard de Honnecourt, whose book of drawings in the Bibliothèque Nationale is among the few surviving collections of master-drawings by a mediaeval architect – who came from Cambrai which is not far from Laon, but in the course of his wanderings went as far afield as Hungary – was so much impressed by the towers of Laon that in his sketch book he drew his own variation upon them, with a pair of great bulls – for are they in fact bulls or oxen? – looking out in two alternate positions, indeed as though he was trying to find the most impressive point of vantage for them. Those curious towers have some kind of palatine touch about them; they date from shortly before the year 1200 but, also, they would not be out of place in the mosaics of Ravenna, and could be palace architecture of that earlier date except for this cargo of live bulls looking out alertly, horned heads in air.

One would expect to find these tauromantic towers, not here at Laon, but some-where remote in Spain where there is a local legend of obviously greater and more pagan antiquity than it would seem; some country cathedral like that of Santo

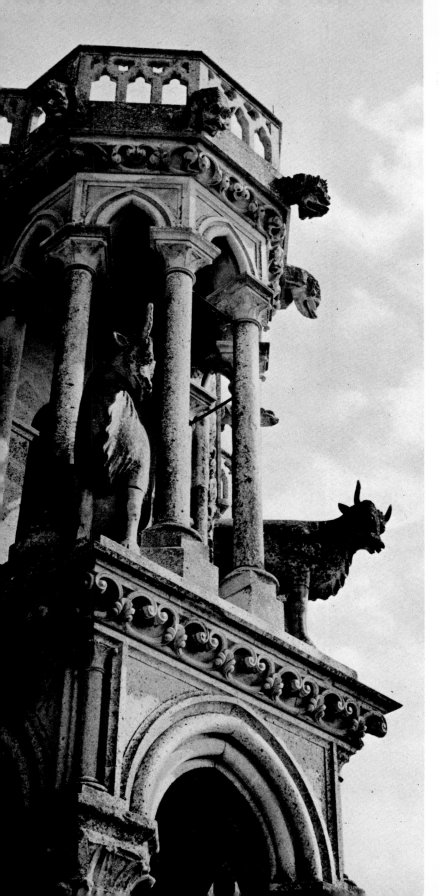

French
Gothic

Oxen in the belfries
of the south tower of
Laon Cathedral

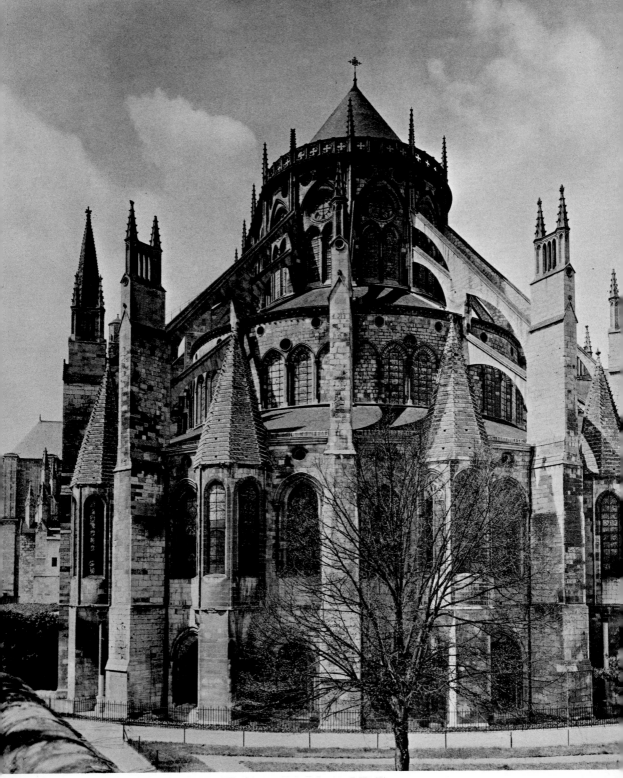
Bourges Cathedral: the apse supported by flying buttresses

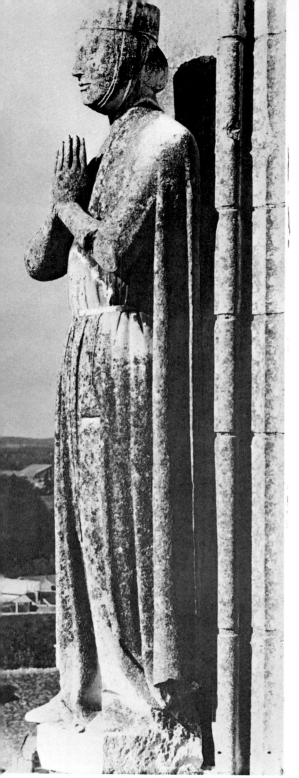

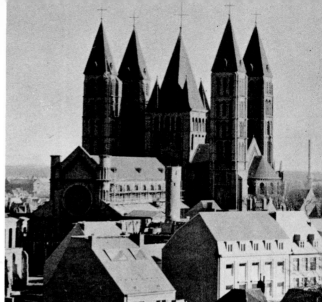

Left Praying figure on Bourges Cathedral
Top right The five towers of Tournai Cathedral
Bottom right 'Wheel-buttresses' at Chartres Cathedral

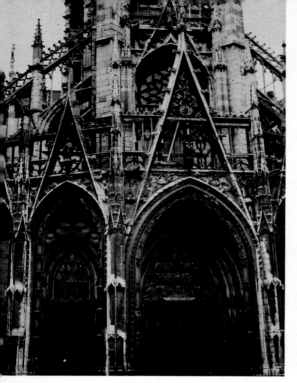
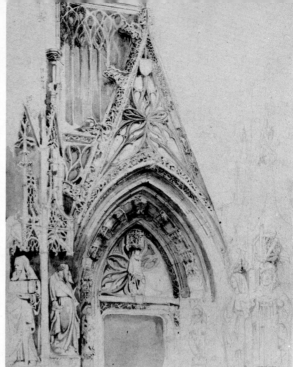
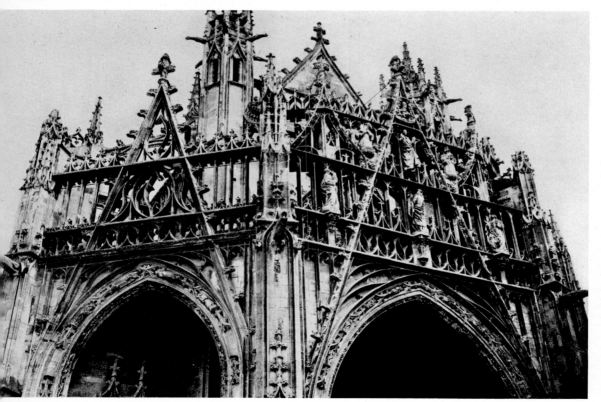

Top left Part of the pentagonal porch of St Maclou, Rouen, with prickly arches and attenuated tracery
Top right South porch of St Wulfram, Abbeville, drawn by John Ruskin. One of the three portals
with pointed gables, showing part of the openwork balcony above them, 1488–1539
Bottom Porch, forming three sides of a hexagon, of Notre-Dame, Alençon
Opposite West façade of Rouen Cathedral showing the multi-petalled rose window with
Flamboyant tracery

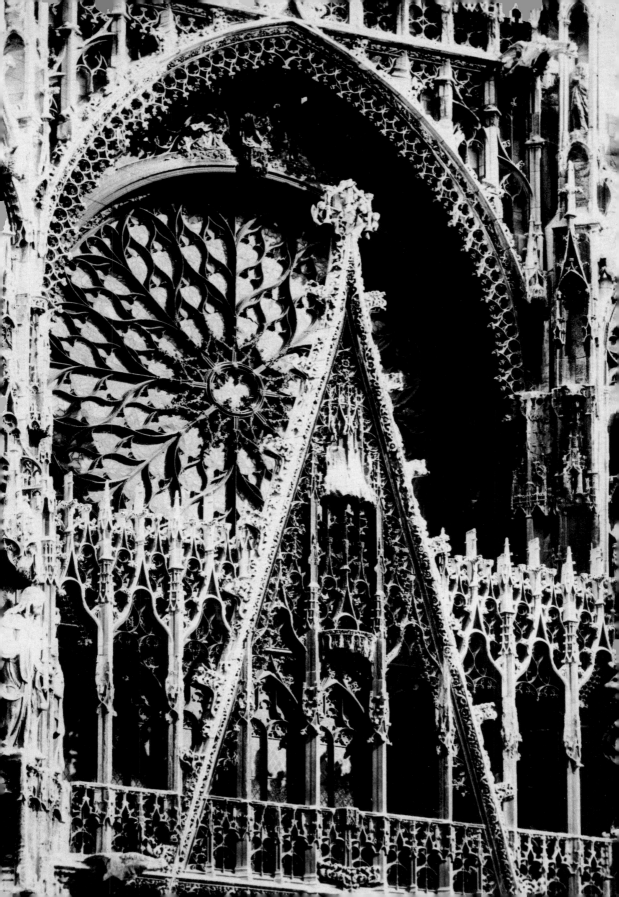

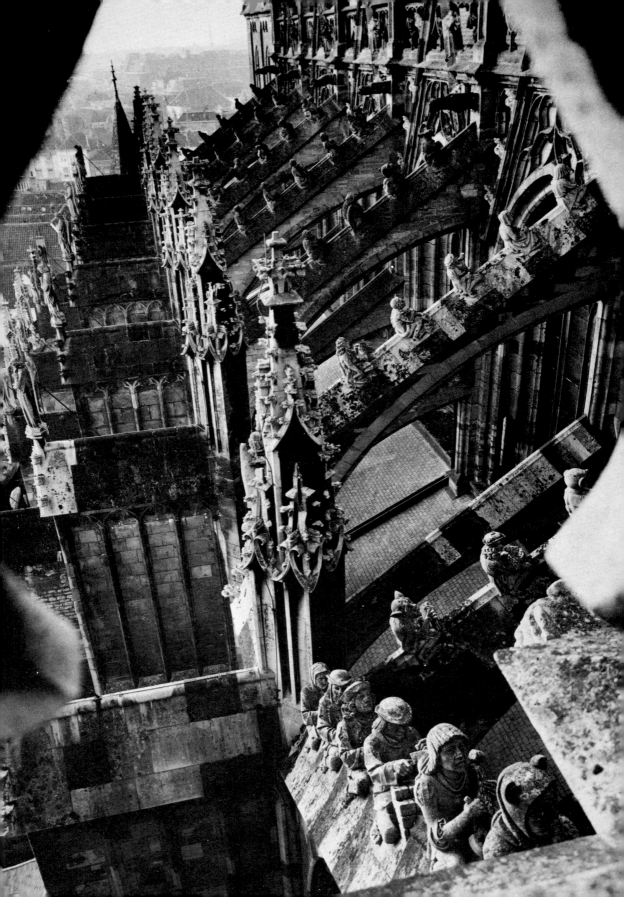

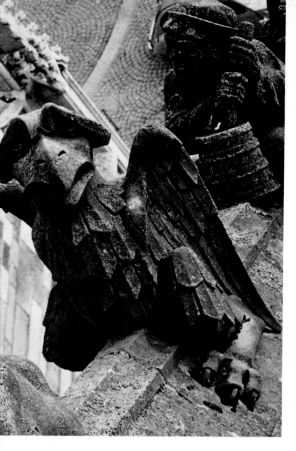

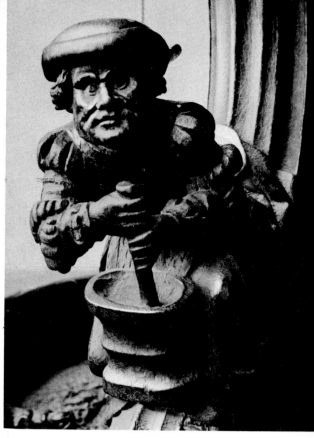

Above Detail of the stone figures at 's Hertogenbosch
Opposite Stone figures and monsters swarming up
the buttresses of the Cathedral of St Jean at
's Hertogenbosch
Right Carved figures of a chemist (*top*) and a
carpenter, from the choir stalls at Amiens

Engraving by Daubigny to illustrate an 1844
edition of Victor Hugo's *Notre-Dame de Paris*,
showing the old gargoyles on the roof of Notre-Dame

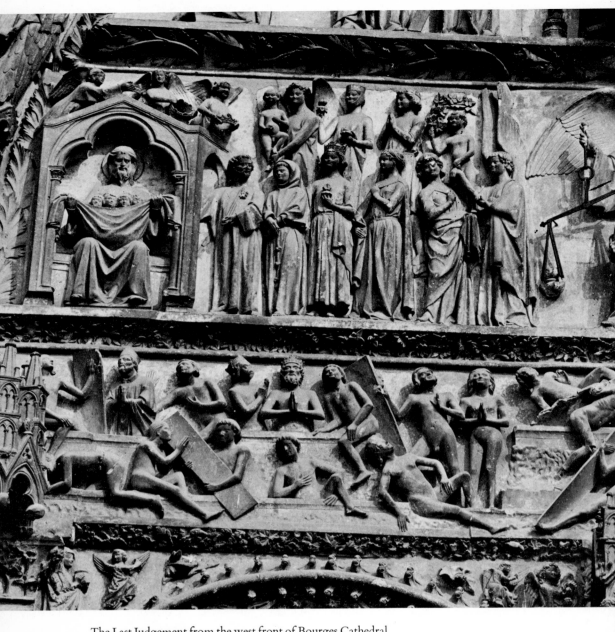

The Last Judgement from the west front of Bourges Cathedral

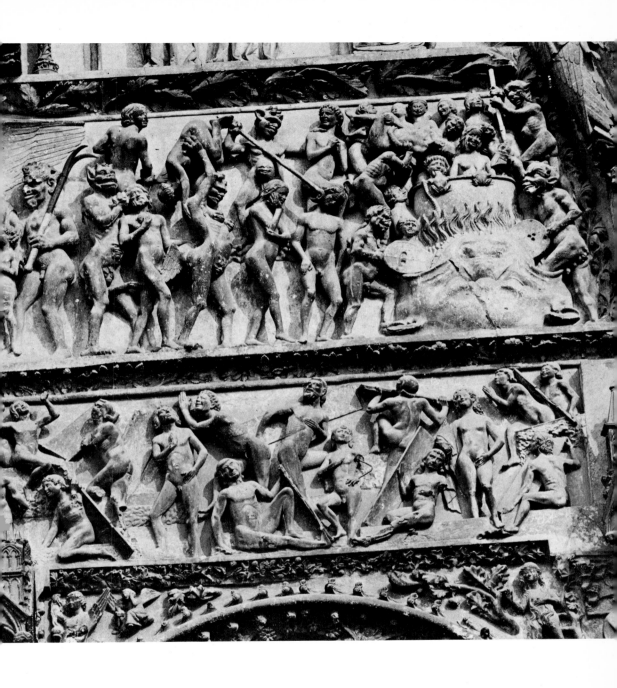

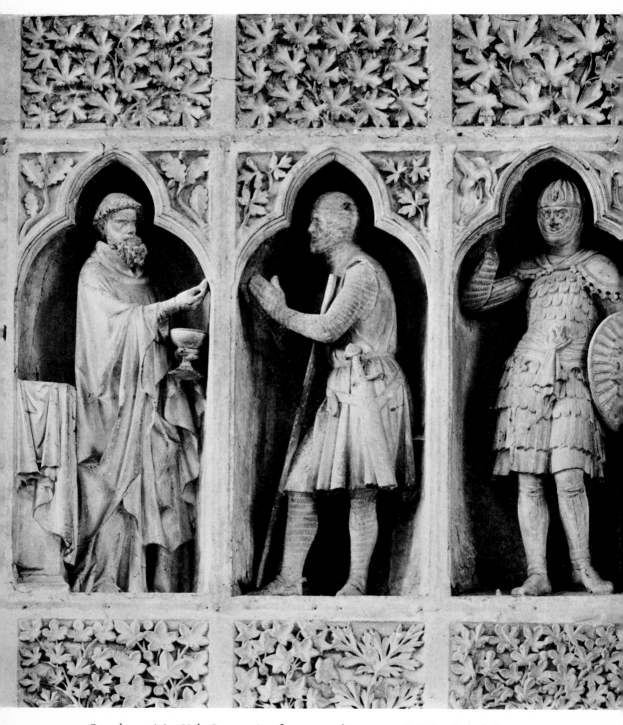

Crusader receiving Holy Communion, from a carved stone screen in Reims Cathedral

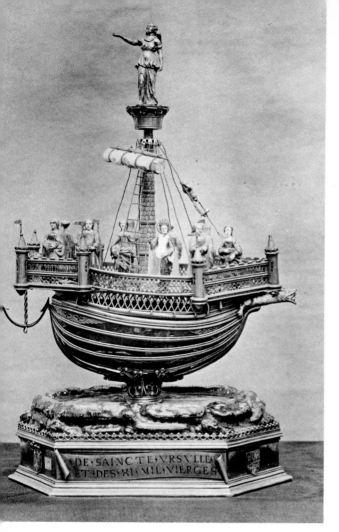

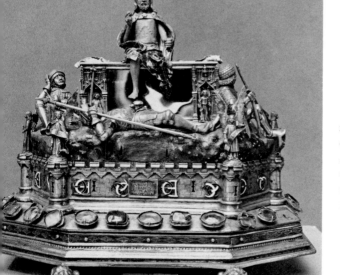

Above Open-air hexagonal chapel at Avioth, near Montmédy, called 'La Recevresse'

Top left Ship reliquary from Reims, with figures of St Ursula and her ten virgin companions on board

Left The Resurrection reliquary from Reims, of gilded and enamelled copper, with the figure of Christ emerging from His tomb and men-at-arms sleeping at His feet

An anthology of rose windows

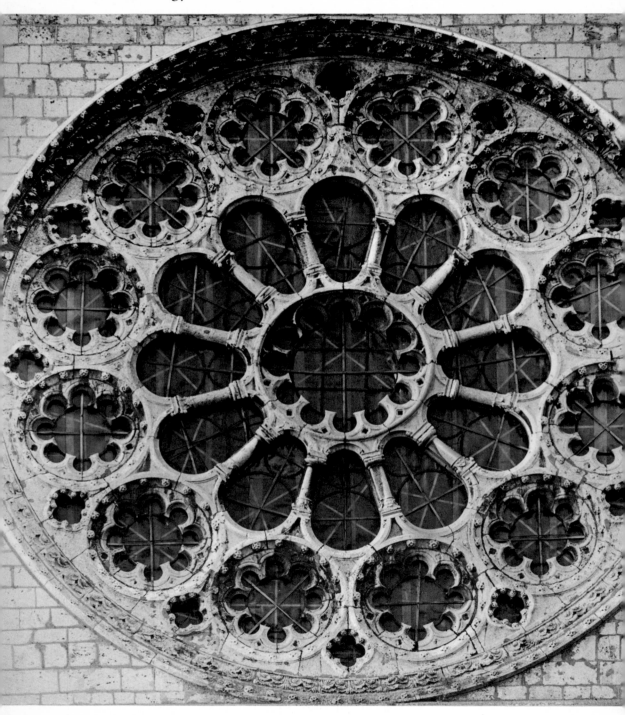

Romanesque wheel window from Chartres

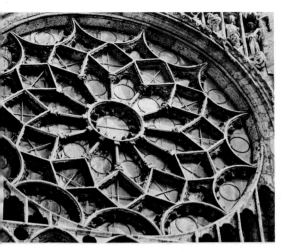

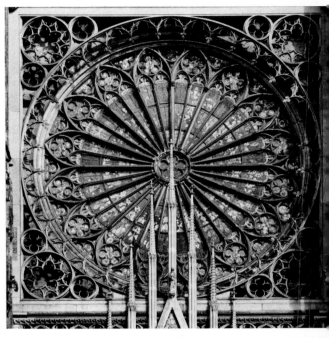

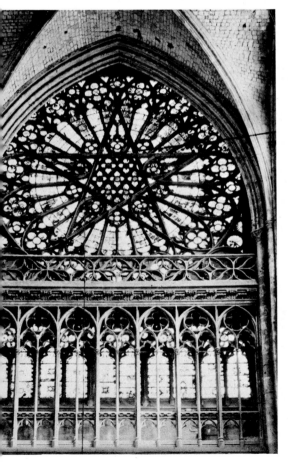

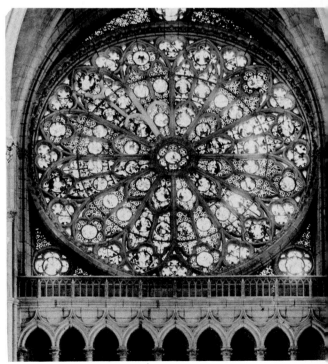

Top left Early Gothic round window at Chartres, transitional from wheel to rose
Bottom left Stained glass window with pentagram at St Ouen, Rouen
Top right Rose window with stained glass and openwork rosettes in the corners around it from Strasbourg
Bottom right Rose window with stained glass from Reims

1,2

3,4

Drawings from a notebook of Rev. Thomas Kerrich, an early 19th-century amateur of rose windows

1 Wheel window from Castle Hedingham and primitive rose
2 Italian version of the Romanesque wheel window at Orvieto
3 Rose window in Venetian Gothic at St Mark's, Venice
4 Another Italian window, from Cremona Cathedral, more a rose than a wheel
5 Large petalled rose window and pentagram window at St Ouen, Rouen
6 Rhenish Gothic rose window at St Catherine's, Oppenheim
7 English double rose window at York
8 Rose window at Reims
9 Leaf window at Lincoln in the late Gothic 'Decorated' style, unique to England
10 Wheel window at Reims

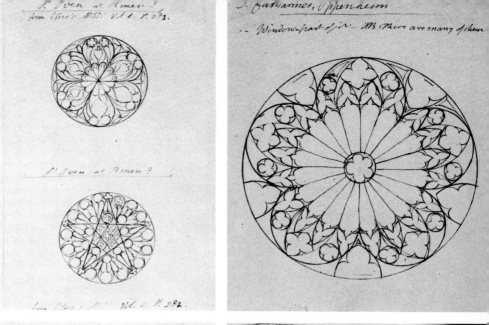

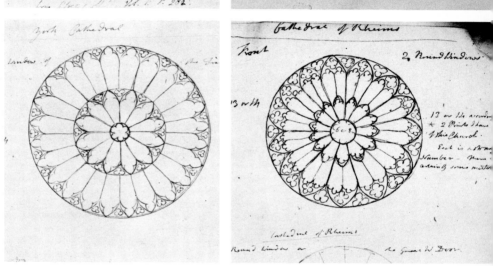

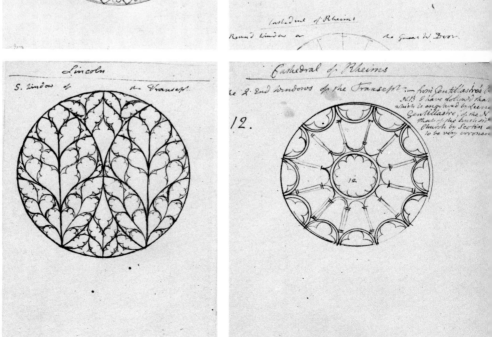

5,6

7,8

9,10

12.

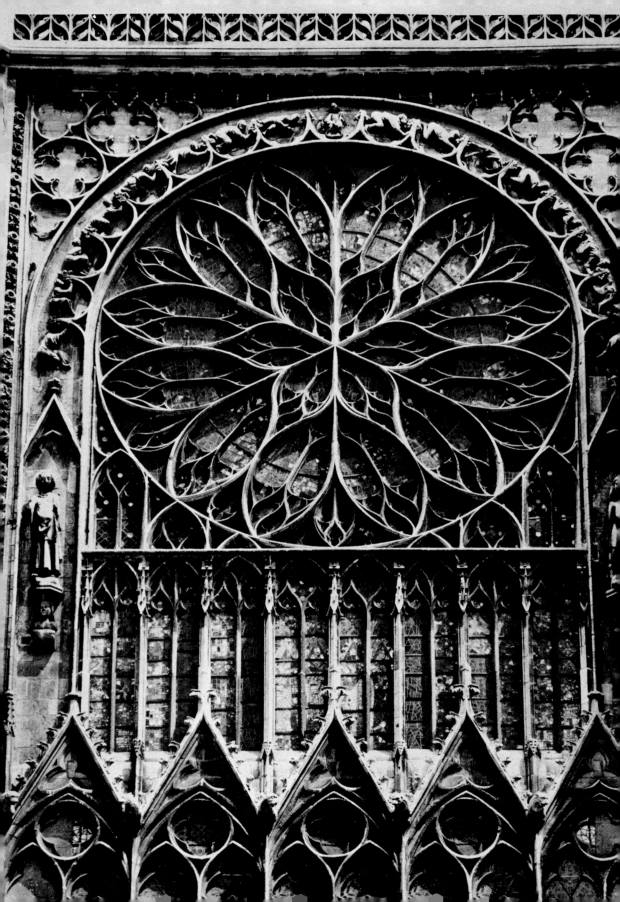

Domingo de la Calzada, where the white cock and two hens of the saint are kept in a beautiful fifteenth-century cage high on the wall of the transept; and on the saint's day the white cock is killed, another one is put into the cage out of the chicken-run in the cloister, and there is a bull-fight and fireworks in the evening. So it could be at Laon, which should be in a historical enclave of its own with legends of the crinolined snake-goddess and the minotaur; and one comes away from it looking back in wonder at its pillared porches with the sky showing through them, and at the bull-crowned towers.

Opposite: Multi-petalled rose window with tracery in the late Gothic flamboyant style at Amiens. Above the rim of the window figures are ascending and falling from a Wheel of Fate

I I

Italian Gothic

It is, I think, arguable that the Italians never had their heart in Gothic architecture any more than their temperament and real feeling enabled them to put more than a proportion of their energies into the prosecution of the Second World War. Both were things alien to them and not in their bloodstream. Roman remains above ground, together with relics of the mysterious Etruscans being upturned out of the soil, with the knowledge that there had been a literature and a civilization ten to fifteen centuries earlier, made them rather less than amenable to fashionable and foreign influences from France. The more so because throughout the Middle Ages, and even until only a century ago, it is difficult to think of them as primarily Italians, but rather as Florentines, Venetians, Neapolitans, inhabitants of Papal Rome, with the mini-tyrannies and minor duchies to add in. If, and when they accepted the Gothic they had to temper it to accord with their love of colour and their more southern setting.

Of this there is convincing evidence in the town backgrounds in paintings by Fra Angelico, Benozzo Gozzoli, or the host of other painters, even if it is to be noted that the houses depicted are mostly of traditional Latin type, not very different probably from those of ancient Rome or of the Etruscan cities, with perhaps a Gothic loggia or a bifora window built in. This, because, though it was not in their breeding, they loved, as always, to flaunt their modernity and keep up with the times. But there is no more accessible example of the strengths and weaknesses of Italian Gothic than the Duomo and Giotto's Tower of Florence. Neither the exterior, still less the interior of the Duomo, is a fair introduction to the surpassing wonders and splendours of mediaeval Italy. Air arrival has altered most things, and not always for the better, but if you have come into Italy by road or rail along the Mediterranean coast, the coloured marbles of the Duomo may remind you of the candied fruits of Genoa, but without the palm trees and carnation terraces of the Italian Riviera; while if your approach to Florence has been by way of the Italian Lakes, you will miss the blue waters and the magnolias of Como, and regret the decks of oleanders and batteries of oranges and lemons of Isola Bella. On a wet morning, and there may well be one,

the Piazza del Duomo of Florence can be indescribably depressing. And the truth when you look into it is more than a little disconcerting. For the coloured marble façade, as we see it now, was created in 1875–87 from the designs of a nonentity, Emilio de Fabris, and in fact has very little to do with the unfinished old front of the Duomo which was removed or demolished in 1587. This had been begun by Arnolfo di Cambio; and a drawing of it is to be seen in the Museo del Duomo from which it is to be gathered that there is as much resemblance between them as there is genuine family likeness linking together St Pancras Station Hotel, admittedly a masterpiece of the picturesque – unexpectedly, in the idiom of Victor Hugo's ink-drawings – and the Venetian Gothic palaces along the Grand Canal; or, in simpler terms, it is the eternal, traditional dissemblance between chalk and cheese. In the drawing it can be seen that the original front was articulated and had force and meaning, all of which in the counterfeit is lost and shallow and quite meaningless.

Giotto's Tower, only a few feet away, speaks in another language; but its history, too, has its surprises. It is in the 'painter's Gothic' of Florence; but only the first floor of the tower or campanile, the stalk, so to speak, of the flower as it grew out of the ground, is from Giotto's hand. The other four stages or flights of it are by different hands; the three of them above Giotto's being perhaps by Andrea Pisano, who may have altered the design, if it was ever made, but at least it is coherent and continuous with its windows which grow in size as the campanile climbs, with some beautiful if not easily visible statues on its way, all in polychrome marbles up to its corbelled cornice where, at the very summit, it is said – I have not seen them – are the piers from which according to Giotto's original plan there was to rise a spire more than a hundred feet high. This, indeed, would have been unanticipated in effect and difficult to realize as an accomplished fact.

Frankly, the interior of the Duomo of Florence is most disappointing. About all that can be said of it is that it is big and bare. It has an exceptional, an even memorable vacuity and emptiness. In any event almost everything it ever had of interest has been led out, as it were in chains, and put in the cathedral museum. The *cantorie* or musicians' galleries with their beautiful reliefs of singing and dancing children by Donatello and by Luca della Robbia are perhaps happier there than in their original dreary and boring setting above the sacristy doors. There are of course things of interest in the Duomo – stained-glass windows from designs by Ghiberti 1381–1455, and a Pietà by Michelangelo – but they have to be searched for, and do not look their best when found. What is beautiful, really and truly beautiful despite its mixed parentage, is the so-called Giotto's Tower; and to someone who has known Florence since early childhood, Brunelleschi's dome or cupola – which is anything but Gothic – rediscovered after long absence and forgetfulness on the part of the writer,

and that can never have looked more sublime and full of mastery in its floating bulk than when seen a couple of years ago from the upper storey of the cloister of San Lorenzo, near by. It has the thought and physical greatness and signature of person of a Beethoven, and among domes is one of the masterworks of all architecture.

The Baptistery, with its golden doors by Andrea Pisano and by Ghiberti, and its mosaics in which Cimabue may have had a hand, is of an earlier and better world, aesthetically, and one in which Italian Gothic had no part to play. But the searcher after that can be no happier with the front of the huge Franciscan church of Santa Croce than with the façade of the Duomo, for the polychrome front of Santa Croce was 'executed' in 1857–63, from a design said to be by Cronaca, by another nonentity at the expense of a Mr Francis Sloane, of whom little else is recorded except his death just after the Unification of Italy in 1871 – and of what benefit has that been to the arts in this most fertile of all soils for artists of every sort? It may be said in parenthesis that there is another disappointment in store in the matter of towers. After long acquaintance I am unable to say I admire the 'lily-tower' of the Palazzo Vecchio; still less, that of Santa Maria Novella. The only less-than-mythical Arnolfo di Cambio (1232–1301) is of course mentioned in connection with the building of the Palazzo Vecchio, as he is, too, in the plan for Santa Croce; but the tower of the Palazzo Vecchio can have had little or nothing to do with him, it being really a question of the whole outline of the Palazzo Vecchio with its projecting gallery and battlemented walls resembling the castle of the Counts Guidi at Poppi, into which the name of Arnolfo di Cambio, a Florentine *deus ex machina*, is again dragged in. The outline or silhouette of the Palazzo Vecchio seen from the terrace below San Miniato (Piazzale Michelangelo), whence you look down over the city, is best described as Florentine, and again Florentine. Together with Brunelleschi's dome it is the signature of Florence, but whether it is beautiful and not more of a town-fortress than a work of art is, I think, a self-answering question.

The true flowers of the soil in Tuscany are there burgeoning and waiting to break out. It is the early flowering of the Renaissance that is in the very name of Florence, made manifest in the buildings of Brunelleschi wherein there is no trace of Gothic; as, also, in the paintings of Filippo and Filippino Lippi, Benozzo Gozzoli, and Botticelli, in the sculptures and bas-reliefs of Donatello – and – if the reader can forgive the plethora of names – the minor, but not less exquisite and beautiful works of Mino da Fiesole, Agostino di Duccio, the Rossellino brothers, and Desiderio da Settignano. Italy was, indeed, the most prolific of soils for works of art. But of all these names it is only perhaps in Filippo Lippi, the father of Filippino by a nun who was his mistress, that there is still the breath of Gothic.

The lover of Gothic *per se* will feel saddened on setting foot within Santa Maria Novella or Santa Croce, and find himself harking back to the nave of Lichfield or the

Angel choir of Lincoln. Yet the former of these Florentine churches has been described as 'the purest and most elegant example of Tuscan Gothic', but the temperament and energy of the Gothic has not survived transit or passage across the Alps. Compare, too, the cloister of Santa Maria Novella with a dozen, or even twenty cloisters in Spain or Portugal, the lands of cloisters, (or in Provençal France), and the comparison is depressing. Not so, of course, where Brunelleschi was at work in Santa Croce, at the Cappella Pazzi; or in the truly marvellous frescoes in the so-called 'Spanish Chapel' in the cloister of Santa Maria Novella.★ In both of these the Italian genius is at work; but in the 'Gothic' vessels of both churches it is as though you called on an Italian opera composer to write a symphony.

Only perhaps in the church of Or San Michele with its low dark interior is there the true Gothic spirit, and in the paintings by Fra Angelico in the monastery of San Marco. But, then, Fra Angelico da Fiesole was somewhat of an anomaly, if a beloved one, in his own time and no doubt received angelic visitants within his convent cell. Is there a more 'beautiful' painting in the world than his *Deposition from the Cross* with its Tuscan landscape background; while the orchestra of angels in his *Coronation of the Virgin*, and a trumpet-playing angel from any one of his *predelle* on a golden background reveal what the Gothic could mean to an Italian monk with a mind and imagination free from influence or penetration from the classical past. It may seem only to be a step, but it is a long one from the saintly humilities and ecstasies of Fra Angelico to the ceramic reliefs and roundels of the della Robbias wherein, beneath the blue skies and smiling faces and behind the laurel leaves and wreathed lemons, there is the sempiternal Italian street song, and some influence of the antique notwithstanding one can hear the vendor of ice-creams and the strains of the barrel-organ.

The journey from Florence to Siena of some forty-five miles, but only to be achieved if I remember aright from my childhood with two changes of trains at Empoli and at Poggibonsi, did really, and does still lead from one world to another.† There may be readers even today who recall the wonderful close to Ruskin's *Praeterita* in which with failing mind and in his last moments of lucidity he writes of arriving in Siena on a summer evening lit by the fireflies. It was his farewell to letters, and the falling of the curtain behind which he was to be obscured in semi-imbecility for the rest of his days. It is a passage which it is irresistible to quote:

★ The frescoes in the 'Spanish Chapel' of Santa Maria Novella are fully described in my *Splendours and Miseries*, 1943, pp. 112–15, and in *Monks, Nuns and Monasteries*, 1965, pp. 100, 101.

† The degree of change in Italy since, say, 1910, is exemplified in the growth of population of a small Tuscan town like Pistoja from 15,400 to 83,500, and of Prato from 17,200 to 107,000, by 1963. Gubbio, which had 6,300, has now 34,000 inhabitants. Siena, at least, has only doubled its population from 32,800 to a modest 60,500.

Fonte Branda I last saw ... under the same arches where Dante saw it. We drank of it together, and walked together that evening on the hills above, where the fireflies among the scented thickets shone fitfully in the still undarkened air. *How* they shone! moving like fine-broken starlight through the purple leaves. How they shone! through the sunset that faded into thunderous night as I entered Siena three days before, the white edges of the mountainous clouds still lighted from the west, and the openly golden sky calm behind the Gate of Siena's heart ... and the fireflies everywhere in sky and cloud, rising and falling, mixed with the lightning, and more intense than the stars.

Siena is a city which can yet inspire that radiance and urgency. With Toledo, and with Fez, it is still the most complete and convincing relic of the Middle Ages in the western world. But in curious contradiction Ruskin seems hardly to have been aware of its native school of painters. This, though, was a blindness that he shared with others for they remained almost unnoticed until attention was drawn to them at the beginning of this century and systematic study was begun on them. Siena is still, by and large, a mediaeval city, and more genuinely Gothic in character than for instance Gubbio which is still a town predominantly of the thirteenth and fourteenth centuries; but more basically Italian, and at that Adriatic Italian, than it could be said that Gubbio, as a city, belongs to the universal Gothic of many parts of Western Europe. As always in Italy, it is in painting that is to be found the forefront of the movement, and the trend of fashion; and in Gubbio the most 'Gothic' work of art is the exquisite, blue *Madonna del Belvedere* in Santa Maria Nuova, which is the masterpiece of Ottaviano Nelli (d. 1444). But that, again, is of a different school from Sienese painting.

It was of course the universality of mediaeval building along the narrow streets of Siena which had so much appeal to Ruskin; and it is still an experience to come down into the Campo of Siena which is shaped like an amphitheatre backed all round by buildings of the Middle Ages, with the Palazzo Publico rising before us and holding its three hundred foot Torre del Mangia in the air. This, indeed, unlike the tower of the Palazzo Vecchio of Florence, is a thing of beauty and a paragon among towers. Not dissimilar in conception from that of Florence, it has a corbelled and projecting balcony with battlemented surround; but it has the supreme gift of colour, and where the Palazzo Vecchio is dark brown like the Arno mudbanks this has the pinkish-red of life. The concave front of the Palazzo Publico, for it is too early in date to call this a façade, is most agreeable in surface and it is a pleasure in itself to look up at its high bifora windows with their fine capitals and columns.

Within, and among the wonders of all Italy, are the frescoed halls upon the upper floor. Here is to be admired the equestrian portrait of Guidoriccio, the Sienese commander, riding forth against a landscape background that is as formal as a plan of battle; but by no stretch of the imagination, willing or unwilling, could this be

called a Gothic painting, although Simone Martini (1285–1344) who painted it had been to Avignon and knew the French Gothic therefore at first hand. But his visit to France was towards the end of his life, after he had painted Guidoriccio da Fogliano, or that map-like landscape with the tents of his soldiers in the background. The frescoes of *Good and Bad Government* by the Lorenzetti brothers, who belonged to the next generation, show the dawning of the new taste in the astonishing painting of the streets of the town, where it is to be noted that some half of the windows in the houses are still round-arched, and it is only what are evidently the very newest buildings that flaunt the Gothic windows. The date of these frescoes (1337–9) must very nearly correspond with the building of the Palazzo Chigi-Saraceni, most typical of the red brick fourteenth-century palaces of Siena. In the companion fresco of *Good Government*, outside the gate of the town there is the first rendering of landscape in the unique Sienese manner which persisted into Sassetta who died as late as 1450, a rendering of the landscape scene which has such curious similarities with Japanese painting. In the frescoed landscape it is the 'shorthand' convention or rendering for the sloping hills planted with vines that recalls Japanese paintings of hills thick with pine trees. The same convention is to be seen again in a Madonna by Giovanni di Paolo (d. 1482) in the picture gallery at Siena, wherein the Madonna is in a grove of orange-trees (but they are mini-oranges like the *cumquats* of Chinese gardens) and the hills and fields and towns lie out, quilted in the distance, like newly settled land looked down on from a helicopter. Yet another instance of the same landscape is to be seen in Giovanni di Paolo's *St John Baptist entering the wilderness* (Art Institute of Chicago). But this little painting, which is part of a *predella*, depicts woods, a distant town and newly planted fields, and is therefore the wilderness reclaimed. One critic makes the sensible suggestion that this and similar effects in Sassetta, and other painters depict the reclaiming of the *creta* country to the south of Siena, with its newly planted olive trees, 'crumbled clay gulleys' and 'wrinkled landslips'.* It is the landscape towards Volterra, and that lies around Monte Oliveto Maggiore which the monks turned from a wilderness into a smiling oasis by the planting of olives and cypresses to hold up the slopes and prevent them from slipping and sliding in the rains.

Many of the most beautiful paintings of the Sienese school, thanks to the picture-dealers, adorn American museums and private collections. The Accademia di Belle Arti for this reason is a little disappointing in its native school, but there are still lovely paintings in the city churches, to include the portrait of Saint Catherine of Siena, in the church of San Domenico, by Andrea Vanni who was her friend. It is near the pillar of the 'svenimento' where the saint fainted away from loss of blood and malnutrition, and is a touchingly life-like portrait of the young nun with the

* *Siena and the Hill Towns,* by Alec Glasfurd, London, 1962.

stem of a lily in her hand. There are, also, paintings of the *Miracle of the Snow*, a legend according to which a Roman patrician had a vision of the Virgin who told him to build a church where he would find the outline or plan of it marked in snowflakes after a fall of snow. A beautiful painting of this subject, complete with its *predella* of little additional scenes by Sassetta, is or was in a private collection in Florence; and another rendering of it by Matteo da Giovanni with angels holding snowballs in their hands is in the little chapel of Santa Maria delle Nevi in the town. Mention should be made, too, of the *Tavolette della Biccherna e della Gabella*, which are painted scenes on the covers of the Inland Revenue Department receipts, no less, during the fifteenth century; little scenes by Sano di Pietro, Taddeo di Bartolo, and other masters, now displayed in the Palazzo Piccolomini where are housed the archives. There are some hundreds of these, and among them many delightful and surprising works of art. Then, too, there are the paintings by masters of the Sienese school in churches in the countryside, as for example, the glorious *Assumption of the Virgin*, by Vecchietta. This is in the Duomo of Pienza, the little model town of Renaissance palaces by Rossellino built for Pope Pius II (Aeneas Sylvius Piccolomini). And this is to no more than make mention of Nerocchio to whom the fairest of fair hair was something of an intoxication; and to whom it should have been vouchsafed to witness a market-day in mediaeval Friesland, whence Saskia van Uylenborch was to emerge with the flaxen hair that so entranced Rembrandt, and perhaps led him through over-spending and extravagance to bankruptcy and ruin.

But the Sienese school of painting which is among the minor, if special delights of all the human arts, must not delay criticism of the Duomo of Siena. Inside and out, Siena Cathedral startles and seeks out to browbeat and astonish in far from a pleasing way. The zebra-striped tower may be the first part of it to catch and hold the eye, and then the west front the lower part of which up to the cornice is from designs by Giovanni Pisano. But, above that, Italian exuberance with red, black, and white marble to play with and the quarries of Carrara not too far away has broken loose, and the upper part of the façade over the three gables has mosaics, much purposeless arcading, and as many spectators in statuary as could crown the more expensive benches at a football-match with the sensation, too, that they are all cheering, or, at the least, talking. Within, the Duomo is no less vociferous and noisy. It has the zebra stripes laid on or applied with utmost energy, and without mercy; while with imbecile insistence sculptured heads of the first hundred and seventy-two Popes of Rome with their names subscribed are in grisly procession all round the cornice of nave and choir. In the same manner the old Queen's Hall, and many theatres and opera houses all over the world, are adorned with just the names of great composers, Spontini, Piccinni, etc.; for the forgotten have to rub shoulders with the more favoured to fill up the hall of fame. But it would be no more useless to

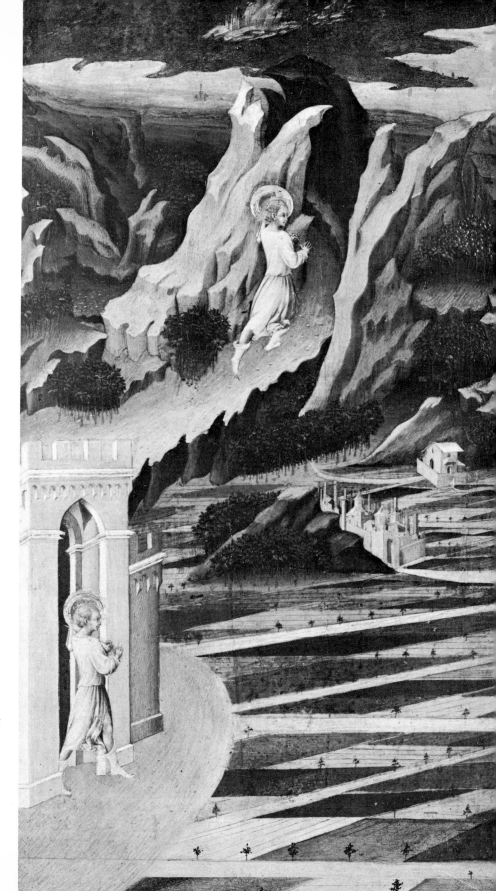

Italian Gothic

St John Entering the Wilderness by Giovanni di Paolo

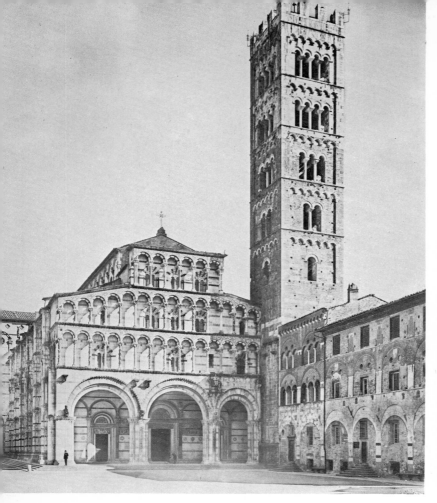

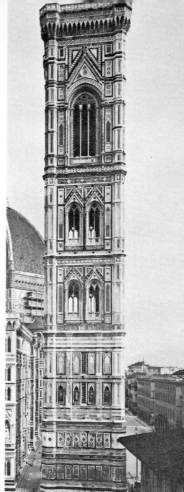

Above Cathedral and tower of S. Martino, Lucca, in Tuscan-Romanesque style
Above right 'Giotto's Tower' at Florence, with polychromed marbling. The first floor only is from Giotto's design.
Right Piazza dei Signori, with the Torre dei Lamberti, at Verona; drawing by John Ruskin

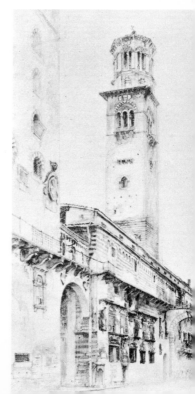

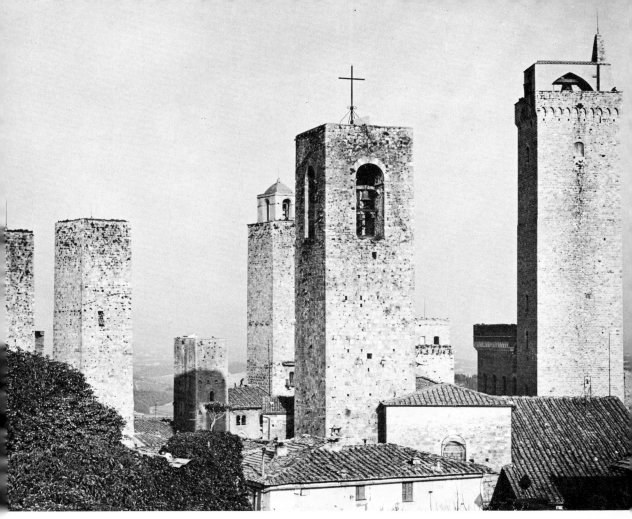

Above Some of the thirteen towers of S. Gimignano. Those that were close enough, and belonged to the same families, were sometimes linked by wooden bridges at the top

Left Detail from the *Triumph of Death*, attributed to Francesco Traini, *c.* 1350, in the Campo Santo, Pisa

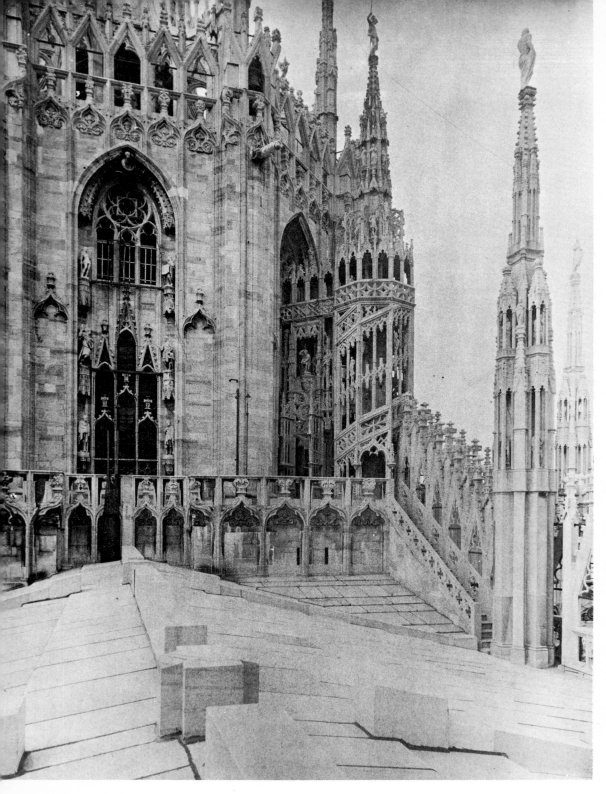

Above Spires and hexagonal open stairway of white marble, on the roof of Milan Cathedral
Opposite St George's princess with fairy-tale panorama of Gothic towers and spires behind, from
Pisanello's *St George starting off to fight the Dragon* in the church of Sant' Anastasia, Verona

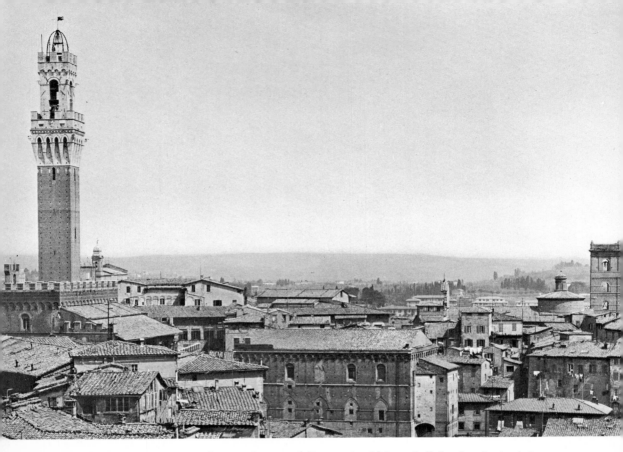

View of medieval Siena, showing the Torre della Mangia with its corbelled and projecting balcony and battlemented surround

A view of the Grand Canal, Venice, by John Ruskin, with the Ca' d'Oro in the foreground

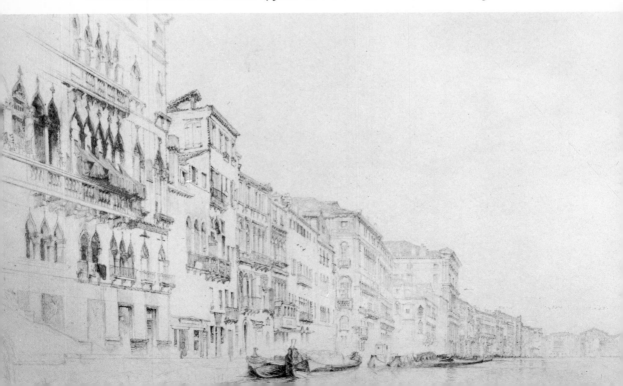

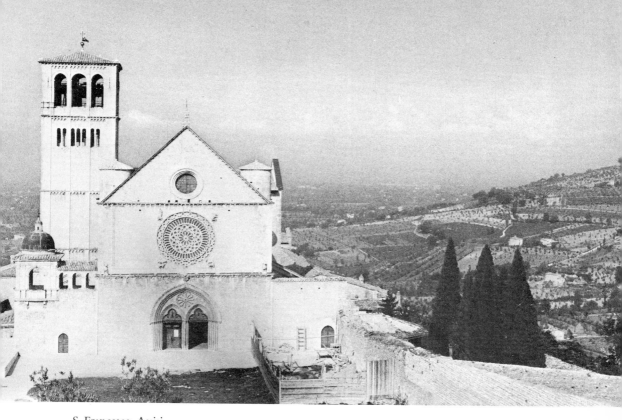

S. Francesco, Assisi

The quays, and little chapel of Santa Maria della Spina, Pisa, intended for the prayers of departing
and homecoming sailors

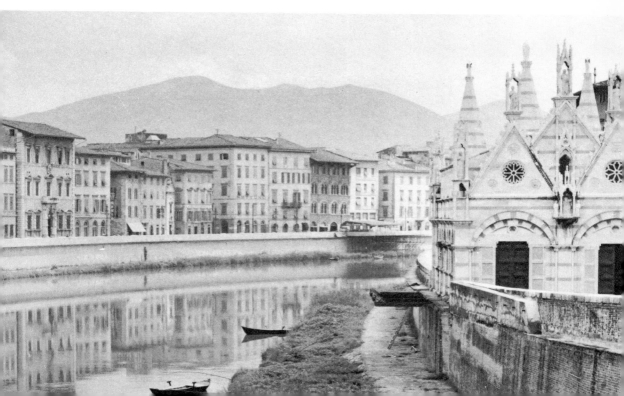

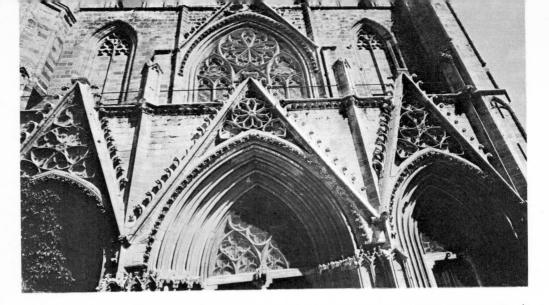

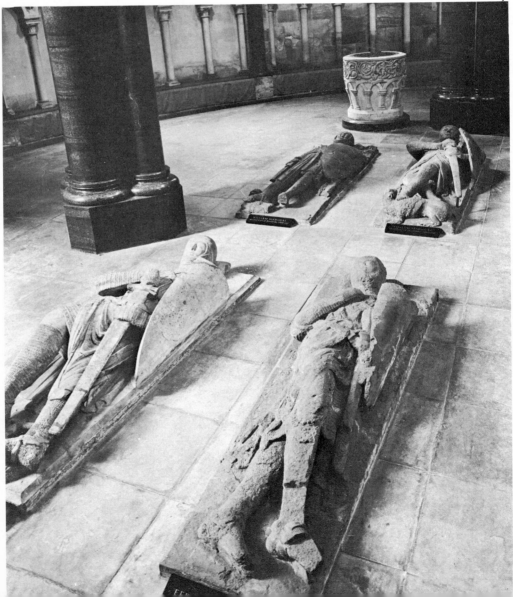

put up telephone numbers; or, by way of novelty, the new computer numbering which saves the copying out of long addresses. The work of art in the Duomo of Siena is the magnificent octagonal pulpit by Niccola Pisano, father of Giovanni, which for all the trefoil arches above its lion-carried columns is entirely classical in conception and execution and shows close and admiring study of Roman sarcophagi.*

The impractical nature of this extravaganza is illustrated in exactly the meaning of that word by the extraordinary flooring, a perversion in taste that was persisted in and continued in the making during nearly two hundred years. Not the least strange feature in this indulgence being the finding of panels of inlaid marble with graffiti by favourite painters, Neroccio dei Landi or Matteo di Giovanni, upon this pavement. It is as though some hostess or hotel keeper – for the simile has to embrace things on an universal scale – with painter friends insisted upon her guests contributing a drawing to her album, and this was published long after her death. In fact a Victorian writer† produced a whole volume on the subject. But this is not the point. The fault of the inlaid and incised pavement is that it reduces all its painter contributors to the same level, while being so impractical in use that most of it is kept under wooden floorboards all the year round. The only comparable sensation is the floor of the Co-Cathedral of St John's at Valletta in the isle of Malta, where the entire floor is inlaid with the marble tombstones of the knights but these, mostly of the Baroque period, are redeemed by the fantasy of the heraldry and the play of skeletons, death's heads, crossbones, hour-glasses, and other emblems of death, forming a veritable and genuine *danse macabre*, and by the poetry of the long French names in the *langues* of Provence and Auvergne. At Siena the inlaid pavement of the Duomo is frankly very ugly, and derogatory to the painters concerned. As to the rest, the rose-window in the choir is ascribed, improbably, to Duccio, and there is the Piccolomini Library with its frescoed walls by Pinturicchio which are still Gothic in a sense despite the Renaissance ornament in their painted framing. They form a charming and beautiful apartment, even if the paintings in the missals exhibited by Liberale de Verona and other masters rank much higher as works of art than the paintings on the walls.

San Gimignano is certainly a mediaeval town, but is it a Gothic one? I would say it is a mediaeval Italian town, which is something different. It looks that, now; how

* This is one of four great pulpits by the Pisano family. The others are the earlier, hexagonal pulpit by Niccola in the Baptistry at Pisa; Giovanni's pulpit for the Duomo at Pisa, and his hexagonal pulpit for Sant' Andrea at Pistoja. These works by father and son cover a period of thirty to forty years, and show a constant and interested wavering and veering between Classical and Gothic, with the Romanizing influence winning in the end, no less than in the beginning. Niccola Pisano's pulpit at Siena is in many ways closer to the classical than Canova.

† R.H.H.Cust, *The Pavement Masters of Siena*, London, 1904. For an account of the morbid fantasy employed in the tombstones at Valletta, cf. my *Malta*, 1958, pp. 9, 10, and at Mdina, p. 44.

Opposite
Top: Triple portal of the Gothic cathedral of Famagusta, Cyprus – built by the Crusaders
Bottom: Effigies of Crusaders, lying in the Temple Church in London

much more so when it had, not thirteen, but fifty-six towers standing! Rather, it is a Romanesque town – it comes as no surprise that Volterra, a town the other side of Siena, had two local families who were in all probability of genuine Roman descent and origin – with a population of probably no more than six thousand at its height of prosperity and – a fascinating detail – 'the more important families in the town built pairs of towers sometimes linked at the top with wooden bridges'.* Nights, at San Gimignano, may have been quiet after midnight, but from dawn onwards, they will have been as noisy and quarrelsome as in the street brawls of Prokofiev's *Romeo and Juliet* with its curious echoes of Puccini, who after all was of not distant origin from Lucca. The frescoes in Sant' Agostino by Benozzo Gozzoli are the most beautiful objects in San Gimignano, but it would be a libel on this most delightful of painters to call him Gothic. The fresh winds of spring blow through his painted architecture, and if there is a pointed window it is disapproved of and put in a corner. His skies and buildings are of the Renaissance, not of the Gothic.

At Pisa and at Lucca there is their own brand of mediaeval architecture, not to be confounded with that of Siena. No one, on seeing the Baptistery of Pisa, or, for instance, the front of San Frediano in Lucca, could fancy himself to be either in Florence or in Siena. Rather, it is more strictly speaking the Tuscan-Romanesque, but with local reservations of particular application to Lucca and to Pisa. And very different again from the same 'Tuscan-Romanesque' of San Miniato, outside and above Florence, which is of green and white, if not exactly polychrome, marble. The group of buildings at Pisa formed by the Duomo, the Baptistery, Leaning Tower, and Campo Santo, are unique in Italy, and indeed in the world. After all, the Doge's Palace and Libreria Vecchia of Sansovino are not visible at all from most of the Square of St Mark's and you have to walk out into the middle of the Piazzetta in order to see them. Here the buildings are all grouped together and a little way away from the town. But none of the four buildings is in the Gothic manner. All are in Tuscan-Romanesque so called. Even the cloister of the Campo Santo has round-arched windows. But the Campo Santo contains on its south wall the marvellous, if damaged fresco of the *Triumph of Death*, painted about 1350, and attributed to a Pisan master, perhaps Francesco Traini. This is indeed a most marvellous painting. It depicts a hunting party riding out, or, more probably, its subject considered, riding back from the chase. Ten of them, knights and countesses, or princesses, with fine sleeves and hats of various shapes. They are gaily talking and turning their heads, to make conversation easy. But the whole party in that very moment have reined in

* Cf. Alec Glasfurd, *op. cit.*, 1962, p. 109. A population of round six thousand as in the cities of Ancient Greece, would seem ideal for the patronage and creating of works of art. What hope is there in the coming con-urbination the whole way from London to Birmingham and back along the M.1. motorway? The answer is none whatever, under either Socialist or Tory rule!

their horses, and come face to face with death. What they see are three bodies of kings in open coffins, in different stages of decay; and the hermit Macarius who holds a long scroll of writing, and bars their way. The far side of the fresco is an orange-grove with angels in flight among the branches; but there is the warning of pestilence, a procession of beggars is on the march, and there is the open charnel pit, and the corpses thrown into it.*

I have tried to write in another place of the exquisite, indeed ravishing frescoes by Benozzo Gozzoli on the other wall of this cloister, but they cannot of their very nature come into any account of Gothic Italy. What must be included, though, is the little chapel of Santa Maria della Spina in riparian Gothic, which is to say, Gothic of the river bank, and in fact one of its walls comes up from out of the river Arno. It is so called because it housed a single thorn or prickle from the Crown of Thorns, and was intended for the prayers of departing or home-coming sailors. This little building, as spiky and prickly as the object of its inspiration, is indisputably in French Gothic, and here on the sea-coast in what was once a great sea-port, may be by an architect who had personal experience of the Gothic of France.

We come now to the problem of whether a town entirely surrounded by walls or ramparts, full of mediaeval churches, and with many towers and old palaces, can be said to have avoided or by-passed the Gothic. I know Lucca well from being taken there by my father at all ages from ten years old onwards, and it never struck my imagination as being Gothic; but, rather, it is mediaeval Italian, and in a vernacular or patois of its own with perhaps a Gothic window, doorway, or other detail, thrown in so as to keep up with the times and prove it was abreast with what was going on in other lands. On the other hand Lucca has none of the hermetic, archaizing tendencies of the Sienese. It had no school of painters who had become old fashioned and perhaps the better for that in their lifetimes. In fact, like Pisa it had few, if any native painters, and the interest lies in its architecture. The ramparts, it is to be noted, date from 1540–1640; they are therefore not mediaeval at all, any more than that anomaly in North America, the walled city of Quebec. And the churches are very decidedly non-Gothic in so far as they can help it. There are Gothic windows in the Cathedral aisles, but the shell or vessel of the building is eleventh-century Romanesque. The interior, it is true, is a little more Northern in feeling perhaps because of the large size of its windows. But the individual style of Lucca is most apparent in San Frediano, of dedication to a sixth-century Irishman, Bishop of Lucca, whom it is difficult to visualize otherwise than as one of the red-bearded, tweed-clad saints or apostles of *The Book of Kells*. It has a pillared front in many tiers which made an unique impact even on a ten-year-old child who will always remember seeing

* For a full account of this fresco of the *Triumph of Death*, as of Benozzo Gozzoli's paintings in the Campo Santo, including his *Noah's Vintage and Drunkenness*, cf. *Splendours and Miseries*, 1943, pp. 106–15.

it for the first time, henceforth coupling it in his memory with St Mark's at Venice, and the interior of the Baptistery at Florence, as among the old and beautiful – but not beautiful only because they were old – objects of the world of human beings. How lucky I was to have been shown such things at that age! The shrine built at Lucca to accommodate the Erse-speaking St Frigidianus is not so much a church front as a card-house built, not of columns, but of colonnettes. Round about this church are several brick towers of the old Lucchese families, one of them with trees growing from its top; while the ruins of a Roman amphitheatre, hereabouts, push the probabilities of genuine Gothic into the background, make such brick buildings of the late fourteenth century as the Palazzo Guinigi a little spurious and indeterminate in style, and excuse the native vernacular in architecture for its accent which is more late Latin or Romanesque than the speech of mediaeval France.

Genoa, by reason of geography, was more exposed to Northern influences, but it is idle to look in it for anything more than a Gothic doorway or window in its steep and narrow streets. The cathedral, with a façade in alternate courses or stripes of black and white marble is in Tuscan-Romanesque, and its three great arched doorways are French enough, yet the whole, exterior and interior alike, is unsatisfactory and unconvincing, as might be anticipated in a commercial republic of which the wealth was to find expression in a street of palaces, the Via Balbi, of a florid splendour that inspired Rubens, fresh from the *nouveaux riches* floridities and strapwork of Antwerp to a volume of engravings. The 'Gothic' of many little harbour towns and villages high in the hills of the hundred and more miles between Genoa and Nice found its outlet in the flights of steps and arches joining the houses together in case of earthquake, making a virtue out of necessity and forming a paradise for nineteenth-century sketchers.

The same ingredients, heated at different degrees of temperature, occur in the Swiss-Italian frontier town of Domodossola, recur again in the 'picturesque' villages above the Italian lakes, and come to a halt at Milan Cathedral which Victorian travellers liked to think was a copy of one of the Italian Alps. It is in fact, like Cologne Cathedral or the new Milan railway station, one of these edifices that are nearly indescribable in words, and for a sensation it is best to get as quick as possible on to the roof from which indeed both Alps and Apennines are to be seen. But it is the spire and array of pinnacles that are interesting; and thus sated one can descend into the Gothic building. Though no one might suspect it, Milan Cathedral is built on a mathematically or geometrically based design.* It is to be admitted that the nicety

* 'It was determined that the elevation should be built up on equilateral triangles so that each aisle should have half the width of the nave; the height of the springing of each aisle should be equal to twice, and two-and-a-half, times, the aisle width respectively; the nave vault should start at a height twice the width of the nave, and so on, until the apex of the nave vault stand as high as the width of nave and aisles combined ... The formula was established with the aid of a geometrician, Gabriele Stornaloco of Piacenza.' Cf. *The Cathedrals of Italy*, by J. W. Franklin, London, 1958, p. 184.

of these calculations is lost on the spectator, for the effect of the interior is haphazard, as of slow accretion. The white, or slightly pinkish marble of the exterior loses its colour in the interior which is a forest of columns; and then the sun may come in again through the enormous windows, bearing with it more than its share of noise from the traffic outside, and the high walls become pinkish again with, if one likes to imagine it, something of the glow of sunrise or sunset on the snows. But one emerges from Milan Cathedral with no very clear idea of what one has seen inside it, and its indeterminate, involved, and insensately protracted history of construction is to blame for this. For a true breath of the Gothic it is better to repair to the frescoes of tennis- and card-players and dancers at the Palazzo Borromeo. In what style, then, is the Castello Sforzesco, built by the Visconti and enlarged by the Sforza family? It is in the style of the wooden fortified bridges of Verona, Lucerne, Cahors, and the old wooden bridge of the Rialto as seen in the painting of *The Miracle of the Holy Cross*, by Carpaccio, in the Accademia at Venice. In other words it is in military Gothic which had less definition of frontiers and was worked according to other books of rules.

The Certosa di Pavia described as being in the Lombard-transition style is in reality a hybrid building in a manner that has a parallel in the red sandstone Hindu-Moghul creation of the Grand Moghul Akbar at Fatehpur Sikri.★ By no distortion of the term can this erection and mausoleum of the Visconti be classed as Gothic. Despite its date, begun by Gian Galeazzo of the name in 1396, it is described 'as unquestionably the finest example of Renaissance work in North Italy', while its abundance of red brick, terracotta, and red and white marbles heightens its affinity to such Hindu-Moghul buildings as the Tomb of Humayun, or the Mausoleum of Akbar at Sikandrah, and renders it unwelcome to late-twentieth-century taste. Not that this is in permanent judgement upon it, but these parallels make it contrary to the ideals – if there are ideals? – of the age. At Bergamo, more than at Brescia, the north is in the air, or is it only that Bergamo has its upper town, and even the lower town is at twice the height of Brescia and the Bergamasque Alps lie at no distance?

At both towns, Brescia and Bergamo, we are already in the *terra firma* of Venice, with the Lion of St Mark in evidence in the chief square. But there is little or no sign of Gothic in either; least of all in the Capella Colleoni of Bergamo which is early Renaissance *in excelsis* coming to completion with frescoes by G.B.Tiepolo. It is a different matter at Verona. In the church of Sant' Anastasia there is Pisanello's fresco of *St George starting off to fight the Dragon*. The lady standing by him, on the other side of his steed, wears the most beautiful of long gowns and headdresses; the Kalmuck-looking individuals in the distance are mediaeval enough, and so are the

★ For an account of Fatehpur Sikri, cf. *The Red Chapels of Banteai Srei*, 1962, pp. 165–70. The Certosa di Pavia is described in *Monks, Nuns and Monasteries*, 1965, pp. 106, 107.

two hanged men dangling from the gallows. Even the town on the skyline in the distance, with its crenellated towers, two structures looking like Gothic tabernacles, and above all the toy forts in the right-hand background, are typical of this great Italian of the Gothic, whose medals of Alfonso of Aragon, of John VIII Palaeologus of Byzantium, in his peaked hat of the Basileus, and his drawings of birds and animals, make it a tragedy that his frescoes in the Doge's Palace at Venice, begun by Gentile da Fabriano were all destroyed, and made way for the later series by Tintoretto and by Veronese. The wreck of another lovely fresco by Pisanello is in the church of San Fermo Maggiore; an *Annunciation* with the seated Virgin under a Gothic canopy of much elaboration. But all else in San Fermo – as indeed nearly everything in Verona – pales in excitement beside the miraculously beautiful and clear triptych, complete with copies of its *predella* from galleries in Tours and elsewhere, by Mantegna. This is perhaps the most lovely and perfect of all Italian paintings left *in situ* on the altar for which it was ordered.

But above all, it is the Tombs of the Scaligeri that strike the note of Gothic in Verona. There are five of these most curious equestrian statues, all of them standing in the open air; and there is nothing quite like them anywhere else in Europe. The Scaligeri were the fourteenth-century tyrants or dictators of Verona, and the canopied and armoured statues of Can Grande I della Scala over the church door, and of Mastino and Can Signorio, all of the same family, together with the iron railing of the little piazza in which they stand, with their crest or device of a ladder worked into its design, are of utmost interest to anyone who aspires to have heard the clank of armour, or seen these warriors clad in steel. Neither of the great equestrian masterworks, Verrocchio's statue of Colleoni (in Venice), nor Donatello's statue of Gattamelata (in Padua) both of them *condottieri* or *generalissimi* of the Venetian Republic quite arrives at this. It is the Scaligeri that give the sensation; but the others of course are much greater as works of art. The Scaligeri are more instant and immediate of effect even if they are like the magnification of armoured knights from mediaeval seals; Colleoni and Gattamelata impress and satisfy, but do not stamp themselves upon the memory.

Padua, which is so near to Venice, was singularly unaffected by Venetian Gothic. The church of Sant' Antonio may have 'a ground plan borrowed from earlier French Gothic churches', but the two towers and seven domes of the exterior, and the surpassing richness of the altars in the interior proclaim it as a work of Latins, and of Latins who have had experience of the Orient, and seen perhaps the Greek churches of Istanbul. But at Padua we are almost within sight of the Campanile of St Mark's, and there can never come such a moment again as embarcation in a gondola, or vaporetto for that matter, and progression down the Grand Canal. The fifteenth-century palace of the Ca' d'Oro is soon waving its lacy lozenges, quatrefoils, and

other orifices in the green wake of passing barges and vaporetti. The Ca' d'Oro is very famous, but is it beautiful? I believe most persons would now agree that it is less so than the earlier, twelfth-century, even Byzantine palaces with their inlaid discs of verde antique and porphyry, and less irrevocably and solemnly Venetian, and of La Serenissima, than the later palaces of Sanmichele, or of Longhena. The next experience of Venetian Gothic is the Palazzo Foscari which is on the right-hand side at the bend of the canal. This is typical in its red brick and white stone dressings, it was extolled by Ruskin, and its progeny extends to the St Pancras Railway Hotel which in its picturesque mass and outline is an improvement upon the original. And so to the Doge's Palace where the same hand may be suspected that worked on the Ca' d'Oro. This beautiful and wonderful, indeed immortal building of pink or red and white marble, is far removed from a façade in the later meaning of that term; as is indeed proved in its irregular and broken fenestration, which is hardly to be noticed and not to be deduced against it as an architectural error. It is unique as a waterfront building, though as much of a 'near miss' as Milan Cathedral; redeemed by the thronged Bacino di San Marco that lies in front of it, and by so many associations of history and architecture that it is not looked at dispassionately.

The huge red brick Franciscan and Dominican churches of the Frari and of Santi Giovanni e Paolo call for attention. But it is the brick if nothing else of the Frari, that is so disappointing; and particularly so to persons who have seen Gothic brick churches in Holland, or in Northern Germany. The plan of the Frari is simple and impressive enough with its twelve circular piers, but it is the monuments of great men that make it so depressing. SS Giovanni and Paolo has really impressive and wonderful fifteenth-century tombs of Doges, many of them three or four storeys high. The prevailing image after seeing the interior is of funerary monuments of militant Venetian Doges by the Lombardi family of sculptors. But this is little to compare in strength with the still living and verdant imagery of Carpaccio's two great series of paintings,★ and with the positive miracle of his *Miracle of the Holy Cross* which gives us the living picture of life in Venice in the fifteenth century; and wonder of wonders where we would most have wanted to watch it in the full splash and flurry of movement at the foot of the Rialto, a miracle to which we could only wish for pendant and precedent a painting of life in Byzantium with the statues of the Ancient World still standing, and the living present as to costume coloured by the furs of Muscovy and the brocades and turbans of the Orient, as it was indeed before the sack of Constantinople by the Frankish Crusaders and the Venetians under Doge Dandolo in 1204.

It is of little use to look for Gothic in Parma or Piacenza, or in Mantua or Ferrara, so strong is the association in this latter pair of duchies with the Gonzagas and the

★ In the Scuola San Giorgio degli Schiavoni and in the Accademia.

d'Estes; unless it be in Ferrara, in Cossa's frescoes in the Palazzo Schifanoia, where the breath of the Early Renaissance blows strongly and dissipates the mists and uncertainties of the Middle Ages. And it is little better in Bologna. There are Gothic palaces and churches if you look for them, but their effect is half-hearted in view of the arcaded streets of the city, the general effect of the Piazza with its bronze statue of Neptune by Giovanni di Bologna, and all the terracotta decorations on the fronts of the palaces by the 'great masters of the art', Formigine and Terribilia. This, despite San Petronio being built 'in the Gothic style', and 'the most highly developed creation in Gothic church architecture in Italy, far superior to that of the Duomo in Florence', an effect which it in fact achieves, and with ease, from the vastly greater interest of the paintings and works of art in its interior. Memories of San Petronio and of San Domenico in Bologna, and of the city generally since childhood, and at the very least since I was ten years old, would never persuade me that Bologna is a mediaeval city, or that this fountain-head of the Bibiena, and other dynasties of theatrical perspective painters, contains more than enough of Gothic detail to maintain a reputation as among the oldest and most important towns in Italy.

Moving south again into the polychrome area south of Florence, it is to find Perugia too much divided between the Romanesque and early Renaissance to yield much of interest in the Gothic field. The Cathedral of Perugia, with a demonstrably unfinished exterior, as is so often the case in Italy (and more often in Italy than in Spain), and the church of San Domenico almost entirely rebuilt by Maderna in 1621–34, dim and 'Gothic' in the dark sense as are both interiors mentioned, mark the absence of authentic Gothic from this predominantly fifteenth-century town with its paintings of the Umbrian school. More particularly, the ravishing little panels of the *Miracles of San Bernardino* by Fiorenzo di Lorenzo, possibly two of the paintings being from the hand of Perugino. Assisi, on the contrary, is a city of Gothic sensation owing to the paintings by Giotto and his pupils, and with the bulk but not the beauties of Gothic architecture. The huge vaulted substructure of the convent of San Francesco, reminiscent in mass and solid weight of the Papal Palace at Avignon, lacks both the sharpened niceties of French Gothic and the earlier Apocalyptic fervour.

But, certainly, the triumph of Italian polychrome building is the outside of Orvieto Cathedral except, that is to say, for its striped or banded sides in zebra stripes of basalt and travertine in Sienese manner, of which the striped dresses of their annual *Palio* are the typical outlet and expression. It is a 'triumph'; but, on the other hand, is it a success? Arnolfo di Cambio is, of course, as usual in this region of Italy, associated with its planning; but, decidedly, an architect more than a painter must have been the responsible agent for its building. The front consists, basically, of four buttresses and three gabled doorways. Above the doorways is an arcaded gallery, statueless for once, and not crowded with stone witnesses. The relief carvings to all

Opposite: Tomb of Mastino II Scaliger in Verona; water-colour by John Ruskin

four sides of the triple doorways are beautiful, but not to be compared with the marble reliefs in the Tempo Malatestiano at Rimini which form the *ne plus ultra* of the art of bas-relief for all time; but the mosaics of the front I would call frankly ugly, while the rose-window cannot aspire to inclusion in any anthology of rose-windows, it is so unimaginative and unrosarian. The interior is, at least, redeemed by the beginnings of a frescoed scheme by Fra Angelico, and its completion on a large scale by Luca Signorelli.

To look for Gothic in Papal Rome is as useless as to search for sham Gothic in Istanbul, but at the distance of some sixty to seventy miles from Rome, and in slightly different directions, are the abbeys of Casamari and Fossanova which are in the Burgundian-Cistercian style of the early thirteenth century. Both monasteries have chapter houses, the mere spelling of which pair of words returns us in spirit to the Gothic North, and there are refectories, octagonal towers, and lancet windows, which are all very well for persons of southern or mercutian background and origin, come out from Rome to look at them, but a little disappointing and tame to those who have in their blood such heroic monuments to faith and austerity as Fountains, or Jumièges, or Vézelay.

Naples under its Angevin kings (1265–1409), the first of whom was younger brother to Saint Louis of France, offers more interesting possibilities. And these are fulfilled and to good measure in the convent church of Santa Chiara, unwittingly restored or converted overnight from a Baroque ball-room into a thirteenth-century interior by the American Air Force who dropped bombs on this 'god-box' in mistake for the main railway station. The effects were sensational indeed. The interior built for Robert the Wise between 1310 and 1350 was revealed intact under the frescoes and the stucco. At the back of the high altar is his Gothic monument, rising to more than forty feet in height, with the king on his throne below a canopy, erected by sculptors from Florence, but conscious, it would seem, of inspiration from France; while other, and beautiful tombs are to titular Emperors and Empresses of Constantinople of Frankish line.* There are more canopied tombs of the Angevin kings of Naples and their families in San Lorenzo Maggiore and in San Giovanni a Carbonara, in which latter is the monument with equestrian statue of King Ladislaus, last male of the Anjou family. The Pisan or Tuscan Gothic makes unexpected appearance again at Amalfi, all the more unlikely because of its admixture of Saracen or Moorish motifs; and because in fact the undeniably characteristic and effective façade of the cathedral in bands of black and white stone, which turn a reddish colour after rain, at top of a steep flight of steps, is in fact a nineteenth-century reconstruction. Yet it catches the right atmosphere and cannot surely be far wrong.

* There are long and full accounts of Santa Chiara, alike in my *Southern Baroque Art*, 1924, and in *Monks, Nuns and Monasteries*, 1965.

The Saracen motifs – by reason of the maritime history of the Amalfitan Republic they are more likely to be Saracen than Moorish – are revealed in the curious cupola to the cathedral tower where the interlacing ornament and the eye-shapes or *ocelli* are reminiscent of those painted on the prows of fishing boats. They come again, and with still stronger impact, in the triple interlacing of the arcades of the cloister; and once again in the simpler cloister of the Cappuccini above the town. This taste of the Orient is to be sought for also in the villages above Amalfi, at Scala and Pogerola, and again at Majori and Minori on the coastline, where it mingles curiously with Byzantine touches which to those who have seen it may recall Mistra, in the Peloponnese; while at Positano, at a dozen villages along the Salerno peninsula, and of course at Capri itself, there is more than a hint of the flat-roofed white towns of the Cyclades and Sporades.

Just exactly those motifs that form the curiosity of the cupola of Amalfi are to be seen again on the exterior of Monreale Cathedral, above Palermo. Whatever it may be, it is decidedly not Norman in origin, even though Monreale was a foundation of the Norman Kings of Sicily; and its 'Byzantine' mosaics apart which must be the work of local and not Greek craftsmen, Monreale is a building in Siculo-Norman style. It could be said, in general, that Sicily because of its Norman and Angevin association, and from even later after 1409 when it was joined with Aragón, is particularly rich in minor Gothic detail. There are for instance Gothic doorways and windows in Taormina, and in many small towns in all corners of the island.

For grander and more beautiful instances of the genuine Gothic we should follow after the Crusaders to Cyprus, to Syria, and to Palestine. In Cyprus – the ruined abbey of Bellepais, of significant name, with its high walls, cloister, dormitory, chapter house, and refectory with intact pulpit, is in reminder of the Gothic North, while above it are the ruins of the yet better-named castle of Buffavent, in the steep rocks. The two towns of Nicosia and Famagusta, too, are full of French Gothic remains. At Nicosia there are the old cathedral, now a mosque, and the remains of two or three churches, while the palace of the Lusignan kings of Cyprus still has its Gothic windows. At Famagusta, again a lovely name, the Greek Cathedral is a Gothic building said, a little euphemistically, to have a façade recalling that of Reims, and there are other vestiges as well.

At Rhodes, the *Via dei Cavalieri*, as it was termed under the Italian usurpation, has the fifteenth-century *auberges* of the Knight in golden stone recalling the wool-villages of the Cotswolds, or the mediaeval towns of the Dordogne. It has not the purity of what is left in Cyprus, complete in itself as that may be. But the Frankish element is in purity again in Palestine and Syria. The chief vassals of Godefroy of Bouillon, the first king of Jerusalem (d. 1100), were the Prince of Antioch, the Counts of Edessa and Tripoli, the Prince of Tiberias, the Counts of Joppa and Ascalon, and

the Lord of Montroyal. Their castles were called Mirabel, Beauvoir, Belfort, Chastel Rouge, Nigraguarda and Blanchgarde, Toron and Scandalion, names taken from the Arthurian cycle and from the literature of chivalry. The leaders of the First Crusade were all Frenchmen; Raymond, Count of Toulouse, Robert, Duke of Normandy, Robert, Count of Flanders, Bohemund and Tancred, Godrey of Bouillon, and his brother Baldwin. They took Jerusalem in 1099. The most impressive of all fortresses is their Krak des Chevaliers, in such perfect repair that the knights in armour could move in again and take up garrison tonight. Its vaulted passages and guardroom and dormitories still seem to echo with the tread of their steeled feet. Two thousand armed men were its full complement.* Another of the Crusader's fortresses, built of black blocks of basalt sixteen feet thick, was guarded night and day by four knights and twenty-eight men-at-arms. Yet another fortress, that of Sahyun, had a moat hewn a hundred and ten feet deep into the rock, and an isolated column of stone of like height left to carry the drawbridge.

After which it is disappointing to find so little left in Jerusalem of the Crusaders who ruled it, with warlike intermissions, from 1099 to 1244. Almost the only relic of their time is the wrought iron grille, between the inner row of columns railing off the rock in the Dome of the Rock or Mosque of Omar, which is the work of French ironsmiths of the end of the twelfth century, dating from when the Mosque of Omar was turned into a church. It is of French workmanship, and so proves itself at the first seeing. But the Crusaders ruled Tripoli for a hundred and eighty years, and Edessa and Antioch for nearly as long, and little or nothing is left of them. And the Frankish Emperors of Byzantium ruled there from 1204 to 1261. The Crusaders, with instigation and assistance from the Venetians under the ninety-year-old Doge Dandolo had sacked the city, left nothing of their own, and destroyed this living relic of the world of ancient Greece and Rome. It could be advanced in excuse that the Turks were in the offing, and sooner or later something of the kind was bound to happen. But this is equivalent to saying that if Dr Crippen had not murdered Mrs Crippen, and buried her remains under the kitchen floor in Hilldrop Crescent, someone else would surely have done so; and of such, magistral or minimal, are the mysteries and imponderables of history.

* For an account of the Krak des Chevaliers, cf. *Arabesque and Honeycomb*, 1958, pp. 153–6. A fantasy upon the names of the Crusader's castles comes in my *The Gothick North*, 1929, pp. 191–7, though it is less fact than fancy.

12

Gothic in Spain

A noisy night with sleep utterly impossible and out of question. With huge lorries, their loads lashed down under tarpaulins, passing under our windows all night long. At least traffic lights, the ultimate refinement in traffic torment had not yet reached provincial Spain. But the cocks were crowing shrilly from three a.m. onwards, and the nuns in a convent across the street after much metallic clanging of bells were at their prayers by five o'clock in the morning. The heat around those early hours was appalling. But there was something feverishly exciting about that sleepless night in Zaragoza. What sort of place would it be where we were going tomorrow? Indeed, in a few hours time.

Would it at all resemble Calatayud which we had seen that afternoon, with its troglodytes in their cave dwellings, its brick towers or belfries, of semi-Moorish design – Calatayud, the birthplace of Martial, the Roman satirist of Domitian's reign, though Ford describes him as typical of the *Andaluz gracioso* and writer of *seguidillas* – Calatayud where the Churrigueresque stuccowork inside the cathedral and the *coro* has lifesize figures of winged horses reminiscent of a Dravidian temple in Southern India? Of the granite pillars carved into more than lifesize figures of men on rearing horses fighting wild animals or spearing tigers, their horses' feet upheld on the shields of men on foot beneath them – all this in the court of the great temple at Srirangam in Southern India – but you can see these prancing horses, their hooves higher than a man's head, in any book on Indian architecture. And in a sort of trance born of want of sleep we were up early ourselves and on the way out of the town.

A road along a river bank lined with poplars, and forming a belt of green, for as far as the eyes could see. But only a mile or two away from the river bank it was the burning plain again. We were on our way to Tudela because a friend, who knows more of Spanish architecture than any living person, had told me a year or two before this to go there in order to see the painting by Hieronymus Bosch that, most appropriately, was to be found in the midst of that apocalyptic landscape. It was the only work by the master in any church in Spain. By which time we had reached Tudela

and were on our way to the cathedral which is surrounded by old buildings and not easy of approach. Within all is grand and dark, with the usual enclosed Spanish *coro* in the middle of the church. When we entered, a beggar was slowly making the round of the altars; a beggar with his legs twisted behind him, and who propelled himself forward by means of a two-pronged wooden contrivance held in each hand, exactly as in Bosch or Bruegel paintings. But it gave one an odd feeling to come up to this beggar in order to put a coin into his hand and find that he had a young and intelligent face, and not at all a mediaeval expression, but the look of someone who had undergone terrible suffering and misfortune in our own time.

There are high painted altars or *retablos* in this church; and there close to the railing of one of the chapels to the right of the high altar was the little panel by Hieronymus Bosch. But the railing of the chapel was locked and no one had the key. We had come all this way to see it and could not get inside. Moreover, the painting was only a few feet away but so small in detail and complicated in symbol that it was not possible even to guess at its subject. It was not by Hieronymus Bosch himself, that much was evident. Nevertheless, in the absence of an authentic painting by him in any Spanish cathedral, it was exciting enough to find this little panel that was so near to him in feeling in a small country town in Spain.

For it is in Spain of all countries that his pictures should be seen. And where better than here at Tudela, anywhere in the world? 'L'Espagne les rechercha avec passion; le souverain comme les grands les apprécièrent à l'égal des plus grands chefs d'œuvres de la peinture ... l'essentiel de ces travaux se trouve aujourd'hui fixé dans la peninsule.' 'Spaniards collected them with enthusiasm; the sovereign like the great nobles (grandees) esteemed them as among the greatest masterpieces of the art of painting ... everything that is essential to studying his work is to be found today in the Iberian peninsula.'* Did not Philip II, a lover of the arts, have his painting of *The Seven Deadly Sins* in his bedroom at the Escorial, where there is a view 'through marble shutters, of the high altar of the church upon which his dying gaze was fixed'? As, also, it should be said, across the church to the bronze funerary group of his father and his mother, Charles v and Isabella of Portugal, and their relatives, kneeling with their faces to the altar; and looking down on them from immediately above where the bronze group of himself and his wives was to be erected, three of his wives, that is to say, excluding Mary Tudor; sculptures by the Italian Pompeo Leoni, that are incomparable in majesty and solemnity in their grim and severe setting, and of a grandeur and a dignity that are all of Spain.

And I was wondering and anticipating this painting we had come to see when I remembered, if vaguely, reading something about Bois-le-Duc where Hieronymus Bosch was born. And here, back at home, I transcribe it from three different sources:

* *Jerome Bosch*, by Jacques Combe, Paris, 1946, p. 49.

'the cathedral of St Jean, undoubtedly the finest in Holland, despite its Flamboyant Gothic style, is notable not only for its fine proportion and rich decoration, but also for its army of little stone mannikins swarming over the flying buttresses and stone copings in a frantic effort to escape the grasp of the demon-gargoyles, or to reach heaven as quickly as possible.'

And in French: 'l'extérieur, d'une ornamentation de style flamboyant, présente plusieurs détails originaux et curieux (de personnages à califourchon sur la faîte des arcs-boutons semblent gravir avec peine la pente des remparts).' Or, again, 'on remarquera notamment un monde fantastique de personnages grotesques à cali-fourchon sur le sommet des arcs-boutons,' which two accounts in French taken together could be rendered 'a fantastic world of grotesque beings astride the top of the flying buttresses seem scarcely able to reach the sloping roof-ridge of the church.'* All this at 's Hertogenbosch or Bois-le-Duc, his birthplace, in, or rather, outside a church where the strange world of monsters and demons was finished and ready in his lifetime (the church of St Jean was rebuilt after a fire, between 1429 and 1450, and Bosch was born in 1450, or thereabouts, and died there in 1516). So the demon-gargoyles and sprites or mannikins riding the flying buttresses of Bois-le-Duc had been there before his eyes since childhood.

The information as to the swarm of beings on the flying buttresses of Bois-le-Duc was as that lost key to the chapel put into my hand. And with my mind still on that world of grotesque creatures on the flying buttresses and stone copings of his birthplace I take the key and unlock the railing into the chapel. We are ready now to enter the kingdom of the beggars and the blind, that further kingdom of Hierony-mus Bosch and Pieter Bruegel, 'le royaume des lêpres et des gueux'; lepers with their faces swathed and wearing great straw hats, bearing bowls of wood to collect alms in, for none may touch them. And in a land no further from home than Flanders, with most of their extremities and features gone, they have fox-tails, four of them back and front, sewn upon a linen shift or surcoat worn over their other clothes; this being their emblem or insignia worn at the Leper's Processions on the Monday after Twelfth Night, and on a day during Carnival.

But it is not far from Spain. Or, if we prefer it, Spain is not far away. The beggars, who are as many as the rooks at this moment building their nests in the high elms on this windy day, are an international fraternity with their own cant tongue and secret or trade signs. Iheronymus van Aeken – that is how Jerome or Hieronymus Bosch wrote his name – who may have gone no further afield than Ghent or Antwerp, knew all their tricks. So much for the beggars who are as inevitable as the flies of summer. But who do not die so easily, and are here and there in hundreds.

* 1. *Fodor's Modern Guides: Benelux,* London, 1958, p. 544 (author, H. Gordon Franks); 2. *Guide Bleu: Hollande,* Paris, 1926, p. 290; 3. *Guide Michelin: Benelux,* Paris, 1964, p. 194.

As to the blind, there have been extraordinary gatherings and concourses of those, too. As, for instance, and for an example of the Golden Section or the Golden Mean in its alternation of hideousness and beauty, during the progresses of the Sultan of Morocco about his kingdom, only a generation or two ago; when there were twenty thousand persons, no less, men and women, including hundreds of the Sultan's ladies, in the town of tents, and, after morning prayer in the encampment before the start of the day's march, saddled horses were brought by the Black Guard trotting past the Sultan for him to choose a mount. Sometimes a white, saddled and trapped in turquoise-blue; a grey housed in rose-coloured silks; or a black, his head half-hidden in primrose-yellow tassels; and we are told that amongst other strange groups of camp followers who also moved with the court, were hundreds of beggars, for the most part blind.

There were even the relics of this ceremony only four years ago in Tangier, when I saw the Sultan, now King of Morocco, riding to the mosque to attend Friday prayers. The street was strewn with sand and lined by the Black Guard brought in buses from Rabat. Their band played at the door of the hotel; black, black faces, white spats, gloves, trousers, and red fezzes. There was a dash of trumpets in the square, and the women whinnying like mares for the young king to come by car, where his six barbs were waiting for him. One, milk-white, a phantom of the whey-bowl, with saddle cloth of crimson silk; another, primrose or daffodil-coloured horse, yellower, far yellower than sorrel; and the grey which he mounted. And among them was the barb 'Bois de Rose', a famous horse of the King of Morocco, with a huge progeny; and when groomed and rubbed carefully, the Ambassador told us, of a golden skin with lights of rose in it; a courser from the stables of the dawn, or white stallion of the rosy-fingered morning; but, here, of golden southern skin, held waiting by a wrist of ebony or porphyry from Niger or from Senegal.

The Moors indeed are not to be dismissed lightly from the history of Spain. Toledo was a bilingual city, where Castilian and Arabic were spoken, during all but the last half dozen years of El Greco's life. Andalucia included, there could be few cities in Spain more Moorish of aspect than Calatayud, which was invoked in the first few lines of this chapter. Is not the name of the city itself derived from Kalat Ayub, 'the castle of Job', while the troglodyte caves in the castle hill are in the quarter called 'la Morería'? It has been written that 'the group of river valleys centred round Calatayud are the heart of the most Moorish section of Spain';* and this could be said in general of the whole region lying between Calatayud, down to the green-tiled, *Mudéjar* towers of Teruel. While continuing to the coast in the direction of Valencia there are towns like Jerica (Jericho) and Escalona (Ascholon) that, as suggested by their names, had a Jewish (Sephardic) population in the Middle Ages.

* Cf. John H. Harvey, *The Cathedrals of Spain*, London, 1957, pp. 187, 188.

When to these strains are added the Hellenic, as evidenced all along the coast from Rosas, the Greek colony of Rhoda on the Costa Brava, to the Punto Ifach, the Greek Hemeroscopeion which is near Alicante; with the Phoenician or Carthaginian as shown by Cartagena, founded by Hasdrubal, son-in-law of Hamilcar Barca, to be the New Carthage. And add in the Moors who were probably outnumbered by the Berbers they brought in with them and who may have settled in quantity in Aragón 'which was too ungenial for the Moors of the plain', and who in their character and disposition may have given half its import to the adjective that derives and was inspired by the name of Aragón; to complete with the native Celtiberian, and the sempiternal Goth of dilution or of infiltration into the blue blood of Spain; – and it will be perceived how many different voices have contributed to the Spaniard.

Upon all of which are superimposed further influences, subtle or broad of implication; the discovery and conquest of the New World, and the fantastic flow of gold and silver therefrom into the Royal coffers, however much was spilt upon the way; and it could be said, the Habsburg chin and physiognomy which became the insignia of the Spanish monarchy and from which in flattery and homage the Spanish lisping is derived – if we are to believe that! But certainly with the universal dominion of Charles v, most significant and important of European monarchs since Charlemagne, another strain is added to which could be adduced in evidence the addiction of his son Philip II to the paintings of the Fleming or Dutchman Iheronymus van Aeken; and which persisted for a hundred years or more down to the flaxen hair, and pale features of the child – Infanta Maria Teresa de Austria, of significant name, in the rose-pink and flashing silver of her hooped skirt in the portrait by Velázquez. For like so much else that is typically and irrevocably Spanish, like the beggars and the sprites or demons of Bosch transferred to the high plains of Castile and Aragón, like the elongated saints and the spiritual ecstasies of El Greco which gave a new meaning and dimension to the most Spanish of all cities which is Toledo – the Infanta, daughter of Philip IV of Spain, had very little Spanish blood in her. The Spanish Infanta incarnate, like her pallid father of the portraits, was an imposition from outside. But it was a personal invasion which arrived from inheritance and at invitation.

From all of which the conclusion is to be reached that unlike the 'Italian' which is for export and not only for home consumption, the 'Spanish' is for Spain alone. It is the fusion of many elements, some of which have set themselves up as 'Spanish' without being Spaniards at all. What could be more 'Spanish' than El Greco's *Burial of Count Orgaz* or his *View of Toledo* though the painter put his signature to both pictures in Greek letters? It is not necessary to bring in Bizet's *Carmen* or Debussy's *Ibéria* at this point as the 'Spanish' works of foreigners who had not set foot in Spain. There are enough 'Spanish' works by Spaniards, to which foreigners at

invitation or on their own initiative have added further, if no less 'Spanish' contribution. Such is the situation, and it is this that makes Spain different from Italy or France.

England is another matter. Our native atmosphere is gentler, and once started on our course to some small extent by French masters in the twelfth and thirteenth centuries we have continued on our way with little influence or admonition from outside. Perhaps the only exception is with Sir Anthony van Dyck, to give him his English title, who in his less than ten years residence in England set up the visual image of an Englishman to a degree only equalled by the examples of Lord Nelson and Lord Byron and whose ghost, it could be said, haunted English painting for all of two centuries until the death of Sir Thomas Lawrence. When the world of Van Dyck is invoked it is the court of Charles I that materializes and not the portraits of his Genoese or Antwerp periods, and its setting derives from the Cavaliers and their ladies, personages to whom there was not the physical still less the sartorial equivalent in other lands. This dramatization by an alien hand never occurred or had opportunity in Italy or France; but if we are to look upon historical figures like the Fleming Charles V – or was he Burgundian or Austrian? – his son Philip II crowned in Winchester Cathedral as King-consort of England, or the Cretan El Greco, as Spaniards – then these contradictions were happening for much of the time in Spain. Nowhere more so than in what is even more typical of Spain than a bull-fight – since there are bull-fights in many Latin-American republics – which is almost any cathedral in Spain. For the elusive quality of which nothing could be more typical than the journey to Tudela, with which this chapter opens, in order to see a painting by Hieronymus Bosch which was at the same time visible, invisible, and in the end not there at all, in the sense that it was a work probably by the hand of Hendrik Met de Bles, or some other follower of Hieronymus Bosch, but not by the master himself.

Arrival at yet another cathedral in Spain is something of which I have often dreamed, having by now alas! visited nearly all of them,* though for the few missing from that total I could put in substitute others in Cuzco, Quito, and in Mexico, and in that manner not fall far short of the entire number. It is a traumatic experience of exciting, even thrilling interest for the closest written and most informative of guide books cannot and will not tell what one may find. Even today in actual experience it is an adventure not so very different in kind from that of the genuine explorers of the scene who in a very real sense were advancing into unknown country only traversed in ignorance by the English and French armies of an earlier generation during Napoleon's wars. As to the foremost and best of them among Englishmen, Richard Ford excepted, even in my own early experience of Spain dating from 1919 it was true that 'if one flags after fourteen hours in a train, one remembers that he sat

* Except for Burgo de Osma and La Seo de Urgel.

sixty-six in a diligence; if one turns from a lump of chocolate and a cold omelette as the long day's provision, one remembers that he lived for weeks on bread and grapes.'*

I say I have often dreamed of another Spanish cathedral, or at the least sent myself to sleep thinking of one, for the reality is familiar enough in its endless divagation. The experience is unique and not to be matched for its special quality. In Italy after little experience one knows beforehand what to expect. But indeed after Spain there is only England. Chartres is incomparable in its sculptured porches and its stained glass windows. Bourges, hardly less so. There is nothing in the world to equal those, if for a full appreciation the extreme rigours of a Wagner festival would be needed with, in place of the hours spent in a darkened theatre, attendance without and within the cathedral from four o'clock of the summer morning onward for some days on end, beyond which experience one could say in all solemnity that it is not possible fully to understand the three 'rose-windows of the dawn' at Chartres. 'The moment of truth' at Chartres, that ill-used phrase, is at dawn and again at sunset; and the costive, plebeian hours are those that lie between. That said, it is true that the wonders of England are the string of cathedrals lying inland from our east coast, Ely, Lincoln, York, and Durham; and in the south, Canterbury, Winchester, Salisbury, and Wells. They may not equal the French in original genius; though what other epithet can be allowed the lantern of Ely, or the strainer arches of the crossing and the vault of the chapter house at the last named of all. These are among the beauties of architecture anywhere in the world, only too little extolled because they are in England. More-over, it is the precincts of the cathedrals in England that are unique; as witness, the green lawns and old houses of all dates of the Close at Salisbury, or the Vicars' Close, 'a mid-fourteenth-century planned street of priests' houses' at Wells, features and appurtenances to which there is no parallel elsewhere. In France, by comparison, the cathedrals have been encroached upon and degraded. They are pressed and crowded in upon by houses. But the Close at Salisbury and the Vicars' Close at Wells have the sempiternal Englishness of the view of Warwick Castle from the bridge below it across the Avon; of the lake and hanging wood of Blenheim with the colonnades and heroic roof-line in the distance; of the Palladian bridge at Wilton; and of the parks at Petworth, Longleat, Badminton.

* Georgiana Goddard King in her Introductory Note to *Gothic Architecture in Spain* by G. E. Street, London, 1914. The book, with its dedication to Mr Gladstone, was first published in 1865. In her preface to the 1914 edition, dated 'Bryn Mawr, Vigil of St Andrews', 1912 (p. 184) the editor writes, 'I did not try to penetrate the Vierzo, almost as inaccessible as sixty years since.' The monasteries and trout streams of the Vierzo in their fastness much overpraised by Ford are now easily seen by car, but the traveller would still have a difficult time who tried to spend a night at, for instance, Morella or at La Alberca, in one of the valleys of Las Hurdes, which is still the most primitive part of Spain. Certainly these conditions of hardship in travelling in Spain prevailed until long after 1909 when the late Royall Tyler published his most excellent work, *Spain: a Study of her Life and Arts*.

In Spain the excitement is of another order altogether. Where else but at Seville and at Córdoba does one pass through cloisters or courts of orange-trees? That is of the Orient surely, and of a world that accepting those are perfumes and scented blossoms of Arabia extends itself further and beyond the lacquered Indies to end at the far side of the world with the maples and the clipped azaleas of Kiyomizu. 'Whoever thought to see a mediaeval temple against a falling foreground of reddening maples,' in the month of November when the dying maples have turned in all their shades from fiery crimson to azalea yellow? Where else but at Kiyomizu, and the other wooden temples of Kyoto? This said, and its wider implications expressed, because the cathedrals in Spain are of polyglot experience, and it is not only Castilian that is spoken with whispering and hidden mutterings of Arabic.* There are the tongues of the North as well but spoken in no sense of exile. They have quickly accommodated themselves to their strange surroundings, and are soon speaking their own language with a Spanish accent. Or it is Spanish with a foreign intonation which is yet something added to, not taken away from Spain.

Here I am bound to say that León just because it is the most French and least Spanish of its peers I find to be less exciting and to possess less of the mystery of its companion shrines. If, as has been written, 'it is a Spanish translation of the French thirteenth-century Gothic, the work of the masters Enrique (d. 1277) and Juan Perez (d. 1296), among others', later restoration has brought it back as closely as possible to the near French original. For myself, I vastly prefer Santiago de Compostela, marvellous as to its exterior, as to its western front or Fachada del Obradoiro with its twin towers at the head of its double flight of stairs, and more so still as to the wonderful 'walk round'† of the cathedral past the Romanesque doorway of the Platería up the steps whence one can look up and admire the Clock Tower or La Berenguela, and so into the fourth plaza of the cathedral known as the Azabachería, but I have to confess that I find the interior of Santiago more than a little disappointing owing to its smallness, not only of scale, but of actual dimensions. The exterior is unsurpassed in interest, in general and in particular, but the interior falls short of this and the discrepancy is quickly felt.

At Seville it is the brick tower of the Giralda, in the knowledge that it was a

* Instances of which are an inscription in plaster in which a Gospel text in Gothic characters is followed by the name of the architect, Musa 'Abd-al-Maliq, and in Arabic script the Koranic phrase, 'There is no God but Allah, and Mahomet is his prophet'. Cf. *Northern Spain* in the *Blue Guides Series*, London, 1958, p. xci, in the article on *Architecture in Spain* by Bernard Bevan. This is at the *Mudéjar* church at Maluenda, a small town between Zaragoza and Valencia. Or the no less extreme instance of the choir stalls at Huesca which are by Mahomet de Borja, whoever he can have been!

† I have tried to describe this 'walk round' of the exterior of Santiago, an architectural experience unique of its sort, and doubtless as interesting as a tour of the Imperial Palace or Forbidden City of Peking, in *Southern Baroque Revisited*, 1967, pp. 135–7.

minaret and that its lower stages are still the work of Jebîr, the architect of the Caliph who united Andalucia with Morocco, the same architect who built the stone towers of the Koutoubia and the minaret of Hassan at Rabat both of them in Morocco – it is the court of orange-trees and the huge and mysterious interior of Seville that make the impression. These, and were one lucky enough to have Seville as the first Spanish experience of the kind, the almost overwhelming sensation as one comes from either side of the nave to the high altar or *capilla mayor* and meets the blaze of lights from the huge golden *retablo* that rises to the ceiling. This is a carved and gilded work unparalleled of its kind even in Spain, while the *reja* or wrought iron screen in front of and railing off the *capilla mayor* among all the marvels of its sort is one of the most splendid in all Spain. Something else peculiar and especial to its country of origin is the processional way leading into the *capilla mayor* from the *coro* or enclosed choir wherein is all the abracadabra of great lectern-supporting gargantuan illuminated choir books, the rows of late Gothic choir stalls themselves, sufficient for ninety-six intoners of Gregorian, no less, and the pair of towering organ-cases with their vertical and level artillery of organ pipes. The iron *reja* is the work of the great ironsmith Fray Francisco de Salamanca, a Carthusian monk of Miraflores, outside Burgos; while the *retablo* is by the Fleming Pieter Dancart who worked also upon the choir stalls. He may have been Flemish of origin but nothing could be more Spanish of effect than this golden tabernacle in its many compartments that climbs from floor to ceiling. After which, unsated, one is ready for the surprises and no less considerable wonders of the *sala capitular* and *sacristía mayor*.

Perhaps in this city of the *seguidilla* and the *sevillana* it is only to be expected that there should be dancing with castanets before the high altar. This is performed by the *seises* or choristers on eight days during Corpus Christi, on the afternoons of eight days for the Immaculate Conception, and for three days during Carnival, nineteen performances in all each year. It is supposed to be a survival from the Mozarabic ritual, *seises* meaning 'six', but there are in fact eight or ten small boys, dressed like pages of the reign of Philip II (1598–1621); crimson doublets with yellow stripes, and white satin kneebreeches slashed on the outside to show a crimson and yellow lining; their stockings are white, and they have white shoes with crimson and yellow laces. Over the right shoulder they wear a white sash, ending in a crimson and yellow tassel on the left side. Their hats are of damask to match their tunics, turned up in front to show the white satin lining, and with a plume of coloured feathers at one side. In further detail, they wear scarlet and white for Corpus and blue and white for the festival of the Virgin. Where else could this be than in the city of the *saeta*, the impromptu 'arrow of song', of Gitano or Flamenco inspiration, uttered by the Gypsies as the holy images are carried past; than here in the city of La Macarena, where the embroidered dresses of the Virgin are to be seen, and as well the rose-pink 'suits of

lights' offered in gratitude for lucky escapes by Manolete and other matadors? And the *seises* of Seville, in conclusion, wear their plumed hats while dancing, and are attended by a man in black wearing a wig and a white ruff, and carrying a silver mace.

Yet, with all this, it is the cathedrals of Burgos and Toledo that prevail. It is the accumulation, the bigger orchestra of detail in these two latter. The exterior of Santiago with its four plazas and their facing buildings to which as much attention could be devoted as to a 'walk round' lake by one of the great tea-masters of Kyoto, even though the effects are unconscious and have accumulated during the ages, affords a panoramic experience of the architecture of all ages to which there is no parallel elsewhere. Burgos and Toledo are of another order. At Burgos it is the twin spires of open stonework by the German master Hans of Cologne, and its central lantern that flowers into eight elongated and floreated turrets by the long-ago Hispanicized Francisco de Colonia, his grandson, that form the sensation; I have called them the 'bluebell spires of Burgos', but in fact they are like the golden dried husks of bluebells and not the living flowers, and the central lantern is like some circular freak of nature, circle or fairy ring of bluebell husks. Would not the two twin spires of Burgos be more interesting were they different from each other, as at Chartres, and not the exact twins as at York or Lincoln? Slavish copies upon this scale always weary and depress. But the exterior, although it does not compare to Santiago, well repays the circumambulation.

At Burgos it may well be that attention is first drawn to the Capilla del Condestable which is by Simón, the intermediate or middle of the three generations of masters from Cologne. In it lies buried Don Pedro Fernandez de Velasco, Conde de Haro and Hereditary Constable of Castile, and his wife, and the chapel still remains in the possession of his descendants. There are statues of 'wild men' or satyrs, of pages in pairs like the knaves off playing cards holding up shields of arms, and domesticated lions in pairs erect on their hind legs; and up above our heads the open-work, eight-pointed star-vault or *cimborrio* of the ceiling; while the chapel has a beadle in a gown of green velvet, and its own sacristy and treasury. The emphasis put at Burgos upon the railed-in processional way from the *Coro* to the high altar, and back again to its fantastic accommodation of no fewer than a hundred and three carved walnut choir stalls, perhaps lead one to expect some unusual, even transcendental importance placed here upon processions. And walking round the cathedral into the north transept one comes upon the extraordinary conception of the Escalera Dorada, a double stair coming down to the floor of the cathedral from the steep bank outside, a stair with a balustrade which is a masterpiece of wrought iron work by a French ironsmith or *rejero*. The architect was Diego de Silóee, son of the sculptor of the tombs in the Cartuja outside Burgos, who also was of German and probably

Jewish origin. In the excitement engendered by this strange architectural invention, one wonders for whom it was intended, and what processions were to come down that stair on to the floor or stage of the church.

This is the answer. 'To be best appreciated the Escalera Dorada should be seen on a Maundy Thursday, during the pomp and pageantry of the ceremonial washing of the feet of the poor.' And the same writer tells of 'the hundreds of candles ranged upon the balustrade of the flights of stairs, making the gilt bronze dolphins and the winged angel heads dance and shimmer ... while the organ booms and the servitors in their astonishing dalmatics of gold and silver damask and wearing long red wigs carry the silver basin and linen towel before the mitred Archbishop of Burgos.'* The 'long red wigs' are a peculiarity before noticed. I have written elsewhere of how during a visit to the old cathedral or La Seo of Zaragoza, while a funeral was in progress, I caught sight of a man 'dressed like a notary or lawyer's clerk of the mid-eighteenth century, and wearing a short, close fitting wig, close and unkempt, or ragged from long wear, and to which his face and the expression of his features had, as can happen, grown into or accustomed themselves'. He was one of the two beadles of La Seo; and both beadles in their wigs now appeared heading the procession. I described them as 'yellow, musty wigs', but, also, they had red, or shrimp-pink lights in them.

What is the point or meaning of the red wigs? Are we back again *mutatis mutandis* in the time of Anne of Denmark, mother of our Charles I? – of whom there is a portrait in starched ruff and monstrous farthingale, on which sits perched a small black terrier dog. She wears a red powdered wig, and on a ribbon in the sky is written her motto '*La Mia Grandezza Viene Dal Eccelso*' (a motto which was surely not without effect upon her son). Another portrait of her shows her 'in a white dress with a feathered fan and a flaxen wig, this time almost albino'. Red hair we know is admired in Spain. Was a red-powdered wig the fashion; or was it perhaps the hieratic wear of scriveners and lawyers come down in the world? And I was seized with curiosity about these red wigs, to the extent of wanting to know how often they were renewed and where they were made. Quite a few of them are still worn in Spain in cathedral circles. What colour of wig is worn by the man who attends the *seises* of Seville, 'wearing a wig and a white ruff' when they dance before the high altar? And at Sigüenza, far away in Castile, an ancient city still with fewer than five thousand inhabitants, with an early Gothic cathedral and the beautiful tomb of the Doncel, a young man by name Martín Vasquez de Arce, slain before Granada in 1486, and depicted lying on an elbow, reading a book of poetry, we would hope, not just his missal; but, also, at Sigüenza and nowhere else but there and at Seville, the choristers during certain festivals wear pages' dresses like the *seises* and we would think dance with castanets and are attended by a beadle in a long red wig, but these

* *Baroque in Spain and Portugal*, by James Lees Milne, London, 1960, p. 43.

hazards it has not proved possible to verify. So few persons stop at Sigüenza, and never at the right time to see the ceremony. The unvarying nature of these strange red wigs would lead one to think there must be some ecclesiastical wig-maker-in-chief who makes or refurbishes them. In Seville, let alone in Sigüenza, no mere barber would undertake this! There must be an address to which to apply for new ones, or send the old ones for repair; and perhaps it is only the incident, here relegated to a footnote, that makes me think the address may be more Catalan than Spanish.*

Toledo is the place in all Spain where the ecclesiastical past is most pronounced and vivid. More so even than at Santiago de Compostela. At Toledo the cathedral is larger in scale, more complete in its appurtenance of *sacristía* and *antesacristía*, *sala capitular de invierno* or winter chapter house, with its *antesala*, *vestuario* and *ropería*, names which speak for themselves. And, as well the *ochavo* (an octagon designed by the architect son of El Greco), the *tesoro*, and in speciality, beside all the other chapels, the *Capilla Mozarabe*, where the Visigothic or Mozarabic liturgy is performed daily (as in six of the parish churches of Toledo until 1851, and in the *Capilla de Talavera* at the old cathedral of Salamanca, six times a year). Of and among which holy places in Toledo, there should be more special mention of the *Sacristía* which is a picture gallery in itself, with its painting of the *Expolio* by El Greco and its painted ceiling by Luca Giordano; the work of *Mudéjar* or Moorish craftsmen which is much in evidence in the ceilings and doors of many of the chapels, and the *vestuario* and *ropería* with their astonishing collection of vestments, some of them as with the robes of the *Nōh* actors of Japan, made from the robes of great nobles, or even kings; complete sets in crimson or green velvet of the sixteenth century, and earlier sets of heraldic import like tabards, or like the kings and knaves off playing cards.†

At Toledo there are no fewer than three chapels in the Flamboyant Gothic of the *Capilla del Condestable* of Burgos. One of them, the *Capilla de Santiago*, was built in the form of a hexagon by the Condestable Alvaro de Luna, Master of the Order of Santiago. This knight, who was beheaded by the Infante, later Henry IV in 1449, is buried in a tomb erected by his daughter. His marble effigy lies, in marble in full

* The late Sir Eric Maclagan sought out and visited the snuff-mill, near Barcelona, where snuff of a particularly strong brand was ground for the Cardinals in Rome. He duly gave me some of it. The purple cloth for their robes is woven in Cologne, called, of old, the 'Rome of the North' because of its number of churches, and where carnival was celebrated 'with as much spirit and pomp of masquerading' as in Rome or Venice. I have to admit to writing one day in a spirit of niggling enquiry to find out where the ten 'spinster ladies' of the almshouse or Hospital of the Holy Trinity at Castle Rising, in Norfolk, bought their new hats. I had seen them crossing the road to church on a Sunday morning in their long red cloaks with the Howard badge of a white horse (founded by the Earl of Northampton in 1614), and pointed black hats of James I's time. There is no sight so genuine as this in all the principality of Wales. Reply came to me that the new hats were supplied in bulk, every four or five years, by a hatter in King's Lynn.

† The collection of vestments at the monastery of Guadalupe, in Estremadura, is even more varied and beautiful than that at Toledo. It is probably the finest collection in the world.

armour, with his wife at his side, his sword between his legs, with four knights of Santiago in hauberk mail kneeling at the corners. According to Ford 'under these tombs there exists a vault, which had to be repaired at the beginning of [last] century. The workmen who entered it said that the skeletons of Don Alvaro and his wife were seated at a table, the head of Don Alvaro being placed before him.' Don Alvaro had, it seems, prepared a tomb for himself during his lifetime, which his executioner the Infante, later Henry IV, destroyed and had two pulpits of gilt bronze, still in the *capilla mayor*, made of their metal. In appendix to which romantic history it is almost too good to be true that the earlier bronze effigies on the tomb of Don Alvaro and his wife, Juana de Pimentel, 'were so articulated as to rise from a recumbent to a kneeling posture when mass was being said'.*

There is, as well, the extraordinary affair of gold and marble known as the *trasparente* which may be admired or not according to taste and mood, though it is impossible to deny that it has attributes of poise and balance more appropriate to a troupe of acrobats than a monument to celebrate the gift of the Holy Communion to mankind. But all such excitements pale before the more solid achievement of the *coro* and the *capilla mayor*. The last named has a painted and gilded *retablo* that rises in five storeys and a multitude of monuments both on its inner and its outer walls; while the *coro* has choir stalls to the number of eighty all told, of which fifty seats and five flights of steps are of walnut wood carved with reliefs of the conquest of Granada by Ferdinand and Isabella, to be studied, if strength is left, for their Moorish costumes. These, with show of scimitars and turbans, are by Rodrigo Alemán, of whom more later. After which only the most resolute will have energy to admire the stained-glass windows which would entail yet another perambulation of the entire church; or can wait for the *tesoro mayor* to open with much jangling of keys, and be shown the silver *custodía* of Enrique de Arfe and other treasures. Instead, we leave by a side door with only a passing thought for the *Gigantones de Tarasca*, giants and 'big-heads' or *cabezudos* of pasteboard, including a comic giantess called 'Ana Bolena', that were housed when I saw them in 1919 in a room in the *claustro alto*, or upper cloister.

After Burgos and Santiago, after Toledo and Seville, what more could there be? But the answer is that Salamanca and Granada – the latter, even without the Alhambra – are almost as wonderful and as full of treasures. At Salamanca, in particular, the perfection of the Isabelline Gothic is to be seen at the New Cathedral or *Catedral*

* Compare the 'articulated' statue of Santiago in the Royal Nunnery of Las Huelgas, outside Burgos, 'which performed the ceremony of knighthood, and even placed the crown upon the heads of kings'; and the 'removable' armour and heraldic coats-of-arms on the bronze effigies of Charles V and of Philip IV, by Pompeo Leoni, in the church of the Escorial. These kneeling effigies are twelve feet high, but their stature seems normal in that gigantic church.

Gothic in Spain and Portugal

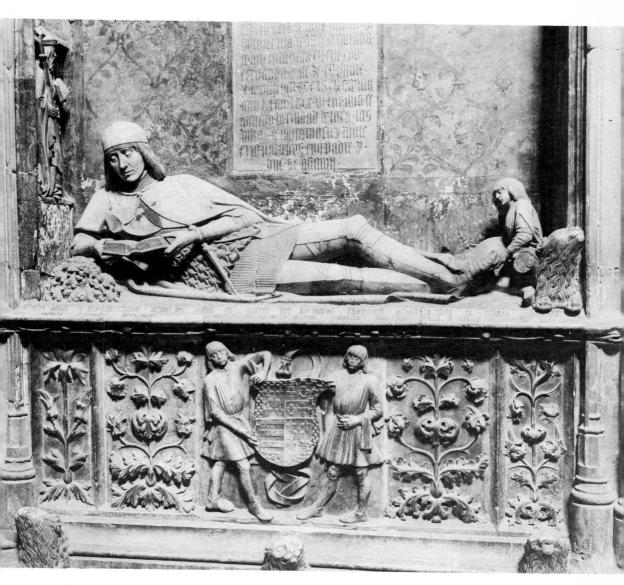

Tomb of 'El Doncel' in the Cathedral of Sigüenza

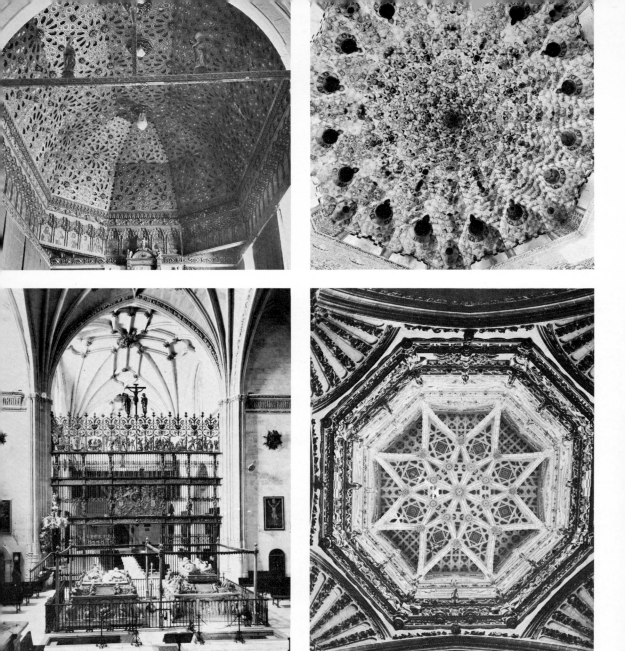

Top left Artesonado ceiling of the throne room at the Royal Convent of Santa Clara, Tordesillas
Top right Honeycombed ceiling in the Sala de las dos Hermanas, in the Alhambra, Granada
Bottom left Reja in the Capilla Real at Granada
Bottom Right Vaulting of the octagon over the crossing of Burgos Cathedral
Opposite Honeycombed ceiling of the Sala de las Abencerrajes, in the Alhambra

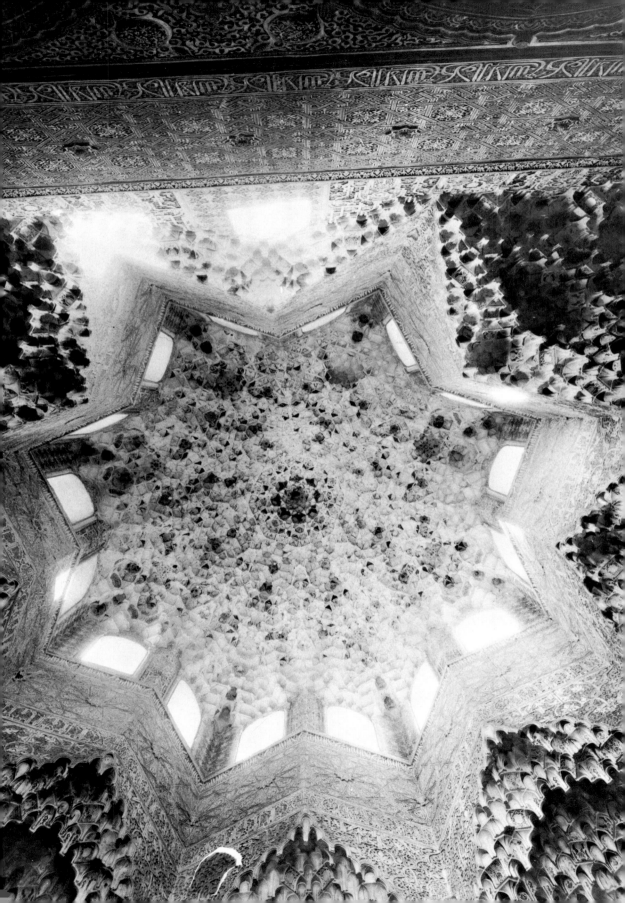

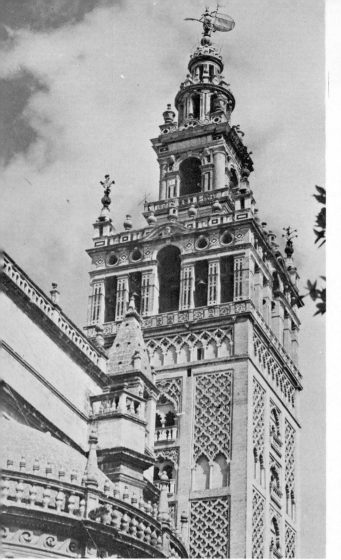
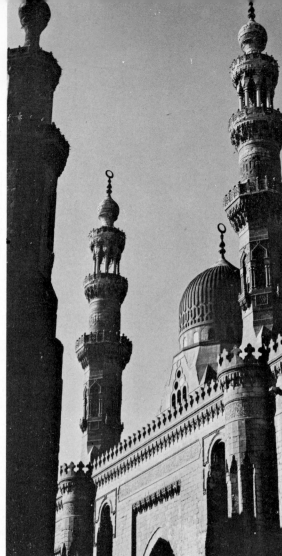

Left 'La Giralda', the Moorish bell tower of Seville Cathedral
Right Minarets of the Coronation Mosque and Sultan Hassan Mosque, Cairo

Opposite

Top Moorish castle of Coca in Old Castile
Bottom left Seises in costume preparing to dance with castanets, for the celebrations of Corpus Christi
Bottom right Manueline doorway opposite the entrance to the sacristy at Alcobaça, decorated with tree motifs, coral and seaweed

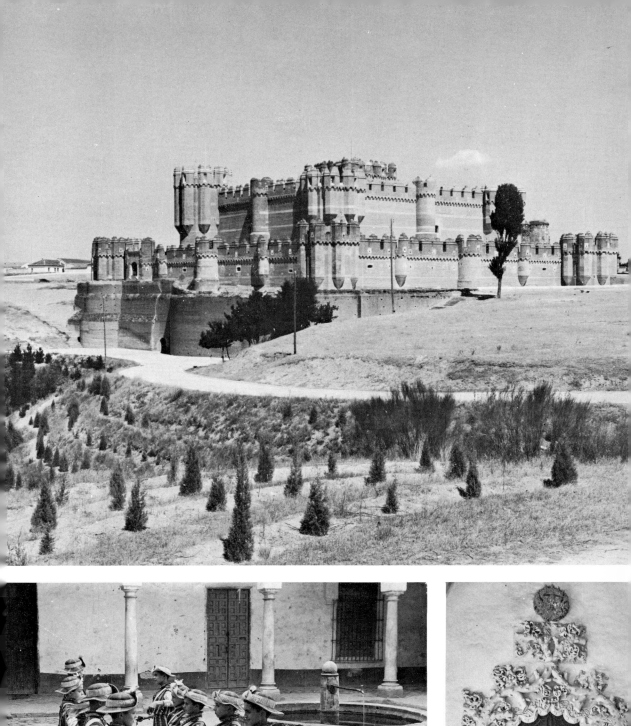

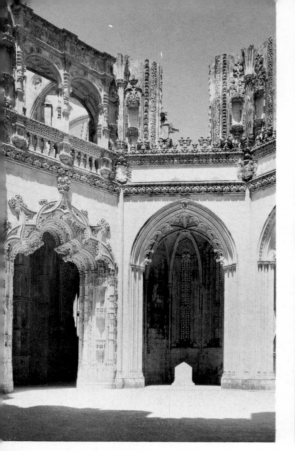

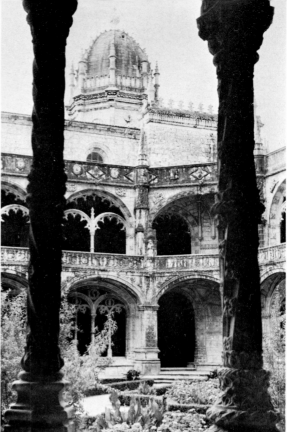

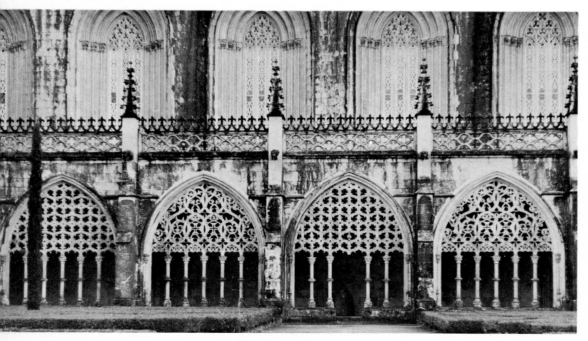

Top left The unfinished chapels of Batalha with portal, 1509, by Mateus Fernandes
Top right Cloister of the Jerónimos at Belém, by Boitac and João de Castilho
Bottom Traceries of Royal Cloister at Batalha
Opposite Façade of the Royal Convent of Christ, Tomar (1510–14), with maritime motifs: ropes, anchors, corks and a porthole with furled sail

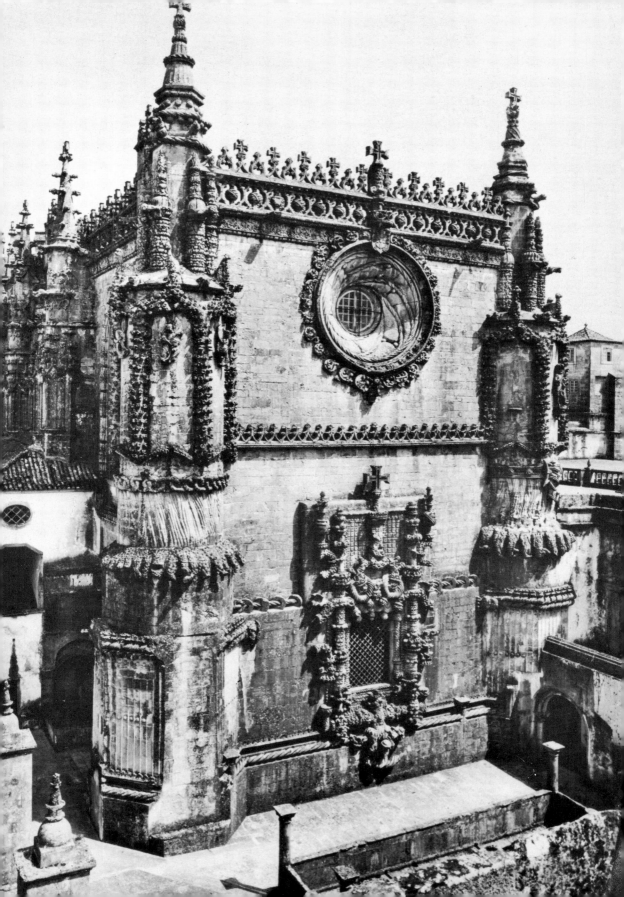

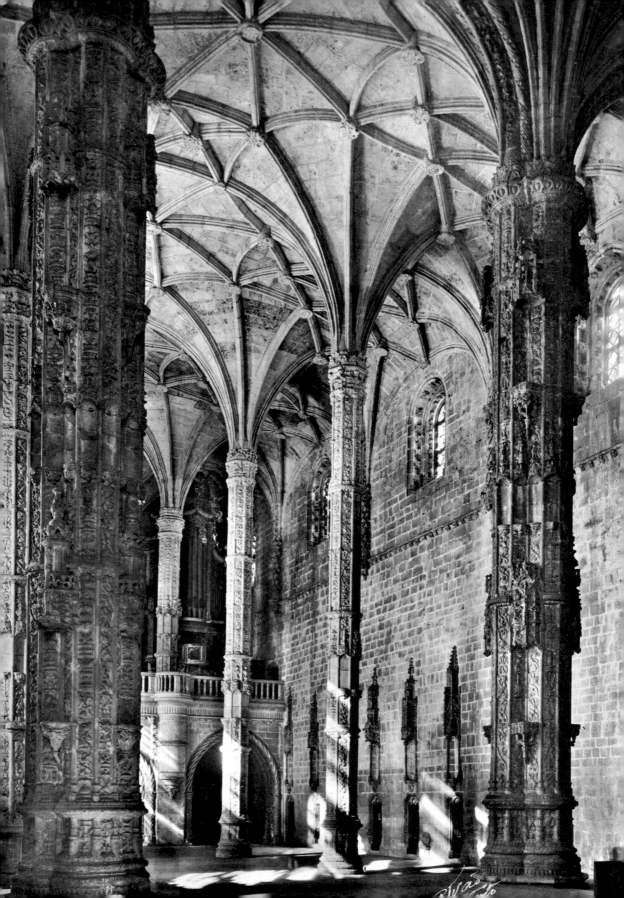

Nueva in its portals or flat entrances carved with a multitude of statues, busts, medallions, and coats-of-arms in the pale golden, the even silvery-golden stone of Salamanca, and in a kind of Gothic entirely different from that of Burgos, less Northern perhaps in spirit, lacking as it does the influence of the two dynasties of sculptors and architects from Nuremberg and Cologne.* But, then, the *Catedral Nueva* of Salamanca is the work of a native born Spaniard, Juan Gil de Hontañón and his son Rodrigo, who were also responsible for the cathedral at Segovia. There is German influence nevertheless in what seems so typically Spanish, as can be seen in the stellar vaults of both cathedrals mentioned, as, also, at Burgos where I have compared the open traceried, eight-pointed star-vault or *cimborrio* of the ceiling to a white passion flower or clematis from the blanched colour of the stone. Salamanca is a city that has more of architecture in it than Santiago de Compostela, but the buildings are more even of distribution and not centred entirely round the Cathedral. There are wonderful things in Salamanca from the Romanesque at the *Catedral Vieja* down to the notorious works of the Churriguera and Quiñones families of architects which yet emerge as remarkably restrained and sober on examination. Indeed the Isabelline Gothic could be more seriously criticized though the unerring technique and irreproachable taste of its flat ornament disarms judgement. Although it is so different both in theme and in intention, some of the freshness of view, as of a *primavera* and a spring awakening touches the ornament and the foliage of the Isabelline Gothic and makes it akin to the majolica reliefs and the medallions of the della Robbias, though colourless in its pale golden stone, and despite its being not a new beginning, but the ending of the Gothic. At Granada it is the *Capilla Real* of the Cathedral, where Ferdinand and Isabella lie buried, that redeems the comparative dullness of the rest of the building, in part it has to be admitted because of the astonishing *reja* of the Royal tombs, the work of Bartolome de Jaén. It is immensely tall with much display of heraldry upon its upward course, to end with elaborate silhouette scenes from the Passion below the final floreated cresting which is not far below the ceiling. One forgets the white marble tombs by a Florentine sculptor of the conquerors of Granada in the splendour of the *reja* and the interest of the other treasures.

In Spain, by contrast to other countries where there are Gothic buildings, it is noticeable that one remembers more often some of the contents than any part of the shell or fabric of the building. This, in criticism of the architecture, but by way of proof of the incomparable nature of the contents. Thus, at Barcelona one remembers the interior darkness which is very pronounced, the turban'd Moor's head under the

* Hans of Cologne had been brought to Spain by the bishop of Burgos, Alonso of Cartagena who was of Jewish descent, on his return from the Council of Basle. Gil de Silóee was Jewish, and the son of a merchant of Nuremberg called Samuel and his wife Miriam. In the next generation, the children of both families were born in Burgos.

Opposite: Interior of the Jerónimos at Belém, supported on giant columns

organ; the *sillería* or array of choir-stalls commemorating in their coats-of-arms the first and last Chapter of the Knights of the Golden Fleece held here by Charles v in 1519, a work, it could be said, by Teutonic sculptors of proper German mediaeval heraldry; and the 'Capitoline' geese of the cloister-pool complete with their hutch – but one forgets the building, itself, 'the crowning glory of Gothic architecture in Catalonia'.

I think it is the same nearly all over Spain. For what does one remember of the Cartuja monastery, outside Burgos, though this is perhaps not a fair example for the church is not much more than a chapel yet it contains the finest tomb in Spain? This is the monument to Juan II and Isabel of Portugal, which is double star-shaped or sixteen-sided, or, if that be simpler to understand, like the interesection of two squares superimposed upon each other. Both this, and the wall-tomb of their son, the Infante Alfonso, and the equally astonishing *retablo* are the work of the mysterious Gil de Silóee to whose Jewish origins the 'star of David' pattern of the Royal tomb perhaps has reference. At Zamora one recalls the Byzantine-looking dome of the Cathedral (like nothing in Byzantine lands!) with its corner turrets that suggest Saracenic helmets, but it is the marvellous tapestries that stay in mind.

The journey from Palencia, which lies north of the Duero soon to transform itself into the Douro and flow down through the vine-clad hills to Oporto, all the way to Plasencia which is not far from the Tagus upon its way to Lisbon, takes one through some of the least known but most interesting parts of Spain. Since there comes a time in our lives when there must be an end to everything, even to hypothetical journey-ings in Spain, let us so contrive it that we pass through Tordesillas, where is the Royal convent of Santa Clara to which the public these last four years have been admitted, as to the *Descalzas Reales* in Madrid. It was at Santa Clara that Juana la Loca, mother of Charles v, passed forty-nine years of imprisonment, or was in fact shut away for madness. It had been the palace of Pedro the Cruel, and the truly marvellous *artesonado* ceiling of his throne room, the work of Moorish carpenters, is now the roof of this part of the convent chapel. From Tordesillas the journey could be continued by way of Madrigal de las Altas Torres, most beautiful of place names, where are more *Mudéjar* ceilings and the brick walls of the little town 'form an exact circle 744 yards in diameter'.* Thence to Ciudad Rodrigo, near the frontier with Portugal, where is a spiky cathedral in provincial Gothic, of stone which is 'like fossilized mud of varie-gated colour, and looks as though lumps would fall out at a touch', but I must admit to some confusion in my mind between it and the cathedral at Badajoz, another frontier town with Portugal. As I write, I have both of them clear in my mind again;

* Bernard Bevan, *History of Spanish Architecture*, London, 1938, p. 122. The quotation, below, about the cathedral at Ciudad Rodrigo is taken from *The Cathedrals of Spain*, by John H. Harvey, London, 1957, p. 120.

but it is the cloister at Ciudad Rodrigo that I remember in particular, and some disappointment at the supposedly 'Rabelaisian' scenes on the carved choir stalls by Rodrigo Alemán. At Ciudad Rodrigo again, and for a last time, I could not resist one more foray out of the feudal castle which is now the *parador* to the extraordinary village of La Alberca with its inhabitants who are probably of Berber origin. And thence, on a hypothetical day indeed, for they are many miles apart on the worst roads, through the costume villages of Montehermoso, Lagartera, and Oropesa, to Plasencia where the remarkable torso, no more, of the cathedral is a work of genius which leaves a very strong impression. It is unfinished but on a giant scale, the work of Juan de Álava otherwise unknown to fame, while it is on the *sillería* of no fewer than seventy-two choir stalls that the sculptor Rodrigo Alemán has run riot and left behind him the legend of his imprisonment for blasphemy in one of the towers, where he made himself a pair of wings from the feathers of the birds (jackdaws?) that he snared, threw himself from one of the windows, and was killed, a legend that magnifies of itself when one looks up at the giant fragment of a church and sees it has no tower.

I find that one remembers Spanish cathedrals very notably on account of their *rejas* or wrought iron screens which are a feature peculiar to Spain, and as characteristic of the country as that they should by tradition be the foremost makers of cloaks and of fans. The iron grilles of the *coro* and the *capilla mayor* at Toledo, Burgos, and Seville are magnificent of effect and afford wonderful examples of the work of the *rejero*, very different in temperament from the Italian stucco. The title of '*maestro mayor de las armas de hierro en España*', which was accorded to the greatest of their ironsmiths, Juan Francés, is more than justified in his screens to the Mozarabic chapel and the *sagrario antiguo* in Toledo Cathedral. And he worked again at Burgo de Osma, a town lying between Segovia and Palencia; his fantasy in this intractable medium reaching to its height at Alcalá de Henares where the iron screen incorporates the arms of Bishop Fonseca and includes a hare hunt in its cresting.* This fantasy will come as no surprise to those who know the *rejas* of Toledo, Seville, or Granada. The towering iron grilles of the *capilla mayor* at Cuenca stay long in memory, and the Spanish *rejas* in entirety of which they are part, form a subject to themselves; the work, as it were, of ecclesiastical armourers, in antithesis to the armourers of Augsburg and elsewhere. Those knights of noisy tread, like sculptures in blue steel, of blackened or sinister intent, with the *rejas* of ringing metal here in mind at Cuenca, even now not easy of access, 'one correo daily from Madrid in eleven and a half hours', but in the 1882 edition of Ford – and in Cuenca it is difficult not to think of this – 'railway in construction, open in this year to Tarancón' (about half-way), 'meanwhile, diligence from Madrid daily', and the owner of the hotel which is 'tolerable,

* Bernard Bevan, *op. cit.*

good food, keeps a little *tartana* which may be hired for excursions'. Where to? Perhaps up a delicious river valley 'where fine violet jaspers are found'. And were one taken ill at Cuenca in 1882? It can have been no better at all than the regimental surgeon in Wellington's wars, only those eight years after the Carlist army had entered the town 'by a double treason' and the nineteen-year-old Doña Maria de las Nieves 'urged the troops on to sack the town'. Spain of the Spanish castles was a living fact, then, and till even later.

All or any expectation of which is more than fulfilled by the castle of Coca, not far from Segovia, of rose-coloured brick, all barbicans and turrets, and not so much even *Mudéjar* in effect but looking as though it has been transported all the way from Rajputana. But perhaps the astonishing view of Olite from the train window between Zaragoza and Pamplona is even more of an epitome of all castles in Spain. But there is no need to scramble up hills in order to see such castles. Daroca, between Calatayud and Teruel, again in the part of Aragón which is more Moorish, perhaps more Berber than Andalucia itself, has its hundred towers; and there is the extraordinary day-by-day spectacle of Avila, more Romanesque than Gothic it is true, with its walls and gates and semi-circular towers, and within those walls on that high plateau with the great boulders lying about as though swept down by an eternity of glaciers, inside the high-lying city where it can be so cold at night, mediaeval churches and convents of the Middle Ages with mediaeval sweets, Yemas de Santa Teresa, Huesillos fritos, Glorias de Avila, and others, for sale at the nuns' grille.

It is the inventoried or detailed, not the total comparison that makes Spain richer in such things than England. For if it be true that there is nothing in Spain to exceed the totality of Ely, Lincoln, Durham, or of Winchester, Salisbury, Wells, then, again, we must bear in mind the overwhelming whole-hearted impression of Toledo, Seville, Burgos, with no suggestion at all of any weakening or altering of faith. The Protestant ascendancy has left its ranged chairs and hymn books, its Jacobean four-poster or tester tombs, and the wigg'd peers and gentry of Roubiliac, Scheemakers, and Rysbrack. But it is a change of key. Another spirit has entered them. Such churches are altered and are not the same again. Their continuity is broken, even if it has been resumed but is like an old house now lived in by another family. That is why I think for instance that Canterbury can never have the same solemnity as Toledo or Seville. The course has been deflected. The river has changed its channel, and even the old music does not sound the same. It is the very bric-à-brac of Spain that makes the atmosphere. The organ-cases, often in pairs like twin castles, level their artillery of pipes at you and let forth their salvos, their broadsides, and chain-shot of sound. There are tapestries such as one could scarcely believe to have existence, such as the 'black tapestry' of Zamora in the *sala capitular*, or up a winding stair.

13

Some Tapestries of the Gothic Age

Fine tapestries of the Gothic period are at once the most poetically evocative, the most involved, and the least fully documented of all artifacts of the so-called Middle Ages. This latter qualification through no fault of those engaged in research upon them, but because by their very nature and in their mere texture or fabric they lend themselves and are a pawn to mystery. Moreover, in the majority of instances it has not been possible to name the draughtsman who designed them, let alone be certain on which loom they were woven, whether in Arras or Tournai to name the two chief centres of their manufacture. In every case it would be true to say, these tapestries are crowded compositions packed with figures that should betray their author by tricks of handling, or certain little familiar and identifying details. How many dozens of men, women, and animals in the Hardwick *Hunting Tapestries*, each of the four hangings over thirteen feet high and up to forty feet long, yet their anonymity of authorship is unbroken and complete! The set of tapestries of the *Trojan War*, perhaps originally twelve or more in number – of which four are at the Cathedral of Zamora in Spain – making an estimated total length of some hundred and twenty-five yards of tapestry and with evidently some hundreds of figures portrayed, are no less nameless as to their designer. From which it is perhaps to be deduced that these productions which are so unbelievably rich in poetry took little account of the draughtsman who was necessary and inevitable, but as soon forgotten in most cases as the librettist of an opera, and that both patron and loom-owner were only interested in the finished tapestry which might take years to complete.

Certainly the patron had to be given his money's worth, and not a corner of the tapestry was to be without its figure or its field of flowers. Any emptiness was unthinkable, even in the sky which must at least be filled with hills or clouds. The likeness between the theme or subject of a tapestry and the libretto of an opera can be pursued further, the tale told in a tapestry, still more in a whole set of hangings, being extremely involved and difficult to follow. In the *Trojan War* tapestries, aforementioned, the authority was Benoît de Saint-More's interminable thirteenth-century *Roman de Troie* purporting to be based, not on Homer, but on an alleged Greek

and a Trojan eyewitness of the siege. Another, and later source was the manuscript specially compiled for Philip the Good of Burgundy who claimed Jason as a mythical ancestor of his family, hence his foundation of the Order of the Golden Fleece, snatches or quatrains from which, and other endless libretti appear in Latin Gothic inscriptions in many tapestries. It is to be remembered that only the learned, then, could read, and detailed explanation must have been tedious indeed. But tapestry could not exist without a subject, and as with the words in opera almost anything would do. And yet as with an opera it is the music that counts, and what is only a cartoon crammed with figures comes to life upon the loom. In most cases it is doubtful whether the original designs would count as works of art; but when the figures are woven lifesize in all their patterned dresses, and the foreground is alive with flowers according to the imagination and skill of the craftsmen, then the tapestry if still crowded and inchoate in story or narrative may emerge, cathedral-like, and among the co-ordinated, if anonymous wonders of the Middle Ages, only anonymous, though, because we cannot find out their names. Yet names they had, and it is certain they employed specialists for the faces and the hands, others, too, in all probability for the patterned dresses and minor craftsmen for the fill-in of flowers.

It was of course a commercial undertaking like all others, and not as we might surmise from our delight and pleasure in them, mere poetry-making. But if the names of both designers and craftsmen are hard to come by, at least the weavers and owners of the tapestry workshops are known by name; and of course on occasion the owner of a workshop in Arras or Tournai would himself be a painter and designer of tapestry cartoons. Perhaps the most active of tapestry-contractors or high-warp weavers of Tournai was Pasquier Grenier who worked in great part for the Court of Burgundy, producing among others *The Story of Alexander* in seven hangings; the *Knight of the Swan*, another mythical ancestor of the Dukes of Burgundy, woven with silver and gold thread of Cyprus; 'country' subjects like *The Woodcutters*, 'peasant folk and woodcutters who are seen working and labouring in the woods in divers ways'; and 'chambers of orange-trees and of woodcutters' for the Duchesses of Bourbon and of Gelderland.*

There is continual confusion and uncertainty between the tapestries of Arras and of Tournai; Arras which has always been in France, and Tournai which was French territory at the time of the Gothic tapestries but became a part of Burgundy early in the sixteenth century and is now Belgian. The two towns, which are in any case French and not Flemish-speaking, lie less than fifty miles apart. Tapestries were also woven in Paris, as witness Pierre Baumetz, weaver of tapestries 'with fine Arras thread' (1385–99), who also sold hangings with figures of knights and ladies, and cushion-covers 'with white ewes under golden-yellow hawthorns' – a botanical

* *French Tapestry*, by Roger-Armand Weigert, London, 1962, p. 59.

flight of fancy? – 'on a green field'.* The Duc de Berry, owner of the greatest collec-
tion of illuminated manuscripts in the world, had 'a swan-chamber' composed of
backcloth, canopy, counterpane, bed-curtains, cushions, and six or more tapestries
of various sizes, all worked with the swan motifs.† An idea of the enormous numbers
of tapestries owned by such personages as the Duc de Berry or his brother Charles VI,
and carried about by them on their journeys as furnishing for the bare stone walls,
is provided by the progress of that same King of France and his court from Paris
to Reims in 1380–1, and the mention in his record of petty expenses of Guérin
Briquart, 'hook-maker, dwelling in Paris,' from whom two hundred hooks are
bought on 3 October 'for hanging the tapestries in the chambers of the King and
my lord the Duke of Valois, at Melun'; a thousand hooks a fortnight later; four
thousand on 1 November for the stay at Igny; and later, two thousand hooks for the
King's rooms at Reims.‡

There is the flavour of an encampment, of a town of tents about these tapestries
for ever on the move. By such means their owners made familiar surroundings for
themselves at the end of each day's journey. It is not unlike the removal from winter
quarters in Samarkand, as reported in *The Embassy of Clavijo* to Timur's summer town
of tents hung with the finest products of the Persian and Central Asian looms,
including, it is more than probable, specimens of the 'hunting carpets' that form the
only textile equivalent to the Arras and Tournai tapestries, and that within the life-
time of the next generation were designed by the school of miniature painters of
Herat and Isfahan. The Persian rugs were used like tapestries for wall-coverings but
in great circular or oblong tents, not in the draughty castle halls; while the Gothic
tapestries were given rough treatment, roped up in bales and put on mule-back
excepting, we may surmise, for those woven with silk, or with silver and golden
wires. There would be only the difference between a pattern of arabesques and
medallions, with lozenges, stylized cypress trees and identifiable flowers, roses,
tulips, and the ranunculus, and the 'swan-chamber' or 'chambers of orange-trees'
of the Duc de Berry and those high born duchesses in steeple hats or pike-horn
head-dresses. The choice lay between the abstract and the pictorial, with the accent
of warmth and comfort on Timur's summer town of tents, for stone walls could be
cold and bare even in the summers of the Île de France.

An empty ground was never part of the scheme in a tapestry of the Middle Ages,
and neither designer, weaver, or princely purchaser would for instance have under-
stood those empty green spaces that fill one half at least of Graham Sutherland's
tapestry of *Christ in Glory*, at Coventry Cathedral. It would seem to them a waste

* *Op. cit.*, p. 165.
† *The Art of Tapestry*, by various authors, edited by Joseph Jobé, London, 1965, p. 15.
‡ *Op. cit.*, essay by Pierre Verlet, p. 12.

both of time and money, and it must indeed have been dull work for the weavers during days and weeks on end. It would not in fact have been allowed to happen. The cartoons would never have been passed for work to begin upon them. Their business, and their inability or unwillingness to leave alone, is a reproach to be laid against the Middle Ages, but that kind of restraint and of holding the hand was not in their nature. Their energy was wholehearted and spilling over, and 'the little the more' dictum of Mies van der Rohe would be quite meaningless and incomprehensible to their minds. A space left empty was a breach of contract, almost, and as in a peasant orchestra they wanted all the instruments to play at once.

On the other hand this overcrowding which is so typical of the mentality of the time, amounts on occasion to the incomprehensible. An instance is in a fragment – there are four of them from a set of *The History of Titus* – preserved in Notre-Dame-de-Nantilly at Saumur. It is a battle scene, an extraordinary mêlée of armoured men and horses with not an inch between them for breathing space. At the first glance it is as though the well known battle paintings of Paolo Uccello in all their painstaking experiment in perspective and foreshortening had been laboriously taken, not cut, to pieces and patiently reassembled, jigsaw fashion, as a kind of patchwork. Horses' heads with staring eyes, in a panic from the clash of armour and the din of trumpets, are in the foreground, in no association with their riders; the only credibility, it could be said, a dying horseman, a black bearded and turban'd Oriental, perhaps a Saracen, pierced with a striped lance like a barber's pole, and with blood gushing from his side. The armoured Romans, helms, breastplates and gauntlets of blued steel, form a solid mass together, charging with the same set expression on their faces, while two focal points or directions in the tapestry are, respectively, a straight-bladed sword held in a mailed fist – but by which of the warriors? – point downwards, vertically; and on the other side of the tapestry, a curved sword or scimitar held forcefully downward with its jagged blade by a sleeved hand with some kind of furred covering for the forearm, near to the grimacing faces of both a bearded and a beardless Oriental; and a pair of pennons on long poles, the one fluttering in the wind of battle, and the other held still for us to see its device of a mermaid looking at herself in a glass but an inch or two away from the snarling trumpets.

The deservedly famous set of tapestries of the *Hunting of the Unicorn*, which have now transferred from the La Rochefoucauld family at the Château of Verteuil in Charente, via the Rockefeller collection, to The Cloisters at New York, are beautiful indeed, and from the aesthetic and certainly the poetaster's point of view more satisfying than the equally well known series of the *Lady with the Unicorn* – but those are lovelier still when called *La Dame à la Licorne*! – in the Musée Cluny at Paris. It is irresistible to take the two sets of the unicorn tapestries together, beginning with the *Dame à la Licorne*, there being six hangings in each of the series. The Five

Senses are the theme, it is supposed, of that number of the *Licorne* set of tapestries; while the sixth panel which is equally baffling and mysterious seems to carry a more direct and human message. All the set are woven on a pink or red ground, of perhaps too facile an analogy with the concepts of rose coloured, *couleur de rose, rose du Barri, la vie en rose, vin* or *champagne rosé*, even the 'rose period' in the paintings by Picasso. That is to say, the very colour ground of the *Dame à la Licorne* tapestries puts them in a category apart and to themselves as is indeed the case, too, in very differing circumstances with Boucher's tapestries on a rose-coloured ground. And if these latter seem to foretell the troubles of the Revolution, and to carry in themselves the seeds of rebellion against unheeding luxury, then the *Dame à la Licorne* set of tapestries only retreat further into themselves in mystery and poetry. Perhaps even they are more beautiful in theme or idea than on closer examination when their lack of depth, the islands of verdure – like flowering and floating meadows on which the figures stand in each of the tapestries, and the animals, birds, foxes, coneys, monkeys, lambs, sprinkled about the background which is but rose-coloured and sewn with sprigs of flowers, disappoints a little, even palls, but returns again ever mysterious and beautiful.

A lion, on occasion holding a pennon in both paws, and a unicorn appear in each one of the panels. The poles and banners in every case are emblazoned with three crescents argent, or, in fact, half-moons, which have been identified as the arms of the Le Viste family, 'of the higher bourgeoisie, originating in Lyon', a phrase that it is true effects a minor fall or declension in poetry in the reading, so extreme is the romantic tension in this set of tapestries. For the potency of which we have an unexpected witness in the person of Georges Sand, but, then, her youthful association must be remembered with Chopin and with Liszt, and the fact of her having heard strains of music from these two great musicians so often on summer days and evenings thirty years before this when they were her guests at Nohant. The *Dame à la Licorne* tapestries were then hanging in the Château of Boussac in the Auvergne when Georges Sand arrived there on an October evening in 1870 during the Franco-Prussian war, shortly after the disaster of Sedan. She writes of the experience in her *Journal d'un Voyageur pendant la guerre*, by that time an old lady herself and travelling with her granddaughter. Perhaps on this temporary return to the romanticism of her youth Georges Sand was exaggerating and writing for effect, but she describes the wind blowing down the passages and under the door. Her candle flickered in that uncanny wind and she could not sleep. Then, she says, she remembered leaving a letter above the fireplace in the drawing room where three of the tapestries were hanging, and she took her candle along with her to get it. 'Le grand feu qu'on avait allumé dans la soirée continue de bouler, et jette une vive lueur.' And she recalls the story, long discounted, that the tapestries portray Prince Zizim, brother of the Grand Turk Bayazet, who was held prisoner in the Tour de Bourganeuf, and fell in love

with the mysterious lady in the tapestries. Georges Sand writes of the lady's costume and her different head-dresses, and ends: 'cette dame blonde et tenue est très mystérieuse, et tout d'abord elle a presenté hier à ma petite-fille l'aspect d'une fée'.* Of an Oriental prince there is no sign whatever in the hangings and it may be that the legend only arose because of the insistent heraldic crescent moons upon each tapestry. It is to be said, too, that the unicorn plays but a small part, little more than that of an enlargement of any of the other animals in the tapestry.

In the one of the set that represents the Sense of Touch, the lion not holding a banner this time but wearing a heraldic shield with waistband, looks at us with a silly expression while the unicorn, caparisoned in like manner, has less the air of a unicorn than that of one of the goats that in the past drew goat-carts at seaside spas and watering places. The lady of the tapestries, her long fair hair showing below her waist, clasps the unicorn's horn in her left hand to signify touch, and holds the standard carrying the family banner in her other hand. There is the sense in this tapestry that it is more of a *verdure* than a woven scene, and its red ground has darkened and coarsened with age. It is, also, inferior in quality of weaving to the other, Rochefoucauld *Hunting the Unicorn* tapestries, now in The Cloisters.

But the panel representing the Sense of Hearing is of another and better order. The mysterious lady of the tapestries plays a chamber-organ on a floating isle or raft of flowers while her maid works the bellows. Even the two wooden end-posts of her chamber-organ carry a lion and a unicorn; the lifesize lion with his plume-like tail rising neatly from his haunch and holding the banner in his front paws, has a pair of rabbits at his feet among the flowers, while the unicorn holding the banner between his forelegs turns his head to listen to the music. Behind the unicorn there stands a pomegranate tree. It is true that the reiterated figure of what is recognizably the same lady in different robes and headdresses in each one of the tapestries has its cumulative effect and begins to assert some kind of potency or magic. There must be some reason for her perpetual presence but she begins and ends in mystery. In the Sense of Sight the mysterious lady, seated, not standing on her raft of flowers and wearing, it is true, an Oriental-looking headdress, has the unicorn's forelegs on her lap while she holds a mirror to its face. One of the traditions concerning the unicorn was that it would run up and put its head on the lap only of a virgin or snow-white maiden. An oak tree and a pomegranate tree stand behind the lion and unicorn. There is a spotted stoat or weasel at her feet among the innocently playing rabbits; and the scene is set for the climax of *La Dame à la Licorne* where the lady stands before a flame-spotted round tent, emblematic of passion, the tent is itself patterned with pomegranates,

* 'The big fire which had been lit during the evening continued to burn and throw out a bright light … This blonde lady and her dress are very mysterious; and at first sight she seemed to my granddaughter to have the look of a fairy.'

and the motto *Mon Sevl Desir* is on the frieze of the tent, with the initials A and I, presumably those of the lady and her lover to each side. Who, then, were this pair of lovers, of whom the identity is but guesswork; and why should it be that this tapestry of local, probably Touraine weaving, not from the looms of Tournai or of Arras, and not even a tapestry of grand subject, but in reality only a set of *millefleurs* or of *verdures*, should assert this power of fascination? Did we but know the answer, we might know the secret, not alone of the *Dame à la Licorne* but, alike, of the *Dama de Elche* and the *Inconnue de la Seine*.

The *Hunting of the Unicorn* set, now hanging in The Cloisters, are more strictly beautiful, if less mysterious, but they too have secrets that it is impossible to solve. Whose are the initials FR on one of the tapestries? Are they those of François de la Rochefoucauld who was godfather to François I? Or whose, again, are those other initials A and E, the latter spelt backwards, that are tied together with a tasselled cord and worked in gold and silver in the tapestry with a fountain in the middle, which initials appear again on the collars of many of the hounds? These are French tapestries but, once more, of unequal execution, for the first and last of the set of six seem to be later in date, while this last of them which is smaller in size anyway, and the two additional fragments of unicorn tapestries, may not even have belonged to the same series. Certainly they do not appear to be from the same hand. But conjecture is of little use for nothing definite is known, which only adds further beauty to the *Hunting of the Unicorn*.

The first of the set is the *Start of the Hunt*, and were it not for the initials among the trees and on the collars of the hounds it could be doubted whether this tapestry belongs to the same set at all. It is inferior in weave, and the three noblemen in feathered hats with their greyhounds led before them to find the scent – one might be tempted to call them 'friends of Prince Siegfried' in *Le Lac des Cygnes* – are short and dumpy in build, their faces are characterless compared to the finished portraits, for that is what they amount to, in the four other of the tapestries, the flowering wood they walk in is more of a *verdure*, the flowers are in retail, so to speak, more than woven individually and, lastly, there is no unicorn in the tapestry. The initials are the only connecting link; and if this perhaps later tapestry replaces an earlier one that had been destroyed a few years before, the most that can be said of it is that it is a poor echo or reflection of some weaker counterpart of *The Night Hunt* of Paolo Uccello, but a result arrived at surely in entire ignorance of its fairy tale prototype.

In the *Unicorn at the Fountain* poetry once again asserts itself, and we are to understand that the animal has been found, a little improbably, within a short distance of the castle. It plunges its horn into the stream of water flowing from the fountain basin, and other wild animals, lions included, wait for it to do so to purify the water before they will drink themselves. On the left of the tapestry a lymer or *limier* with

peasant features – shepherdesses in tapestry were allowed to be beautiful, but never woodcutters or peasants – leading an initialled hound points to the unicorn, as though in fact the gentlemen out hunting had not seen it, and indeed all their faces are turned as though talking to each other, oblivious of the milk-white animal but a few feet away. They form, it must be said, a static row or ring around the fountain and at the moment play no part at all in the hunting.

The next of the tapestries is more animated. It has been called by commentators, indifferently, *The Unicorn tries to escape* or *Crossing the Charente*. It is but a token water that the unicorn is jumping with two spearmen waiting for him on the other bank. Close on his heels are many huntsmen and a number of hounds, but they are in pursuit and it is the pair of spearmen who have to stop him. The *limiers* on the far bank are unleashing their hounds, but even this tapestry is a little lacking in comparison to the pair of tapestries that follow.

The Unicorn at bay, or wounding a dog is no less than a marvellous experience in the beholding; no less so than first sight of the Hardwick *Hunting Tapestries* now, lamentably and to the lessening of their every attribute and every thing connected with them, removed from their home at Hardwick Hall or at Chatsworth, and in the hydropathic apathy of the V. and A. Museum. *The Unicorn at bay* is lively as Benozzo Gozzoli at his best in Pisa or San Gimignano; but the *Unicorn wounding a hound* would be the truer title for this tapestry. A brook runs through the flowering foreground with a stork or heron on the near bank, and some kind of coot or moor-hen disturbed and rising from the water. One huntsman is not across it yet, and is in the act of leaping the stream, as are a pair of greyhounds; and there are dogs of two breeds in all directions, for as well as whippets or greyhounds there are mastiff-like dogs with heavy jowls and ears. Men with spears are closing in from all sides, and in the very middle of the tapestry the unicorn stands head down on its front legs, kicking up its hind legs dangerously, and driving its horn into the back of a greyhound. One huntsman with a spear stands ready for it as soon as the unicorn lifts its head; while, at the back, another spearman is just about to drive his lance into the unicorn's hindquarters. The dresses of the hunters in this tapestry are rendered most elaborately with the usual clear distinction between nobleman and peasant or hunt-servant. The acrobatic pose of the unfortunate, poor unicorn is key to the whole scene and we look up from it to the fur-hatted popinjays at the top of the tapestry, and to the inevitable castle in the distance.

The death of the Unicorn is the last of the true set. It is being slaughtered in the top left-hand corner. Two spearmen run it through the neck and chest, a hound is on its hindquarters; and below the hunt is over and some of the hunters are walking home with their hounds. A hunt-servant, hatless, spear on shoulder, goes in front of them and has reached the middle of the tapestry, as ever, ankle-deep in flowers. Just

in front of him is a white horse, and a servant standing beyond it raises his hat to the lord and lady of the castle who have come out to greet the hunting party. Behind them we see the castle in full detail, with its barbican and towers, from the top of one of which a man larger than life looks down on the whole scene. Three or more ladies are with them, and also a young boy who fondles a hound and holds its paw in his right hand.

The sixth and last of the panels is smaller than the others and shows the unicorn brought to life again and lying in a round fence, chained to a pomegranate tree. The mysterious initials are to each side of the tree trunk, and we are to take in that the pomegranate bears fruit which are 'symbolic of life, and of the perpetuation of a family through numerous children', many of whom, doubtless, like the seed of the fruit before it is set will come to an early end. There is, too, the fragment of yet another tapestry which only shows a huntsman blowing a horn as though the hunt was still on, and inside a fence up which roses are climbing, the horned head of the white unicorn, only its head and neck and the head and upper part of the body of a huge hound, collared as before, but with a mysterious lady holding up a hand, her head to one side as though listening. This is once more 'une dame blonde et mystérieuse', with 'l'aspect d'une fée', or, indeed, of some sort of sibyl. We know to what she is listening, to what she is lending or leaning her ear, but what exactly is she expected to do next? With her right hand she holds back the folds of her long skirt perhaps because of the dew upon the long grass, and it makes her sibylline or equivocal person – she is not beautiful – a little more human and less that of someone from the Court of Elfhame.

In which sense the courtly humanity of the Middle Ages is to be seen with faded, yet dazzling brilliance in the tapestry of *Le Bal des Sauvages*, in the church of Notre-Dame-de-Nantilly at Saumur. It has been suggested that this represents the ball at the Hôtel Saint-Pol in 1393 when some of the young male courtiers dressed themselves up as wild animals in 'tunics of waxed cloth, smeared with resin and covered with fleecy linen tow', and the Duc d'Orléans trying to identify one of the masquers came too near and set fire to him with a flaming torch. In the ensuing panic five of the revellers were burned to death, and King Charles VI only escaped with his life because the Duchesse de Berry threw her cloak around him. But this disaster was scarcely the subject for a tapestry. It is more likely to be a scene from some courtly romance or poem which perhaps itself was inspiration for the fatal ball. In this tapestry, however, as perhaps nowhere else, are ball-dresses of the Middle Ages to be admired and seen. They are of course long and heavy and trail upon the ground, in time to the music of a wind band; five men playing from a balcony what can have been little more than trumpet fanfares with endless ornaments and variations. One of the knights even still wears his armour. The gentlemen have long pointed shoes, and take the ladies

gently by one hand. Steeple headdresses are displayed here in all their beauty, only rivalled by a tapestry in La Seo at Zaragoza, wherein are a group of young ladies in a room in a high tower wearing every imaginable form of this beautiful invention. It could be said that in this tapestry from the church at Saumur we hear the rustle of the dresses louder than the music of the wind band.

Much might be anticipated of a set of tapestries with *The Swan Knight (Le Chevalier du Cygne)* for theme, and there are various versions of it, all taken from a rhymed *geste* concerning Godefroy of Bouillon, ancestor of Philip the Good of Burgundy, and grandson of the Swan Knight. It is the French version of the Lohengrin legend. A piece of the earlier set, woven at Tournai by Pasquier Grenier for Philip the Good in 1462, and showing four scenes at once from the romance, is in the church of St Catherine at Cracow. At the top left hand corner Elias, one of the interminable list of vague *dramatis personae* is seen feeding his swans, six in number, with their long curving necks in arabesque, as it were, above a pair of pavilions which give shelter to ladies in high wimpled headdresses of delightful complexity, both princess and nun in one, and have long inscriptions in Gothic lettering woven along their cornices. And it is no less of a delight that a learned authority has noticed peculiarities of language in these rhymed inscriptions which relate them to the local dialect of Tournai, and thus give a fixed point to their place of weaving. It was in the same spirit of admiration that it was possible to read a year or two ago that an ornithologist and student of bird song had found differences of local speech in the singing of the blackbirds and thrushes. They sing in patois or country accents, and reveal their origin in that no less clearly than the weavers on the tapestry looms of Tournai.*

The later series of *The Swan Knight* are Brussels tapestries and date from just the turn of the late Gothic into Renaissance. It is an essentially mediaeval legend still Gothic in its dresses and its interpretation, carried out with the full forces of the new order, but in all the careful detail of the Middle Ages. Two of these tapestries out of an unknown number, for the rest of the set are lost, are part of the collection at *The Hermitage*, having belonged formerly to Sir Richard Wallace. They illustrate the beginning and the end of the legend of *The Swan Knight*. The first of them shows the *Marriage of King Oriens to Queen Beatrice*. After the wedding the King went to the

* The cartoons for the earlier set have been ascribed to Bauduin de Bailleul, who in 1449 produced the cartoons for the *History of Gideon*, woven at Tournai; eight tapestries with a total length of about three hundred and twenty-five feet, made for the Chapter Hall of the Order of the Golden Fleece. These tapestries disappeared when the Austrians retreated from Brussels in 1794. The cartoons for *The Knight of the Swan* have, also, been attributed to 'the circle' of Robert Campin (d. 1444), a painter of Tournai, cf. Mme Crick-Huntziger, curator of the Musée du Cinquantenaire in Brussels, and Chanoine Lestocquoy, curator of the Diocesan Museum of Arras, in different learned publications. A full bibliography, chapter by chapter, appears in *French Tapestry*, by R.-A. Weigert, London, 1962, pp. 191–4.

wars, and while he was away seven sons were born, each with a silver chain round his neck. The mother-in-law of Beatrice, who hated her, ordered her servant to leave the babies in the forest, and put seven puppies in place of them. But a hermit saved the children, and took the chains off all of them – except one. Without their magic necklaces the six children turned into swans. Only Elias, perhaps a disappointing name for him, grew up to become *The Swan Knight*. While he was still a boy an angel appeared, and he was bidden to go to his father and tell him the story of his birth; whereupon King Oriens was reunited with Queen Beatrice, and the second tapestry shows her return in triumph. It is only sad that in neither tapestry is there a sign of a swan, or much visual evidence of *The Swan Knight*, but both tapestries are thick with gold and silver thread and are carried out as though from the pencil of a Gothicizing Holbein, a youthful genius perhaps twenty years old – Holbein was born in 1497 – which would give a date of about 1520, the time of the last flowering of the Perpendicular style in England. It is exactly of that period that this pair of tapestries is reminiscent, not least in the faces of the figures which are like the finest portraits.

The Triumph of Beatrice shows her returning to the palace in a carriage drawn by white horses, and just as in an opera libretto, again, it is the telling but irrelevant detail that makes the supreme beauty of the tapestry, particularly in the groups of onlookers on balconies, and in the Gothic folds of the dresses of a pair of kneeling ladies, all of whom, their head-dresses included, are indeed worthy of Hans Holbein, though the cartoons have been attributed to an obscure painter, Jan van Room. Of particular beauty, too, are the borders which are woven with bunches of grapes, daisies, poppies, various fruits, and boughs of wild roses. It is nearly inconceivable that an almost completely forgotten draughtsman should have drawn the cartoons for this pair of tapestries that are worthy, we repeat again, of a Holbein but, then, their extreme beauty lies in the careful and enthusiastic rendering and execution. The tragedy is that others of the series, more demonstrably showing the legend of *The Swan Knight*, should be lost and gone for ever, and only lead a vicarious existence in what one can imagine for them.

The interminable libretti and the immense company of actors and mere walkers-on, the essential improbability of the action, all magnified as an illusion by several scenes acting at once – the unicorn for instance dead or dying in one scene and revived again in the next – together with the further unlikelihood due to the entire absence of perspective, are concomitant and necessary to tapestries as works of art. The foreground is for ever flowering. In tapestry of the Middle Ages it is always spring or early summer. At times, as with the archer shooting his arrow straight at the spectator from the middle of the '*Black Tapestry*' of Zamora, it is an actor playing a minor role who steals the scene. Or we take their pastorals and country scenes. The knight

of the rat-tail shoes, riding out crossbow on shoulder between the wild rose hedges in a tapestry from Tournai, 'fell amorous' of a shepherdess among her lambs; they lay and talked deep in the daisies and anemones through all of a thrush-throat afternoon in June. The swan on her citadel of reeds was safe from him, while he talked with this Melisande of the willows and the water meadows under the clouds of a summer day that floated with white coolness and snowy shade, sometimes preening their flightless feathers; no less than the white cob of the swans with beak like the laundry-peg the Gypsies sell from door to door, who launches noisily with much beating of pinions, till air-borne, and flies round in a low circle among the madrigals of wind in the poplar leaves, and then as noisily to earth again while they still talked among the anemones and daisies. After which it will come as less of a surprise to read that the incomparable *Hunting Tapestries* from Hardwick have been attributed to the looms of Arras, not of Tournai, on the strength of certain 'kidney-shaped flints' lying on the ground in the scene of the *Bear Hunt*, which stones 'rare and unusual in the Tournai region, are common in Artois'.*

Tapestries of religious scenes, which are no less beautiful in themselves than those chosen here for discussion, form no part of this chapter for the plain reason that in any work dealing however superficially with the Middle Ages religion has inevitably so large a part that it is a lightening of the subject to turn to other themes. Not, though, that they are readily distinguishable as such, as for instance in the *Life of St Stephen* in the Cluny Museum, where a young lady, ineffably beautiful, talks to a gentleman – it is of no use to call them 'man and woman' – on the flowering foreshore, while another lady in long black mantle and white sleeves like some grand abbess climbs aboard ship up a ladder, and with her back turned to us, like a great actress, keeps and steals the scene. But it is a relief in the end to change from religious to secular subjects, even where there are such marvels as at La Seo in Zaragoza, or, if even no more than a very few of them were visible at a time, in the Royal collection of tapestries in Spain, many sets of which passed by inheritance through the Dukes of Burgundy to the Emperor Charles v.

The fantasy of the tapestry cartoonist, later to bear last fruit in the *Tentures Chinoises* of Boucher, had their counterpart in the exotic interest roused by the discovery of the Indies. But to coincide with the dying age of Gothic this had to be concerned not with the Spanish conquest of the New World and the nearly incredible successes of Cortes and Pizarro, but with the early voyages of the Portuguese explorers round the Cape of Good Hope to India. Their theme is the lacquered Indies, an

* Mme Crick-Huntziger again. Cf. R.–A. Weigert, *op. cit.*, pp. 49, 50. The same 'kidney-shaped flints' have been noticed, too, in other tapestries with like result of attribution. 'The taste for head-ornaments of ostrich plumes' induces the same authority to attribute other tapestries to Tournai, not to Arras. *Op. cit.*, p. 69.

Tapestries
and
Needlework

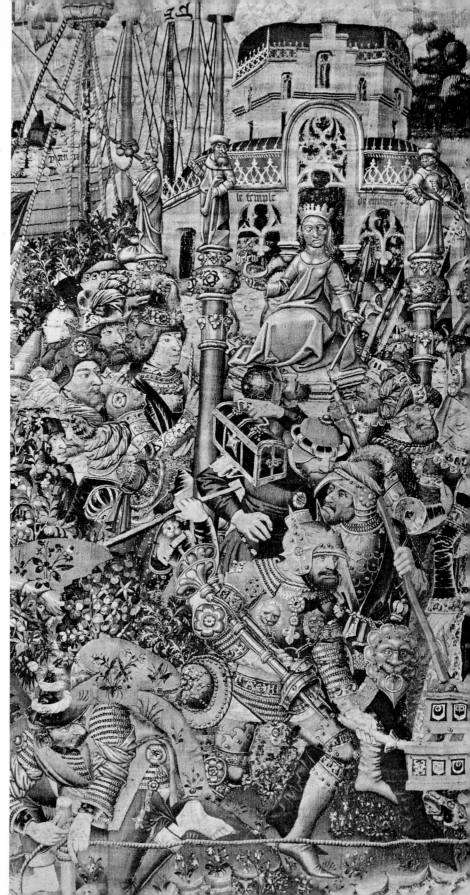

Scene from the
'Trojan War'
tapestries at Zamora

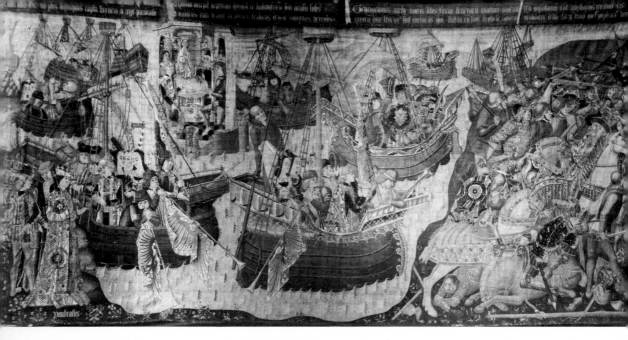

Above Scene from the 'History of Brutus' tapestries ('*Las Naves*') at Zaragoza *Right and opposite* Details from '*Las Naves*'

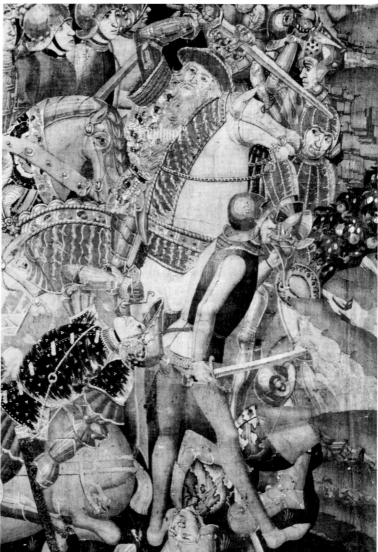

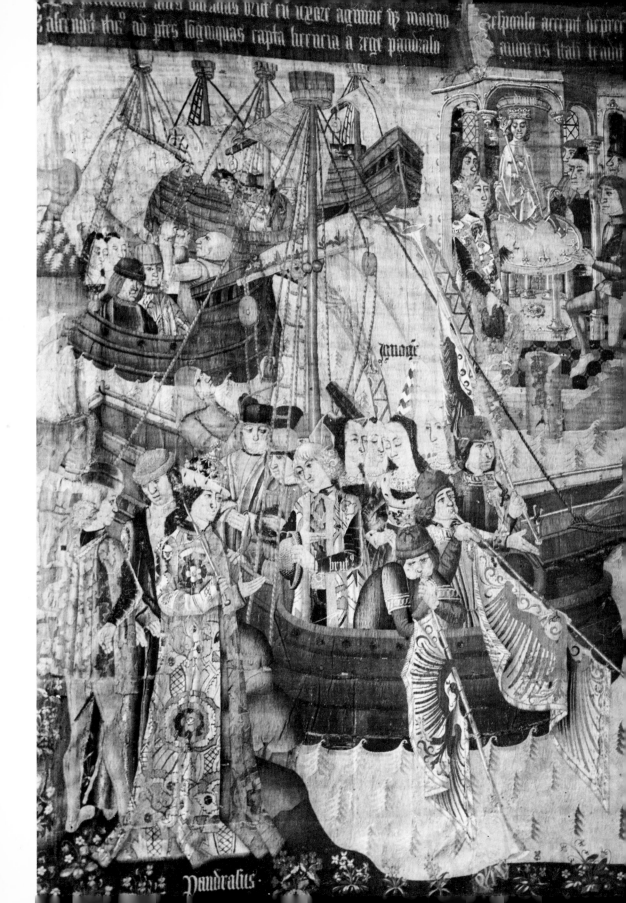

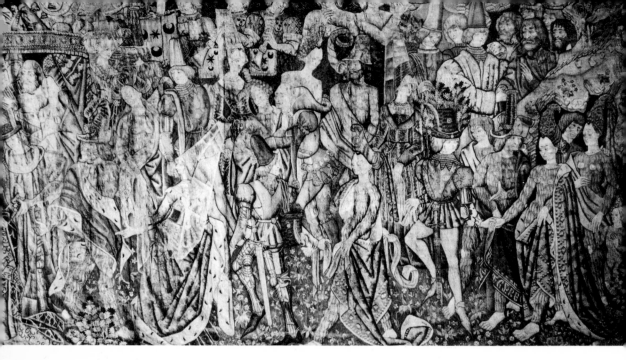

'*Le Bal des Sauvages*', or Dance of the Wild Men, from Notre-Dame-de-Nantilly, Saumur

'The Conquest of Arzila by Dom Afonso v of Portugal'; tapestry at Pastrana, attributed to the Portuguese painter Nuno Gonçalves

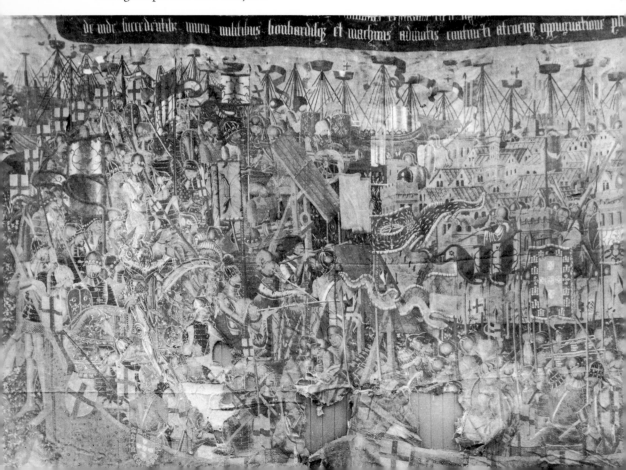

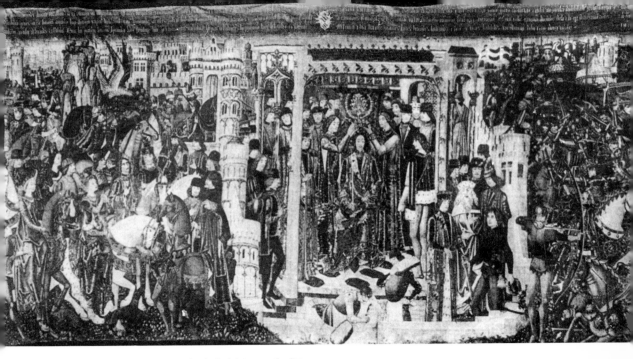

The '*Black Tapestry*' of Zamora

Architectural detail from one of the Hardwick *Hunting Tapestries*

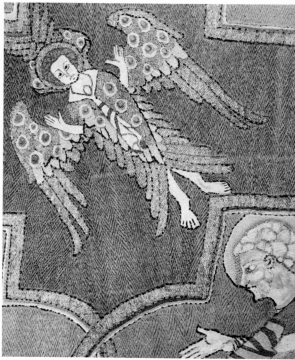

Above and opposite Details from the Syon Cope, of early 14th-century date

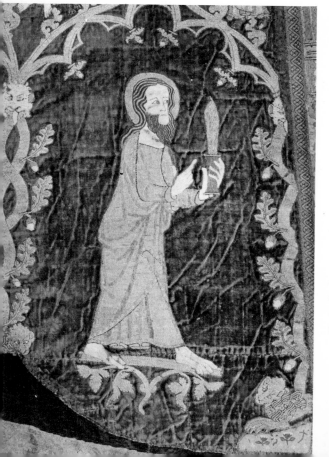

Left Two details from the Butler Bowden Cope, *opus anglicanum* of 1330–50; *top* St Edmund of Bury with an arrow; *bottom* St Bartholemew with a flaying knife

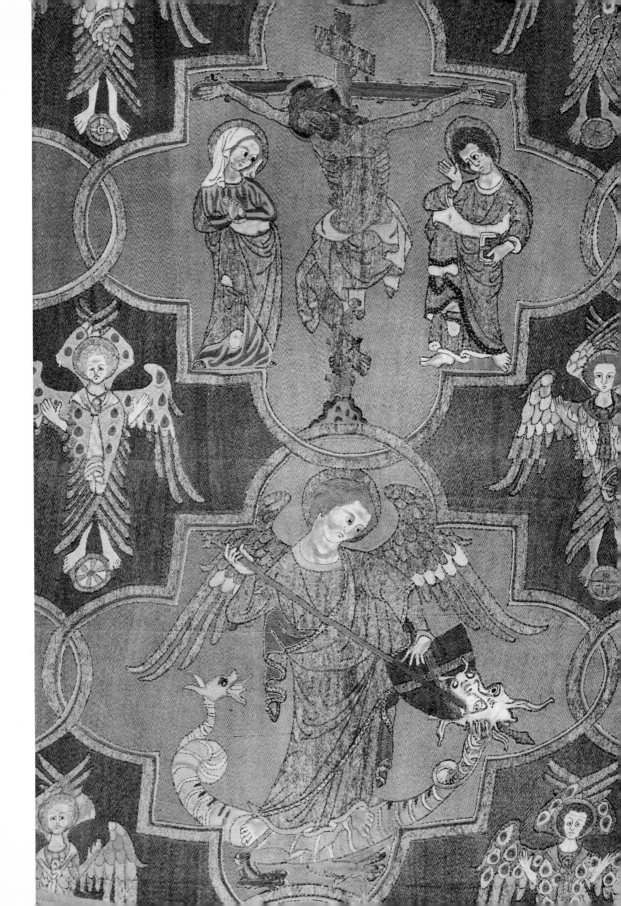

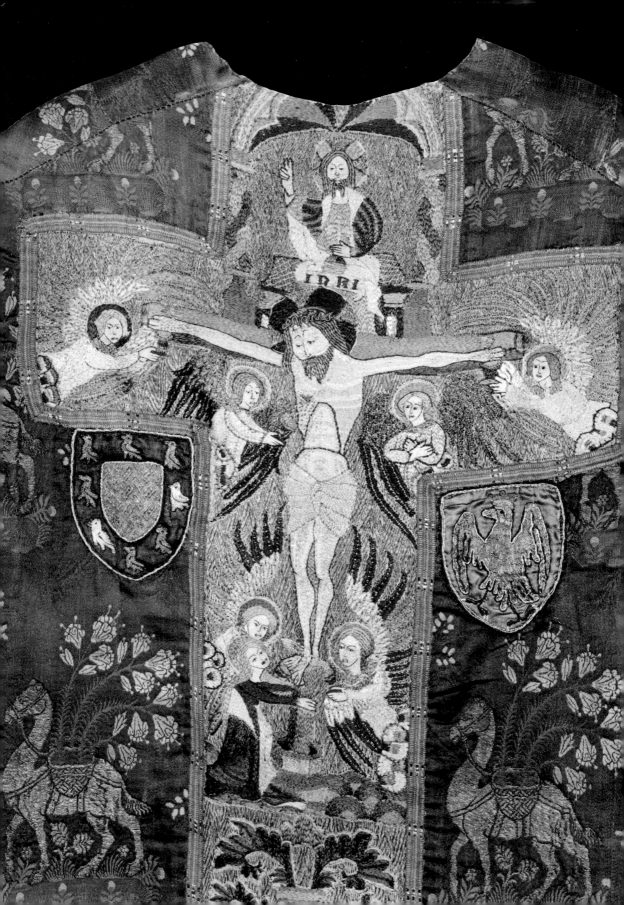

indeterminate locality of which there had not even been time yet to establish either distance or identity, but which hung vaguely in limbo of association with Ormuz and Coromandel, extending thence to Further India, past Kingdoms like that of Vijayanagar, of flowered chintzes and cottons, to the land of Bantam.

Such are the tapestries 'after the manner of Portugal and India' referred to in the Tournai archives, companion pieces to the travels of the early Portuguese explorers, translated though at several removes from their original, and further heightened in fantasy by the credibility of the cartoon designer. They are particularized in 1520 as 'people and savage beasts after the manner of Calkut', the Indian city at which Vasco da Gama arrived on 11 May 1498, when it contained 'many noble buildings, especially a Brahmin temple said to have been not inferior to the greatest monastery in Portugal'. Tapestries of similar subject are referred to mysteriously as the 'Voyage of Caluce' (1513) and as 'the caravan', a generic term intended to cover the whole enterprise and voyages of the fleets of Portugal. It is only a pity there is not as much left of 'the caravan', to make full use of the term, as of some other whole sets of tapestry. Not that there was the one series, so called, but of the whole constituents of 'the caravan', under sail together, there only remain certain elements scattered by storms and by the hand of time. Such would include the tapestries or fragments of tapestries, formerly in a private collection, of *The Triumphal March*; a *Lion Hunt*, one piece it would seem (for there is part of another) from a series on this subject; and a tapestry called, indifferently, *The Ships*, *Shipping the Animals*, or the *Giraffe Parade*, in fact a whole procession and embarcation of the animals; though in another *Ship Tapestry*, which it duplicates in part, we read that 'the animal that swings in mid-air about to join the three camels already in the ship, is a unicorn'. There could not be enough of such tapestries which would be a change, alike from the intricacy of their religious themes and the interminable and weak libretti from mediaeval romances. But the taste for them seems only to have lasted for a very few years from soon after 1500 to about 1520, and then the Portuguese explorers were superseded by the Spanish Conquistadors, but there are no tapestries depicting the conquests of Cortes or Pizarro.

At least, in the Spanish cathedrals there are other and incomparable tapestries in their stead. In particular at Zamora, where the archer out of the '*Black Tapestry*' of *The History of Tarquin* aims his arrow at us out of the tapestry as we climb the stair. In the rooms above are the tapestries of the *Wars of Troy*, four panels out of what was originally a set of eleven hangings. But I cannot repeat myself and write of them, as I did, in the first excitement of seeing these great works of art. One cannot discover things for oneself a second time. But neither, and there is as good reason for this, can I embark upon describing at length the tapestries at Pastrana which I first wrote of some forty years ago.

Opposite: Part of the 'Erpingham Chasuble', showing a pair of camels beneath the Crucifixion, English embroidery of the fifteenth century on Italian silk

Pastrana is a small village hardly more than a hamlet, some thirty miles beyond Guadalajara, in New Castile. The small church contains nothing of any interest, but rolled up on the floor of the sacristy so that one trod upon them, when I went there in 1926, were the tapestries, some two dozen in number if I remember right, of *The Conquest of Tangier and Arzila* (1471–4, in Morocco) by Alfonso V of Portugal, El Africano. Like the tapestries of Zamora, they were woven in Tournai and came to this remote place having been brought from Portugal by Philip II when it was part of his vast dominions, and given by him to the Duchess of Eboli, his mistress, who was also Duchess of Pastrana. One or two of the tapestries hung from nails in the wall, and these one could imagine in more detail than the others which had to be tripped over, and of which the stories could only be guessed at as they were unrolled before one, foot by foot. Most memorable was the tapestry of a naval battle with the Portuguese galleons coming into the harbour of Arzila and engaging the Moorish vessels which were of corsair build, thin and rakish, built for speed. Such details as the style of the portraits in the tapestries, and the shapes and handles of the swords, have suggested that the cartoons may have been the work of Nuno Gonçalves who painted the famous triptych at Lisbon with its portraits of Alfonso V; a man in a wide-brimmed black hat conjectured to be the half-Plantagenet, Prince Henry the Navigator; the monks of Alcobaça in their white robes; a knight in Oriental helm to signify the Moorish citizens of Lisbon; and a Jewish person with the *thora* to represent the rich and important Sephardic colony. It would seem not improbable that the painter may have been sent specially from Portugal for this purpose. It was not a difficult journey by sea from Lisbon to the Channel ports of Burgundy, and absence of a year or two was no grave matter in a more slow going age. Jan van Eyck made two secret journeys to Spain and Portugal on behalf of the Duke of Burgundy, Philip the Good, in 1427 and 1428, which is nearly half a century before Nuno Gonçalves had need to go to Tournai to design the tapestries of Arzila.

There are a number of tapestries at Santiago, but on no fewer than four visits there I have never found them to be interesting. At Tarragona in a room in the cloisters is the beautiful tapestry of *La Buena Vida*, not much different really from its prototype of today, the chief thing missing being the motor-car and the aeroplane, our accomplices, and now less slave than master, in the delusion and snare of speed. The young women are there, but of Gothic feature, in high steeple hats and wimples. They are fully clothed; that is a difference. There is no swimming pool, or water skiing. But the ground is thick with spring flowers; the anemones, fritillaries, ranunculi of the north, the same flowers you would see in the water meadows round Oxford, or in Yorkshire. The 'Beautiful People' have arrived; and instruments of speed apart, what are lacking are the hibiscus and the frangipani, the bay of Acapulco and the palm fronds of the isles. And leaving the flowering cloister in Tarragona,

we are back in the world of travel allowances and taxation forms, of socialized industries and diminishing returns.

Other remarkable collections of priest-owned tapestries are at Palencia and at Zaragoza. Here, again, at Palencia the late Gothic Cathedral stays in mind but without leaving any very clear impression. What I remember is the thunderstorm which caused all the lights to fail so that we had to see the tapestries in the *sala capitular* by candlelight. They are Brussels tapestries worked with the arms of Archbishop Fonseca; a little late in date, too 'flowered' in the foreground and therefore too 'William Morris' in style though, doubtless, superlative of their sort. But in the *sacristía*, next door, the *St Sebastian* by El Greco obliterates any further memory of the flowering fields. It is one of the most extraordinary pictures ever painted, far outdoing any of the 'excesses' of our century, yet a painting pure and simple, and only to be compared in admiration but only semi-understanding to the hippogryph which disdains entry for the Derby because of its race. At Zaragoza the collection of tapestries from both cathedrals, El Pilar and La Seo, are now on view together in a museum at La Seo. There are Brussels tapestries of the *Virtues* and the *Vices*, in the late Gothic of those at Palencia, touched, that is to say, with the Renaissance. There is a tapestry of *The Crucifixion* which is beautiful beyond description; while other hangings have such details as the group of young ladies in a room in a huge tower, all in steeple hats, which are shown in every fantasy and variety. It may be that there is no other such place in which to study this extreme invention of the Middle Ages. But above all there is the famous tapestry of *Las Naves* which is of French, i.e. Arras, and not Tournai weaving. It depicts the nine galleons of the expedition of Brutus, nephew of Aeneas, to Aquitaine, and their passing the Pillars of Hercules for the coast of Aquitaine, which infers the mouth of the Loire. Brutus is already on shore; and the nine galleons of his fleet fill the foreground tossing on the swell, with horses on board, men-at-arms, and ladies in tall steeple hats. No less than the '*Black Tapestry*' of Zamora, or the *Hunting Tapestries* from Hardwick – this is a stupendous work of art.* French or Flemish these tapestries may be; but if I may be allowed to quote from myself, 'they have become as Spanish as the paintings of Hieronymus Bosch from the Escorial, or the Moorish arches of the mosque at Córdoba'.

* For a fuller account of the tapestries at Zaragoza cf. my *Spain*, 1950, pp. 86–88. For the *Hunting Tapestries* from Hardwick Hall cf. *The Gothick North*, 1929, pp. 74–79.

14

Manoelino

Any person about to set foot inside the Abbey of Belém, or the Jerónimos as it is known locally, for the first time is due for an unusual experience. For it is going to be unlike anything he or she has known before. And if it reminds you of somewhere – whether you have been there, or only know of it from drawings or photographs – then, just as quickly, the notion contradicts and cancels itself for after all this is a church and not a temple. It is a Christian country. And yet! Forgetting the light of Lisbon, the blue and white *azulejo* panels everywhere on the outsides of buildings, the barefoot *varinas* coming from the fishing-boats balancing the creels of fish upon their heads, the powder-blue jacaranda trees perhaps in flower, the beds of red and yellow cannas, forget the sunlight of Portugal and step inside!

The sensation of the interior is dark and very tall, now lighter, and very strange indeed. Now clear as clear up to the ceiling, but no less mysterious for that. It is one huge vaulted hall or transept without nave or aisles, which is a reason why it is suggestive or reminiscent of a temple. This transept is enormously wide and high, supported only by six huge octagonal pillars or fretted columns which hold up the vaulted roof. These do most certainly give the impression of huge palm trunks with ribbed leaves, but pollard up to the ceiling. We are in some kind of petrified, stone forest of arrested growth but with a roof of stone ribs and fronds above us, which must be at the same time a formidable piece of engineering. The interior of Belém has, also, been likened to a sea-grotto; and no one who has seen the futile ingenuities of which Indian craftsmen are capable would deny that it would not be beyond their power to so work in and inhabit some sea-cavern that in the course of time it emerged from their hands as a Dravidian temple.

One fluctuates in mind between these two impressions of Belém; a sea-grotto, though compared with what we are to see before long, curiously lacking in corals, madrepores and sea-motifs, or a tropical forest of lianas and epiphytes, even, for one almost looks to see aerial plants growing in the crevices, but there are none. Perhaps the restorer has seen to that and allowed no nonsense of the kind. It is the bare shell of Belém in its strange skeleton that is the interest, for Portugal is not a land of paintings.

There is nothing to delay us at the altars; less still at the sacristy which is like a chapter house with one central pillar. Even the tombs of the Cardinal-king, to whom Philip II of Spain was heir, and of the perilously romantic Dom Sebastião, a case, as it were, of arrested development – and the mental 'arrest' took over from him at the time of the Crusades in his childish history lessons – even this pair of tombs which are supported on black marble elephants are not interesting. It is just the fabric of Belém itself; and not even the two over-richly carved doorways to the church, one of them with kneeling figures of Dom Manoel I (1495–1521) and his wife, which are by the Frenchman Nicholas Chanterene, and not interesting to us in this context because they are in the late Flamboyant Gothic style of Rouen. As doorways, therefore, they are interpolations or interjections in another language.

And now into the cloister of the Jerónimos of Belém which is more extraordinary still, and as one could say of great acting or feats of musical virtuosity, among the more astonishing performances in the architecture of all the world. It might be thought that where it is a question of a cloister there is not much more that could be done about it. After the Romanesque examples of Monreale and of Moissac, and the dozens of 'beautiful' Gothic ones – but in the end, when satiety sets in, it can be the plants and flowering trees that are the beauty of them, and not their stone prison yard – after all the gamut of cloisters in France, England, Italy and Spain, it could be thought every variation had been tried and that all originality was at an end. But the person making such an assumption has not been to Portugal. He cannot have been to Batalha, or to Belém. At both places the conception of a cloister is given new meaning. Here, at Belém, it is a double cloister of two storeys. The shape of the cloister is unusual, to say the least of it. But, also, a flood gate has been opened and a whole new rushing mass or repertory of motif and ornament makes its appearance, to be seen nowhere else except, that is, in Portugal.

The large and high bays of this cloister are of three lights in the lower storey; but above, each light has only one pilaster in the middle which supports a double arch of unusual but characteristic design. But, also, the corners of the cloister at the Jerónimos are 'cut off' so that they form what looks like a double entrance below, and double entrance over that, to some grand sort of balcony or opera-box, wide enough to seat twenty or thirty persons, and of which one can imagine the stone rail with rich stuffs, carpets or shawls, thrown over it for the gala performance of a sacred mystery, bull-fight, or even *auto da fé*. It is of course nothing of the kind, and but the head of a staircase or a landing. And now the repertory of ornament begins to assert itself in full early Renaissance exuberance, for if the cloister is Gothic, or, at least, that is to say, Manoelino, certainly its motifs have the tinge of the new learning, although the new mythology makes its appearance, and armillary spheres, ropes and anchors are in evidence of the age of the great

explorers and of Portugal as a maritime power, first in the field of Africa and the Far Indies.

It could now begin to be apparent that the hand of perhaps more than one architect was at work upon this cloister and that the upper storey, as one might surmise, was completed later. It is those tell-tale arches of the upper storey which have the touch of Spain upon them, and recall buildings seen at Burgos, Toledo, and Salamanca. The upper storey, then, was finished by a Spaniard, in fact João de Castilho who may have come from the Basque provinces of Spain, but accommodated his talents quickly to the native idiom. But the architect of the abbey church, prime designer of the cloister, and inventor and arbiter of the new ornament was the mysterious Boytac, a Frenchman of uncertain provenance, and probably from Languedoc. It is he who, after attribution to others, is now accredited with the design of the Jerónimos, the cloister as well as the church, and as well, in the view of one eminent authority,* the traceries of the cloister at Batalha and the unfinished chapels (*Capelas Imperfeitas*), at the same time.

It has been said before that 'the Manoelino style is no longer so much of a mystery to those persons who know Salamanca, where we may see buildings of an equal fantasy but without that touch of India which was the result of the voyages of the great navigators'.† Though learned opinion as to attributions alters so quickly I think this is still true. But it only becomes credible if a few facts as to this era of exploration are stated. The population of Portugal under Dom Manoel I (1495–1521), after whom the Manoelino style has taken its name, was probably below two millions. They became explorers a generation or so before the Spaniards, largely owing to the example of Prince Henry the Navigator (d. 1460), whose mother was Philippa of Lancaster, the daughter of John of Gaunt, and who established himself near Cape St Vincent, at the southern extremity of Portugal, whence he sent forth during forty years, little ships of twenty-five to fifty tons, down the West African coast in the hope of reaching India, the land of spices. At the time of his death only Sierra Leone had been reached; Portuguese navigators who sailed out into the Atlantic some years before this, 'had seen a great cloud ahead of them, and perhaps remembering Dante's Ulysses, had fled home. But, in 1421, one of them pressed on, sailed into the cloud, and discovered the island of Madeira behind it.'‡ The Azores, in the middle of the Atlantic Ocean, were taken possession of ten years later, and after Prince Henry's

* Robert C. Smith, in *The Art of Portugal 1500–1800*, London and New York, 1968, which suggests solutions to many of the problems of attribution in Portuguese architecture. Amateurs of Portuguese wood-carving should consult the same author's books on this subject – *A talha em Portugal*, Lisbon, 1963 – and on choir stalls, *Cadeirais*, Lisbon, 1968, and, for the later period, his books on the Dominican sculptor *Frei Cipriano da Cruz*, Oporto, 1968, and the architect, *Nicolau Nasoni*, Oporto, 1967.

† Quoted from the present author's *Portugal and Madeira*, 1954, p. 98.

‡ Quoted from *Portuguese Voyages (1498–1663)*, edited by C. D. Ley, *Everyman's Library*, 1947, p. xxi.

death discovery after discovery was made. In 1488 the Cape was rounded, and in 1498 Vasco da Gama arrived off the coast of India, while in 1500 Cabral reached Brazil, and in the following year Newfoundland was discovered.

Hence arose the curious maritime empire of the Portuguese consisting, not of large inland colonies as with the Spaniards in South America, but of isolated trading posts, Sofala, Mozambique and Mombasa in East Africa on the way to India; Muscat and Ormuz in the Persian Gulf; Colombo in Ceylon; Diu and Cochin on the Indian coast; to culminate with their one great colonial city of Goa with its churches and monasteries, its inquisitorial halls and dungeons, and its *fidalgos* in their extravagance of pearl-shell window, farthingale and palanquin. Further still, the Portuguese had Amboyna, Ternate, and Tidore, the Spice Islands, and Timor in the East Indies; with Macao, in China, from 1557; while, in the meantime, Portuguese priests and explorers arrived in Abyssinia, the legendary kingdom of Prester John, and in Japan. It is because of this extraordinary generation of discovery centuries ago that Portuguese is still spoken, and there are the family names of Portugal, in Hong Kong and in Ceylon; along the Burman Gulf and even in Upper Burma; in the Moluccas and Malacca, and along the coast of Coromandel and Malabar; in certain West Indian islands (Trinidad, and an old colony of Sephardim from Portugal in Curaçao and in Surinam), in the whaling-post of Nantucket in the USA, and at other improbable places, even if by now the Portuguese blood has become of thin dilution. But these extreme exertions tired out and exhausted the mother country which, it could be said, never recovered from its near century of greatness. At the same time it inspired the Manoelino style, an extra-florescence imposed upon and growing out of the late Gothic, even if the upper cloister of the Jerónimos has touches of the Renaissance at second hand through the Spaniard, João de Castilho.

For to return to that double cloister which more resembles the stone surround of an open air theatre, it is not unfair to say that it has its full share of the braggadocio of the early navigators. Of a certainty there could not be applied to it, nor to the interior of the abbey church, the remark of Thomas Carlyle concerning the Chelsea Hospital of Sir Christopher Wren: 'I had passed it almost daily for many years without thinking much about it, and one day . . . I looked at it more attentively and saw that it was quiet and dignified and the work of a gentleman.' By a freak of history, we have the evidence of eye-witnesses to the Portuguese voyagers, contemporary to and unconscious instigators of the Manoelino style. It is upon seventeenth-century painted screens from Japan. These are the *Nambam Byobu*, *byobu* meaning screen and *nambam* meaning barbarian from the South, the direction from which the Portuguese carracks and caravels approached Japan. There they are to be seen strutting in their tall hats of Elizabethan fashion, in contrast to the lacquered hats of the Japanese courtiers; with beards and long moustachios, long, thin faces, short

doublets, and extravagantly wide breeches, their hands ever and always on their sword hilts.* These painted screens, or this small and special section of them, are in appendix, and in support from distant Japan, of the '*Capitanos*' in Jacques Callot's *Balli di Sfessania*, and of the *bravos* against lurid yellow backgrounds, sword in one hand, dagger in the other, off the painted plates from Montelupo. The *fidalgos* of the gold-ground screens are depicted as though in a state of perpetual nervous tension as, indeed, was probably the truth after world voyages during which perhaps as many as a third of the ship's company died of scurvy and other diseases. And the anonymous Japanese artists rise to the heights of fantasy when they get the *fidalgos* on shore a few yards away from their galleys, and their outlandish appearance and strutting behaviour can be portrayed full length. The Portuguese thus seen, setting foot into Japan, are only a little later in time than the builders of the Jerónimos at Belém. They belong to the next generation of mariners who were active from 1550 onwards, by which time, it is true, the Manoelino style was over and finished with, but the next generation of seamen and *fidalgos* must have been much the same in appearance. The accuracy of the Japanese screen painters, all allowance made for a strong element of dislike for foreigners and for caricature, being supported by similar painted screens, but with Dutch sailing ships and navigators for subject, whereon the difference between the Portuguese and Dutch is very clearly seen. There is no mistaking the Dutchmen for the Portuguese upon the screens.

The Tower of Belém, a few hundred yards further down the Tagus, except for its being built of white limestone, is as Moorish as can be until you come nearer and see that its battlements or crenellations are in the form of shields with the cross upon them of the Military Order of Christ. Then, again, the whole fort or Tower of Belém is roped in, baled in, as it were, by a stone cable below the battlements tied in sailor's knots; and the six little pepper-turrets have domed roofs, reminiscent, it has often been said, of the many little cupolas of the Koutoubia mosque at Marrakesh. We have but to ask ourselves what sort of a sentinel to expect for these pepper-box turrets, and the question answers itself – a little black-bearded man in helmet and breast plate, baggy breeches, and arquebus on shoulder – in fact the ghostly sentinel of Sofala, Ormuz, Bassein, and the rest of the forts of Portugal from all over the world, almost. This is the pattern of the fortified posts of Portugal, Moorish or not of aspect; and its architect Francisco de Arruda had worked on the fortifications of Safi and Mazagan in Morocco, whence even in the hostile conditions prevailing it is not improbable he had been to Marrakesh.

The Tower of Belém, dating from 1515–21, is said to stand almost at the point from which Vasco da Gama and other navigators sailed for India. There has been argument over the fact that the foundation of the abbey of Belém was anterior by

* A few lines quoted from my *Portugal and Madeira*, 1954, p. 22.

one year to Vasco da Gama's setting sail for India – the founding being in 1496 and the embarkation in July 1497 – but this does not invalidate the abbey from being vowed in celebration of the voyages of discovery, exploration being much in the air for it was no more than four years since Columbus had reached the New World, and there being intense rivalry in this matter between Portugal and Spain. The foundation stone was not laid until 1502 – by which time India was very much in the news. Dom Fernando Coutinho had landed at Calicut, burnt the town and pillaged it in 1509 – even if he was put to flight and had to sail away again – only eleven years after Vasco da Gama had first appeared off that coast – all this before the Jerónimos of Belém had risen far above the ground. There can be surely no question that the unique character of that interior must have been influenced by tales and conjectures about the Indian temples. As, also, that double cloister which is more than a little unlike anything else in Europe, even if it is in questionable taste.

The startling, perhaps over self-assertive originality of the interior of the Jerónimos had its precursor in the church of Jesus at Setúbal, inland, across the Tagus from Lisbon. This was an earlier work of Boytac, dating from 1494–8, and must have been an experiment on the strength of which he was given the order to work at Belém. This smaller apprenticework, as it were, makes one conjecture if any architect of the *Art Nouveau* movement can have worked harder to astonish and startle his public. Situated at the western and southern extremity of Europe, on the last shelves of hillside going down into the sea, and alive to all the rumours of new discoveries down and round the shores of Africa and on to India, it was a public perhaps sated with the old and impatient for sign and visual evidence of its own time. Uncertain of the form it was to take, and searching for an answer, a little contemptuous, too, of anything – the Isabelline Gothic for instance – that came to them from Spain, Boytac's experiments were immediately acceptable. In the church at Setúbal his innovations were more bold than beautiful, as was indeed to be expected. The interior of this former church of Franciscan nuns has its surprise in the shape of twisted piers or columns, in a shape not to be confused with the later Salomonic or twisted columns of Jesuit and other churches. They are in fact twined or plaited more than twisted, in a way suggested by twined rope or string. Against the whitewashed walls these six columns, each formed of three skeins of granity, grey stone that enrol and wind round one another, are startling enough in effect, and may have been both the pride and shame of the Franciscan nuns.

The next enterprise of the King Dom Manoel, the Jerónimos of Belém well under way, was the new addition to the church of the Military Order of Christ at Tomar. Considering that many of the navigators were, themselves, celibate knights of the Order, sailing under the red and white cross which is still found on lonely buildings along the African coasts on the sea-route to India – it is not a surprise that immense

pains and expense should have been undertaken at their mother church at Tomar, nor that motifs and imagery taken from the sea should have been predominant in the *nouveau art* of Tomar. The Knights of Christ had been accorded spiritual jurisdiction over all the conquests of Portugal and may have been, if only for a single generation, the richest Order in Christendom. It is the new nave added on to the original octagonal chapel of the Knights Templar – to whose property the newly founded Knights of Christ succeeded when the Templars were suppressed all over Europe – which is the architectural sensation of Tomar, if indeed this term is at all applicable for it is a coralline and rope and anchor and seaweed extravaganza more than it is a building. In any case it is a façade, an exterior wall, a sea-front or panoply of corks, bellying sails, emblems of the Order of the Garter – a much appreciated complimentary decoration from our Henry VII, it is evident – buoys, and every imaginable reminder or insignia of the ocean called into service and made use of for the purpose.

This sea-front, sea-façade, whatever we like to call it, is framed in by buttresses with what I have called before 'suction'-bases half-way up like the bodies of sea-anemones, one of them tied in, precisely, with the buckled garter of the Order, before it wriggles up again towards the crenellation or battlementing – which is in fact the pierced parapet along all the roof-line of the church, formed of the square cross of the Knights in combination with the armillary sphere which was the symbol of the navigators. And the crowning sensation of all this feverish originality is the two windows, one above the other, the lower being perhaps the less sensational of the two, but only by a small margin.

It appears to wish above all else that it could deceive us into thinking it is a rope-window, not made of stone at all, and it is impossible not to connect it in mind with the rather horrible imitation Palissy pottery made in Portugal with fruit and vegetable and crustacean motifs, as, also, with the garden chairs made of pliable reeds or rushes which are a minor feature of shopping in Portugal, and of a like unpleasantness of texture. Furthermore, this rope-window of ropes knotted over and over again as though to outwit a Houdini, then appears to be unknotting itself with an equal intensity of purpose, but with the help of unseen hands. But the upper window, which takes the place of the conventional rose-window, is still more outrageous in its flouting of the ordinary and expected. Most of its surface appears to be filled with the folds of a bellying sail, with more than a suggestion of cork-strung nets and buoys. Both above this window, and under the lower one, there is the representation of a human being; in the latter it is an Ancient Mariner, and supposedly is intended for a navigator. It can only be said in thinking again of this extraordinary affair attributed to Diogo de Arruda, brother of the builder of the Tower of Belém, an architectural extravagance to which I have been subjected ever since I first set eyes on it in 1926,

that had an architect of the *Art Nouveau*, Horta, for instance, or Guimard, who designed some of the early Métro stations in Paris, been asked to make suggestions for a building to be associated with ballooning, or with the early days of motoring, something might have come of it which was not dissimilar from this pavilion, which is not so much of the sea, itself, as of every symbol associated with sea-faring and the mechanics of navigation and exploring. A new vocabulary of design and ornament would need to have been invented only for this celebrating of ballooning, or of early motoring, only for this once and never again, and that is exactly the feeling engendered by a day spent at Tomar in looking at and trying to conjecture the reasons for this exhibition of harbour and sea-motifs all displayed on this one front of a building.

If Tomar is decidedly the most extreme example of the Manoelino there are others which qualify as beautiful and not wilfully eccentric works of art. Foremost among such are the pair of Manoelino doorways to the sacristy, and to a chapel opposite, in the abbey church of Alcobaça. They are of a brilliant and flashing whiteness, identified long ago as giving effect as though they were made of the finest *meerschaum* or sea foam. They are in fact composed from tree trunks and snapped boughs or twigs of coral. The tree-stems as they emerge from the ground have roots as though of coral, while their leafage is appropriately like that of seawood, that is to say, like fronds or tresses of petrified seaweed, as the boughs of both trees meet and entangle together over the door below. In their total dissimilarity from anything seen before one could be inclined to call them 'Indian'. But they are less that indeed than they are of association with the getting to India, and with memories or anticipations of the coral seas. They are assuredly in tribute to exploration and to the new worlds opened by the navigator, if in their imagery there is nothing of the New World as such. But then the activity of the Portuguese, their voyages to Brazil and to Newfoundland apart, lay in the opposite direction to that of the Spaniards. It was the spices of India they were after; not the gold of Mexico or Peru. This pair of coralline doorways at Alcobaça is suggestive not of rumours of the Americas of gold and quetzal plumes but of a sea-pavilion on some island en route to the real Indies. Not even the shade of dark Africa is upon them. They must date from perhaps 1510–20, at just the moment of the set of tapestries known as the 'caravan' and are almost the only other visual evidence that such a world of the imagination had existence. For it has to be emphasized that although the finest flower of the Manoelino they are stylistically very different from the riotous sea-wrack of Tomar, or the more specifically 'Indian' temple interior of Belém, but they complement as though in pride of coralline achievement this bare and needlessly cleaned and restored building of the Cistercian monks. The monastery itself having been desecrated and turned over for years to be a cavalry barracks, there is little sign left of its state when William

Beckford visited it and dined with the abbot on 'swallow's nest soup, and shark's fins prepared by a Chinese lay-brother according to the latest fashions from Macao'. A fitter memorial to its former greatness than the scraped and over-cleaned church are this pair of fantasy doorways that evoke the hot and southern seas.

The Manoelino additions to the great abbey of Batalha are by far more successful as works of art than anything either at Belém or at Tomar. The abbey had been founded by the King Dom João in commemoration of the battle of Aljubarrota in 1388, where he defeated the armies of Castile and achieved the independence of Portugal as a separate kingdom. Secure in his victory, Dom João married Philippa of Lancaster, daughter of John of Gaunt, who may have sent for masons from England to work on the building which in the result is a masterpiece of the fringed and chamfered Gothic. It is an architectural experience of high order only to walk round the exterior of Batalha so perfect is the stone panelling of its chapels, and the bridging or joining of the little fringed apses that lie between them. Moreover, even the stone of Batalha has a physical beauty, very different in its warm golden tone from the white limestone of Alcobaça. There is, also, the interest of the huge unfinished, uncapped piers of the *Capelas Imperfeitas* soaring up above the walls and roof of the church proper.

It was the son of Dom João, called Dom Duarte (Edward) after his Plantagenet forbears, who built out this octagonal structure beyond the apse of the original church. But it was to be an octagon of especial complexity and elaboration with a ground plan in which the central octagon would have had seven big chapels round it, not including that open or eighth side of the octagon which held the grand portal of entry to it, while these larger chapels in their turn were to have six pentagonal chapels in their intervening spaces. Coming up above all this, as just related, are the unfinished piers or buttresses that were to support the dome. This dome or lantern was never begun, and there is no drawing to show what it would have looked like. It may well be that the *Capelas Imperfeitas* of Batalha are better unfinished, as they have remained.

Dom Manoel I completed the ground plan, carried up the chapels to where the roof would begin, and built and completed the magnificent portal leading to them. The unfinished chapels, such as they are, seem to have been the work of the Frenchman Boytac, architect of the abbey church at Belém, and designer of the plaited or twisted columns of the church at Setúbal. But the portal shows another hand, and is attributed to Mateus Fernandes. This portal which is one of the supreme achievements of the Manoelino has at the same time Gothic elements in its very elaboration that relate it to Moorish and to Hindu-Moslem buildings. It is Moorish in its hypnotic repetition of the same motif, which is formed from the words of Dom Duarte's motto repeated over and over again two hundred times. This may

seem uninspired, but in fact the huge stone portal is unparalleled in fantasy. Where indeed is another such stone portal to be found? The answer lies in India. At the Gate of Victory or Buland Darwaza at Fatehpur Sikri, the deserted capital of the Mughal Emperor Akbar. This gateway to an empty city, 'seen from below is the half of a hexagon, standing forward with consummate boldness at the top of its great stair, one hundred and sixty feet from the bottom of the steps to the typical Hindu-Moslem "glockenspiel" canopies strung out along its roof'.* It is more masculine than the portal to the *Capelas Imperfeitas*, but it is not as beautiful. As to the more-than-'temperate zone', semi-demi-tropical nature of the decorative motifs in this doorway, the oft repeated motto apart, it is enough to say that there is the frequent appearance of a 'cone-shaped vegetable form called *massaroca*, thought to represent a magnolia kernel, the surface of which is covered with beads that suggest the grains of an ear of corn.'† Nothing certainly could be further removed from this portal to the *Capelas Imperfeitas* than the conception of a Roman triumphal arch, but that this is unique of its kind is no less than the truth. The effect it gives is of an extraordinary luxuriance and fertility of invention, while its complexity and assurance of ornament is of the late Gothic where that most nearly approaches the Oriental. In looking at it, and wondering at this great portal which is nearly fifty feet high, one is reminded of the Oriental inclination in the ornament of St Mary Redcliffe at Bristol, and *in petto* as it were, of the Roslin Chapel outside Edinburgh where some alien influence has been at work, in the latter place the work probably of one mason only, but of someone who must have travelled far from home.

The seven chapels of the rotunda have carved coats-of-arms in their vaulting which is carried sufficiently far to provide a canopy, if little more than that, to the Unfinished Chapels. In these again the hand of Mateus Fernandes can be traced though it has been suggested that on his death in 1515, Boytac, who is known to have returned to work here, may have been responsible for carrying the work further and starting on the ribs and piers that were to hold the lantern. This is because of a difference in the kind of ornament up there, and the promise of a prolixity of interbranching foliage had it proceeded further, that recalls Belém. The further unfinished stages of the chapel suggest another hand from that of the marvellous portal leading into that open octagon.

If the promotion of the Abbey of Batalha into the national monument of Portugal – which is understandable – and the consequent burial of two of its unknown soldiers, one from the war in France and the other from the campaign in Africa, in the chapter

* Quoted from *The Red Chapels of Banteai Srei*, 1962, p. 169.

† Quoted from *The Art of Portugal 1500–1800*, by Robert C. Smith, London and New York, 1968, p. 53.

house, with a sentry standing guard and a perpetual flame burning, have not contributed to the peace that should surround and invest this marvel of its great past, at least the Royal Cloister of Batalha has withstood the ravages of the bus-tour and the gaping crowd. In part because of its great size which can take a crowd of persons on one aisle alone of its four sides. It is indeed the cloister of all cloisters, filling and completing the theme and leaving no more to be said or invented where a court of open arches and a splashing fountain are the subject.

If this be again, as is thought probable, the work of Diogo Boytac, this Frenchman from Languedoc and expatriate architect was responsible for the two most daringly original cloisters in Europe, at Belém and at Batalha. And in parenthesis, for the abbey church at Belém, the Church of Jesus at Setúbal with the twining columns, and the upper part of the vaulting in the Unfinished Chapels. It is a formidable catalogue of originalities. In the cloister of Batalha the energies of Boytac – but his name looks more credibly French and from the part of France productive of such place names as Souillac, Aurillac, Figeac, or family names, Garrique (the actor Garrick), or Roubiliac, when spelt, not Boytac but Boitac – all the invention of this strange mind went into the design of the stone screens which filled the open arches. There are two principal patterns, into the derivation of which one can read almost any origin one likes. They are just stone designs of pleasing invention; or they can be 'an elaborate network of briar-branches, enclosing the armillary spheres that formed the "devise parlante" of Dom Manoel', in the one pattern; and in the other, 'a singular combination of the double cross of the Order of Christ with the stems and blossoms of the lotus, evidently symbolizing the enterprises of the Portuguese in the distant Orient'. Or, in other words, the briar-rose or eglantine stands for fair Lusitania with its Moorish and Semitic (Sephardic) tinges that are as strong, or even stronger here than they are in Spain, and the lotus for India and beyond. It is to be remarked once more that Albuquerque had conquered Goa for Portugal in 1510; Malacca was taken in 1511, with promise of the Spice Islands and even of distant Japan; Ormuz in the Persian Gulf in 1515, with obvious eye-witness to the mosques and palaces of Isfahan; and China attained in 1517. All this in the score of years from 1497 when Vasco da Gama left the quay of Belém to sail for India; while Diogo Boytac, be it noted, is known to have been at work in Batalha in 1509 and 1512, and again in 1514 and in 1519, in midst of these exciting years.

Or there is the alternate, and not less interesting theory that the stone grilles with which Boytac filled the cloister windows at Batalha are formed with ingenuity from vegetable shapes of artichoke, cardoon, and poppy. In fact in the stone traceries there does seem to be direct imitation of the scaled petals of cardoon and artichoke which overlap one another rather in the manner of the scales of an armadillo. But though from the hand of Mateus Fernandes and not of Boytac, this should come as no surprise

so near to the *massaroca* or magnolia-kernel motif of the *Capelas Imperfeitas*, or 'the incomparable grace of the flowing foliage of a water plant surrounding the outer rim of that doorway'.* It cannot, it is true, be advanced that cardoon or artichoke are in any form of association with the Portuguese early navigators and their voyages to India and China, yet it is beyond argument that the stone grilles of this cloister are inspired by the *moucharabiyes* of Egypt, and more especially of Morocco. We have seen that the brothers Diogo and Francisco de Arruda who built the Tower of Belém had been to Safi and Mazagan in North Africa and it is more than possible that the Frenchman Boytac had been there, too. And could it be Boytac, incidentally, who designed the pair of 'coralline' doorways of Alcobaça? They seem to carry his signature more than that of Mateus Fernandes of the Unfinished Chapels who does not display the far-fetched ingenuities of the Manoelino so much as a last flamboyance and exuberance of late Gothic, with Indian affinity and circumstance relating him to Mughal buildings worked on and elaborated by Hindu craftsmen. In the Manoelino style at its most inventive there is nothing direct of India. But, rather it is Indian by inference, and in ignorance; and the better for that, since thus it has to rely upon invention and not information.

The crowning feature of the cloister at Batalha is the well-house or lavabo in its north-east corner. This has an alabaster, three-storeyed fountain, with water splashing from one basin to the other; while the open sides of this well-house are filled with Manoelino traceries suggesting a portable screen, and that seem to be by the same hand responsible for the sacristy doorway at Alcobaça, that 'coralline' doorway which is prime signature and pattern of all Manoelino. Nothing can alter the impression given by this cloister and well-house that it was designed in knowledge, not only of the Courts of Oranges at Seville and Córdoba, but, also, of the patio or Court of the Lions at the Alhambra of Granada, the two former having been courts of ablution of the Moslems when both cathedrals (of Córdoba and Seville) were in use as mosques. As said before, if the portal to the Unfinished Chapels is of Indian affinity, this cloister is Moorish in theory, but carried in practice to a height of fantasy never attained by the artisans of Fez or Granada in their repetitive and endless repertory of honeycomb and stalactite. They had mathematical ingenuity and endless patience but were not avid for the seeking out and invention of new forms. It was not an Art Nouveau, a Nouveau Art the Moors were in search of; and they had not the inspiration behind them of new worlds discovered, of the world thrown open with fixed points seized and taken over as trading posts, all in little more than a decade of years. This was a sensation that fell to the lot only of the Spaniards and the Portuguese, who in theory divided these new worlds, old and new between them. The Portuguese part in all of which has been to some degree obscured by the

* Robert C. Smith, *op. cit.*, p. 53.

extraordinary exploits of the Spaniards against the Aztecs in Mexico and the Incas in Peru. But their own achievement was hardly less sensational, only it lay in a known direction towards India where Greeks and Romans had been before them, while that of the Spaniards was in a new world altogether.

The comedian Grock said that if Italy was the land of tenors, Spain was the land of clowns – and it could be added, of cloisters. Certainly if Spain and Portugal are taken together, this is true of the Iberian peninsula, compared with Italy or France. Another beautiful water pavilion in the corner of a cloister, but not daringly original like that of Batalha, is that in Barcelona Cathedral. It again is a court of orange-trees, if without the Moorish fragrance of Córdoba or Seville; and in another corner is the canonical aviary where the Capitoline geese are kept in reminder of the decidedly mythical Roman greatness of the town. But it is a cloister in conventional Gothic, and the hexagonal fountain pavilion or *Glorieta* at the monastery of Poblet is to be preferred to it. Other opinion would have it that 'the most beautiful cloister in Europe' is at the Benedictine monastery of Santo Domingo de Silos, which is not far from Burgos; a double-storeyed cloister of the middle of the twelfth century though the same authority dismisses as improbable the story that its capitals 'unsurpassed for wealth of invention and perfect execution' were the work of Moslem, perhaps even Persian slaves.* Its only rivals from the Romanesque age are at Moissac and at Monreale.

The great abbeys apart, Belém, Batalha, and Tomar – and the doorways of Alcobaça and the twisting columns of Setúbal – the other chief item of the Manoelino is the church of Golegã, near Tomar, among the olive groves. Here, once more, on the façade, are the by now familiar armillary spheres, while the *massaroca*, magnolia kernel motif has been identified above the doorway. And only a few years later the Manoelino style was dead, having lasted only for the lives of a single human generation. It was to be another two centuries before the 'Arcadian' Rococo of the North, and the region lying between Aveiro and the Minho began flowering, and it was no hybrid or descendant of the Manoelino. That was a freak flower or 'sport' of its own, of parentage between the not over-distinguished native Gothic and the spirit or *zeitgeist* of the great navigators. This is as certain as that the Palladians of Lord Burlington and his circle owned to Palladio as spiritual parent, or that Robert Adam was 'fathered' by the palace of Diocletian at Spalato. So let us call the Manoelino the 'love-child' of the Portuguese and the Indies; while the fact that none of its practitioners had travelled further afield than Safi or Mazagan in Morocco, or indeed set eyes upon their male parent, but intensified their romantic picture of him which was in most instances wide of the mark and bore but little resemblance to the original. The lotus and the magnolia-kernel motifs, the obsessive interest and

* *History of Spanish Architecture*, by Bernard Bevan, London, 1938.

insistence upon sea-motifs, fishing-nets, cork floats, tie-sails bellying in the wind, and so forth, are sign-manual of the children of 'the caravan', 'that generic term intended to cover the whole enterprise and voyages of the fleets of Portugal'. And by chance, on the very furthest shore they reached to, the *fidalgos* are to be recognized in waspish finery on their arrival out of the empty distance on the painted screens of Japan.

15

Charivari of the Gothic

To the traveller arriving in Morocco by road from Algeria before the incipience of air travel, and expecting nothing better or very different, the reality was equivalent to finding a supposedly vanished civilization still flourishing and in being. Here was Moslem Spain still unspoilt, a sensation made the truer yet more inexplicable by the frequent fair hair and blue eyes of the Berbers and by the feeling that there is as much or more of Spanish blood in Morocco than there is of Moorish blood in Spain. But the overwhelming impression is – or was – of an arrest in time. It was back to the century of the long gown, the pointed hood, and characteristic and peculiar shoes. This, with a Biblical or Semitic slant or lien upon wool and mutton – pig's flesh forbidden – upon primitive dying vats, and men running round with dyed legs and arms; leather-tanning, more especially of goatskin; water-sellers shouting and jangling their wares; and cedar beams, their smell and substance in far off echo of Solomon's Temple. And of course the veiled women.

The arrested moment, then, if no longer now an eternity in time, being our late thirteenth or early fourteenth century, which is equivalent we should remember to the seventh or eighth century of their Moslem era. But, then, Mohammedanism was of more instant, spontaneous success than Christianity. A long life span, shall we say, from 1270 until 1350, with only a bare electric light bulb here or there, tinned goods on a fly-infested stall, or the telephone wires outside a bank, to show that things were altering. Slowly, very slowly, and then suddenly with an appalling rush! How curious if they were to go the other way! For that has occurred, too, and could be happening now without our realizing. But visually, at least, little had changed here during the last four or five hundred years. And it was old already when the clock stopped, when time jammed and the stereoscope stayed fixed. When the lens was on Chaucerian England; and as though for Chaucer, who was born in 1340 and died in 1400, things had remained through his lifetime how he remembered them as a child.

With something new to our contemporary experience which is the incomparable grace and beauty with which young and old alike, moved, kept still, or walked

about. This is a phenomenon not to be noticed in any country in Europe, if we except the stride of the Gypsies, more characteristic than beautiful, as it can be seen in any town in Spain. But it is one of the first features to be observed in Morocco, if not in Algeria, Tunisia, or Egypt, where deterioration or contamination have gone too far already. It is to be recalled that in conversation with the de Goncourts, and in his letters, Flaubert speaks of a novel he had in mind. A book about nothing, precisely nothing; but in reality devoted to the mid-nineteenth-century Orient, to life in Tunis or in Alexandria; and a work in which his cynical despair of human beings would have found an outlet. The very savagery of contemporary Morocco would have inspired him differently; no less than it was an inspiration to the painter Delacroix who may have felt that at last he had found a land where the every day attitudes of human beings were interesting and beautiful. Perhaps something of the classical past, and of antiquity as that inspired Poussin to his painting of *The Ashes of Phocion*, had lingered in Morocco after it had left the rest of the world.

But this is only really the approximation of ideals, one to the other, as it could be equally well the stages of illness, or steps down to disintegration and disaster. Had we been able to see Chaucerian England with our eyes of today no doubt we would have noticed its many points of resemblance to Morocco, not least in the pose and carriage of all human beings from kings to beggars, and from bishops and knights in armour down to lepers. This is the coincidence of states of being, both having reached to the same stage of thought and feeling, and which found expression in their architecture and in other workings of their hands. In similar manner an approximation to the Baroque and Rococo is to be found, not only among the Muslim, but in India of the Hindus, in the temples of Angkor, and in the Buddhist abbeys of Nikko and Kyoto in Japan. That the Moors had attained, and quicker than we did ourselves, to the equivalent of our thirteenth or fourteenth century is indisputable to anyone in knowledge of their Andalucian past, or of the living present in Morocco. And there it stayed; to be discontinued after expulsion in the one place, and only be seen as the outer shell of its own past, and to remain moribund without further development in the other.

Of the mosques in Morocco, little is to be said, for not much more than their exteriors can be seen. It is the incidental, more than the particular in Morocco, that is interesting. But neither is there a Moroccan palace that can compare with the Alhambra of Granada, if it is not heretical to say that the red walls of its exterior in their forceful and masculine beauty far surpass the feminine elegancies of its interior courts and halls. Feminine for good reason, because the larger part of the interior of the Alhambra was intended only for habitation by the king, his women and children, and eunuchs; and although the work of building and stucco decoration was that of male workmen, something of the vacuity of its intention and destination entered

beyond question into the work in hand. They are interiors of lassitude and boredom, there is no doubt of that, very different from the life implicit in the horseshoe arches of the great mosque at Córdoba, which dates from only two to four centuries after the death of the Prophet Mahomet. Then, the Moors, and accompanying Berbers, had been fierce and warlike but, also, there were among them philosophers, mathematicians, poets, and musicians. Of all that ferment there was little left in Granada by 1492 when the Catholic Monarchs Ferdinand and Isabella took possession of the Alhambra. What else, though, or what more could be expected of its filigree pavilions and its finicking elegancies! They come to their culminating point in the Hall of the Abencerrajes and the Hall of the Two Sisters, the arched entrances to which pair of halls are fringed with stalactites, while both halls have the *media naranja* (half-orange) or honeycomb ceilings, works of elaboration which are dangerously decadent and *fin de race* in feeling. The dates of all this are just exactly what one would opine, or, in fact, from about 1350 until 1400, to coincide precisely with the reign of our Richard II who, the harem apart, which one would guess had little interest for him, would have felt more at home among its courts and fountains than its occupying monarchs, Isabella of Castile and Ferdinand of Aragón.

The same conditions, but not often of the same standards of craftsmanship, continued in Morocco but as though petrified, and in a perpetual or permanent state of Hundred Years War with all its attendant miseries and horrors. Perhaps the only aesthetic masterpiece in all Morocco is the Saadian tombs at Marrakesh, entry to which was only obtained in 1917; a tomb-chamber in which the ceiling is a marvellous work of inlaid cedar wood related to so many *artesonado* ceilings all over Spain, while its arches of honeycomb and stalactite are not surpassed at the Alhambra. And the date of this? It would seem to date from the time of the Saadian Sultan Ahmed El Mansour (1578–1602), but to all appearances it could date from the reign of our Richard II (1377–99). In other words it seems about two hundred years later than its real time. There is scarcely any appreciable stylistic difference between the Saadian tombs at Marrakesh and works which date from just the period mentioned as the heyday of our Gothic, in fact the sacred colleges or *medersas*.

Of which there is an example in Marrakesh itself, the Medersa Ben Youssef; but this is yet another petrified specimen looking to be late fourteenth century, and dating in truth from a Saadian Sultan who had it rebuilt in about 1565. A more genuine *medersa* is that at Salé, the old Barbary corsair port from which pirates, Moorish-Andalucian of origin, made raids as far as Iceland, and once took Lundy Island in the Bristol Channel. The *medersa* of Salé, built by the 'Black Sultan', Abou El Hassane Ali – who built the shrine of Bou Medine at Tlemçen in Algeria, the porch to which has the most exquisite of all golden stalactite ceilings – dates from

about 1540, as could be expected, but no *medersas* in all Maghreb compare with those of Fez.

It is to Fez that one must go in order to see *medersas* which in default of the mosque interiors are the city's salient architectural feature. A *medersa*, that in other lands of the Muslim, may be known as a *madrasa* or *medrese*, is a sacred college where the students can spend anything up to ten years of their lives. The limited curriculum consists chiefly of learning the Koran by heart, but for the most part they seem to lie about in the sun in the courts of the *medersas* letting time fly by. There are some six or seven *medersas* in Fez, the most beautiful of them being perhaps the Medersa Attarine which is near the Souk Attarine where the attars and other scents are sold. Built in about 1325, it has cubicles for some sixty students and a two-storey court which it is difficult to see otherwise than as a monastic cloister. The open arcades of the lower storey are closed – perhaps 'shaded' is the better word for it – with cedar wood screens or lattices (*moucharabiyes*) of intricate design, all painstakingly different one from the other, while the columns in between have panels of tilework or *zellijes*, the equivalent or paradigm for the Spanish *azulejos*, in patterns of rayed suns or stars. Above, and over the cedar wood beams which scent the cloister on a sunny day, are unglazed, only shuttered windows, under arches fringed in Merinid or Moorish Andalucian fashion with stucco stalactites, the wall surfaces being worked with intricate arabesque patterns cut or stamped into the plaster. The moment of one of the bearded theological students appearing at a window in his snow-white hood and *djellaba* is a direct evocation of our own mid-fourteenth century; here indeed like bees in amber they are embalmed in time. Moreover it is from the roof of the Medersa Attarine that one can look down into the court of the Kairouyine or Cathedral-Mosque, and conjecture what stalactite vaulting may lie hidden within the Alhambra-like pavilions to either end of its great court.

Other *medersas* of Fez are the Mesbahia, also for sixty students, with a beautifully carved porch and cloister of about 1345; the Cherratine of 1670 which is three hundred years, no less, behind its time; the Seffarine, Sahriz, and Sebbaïne, all lovely of name if not of the first order of beauty; and finally the Bou Inania, next in order after the Attarine, and of the best date, 1350, or thereabouts. Here, the Merinid style which is that exactly of the Alhambra reaches to its height, with bronze doors of impressive bulk, floors of marble and onyx, and coved ceilings of apiarist work with gilded cells in their hundreds and cornices that drip with golden stalactites. It could be that the mosques of Fez would disappoint were one allowed inside them, though it is difficult for the *aficionado* of all things of Spain not to wish to get entry into the Mosque El Andalousi in the quarter of Fez where lived the Spanish Moors from Seville and Granada. The mosques are forbidden, but there are the *medersas* and the drinking fountains, with horseshoe fronts tiled with *zellijes* and overhanging

porches.* If one were ever to forget that Fez is still, and likely to stay for some time longer a living city of the fourteenth century, it is but necessary to recall hearing a midnight conversation in the shadow of one of the gateways in its town walls, wondering who the two or three speakers could be who had so much to say; until at last they came, a hand on each other's shoulders, feeling their way out into the moonlight, and all of them were blind beggars. Such is an experience which could have happened in any mediaeval city, but which would have been improbable in the worst slums and rookeries of London even so late as Tudor times.

But there is another African town, indeed the metropolis of all Africa, where there is the living evidence of conditions approximating to our Middle Ages. The visual signs, that is to say, in the matter of buildings, though in this instance of slightly later date, for in their final phase they show points of similarity to our Perpendicular. Grand Cairo, as it was called, or *Le Grand Caire*, was the city where the fabulous tales of the Arabian Nights were set down, and Ali Baba's treasure had its origin in the robbers of the Pharaohs' tombs. As to the Middle Ages it is no less than the truth that 'during the fourteenth and fifteenth centuries building was in progress in Cairo on a scale that belittles even Venice and Florence, and a style had been evolved which allowed of strange and fanciful developments beside which the mosques of Istanbul might be the work of one man alone'. As, indeed, is the case for most of them were built by the Turkish architect Sinan, one of the great architects of the world, a Janissary and military engineer by training, no one knows of what nation, Greek, Albanian, or Armenian, who built more than a hundred mosques all over Turkey between his fiftieth and his ninetieth years. During the great period in Cairo the luxury of taste was of a refinement unknown elsewhere in the Occident since the time of Justinian. Under Saladin (1169–93) Cairo was more, not less, civilized than London or Paris. Nearly two centuries later they were building mosques like that of Sultan Hassan which are overwhelming in their grandeur. Its huge open court or sanctuary is one of the great effects in the architecture of the world, and as devoid of ornament as any modern building by Mies van der Rohe or Philip Johnson. The Mosque and Mausoleum of Sultan Qalaun are, too, on the same scale; as large, that is to say, as the town churches of Nuremberg, the Frari in Venice, or Santa Maria Novella in Florence; while the tomb chamber of the Sultan has its walls and pillars encrusted with marble and mother-of-pearl.

Both Sultan Qalaun and Sultan Hassan, who were father and son, were members of the dynasty of Turkish or Bahrite Mamelukes (1250–1382), so called because they

* The drinking fountains are in fact finer in Marrakesh than in Fez. There are three of them in Marrakesh; El Mouasine, with triple basins, Sidi El Hassane, and Echrob or Chouf, with porch and stalactites. This is the place, too, in which to mention the Medersa Bou Inania in Meknes, of the best period (1350–80) all worked with beams of cedar wood, cut plaster, and tile mosaic or *zellijes*.

began as 'white-skinned slaves' of Saladin and his dynasty, were trained by them as soldiers, and their barracks lay on the island of Roda in the Nile. In a manner reminiscent of the Shoguns of Japan, Beibars, the first of the Bahrite Mamelukes, brought to Cairo from Baghdad a descendant of the Abbasid Caliphs and allowed him and his successors to mount the throne, while the Mamelukes retained all authority. But the Bahrite Mamelukes were followed in their turn by the Circassian Mamelukes who held power from 1382 till the Turks conquered Egypt in 1517. It could be said that under the first dynasty of Mamelukes their finest mosques were tantamount to our cathedral building at all periods between the reigns of Henry III and Edward III, with indeed a good deal of one-way influence from East to West owing to reports brought back by pilgrims and Crusaders. Then, Egypt became more isolated from the West when the Crusades stopped, and with its lessened authority their architecture diminished in scale, constricted its area, but drew itself to greater height, and began to show natural affinity to our Perpendicular buildings of the reigns of Edward IV and Henry VII.

There is a certain mystery as to the country of origin of the Mamelukes. According to one authority, they are said to have been introduced into Egypt when Genghiz Khan was attacking Russia and the Kouban. A huge number of slaves and camp followers had accumulated in the conqueror's train, and the Sultan of Egypt is said to have bought twelve thousand of them, Tcherkesses, Mingrelians, and Abases to be his slaves. This sounds improbable, though it accounts for the arrival of Circassians in Egypt. But is it known for instance whether there was any difference in language between the two dynasties of Mamelukes? The first are called, loosely, Turkish, which could imply anything from Albanian or Balkan to Cossack or Georgian, while the second dynasty is specifically Circassian. Of whatever origin, they must have arrived in quantity, though a whole regiment of bodyguards numbering five hundred to a thousand may well have been strong enough to take over authority and rule Egypt. After the Turkish conquest of 1517 little more is heard of them, but the Mamelukes became powerful again early in the eighteenth century, when their number is estimated as being between eight and ten thousand. In the end they were massacred in 1811 by Mehemet Ali, the Albanian founder of the latest dynasty in Egypt.

Personal accounts of the Mamelukes from this last period when the Near Orient was in unchanging, cataleptic trance may give the picture of them in their years of power. The British Consul in Tripoli writes thus of them in 1816:*

The dress of the Mamelukes, almost covered with gold and silver, and adapted to constant riding, is martial and graceful. It is in the Moorish style, but unaccompanied by long

* *Narrative of a ten year's residence at Tripoli, in Africa,* from the original correspondence of the late Richard Tully, British Consul, 1816.

flowing coverings. Their heads are encircled with a rich embroidered shawl bound tight round their caps, leaving out a long end which hangs on the left side of the head, and which appears to be solid gold, from the richness of the embroidery, as does the breast of their habit. They wear their trousers extremely ample, and of the finest muslin, quite down to the ankle, with bright yellow boots and slippers. Their origin is not always known, but they are, in general, herdsmen's sons purchased in Arabia, Georgia, and the places adjacent. The Mamelukes are all extremely fair, have light blue eyes, light eyebrows, and little or no beard, a very white skin and a blooming complexion.

Thus, someone who had known the Mamelukes; and their characteristic wide trousers and head shawls with the long hanging end were continued in the uniform of Napoleon's Mamelukes. He had been impressed by their bravery at the Battle of the Pyramids in 1798, and formed a squadron of them which was attached to the Imperial Guard and fought with him in all his campaigns excepting Waterloo.

It was these men, then, or their like, who were not Egyptian, who built the splendid mosques of Sultan Barquq and of Qaït Bey. Sultan Barquq was first of the Circassian Mamelukes; and from these, and earlier more masculine buildings of the Bahrite Mamelukes, one must assume that there has been more than a climatic change in Egypt. But not only in Egypt; in Italy, and France, and England, too. Were the architects and craftsmen Egyptian? We must presume they were, but working under outside order and impulsion. Perhaps the clearest view of these buildings of the Mamelukes is to be had from the hundred and thirty year old work of the Frenchman P. de Coste in his *Monuments de Caire*★ (1837-9). He gives a *parallèle des minarets des principales mosquées* which is in fact an outline drawing of the minarets. It is as though, to quote from my own words, 'the minarets are as many in numbers, and show as much divergence and variety in themselves upon the same theme, as there are steeples of Wren's City churches'. Those, I wrote,

are of the sprinkler or sugar-castor order, of near affinity to silversmith's work of the time, what is shed forth from the openings in their tiers of diminishing octagons being the sound of the church bells. But the Mameluke minarets of Cairo are of thurible or incense-burner type ... The minaret-thuribles of Cairo are contrived, as it were, to shake forth the voice of the *muezzin* and call to prayer. They rise up tapering with the stalactite pendentives to their balconies, usually with an octagonal shaft and little domed pavilion or kiosque on the top, which is mere ornament and has no cell or chambers in it, but it just rings and echoes.

One can look from one to the other of them and compare their stalactitic balconies. This is particularly the case with the *Barquqiya* or Sultan Barquq for there is another mosque with a beautiful minaret next door. In the engraving in question there are no fewer than eight minarets drawn side by side for comparison, perhaps that of

★ P. X. Coste, author also, with E. Flandin, of *Monuments Modernes de la Perse*, 1867.

Qaït Bey being most graceful of all with its pierced balconies and over-fastidious finish.

But the East in all its legendary character is to be seen in the Tombs of the Caliphs, outside Cairo. Nothing in the Orient of the Muslim can surpass them; they are as unforgettable as the Taj Mahal or the blue domes of Isfahan. In part, because of their dusty and dramatic setting. It is the pair of domes of the Tomb-Mosque of Sultan Barquq which are shaped like casques or war-helms, and the pierced wooden lattices of the interior together with 'the crumbling disdainful grandeur of the whole', that give it aesthetic greatness. This, and the minaret of the Tomb-Mosque of Qaït Bey which dates from about 1475, is a hundred and thirty feet high, and represents the perfection of Mameluke elegance; and not only the minaret but its dome, as well, which is melon-shaped, and has a network traced over it to represent the veinings in the melon's rind. I can only repeat that the minaret of Qaït Bey is incomparable in its delicate fantasy and cool suggestion, making an Englishman feel he would like to take the architect and craftsmen on a return visit to see the fan vaulting of Henry VII's Chapel at Westminster Abbey and listen to their comments on that.

If we look for further parallels between Gothic at its different stages and other instances of the same state of mind as shown in the visual art, the arabesques of Cairo and the stalactites and honeycombs of the Andalucian Moors apart, and their kinship proved, then the next step is to tiled buildings and walls and domes of china. For which there are two areas in the Orient, and as many methods; that is to say, panels of pure tile mosaic, or the quicker method which could be called tile fresco. Both kinds of tile work are to be seen in Iran; all the interior of the Masjed-e-Shah or 'Blue Mosque' of Isfahan being done in tiles of the latter kind, while the entrance archway is in pure mosaic. But Shah Abbas wanted quick and dramatic effects which he could see completed in his lifetime, and could not wait for all to be done in tile mosaic. Thus the 'Blue Mosque', no more than the Taj Mahal is of our period. They are seventeenth-century in date; and it could be said with but little of exaggeration in the full blown Renaissance of St Paul's in London or Santa Maria della Salute of Venice. The dome represents a certain stage in humanistic conception and attainment, and this was something the Middle Ages never achieved perhaps because they were lacking in that contentment and complacency. That the tomb-chambers of the Mamelukes should be domed is no invalidation of the argument; it only shows that the Cairenes reached to this state in advance of their contemporaries in Northern Europe who were still engaged in the Flamboyant and the Perpendicular.

The domes of Sultan Barquq and of Qaït Bey and their minarets are contemporary to Brunelleschi's dome in Florence (1420–35), yet how different in degree of intelligence and in meaning! But neither are we to expect the workings of great minds

in pavilions and kiosks of china but rather they are the abodes of poetry and languor, which again must be of a different civilization from that of mediæval Cairo. Not that scenes of violence are entirely absent; on the contrary there is the traditional strangling with the bow-string but it must be against another setting.* Which is that of cypresses and running streams, with the snows of Bithynian Olympus as much in view as the Sierra Nevada at Granada, or the snows of Atlas above the orange groves and slums of Marrakesh. It has indeed an ideally Oriental setting, as physically beautiful as Tuscany, though it is unnecessary to follow the mid-Victorian writer to the end who says of it: 'Bursa is without exception the most beautiful place I have ever seen, with a situation reminding one of Great Malvern.' But it has, at least, suburbs planted with quince trees and with mulberry orchards, where the nightingale sings and the legendary munching of the mulberry leaf by the silk-worm has been heard. Probably Bursa is the most beautiful city in Asia Minor if we exclude Damascus, and it has the 'Green Mosque' or *Yeşil Cami*.

This was begun in 1420 by Mehmet I, Le Çelebi, *le grand seigneur*, though French historians in their turn exaggerate when they write of him as *le Louis XIV Ottoman*. But Bursa was the capital of Turkey before they moved to Adrianople, and then took Constantinople. The 'Green Mosque' is in the spring time of their ascendancy, if more poetically martial and dangerous than war-like, and reveals another state of mind from the second great era of that capital city of a large part of Asia, Europe, and even Africa, and from the minatory and metropolitan domes of the great Turkish architect, Sinan. The Green Mosque of Bursa is the *primavera* of their architecture, and as such shows the lingering of mediaeval feeling. It has been said to be the work of a Persian architect, but no one who has seen the mosques of Meshed or Isfahan would agree to this. It is coloured architecture but the colour is not Persian. Moreover the floral tiles are wholly different in conception. It is to be recalled that Bursa was a famous textile centre, the sumptuous silks and cut velvets with their patterns of 'exploding' tulips and carnations being the work, it has been thought, of Greek craftsmen. Surely, though, like the silk robes of the Turkish Sultans in the Old Seraglio, they are distinctively, unmistakably Turkish! The wonderful floral tile panels of the 'Green Mosque' were largely concealed and covered over until the young Frenchman Léon Parvillée, who was put in charge of the restoration of the mosque in 1863, discovered them beneath the whitewash.† Subsequent to this, much damage was caused by earthquake, and the pair of minarets of the mosque which had tiles of green faience were destroyed. The exterior is of white marble with tile

* The *turbéh* of the Sultan Selim II at Istanbul contains the tombs of seventeen of his sons strangled at the accession of Murad III, their brother, in 1579; while the latter's *turbéh* has nineteen sons buried in it who were strangled on the accession of Mehmet III in 1596.

† *Architecture et décoration turque au XV siècle*, by Léon Parvillée, Paris, 1874, with preface by Viollet-le-Duc. It seems to be proved that the tiles are the work of a Persian potter from Tabriz.

revetments, but it is the interior that is the revelation. It is not emerald green entirely, there is sapphire-blue as well, the prayer-hall is tiled in blues; but the pair of transepts to either side of it have hexagonal tiles with arabesques and flowers of wonderful brilliance of effect, the emerald-green tone predominating. The *mihrab* and its stalactite canopy or hood resembling a hooded fireplace are tiled; and there are little china balconies like opera-boxes, one of them for the Sultan, with little tiled rooms below them, perhaps for the Sultan's ladies.

The Sultan, himself, is buried nearby in the *Yeşil Turbéh* or 'Green *Turbéh*', which is a china octagon only to be described as entirely flowering or blossoming in tiles. Perhaps the treatment is more adapted to this smaller building of the two, which is a cheerful burial pavilion with nothing funereal about it, but certainly the 'Green Mosque' of Bursa as a whole gives a shock of delight. It is a new dimension or another element given to architecture, that it should possess colour. How far are we now from the flushwork of East Anglia! The other tiled buildings – which are in Portugal – are only in blue and white, and more often than not are disappointing. They are suited to garden seats, to sacristies, and to the inner walls of cloisters, but only rarely do they show enough of invention to justify themselves. Perhaps in the rows of halberdiers lining the steps of palaces at Lisbon; in the garden canal of Queluz lined with blue and white tile panels of a fleet in full sail; in the fronts of two churches of Carmelite nuns, standing side by side at Oporto, the whole façade of one of them covered by an immense panel in blue and white *azulejos* of nuns taking the veil; or at the semi-mythical local railway station in Portugal where the mid-nineteenth century mayor and corporation in bowler hats and the top-hatted railway officials await the arrival of the first train in tile-work; perhaps in these few instances, but not again! How beautiful, by contrast, are the flowering tiles at Bursa with the cypress motifs in their borders! In Léon Parvillée's book on the 'Green Mosque' they can be studied in detail in his coloured plates, where the balance of design is near perfection (pl. 42) in a pattern of tulips, from the *turbéh* not the mosque, a flower loved by the Turks and cherished by them because of its fanciful resemblance to a turban. But they were not the shape of modern tulips. They were specie (wild) tulips with long pointed and recurved petals from Anatolia and Persia; together with their hybrids which were the work of Persian and Turkish florists. In another (the following) plate in the same work, there is a superb example of two balancing sprays of flowers which are dissimilar, but achieve an extraordinary balance and harmony between them. The stylistic date, which is not the same as the real date of these floral tiles, is that of the working lifetime of Carpaccio (1490–1520), but that is according to the Occidental calculation of absolute time which is not necessarily correct, and the tiles in fact, as we have seen, date from after 1420. It is a date corresponding to the reign of our Henry VII (1487–1509) in this shifting calendar, where it equates, too, to

the tapestries of *The Swan Knight* and to the fan vaults of our Perpendicular ceilings.

The revetments of china at their most glorious, and carried a stage further so that they have the breath of the Renaissance upon them while they still have the vernal freshness of the Middle Ages, are to be seen in Istanbul. There are marvellous specimens in two of the smaller mosques, that of Rustem Pasha and Sokollu Mehmet Pasha. The mosque of Rustem Pasha, who married a daughter of Süleyman (Soloman) the Magnificent and Roxelana, is by the great Sinan; but his full Renaissance manner is tempered by the earlier, fresher breezes of the tilework, the *mihrab* or prayer niche being entirely patterned with blossoming trees wreathed with lilies, carnations, and the long petalled tupils. Other tile panels which are difficult to define in words have the 'exploding' carnation motif; long stems but with the fruit blossom flowering for convenience like the cydonia flowers straight from the stem; and a motif awkward to identify, but it is part poppy-head and part pomegranate. Sokollu Mehmet Pasha has an unusually beautiful polygonal minaret with openwork stalactite balcony – the minarets of Istanbul are generally disappointing compared to those of Cairo and only impress by number, the 'Imperial' mosques having four, and in one instance (Sultan Achmet) six minarets – and this mosque which was built by the Grand Vizir of Süleyman the Magnificent has china interior walls of utmost beauty and a pulpit or *minbar* which has a canopy or spire of tiles in the shape of the spired chimney-pieces of the Old Seraglio, a mediaeval form of chimney piece that still persists in Macedonia.

When, and if entry is allowed into the *turbéhs* of Istanbul, the full feast of Turkish tilework will be revealed. The *turbéh* of the Sheyzade, two sons of Süleyman by another wife, who were murdered owing to the jealousy of Roxelana, is reported to have tiles of flower patterns on a yellow ground, and there must be superb tiling in half-a-dozen at least of the *turbéhs* of the Turkish Sultans. They are jewelled burial chambers, no less; as proved in the beautiful *turbéh* of Süleyman which has a cupola with 'roses of rock crystal, *cabochons* cut diamond-wise, with emerald centres,' a tomb railing of ivory and precious woods inlaid with mother-of-pearl, and crystal chandeliers and ostrich eggs hanging from the ceiling. These little tomb-chambers of sinister interest and antecedent are something quite unique of their kind suggesting, as they do, an amalgam of a *schatzkammer* with an all male version of the dread happenings in Rillington Place.

The perpetual flowering spring of the tilework can be followed further, where it will be perceived how far removed it is from the tilework of Meshed and Isfahan, by seeking out the smaller mosques of Istanbul. In these the tile panels are memorable subjects in themselves and not mere arabesques however superb in colour and in patterning. Perhaps it is equivalent to the difference between a tune which stays in

mind and an Oriental improvisation in which the music is not written down. Were we living in another age than the present when the amateur has taken over the paint-pot and essays to be a Jackson Pollock, not a few persons could be better employed in taking down the flower patterns in the mosques and *turbéhs* of Istanbul, a theme which has not yet been made the subject of a book. What can be thought of the 'five floral panels in the mosque of Atik Validé at Scutari, where tomato-red vases hold sprays of blue fruit blossom'; of the 'lovely red-currant panels in the little Tekiedj Ibrahim Agha'; and panels 'with marvellous tomato-red borders' (a tomato-red made with liquified coral) 'in the mosque of Ramazan Effendi'?* What else is to be said except that such tile panels must be among the beautiful things of the world! There should be lovely tile panels, too, at the Çinili Cami or 'China Mosque', across the Bosphorus at Scutari, where is in any case another *minbar* (pulpit) 'with a pointed spire of faience', according to the same authority. Such works of art are not far removed in spirit from the pink-ground tapestries of *La Dame à la Licorne*, just as they fulfil the vision of the tiled pavilions of François premier, even of Louis quatorze. They are in the full vernal spring time which relates them, and brings them close to so many of the things treated of in this present book.

It is a mood that occurs in India, but not with the Mughal buildings which could in no sense be described as having anything of the Gothic Middle Ages about them. They are beautiful, but languorous and otiose. When more war-like in temperament and in conquering mood, which would be earlier and in the fifteenth century, some-thing other than this is to be expected and be found. In, for instance, buildings in what has been called the Pathan style, though stringencies of personal taste make it difficult to admire the Qutb Minar, the two hundred and forty foot high, five-storeyed 'Tower of Victory' outside Delhi, with its minaret-like balconies; or to agree with the mid-Victorian architectural arbiter and pundit James Fergusson that 'the Qutb Minar both in design and finish far surpasses any building of its class in the whole world'; and that Giotto's Campanile at Florence, 'beautiful as it is, wants that poetry of design and exquisite finish of detail which marks every moulding of the *minar*'.† The clouds of incense have of late avoided Giotto's Campanile as well as the Qutb Minar and been blown elsewhere, but one would think that Fergusson's judgement had for ever been reversed and proved wrong.

The Qutb is of red sandstone, never a favourite building material; but it is at least used to better effect in much later buildings in Lahore, where, at the Badshahi

* *Byzantium and Istanbul*, by Robert Liddell, London, 1956, p. 175.

† One of the most remarkable 'discoveries' of recent years has been the minaret of Jam, in the wilds of Central Afghanistan, which was unknown and unrecorded until 1957. It, as certainly, resembles the Qutb Minar of Delhi as the two of them together fail in comparison to Giotto's Tower. The mystery is the reason for this minaret, the second highest in the world after the Qutb, where there was never a mosque, nor, would it seem, a city of any size. Cf. *Apollo* for November, 1966, by Derek Hill, pp. 390–96.

Mosque which was erected by a minister of the Mughal Emperor Aurangzeb as late as 1675, the red sandstone façade has flower patterns in white marble encrusted or surcharged upon it with startling more than beautiful effect. It is a hybrid of architecture grand in scale but of eclectic and undetermined parentage, which like Brighton Pavilion, or even Sezincote, might cease from the transvestiment and appear in another guise as Gothic of any period requested. There is even an approach to flushwork but in more lurid colours, not the white, cream, ginger-coloured, or even purple, of our flint pits or of flint found upon our shores, but with tile mosaic of yellow, orange, and green, 'with blue and white predominating' and, moreover, in a novel technique. The flower patterns are cut out of long panels, even, of tilework, and then inserted bodily into the plaster, and fixed there into a glassy base by firing. In this manner designs of entire cypress trees, but of an intriguing blue, not cypress green, are obtained and applied to the facets of a minaret; and as well, trees resembling the *chenar* trees or silver planes of Persia, together with flowers, but more particularly it would seem, irises, both of which latter motifs might suggest knowledge of Kashmir. All this in the Mosque of Wazir Khan at Lahore, in Pakistan.

That a state of exuberant excitement and ordered confusion akin to the Baroque in Spain or in Southern Italy is approached in some Indian temples, is not to be denied. Particularly must this be evident in the temples of Belur and Halebid in Southern India. One of the temples of Halebid is star-shaped with sixteen points, covered from end to end and from top to bottom with carved friezes of deities and elephants, much of this in 'black hornblend stone which takes a dazzling polish', and Fergusson may not be exaggerating when he writes of it that 'the amount of labour ... is such as was never bestowed on any surface of equal extent in any building in the world', and that it may be considered 'as one of the most marvellous exhibitions of human labour to be found even in the patient East'. More astonishing still, the temples of Belur and Halebid lack the overwhelming erotic stimulus of the sculptures at Konarak and Khajuraho. The carved friezes and multiple cornices of Halebid date from the twelfth century of our era, but there is no point of contact whatever with the Middle Ages or the Mediaeval as we understand that.

Perhaps this anomaly reaches to its high point of incredulity with the temples of Angkor where the stages in aesthetic evolution seem to work almost in reverse order. The great temple of Angkor Wat – the ruin of all ruins – dates from the first half of the twelfth century in the full flowering of the Khmer style, while there is the disconcerting and extraordinary phenomenon that the shrines or 'libraries' of Banteai Srei, twelve miles north of Angkor, which were built by a Brahmin who was of royal descent and had been tutor or religious adviser to the god-king, date from two hundred years earlier – one authority, who must be telephonically-minded, if only incipiently as a beginner, has pin-pointed it to AD 967, no more, nor less – and yet it

has reached the stage of decadence that is the equivalent to Flamboyant Gothic in its pink sandstone, carved as though that were sandalwood.

It is difficult to believe that the carvings of Banteai Srei, which have almost the scent of sandalwood about them, can really date from a thousand years ago, so marvellous is their state of preservation. Yet, it would seem that this is ascertained and determined fact. Perhaps a true analogy to the Gothic of our Middle Ages is to be obtained from the multiplicity of little shrines under gilded spires along the platform of the Shwe Dagôn at Rangoon which could so easily be mistaken for the stalls of a fairground. Here, and in the glittering white pagodas of Mandalay, which had dragon-barges on its royal moat among the lotuses, and 'glass monasteries', 'one mass of inlaid glass-work', upon the hills outside. Much of all this dating from the middle of last century; but as 'genuine', or not, as our mid-Victorian Gothic, that is the question?

Index

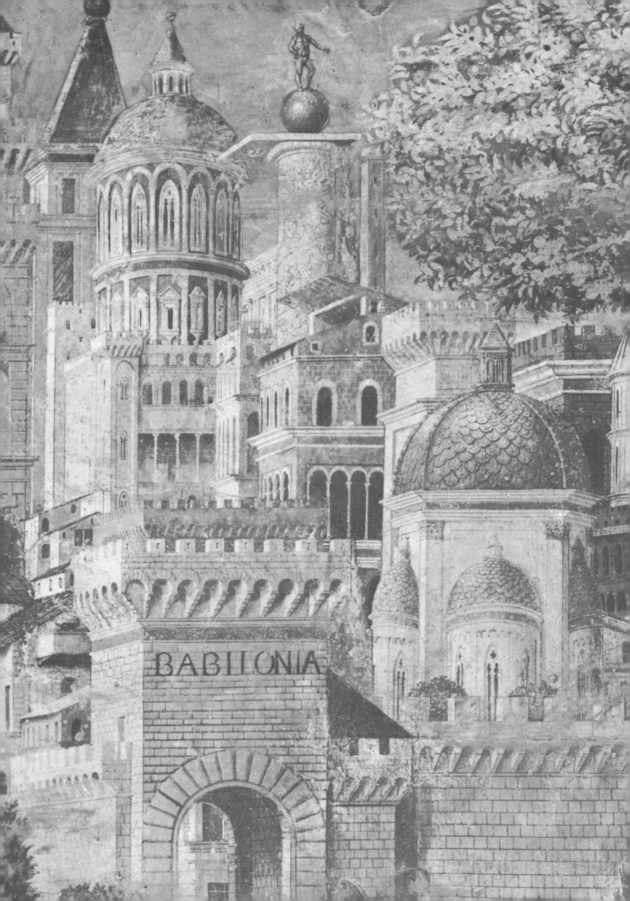